BASIL TAYLOR

Constable

Paintings, drawings and watercolours

PHAIDON

PHAIDON PRESS LIMITED, 5 Cromwell Place, London SW7 2JL

Published in the United States of America by Phaidon Publishers, Inc.
and distributed by Praeger Publishers, Inc., 111 Fourth Avenue, New York, N.Y. 10003

First published 1973. © 1973 by Phaidon Press Limited. All rights reserved

ISBN 0 7148 1594 2. Library of Congress Catalog Card Number: 72–79554

Printed in Great Britain
Text and monochrome illustrations printed by W & J Mackay Limited, Chatham
Colour illustrations printed by Henry Stone and Son (Printers) Limited, Banbury

Contents

For Geoffrey Grigson & John Brealey

Foreword

THE MAIN PURPOSE of this book is to provide what does not, as it goes to press, exist—a large anthology of Constable's pictures and of his verbal observations upon art and nature. The selection of plates has been guided by a wish to strike a just historical balance between the finished exhibition pieces and the informal works, while giving drawings and watercolours, actually so numerous, a minor place. My essay, apart from providing biographical and historical information, is intended as an interpretation of a relationship which, in the history of art, we can seldom study but which, in Constable's case, through the abundance of personal documents, must be the very condition of our understanding, that is the relationship between the pictures, the stream of his personal experience and his continuous commentary, over thirty years, upon his domestic and artistic affairs.

After looking at his work persistently for thirty years and always finding it more perplexing than general opinion has told me I should, I wish that it were possible to acknowledge an indebtedness to a large body of Constable studies, but no such debt can exist, for my reading list and other references, although incomplete, is not very selective. My first acknowledgement must be of the six-volume edition of Constable's letters published by the Suffolk Records Society and of its devoted editor, the late R. B. Beckett. Graham Reynolds's catalogue of the Victoria and Albert Museum collection has been a constant source of enlightenment since it first appeared in 1960 and I find his *Constable, the Natural Painter* the best short account of the artist to have been published since the first edition of Leslie's *Life*. Kurt Badt's book on the cloud studies may not be acceptable in every detail, but I still think it as suggestive and sensitive as I did when reviewing it on publication in 1950.

I must thank Keith Roberts for offering me the opportunity to prepare this book.

Those who have helped me in the experience of pictures and in the study of English art are too numerous to mention and my two dedicatees must be their representatives.

Acknowledgements

GRATEFUL ACKNOWLEDGEMENT is made to the following for permission to reproduce works in their collections:

Lord Ashton of Hyde (150); City Museum and Art Gallery, Birmingham (87); Museum of Fine Arts, Boston (41); Benjamin Britten (Figure 10); The Syndics of the Fitzwilliam Museum, Cambridge (Figure 13, Plates 49, 84); National Museum of Wales, Cardiff (169); The Art Institute of Chicago (165); Cincinnati Art Museum, Ohio (93); Colonel Constable and Mrs J. H. Constable (Figures 2–5, 7, 9, 12); National Gallery of Scotland, Edinburgh (108); Major Sir R. G. Proby, Bt., Elton Hall (18); Glasgow Art Gallery and Museum (90); The Ipswich Museums Committee (Figure 6, Plates 32, 36, 37); Nelson Gallery–Atkins Museum, Kansas City, Missouri (127); Leeds City Art Galleries (40); The Trustees of the British Museum, London (98, 133, 144, 146, 147, 152); Guildhall Art Gallery, London (148); Holloway College, London (79); The Trustees of the National Gallery, London (57, 72, 82, 119, 156, 170–5, 177); National Portrait Gallery, London (Figure 14); Royal Academy of Arts, London (29, 59, 60, 91, 99, 102, 109); The Trustees of the Tate Gallery, London (Figure 1, Plates 8, 9, 14, 26, 31, 43, 44, 48, 58, 94, 96, 105, 117, 122, 129, 130, 132, 151, 158, 160, 176); Victoria and Albert Museum, London (1, 6, 10, 12, 21, 23–25, 27, 28, 30, 33–35, 39, 46, 47, 56, 66, 68, 71, 74–78, 81, 83, 85, 88, 92, 95, 97, 101, 104, 106, 107, 110–112, 114, 115, 123, 125, 126, 128, 134, 135, 140–142, 145, 149, 153, 155, 159, 161, 164, 166, 167); Whitworth Art Gallery, Manchester (2); National Gallery of Victoria, Melbourne (7); Mr and Mrs Paul Mellon (4, 5, 11, 13, 16, 17, 22, 38, 45, 61–65, 67, 69, 70, 89, 103, 113, 120, 121, 124, 131, 157); The Frick Collection, New York (53); Ashmolean Museum, Oxford (20, 42); Philadelphia Museum of Art, (100, 116); The Trustees of the Lady Lever Art Gallery, Port Sunlight (15, 163); Henry E. Huntington Library and Art Gallery, San Marino, California (Figure 8, Plate 80); Toledo Museum of Art, Ohio (168); National Gallery of Art, Washington, D.C. (51, 86); The Phillips Collection, Washington, D.C. (162); Sterling and Francine Clark Art Institute, Williamstown, Massachusetts (50); anonymous private owners (Figure 11, Plates 3, 54, 55, 154).

Introduction

THE CONCEPTS AND PRACTICE of historical study, in all its forms, have been determined as much, perhaps more, by what is unknown and unknowable as by the verifiable or convincing evidence of the past which has survived. No part of this intellectual pursuit has been as evidently affected by such lack of knowledge as the history of art, and the most significant area of ignorance has been the personal identity of the individuals who created the pictures, sculptures and images in other media which are the primary objects of study. How different would be the methods and products of art historians if as much were known about the persons of Masaccio and the Van Eycks, Vermeer and Cuyp, Velazquez and Claude, let alone the cave-painters of Altamira, as we can readily discover about the personality of Van Gogh, his experiences, ideas and sentiments. From the critical as distinct from the historical standpoint, we should also acknowledge that it is only too easy to maintain that what solely matter are the works, existing apart from their creators, easy to adopt a Marxist prejudice in favour of social and economic necessities or ideological factors rather than the genius and skill of the individual, easy indeed when we do not and cannot know much about these persons anyway.

Constable is one of the few painters who, in this respect, offer a different case for treatment. From his correspondence and other writings we know more about his activities month by month over a large part of his life than any other artist working before 1900, with the exception of Van Gogh and Delacroix, both prolific letter-writers or diarists. Because he was by nature self-confessing and constantly eager to declare his motives and difficulties, we can discover quite fully what he wanted to achieve as a painter, what were his creative problems, how he regarded the traditions of art, what he thought of the artistic world he inhabited, how he was affected by the response of those who looked at his pictures and judged them. He would have been a more accessible patient for Freud than was Leonardo. Paradoxically this wealth of evidence may cause a sense of unease, stimulated, perhaps, by certain intellectual and artistic prejudices so powerful in the twentieth century. An artist's identity and the identity of his works, one's intellectual censor warns, are two different things, not to be confused and mixed. A statement of intention is a deceptive guide, is it not, to the character and meaning of what has been achieved by any artist? In these circumstances a writer about Constable ought to begin by declaring his attitude to the verbal documents which can occupy such a sizeable space on his shelves.

This book has been influenced, in every respect, by a conviction that the abundant evidence we have should be used, albeit with an attempt at critical discrimination, and that it can be continuously enlightening not only about the appearance and iconography of the artist's work, but about its intimate physical qualities also. That is the reason why the reader will find here so much quotation from Constable's writings. The other problem which faces the author of a Constable study intended for the general reader is the nature of this artist's common reputation.

His landscapes have probably had more influence upon people's response to the natural world than upon the course of painting as an art. Like Shakespeare and Dickens through their writings, he has been treated as a spokesman for England. What is more, he has been regarded as a naturalist *par excellence*, the man who, by reason of a humble and simple submissiveness, has given an objective account of what may be seen by any observant country-lover in the fields of East Anglia. The judgement can be justified, moreover, by his own remark, 'The landscape painter must walk in the fields with an humble mind . . .', and by others in the same vein. Constable, however, was speaking there and elsewhere in the role of a painter, and not as a zealous member of the National Trust. Despite his moralistic demands for a simple and objective approach to nature, he was one of the most knowing, thoughtful and also emotionally directed artists of his time. The problem of looking at his pictures as creations of art, the product of a wilful transformation of landscape, has been affected by two other conditions.

By chance the view of Constable's art most easily gained, in England at any rate, is seriously incomplete, emphasizing his work's more lyrical, fluent and benign

qualities, presenting the man as the happy, confident observer of a green and pleasant land, smiling in the sunshine. The pictures which somewhat or entirely contradict that conception are difficult to see or quite inaccessible except on special occasions. *A boat passing a lock* (Plate 102) and *The Leaping Horse* (Plate 99) are not easily available and most of the larger pieces made up after 1828 are very remote. The exhibited *Waterloo Bridge* (Plate 154) and the *Salisbury Cathedral from the meadows* (Plate 150) are in private possession; the *Dell in Helmingham Park* (Plate 127), *Arundel Mill and Castle* (Plate 168) and the exhibited *Hadleigh Castle* (Plate 121) are in the United States, with several more of the most characteristic and expressive pictures painted in the 1830s. The *Hadleigh Castle* just mentioned, a most revealing and eloquent work, was out of sight for nearly three generations and it was tempting to account for the stormy violence of the Tate Gallery version (Plate 122) as being the attribute of a sketch, of artistic impulse rather than passion. To form an idea of Constable without keeping the works made after 1828 as firmly in sight as the familiar ones painted earlier is as pointless as studying Turner up to the time of *The Fighting Téméraire* and no further.

Inevitably the standard examples from the 1810s and 1820s have been constantly reproduced, thus fixing them, in attachment to the painter's name, within the general consciousness, and the limiting influence of reproductions does not end there. Constable particularly is victimized by acceptable conventions of reproductive techniques, even when tones and colours have been conscientiously re-created. The physical substance of the pictures is distorted by reduction in scale and their depth of pigment made imperceptible, and thus their singularity in *matière*, notation and touch is softened or totally subdued. This common attribute of the printed image, which can make a German Expressionist look exactly as sensuous as a Matisse, makes Constable seem a bland and easy painter and his pictures themselves a sentimental image of him. Constable the man can be more easily resurrected than most and there is little excuse for mistaking his identity. The pictures have to be not so much recovered from the patina of age as released from the fixed impressions of visual prejudice.

JOHN CONSTABLE was born on 11 June 1776 at East Bergholt, Suffolk, the son of Golding Constable and his wife Ann, *née* Watts (Figures 4 and 3). His father's family, in spite of reports given currency in the nineteenth century, had lived in Suffolk and Essex, owning modest properties there, for many generations. Golding Constable was in the milling trade—the painter described him as 'a merchant'—and had come by his substantial business through a bequest, received when he was twenty-six from his uncle, Abram Constable, a prosperous corn factor in the City of London. Golding inherited not only money, property and business assets, but Flatford Mill on the river Stour, which had contributed to his uncle's enterprise, a wharf and dry dock, a granary and kilns; to this he added another watermill, at Dedham, and a windmill, at East Bergholt. He not only gained an important place in the life and commerce of the district, but earned the affection of those tradesmen who worked for him as millers or bargemen and the other men who completed his circle of employees. His wife came from a similar background, her father being a well-to-do London cooper; the marriage was as happy and well-founded as their individual lives seem to have been.

When his family began to grow, Golding Constable built the large brick house in East Bergholt where the painter was born, two years after its occupation. John was the fourth of six children, the others being three girls, Ann (Figure 8), Martha and Mary (Figure 8), and two boys, Golding, and Abram (Figure 6), who succeeded to his father's interests. This family, so faithful in their attachments to each other and each so responsive to the individual characters and needs of the rest, was surrounded—literally so, as many of them lived in

Suffolk and Essex—by a large company of near and distant relatives.

John Constable, delicate in his infancy, grew to be a strong boy of vigorous character. Having begun his education unhappily at a private school in Lavenham where, like the rest of the pupils, he was severely ill-used, he finished it in the grammar school at Dedham under a Dr Thomas Grimwood, who was both scholarly and kind. He did not, however, do well enough in his studies to justify his seeking a career in the Church as his father would, apparently, have wished, and so he was directed into the family business, becoming known locally, according to his biographer, C. R. Leslie, as 'the handsome miller'. In 1796 he went to London to continue his apprenticeship, staying with maternal relations, the Allens;[1] it was then that any ideas he may earlier have formed about becoming a painter, evidenced by some conventional sketching and copying, were given a stronger impetus and a more definite bearing. He became acquainted with John Thomas Smith, now remembered chiefly for his book *Nollekens and his Times*, a gossipy account of the sculptor in whose studio he had worked as a boy.[2] Smith was an engraver, drawing master and antiquarian, using these talents particularly in another work, *The Antiquities of London and its Environs*,[3] and later as Keeper of Prints at the British Museum. At the time of their first meeting Smith was preparing his *Remarks on Rural Scenery*,[4] a work to be illustrated by his own etchings of cottages, and when Constable returned to Suffolk, he sent his friend drawings of buildings in his locality that suited the study (Plate 1).

Smith's appreciation of the visual pleasure to be had from such subjects and from the equally modest, rustic landscape in which they could be found must, at least, have encouraged Constable's artistic interest in the type of scenery which had been the background to his childhood. At any rate, from this time his appetite for art and a modest, tentative practice began to grow. He started to acquire books on art—Algarotti and Leonardo on painting, and Gessner on landscape.[5] His pictures became more ambitious; he made a moonlight landscape in the manner of John Cranch,[6] whom he

had met in Smith's company, and copied prints by Tempesta and Jacob van Ruisdael.[7] He interested himself in Gainsborough and looked for works of his East Anglian period.[8] He came to his majority in 1797, however, with no expectation that these efforts would provide anything more than a recreation. Three months before his twenty-first birthday he wrote, in a letter to Smith, 'And now I certainly see it will be my lot to walk through life in a path contrary to that which my inclination would lead me.' (II: 10)* Whether or not Smith's visit to East Bergholt in the autumn of the following year had any effect in sharpening Constable's determination or influencing his father, it was decided that he should at least be given the chance of discovering whether his zeal and his slight talent could be nursed into a permanent and profitable vocation. At the beginning of 1799, he went back to London with an introduction to Joseph Farington, a man well qualified to be a guide and adviser by reason of his natural good will, his experience of artistic affairs and his own practice in landscape.[9] On 4 February, Constable was admitted to the Royal Academy as a student, his father having given him an allowance to cover his expenses. 'I shall not have much to show you on my return,' he wrote to an East Bergholt friend, John Dunthorne,[10] 'as I find my time will be more taken up in *seeing* than in painting. I hope by the time the leaves are on the trees I shall be better qualified to attack them than I was last summer.' (II: 23)

It was to be three years before he was able to win his father's consent to his becoming once and for all a painter and not a miller, however illusory the latter may have thought his son's expectations to be. He acquired in East Bergholt a small building opposite the family house for use as a studio.

That consent was given in June 1802 and the nature of the case he must have put to his family can be judged from the letter he wrote to Dunthorne a few days before leaving London for Suffolk:

* The quotations from Constable's correspondence are taken from the six-volume edition prepared by R. B. Beckett (see Bibliography, p. 236). Thus (II: 10) means Volume II, page 10, of the Beckett edition.

'For these few weeks past I beleive I have thought more seriously on my profession than at any other time of my life—that is, which is the shurest way to real excellence. And this morning I am the more inclined to mention the subject having just returned from a visit to Sir G. Beaumont's pictures.—I am returned with a deep conviction of the truth of Sir Joshua Reynolds's observation that "there is no *easy* way of becoming a good painter". It can only be obtained by long contemplation and incessant labour in the executive part.

'And however one's mind may be elevated, and kept up to what is excellent, by the works of the Great Masters—still Nature is the fountain's head, the source from whence all originally must spring—and should an artist continue his practice without refering to nature he must soon form a *manner*, & be reduced to the same deplorable situation as the French painter mentioned by Sir J. Reynolds, who told him that he had long ceased to look at nature for she only put him out.

'For these two years past I have been running after pictures and seeking the truth at second hand. I have not endeavoured to represent nature with the same elevation of mind—but have neither endeavoured to make my performances look as if really *executed* by other men.

'I am come to a determination to make no idle visits this summer or to give up my time to common-place people. I shall shortly return to Bergholt where I shall make some laborious studies from nature—and I shall endeavour to get a pure and unaffected representation of the scenes that may employ me with respect to colour particularly and any thing else—drawing I am pretty well master of.

'There is little or nothing in the exhibition worth looking up to—there is room enough for a natural painture. The great vice of the present day is *bravura*, an attempt at something beyond the truth. In endeavouring to do something better than well they do what in reality is good for nothing. *Fashion* always had, & will have its day—but *Truth* (in all things) only will last and can have just claims on posterity.

'I have received considerable benefit from exhibiting—it shows me where I am, and in fact tells me what nobody else could. There are in the exhibition fine pictures that bring nature to mind—and represent it with that truth that unprejudiced minds require.' (II: 31–2)

In 1806 his uncle, David Pike Watts (Figure 5), paid for him to make a sketching tour in the Lakes.[11] Constable was following the trail of many travellers, artists and writers among them, who had been there since the middle of the eighteenth century. The area had become recognized as a source of visual and emotional experiences similar to those which could be enjoyed by travellers on the Grand Tour in the Alps and the Apennines, a landscape of wildness and solitude, evoking a sense of the Sublime and providing the painter with subjects to feed his imagination and extend his skill. Constable made there some water-colours quite limited in colour and chiefly notable not for any originality of vision, but for their vigorous handling of the washes (Plate 6). From the same visit too, derived a group of oil paintings (Plate 7); all his exhibits at the Royal Academy in the following two years were Lakeland views. The tour, however, was to have only a negative significance for him. It proved that he neither needed nor enjoyed the kind of landscapes that gave spectacular subjects, even if they were English, to stimulate invention or feeling. This was to be the only occasion, apart from some excursions into the Midlands, prompted by commissions which he could not afford to refuse, when he moved out of East Anglia and those southern counties where he found everything to satisfy his interests. He could not, however, afford to neglect other opportunities. In 1805 he had been invited to paint the first of two religious compositions, which stemmed from intentions to support a local artist striving to win a livelihood and reputation rather than from any desire on Constable's part to succeed in such a form of art or indeed from any evidence he might have given that he had a talent for this kind of invention and performance. This was an altarpiece for Brantham church, *Christ blessing the Children*; the other work, *Christ blessing the Bread and Wine*, was made in 1810 for Nayland Church.[12] More employment of this potboiling kind was to be offered in 1807, when

he gained an introduction to the 5th Earl of Dysart, the beginning of an association with the family which lasted into the 1820s; then, as later, he was required to copy family portraits, works by Reynolds among them. Copying portraits—many of the commissions or opportunities coming from relatives, friends or people in his locality—and some topographical landscapes, such as those of Malvern Hall and Wivenhoe Park, were, for many years, to afford the only calculable income he obtained by painting, for the sale of those works which expressed his deepest concerns and convictions were to be depressingly infrequent. Indeed, during his lifetime, extraordinarily few works were acquired from him other than those bought by patrons who were already his friends. Neither his father nor mother lived to see him enjoy any significant public success.

In 1809 he began his courtship of Maria Bicknell (Figures 1 and 12), a girl eight years younger than himself, whom he had met first about 1800 and whom he had since seen only occasionally. Her father, Charles Bicknell (Figure 7), was Solicitor to the Admiralty and, more significantly in what was to follow, her maternal grandfather, Dr Durand Rhudde, was the rector of East Bergholt and a canon in ordinary to George III. If the strength and constancy of their mutual love was a guarantee, then their ultimate marriage was always certain, but it was seven years before they were able to marry, and, in that period of continuing artistic studentship, Constable was forced to suffer the same kind of deprecation by a senior authority, the same degree of prejudice, that he was afterwards to endure in his relations with the Royal Academy and in his efforts to win approval from that unassailable institution. In neither case could he afford to disregard or antagonize the opposition. In the eyes of Maria's father and the opinion, even more vehement and influential, of Dr Rhudde, the young man was, simply, insufficient both as a suitor and as a potential husband —the son of a country tradesman, and not only an artist without secure income or expectation, but a landscape painter, and so without the ambition to succeed in the highest reaches of art. There were times during these seven years when the Bicknell house in

London, not so far from his own lodgings, was closed to him, times when even correspondence between the two friends was discouraged or prohibited. He was torn between anger at being persecuted—his own words—and a dutiful concern not to alienate Maria's loyal affection for her father. The uneasy state of the relationship, shifting as it did between happiness and painful despair, inevitably became interwoven with his painting and with his artistic experience of the Stour Valley.

'You are as fond of the country as I am, how beautiful it will soon be, you have given this place a higher interest to me than it ever had before . . .' From Maria, April 1812 (II: 62). 'From the window where I am writing I see all those sweet feilds where we have passed so many happy hours together. It is with a melancholy pleasure that I revisit those scenes that once saw us so happy—yet it is gratifying to me to think that the scenes of my boyish days should have witnessed by far the most affecting event of my life . . .' June 1812 (II: 78).

Next in importance to this relationship and his family ties was to be his friendship with Archdeacon John Fisher (Figure 13); it probably began in 1811.[13] Constable had known Fisher's uncle, who bore the same name, since 1798, when, as Canon Fisher—a Canon of Windsor and titular rector of Langham—he had visited Dedham. Since then he had gained preferment, first becoming Bishop of Exeter and then moving to the diocese of Salisbury. He was an amateur draughtsman.[14] In 1811 the painter spent some weeks at his palace there and from that time the cathedral, the city and its environs were to provide numerous subjects, the chief of four exhibits at the Royal Academy exhibition of 1812 being a Salisbury view. When Fisher died, Constable wrote to Leslie '. . . we loved each other and confided in each other entirely'. (VI: 265) By 1812 Constable could reasonably believe that if he had even yet to win a livelihood from painting, he had at least proved the reality of his vocation and was beginning to establish himself as a painter worth attention.

'I met Mr West [Benjamin West] in the street the

other day', he wrote to Maria; '—he stopped to speak to me and told me that he had been much gratified with a picture of the Mill, &c which passed the Council at the Academy . . . I wished to know if he considered that mode of study as laying the foundations of real excellence. "Sir" (said he), "I consider that you have attained it" . . . What happiness it is to me to impart to you any little circumstance that in any way connect themselves with our future welfare . . .' (II: 65) Two years later, he could say, 'My ideas of excellence are of that nature that I feel myself at a frightful distance from perfection.' (II: 133)

After two most productive summers in 1813 and 1814, sketching in the open air—a period crowned by the first sale of a landscape to a patron previously unknown to him, John Allnutt—Constable came into one of the most emotional periods of his life. In June 1815 his mother died; his absence from her funeral should be explained not by any lack of devotion, but perhaps by his fear of the anguish that the sight of her burial would have caused such a very emotional man. Much of the rest of that year, however, was spent at home in Suffolk, not merely so that he could spend the spring and summer, as he had customarily done, painting and enjoying his favourite places, but on account of his father's declining health. Golding Constable died the following May, and one consequence of his death was to assure for the future a small increase in the income which the painter had been receiving from home; this, combined with the encouraging progress of his work and Maria's decision at last to liberate herself from her family's objections, led to their marriage, at St Martin-in-the-Fields, London, in October, 1816. They spent part of their honeymoon in Fisher's vicarage at Osmington, Dorset, close to Weymouth Bay (Plate 57), and, as Fisher himself had married only three months before, this must have been a particularly joyful interlude. The happy resolution of this long emotional conflict and the need to provide for a family seems to have generated a new charge of energy, for Constable then set about enlarging the scope and scale of his work. From small finished compositions, such as the *Boat-building* of 1815 (Plate 39) and the larger *Flatford*

Mill, of 1817 (Plate 58), he went on to make the first of the pictures he was to call his six-footers, elaborately composed landscapes painted on canvases six feet wide or high. This painting, another view of the Stour known thereafter as *The White Horse* (Plate 53), was shown at the Academy in 1819 and bought by Fisher. In this year Constable rented a house at Hampstead as a second London home; what was originally intended as a residence suitable for a growing family, where he could live within sight of open country, was soon to become, as her health began to fail, a refuge for his wife. Their first child, John Charles, had come in 1817 and six more were to follow: Maria Louisa in 1819, Charles Golding in 1821, Isabel in 1822, Emily in 1825, Alfred Abram in 1826 and Lionel Bicknell in 1828. From this period Constable's practice was based —apart from his excursions to Suffolk and elsewhere— upon two homes, the one in town, which from 1822 was to be at 35 Charlotte Street, and the Hampstead retreat, which from 1827 was located in Well Walk, in a tall house from whose fourth-floor window he could look down to St Paul's and over the heathland he was to paint so often.

When he moved into Charlotte Street he told Fisher that the five previous years in Keppel Street, the first five years of his marriage, had been the 'happiest & most interesting years of my life . . . I got my children and my fame in that house, neither of which would I exchange with any other man.' (VI: 99) Twelve months earlier, in October 1821, he had written a letter to Fisher which, in its account of his artistic convictions and pursuits, is as significant as the letter to Dunthorne of 1802 and indeed records the ultimate crystallization of his ideas on landscape, soon to be fully embodied in the large work then in progress on his easel, *The Hay Wain* (Plate 72):

'That Landscape painter who does not make his skies a very material part of his composition—neglects to avail himself of one of his greatest aids . . .

'I have often been advised to consider my Sky—as a "White Sheet *drawn behind the Objects*". Certainly if the Sky is *obtrusive*—(as mine are) it is bad, but if they are *evaded* (as mine are not) it is worse, they must

and always shall with me make an effectual part of the composition. It will be difficult to name a class of Landscape, in which the sky is not the "*key note*", the *standard of "Scale"*, and the chief "*Organ of senti-ment*". You may conceive then what a "*white sheet*" woud do for me, impressed as I am with these notions, and they cannot be Erroneous. The sky is the "*source of light*" in nature—and governs every thing. Even our common observations on the weather of every day, are suggested by them but it does not occur to us. Their difficulty in painting both as to composition and execu-tion is very great, because with all their brilliancy and consequence, they ought not to come forward or be hardly thought about in a picture—any more than extreme distances are.

'But these remarks do not apply to *phenomenon*—or what the painters call *accidental Effects of Sky*—be-cause they always attract particularly.

'I hope you will not think [me (*deleted*)] I am turned critic instead of painter. I say all this *to you* though you do not want to be told—that I know very well what I am about, & that my skies have not been neglected though they often failed in execution—and often no doubt from over anxiety about them—which alone will destroy that [the ease of not (*deleted*)] Easy appearance which nature always has—in all her movements . . .

'How strange it is that we should prefer raising up all manner of difficulties in painting—to truth and common sense.

'How much I can Imagine myself with you on your fishing excursion in the new forest, what River can it be. But the sound of water escaping from Mill dams, so do Willows, Old rotten Banks, slimy posts, & brick-work. I love such things—Shakespeare could make anything poetical—he mentions "poor Tom's" haunts among *Sheep cots*—& *Mills*—the Water [mist? & the Hedge pig. As long as I do paint I shall never cease to paint such Places. They have always been my delight— & I should indeed have delighted in seeing what you describe [with you (*deleted*)] in your company "in the company of a man to whom nature does not spread her volume or utter her voice in vain".

'But I should paint my own places best—Painting is but another word for feeling. I associate my "careless boyhood" to all that lies on the banks of the *Stour*. They made me a painter (& I am gratefull) that is I had often thought of pictures of them before I had ever touched a pencil, and your picture is one of the strong-est instances I can recollect of it. But I will say no more—for I am fond of being an Egotist, in whatever relates to painting.' (VI: 76–8)

With the exhibition of *The Hay Wain* (Plate 72) at the Academy in the following spring there began the most eventful and unexpected professional episode in Constable's career, that indirect association with French painting, criticism and patronage which has since been given perhaps more attention than it de-serves by some students of nineteenth-century art. The picture was seen in England by the critic Nodier, who on his return to Paris published an enthusiastic appreciation of the painter.[15] By that time Constable's work, together with works by some of his English con-temporaries, Ward and Landseer among them, had attracted the enthusiastic interest of Géricault, who had come to England in 1820 and had been a guest at the Royal Academy banquet in 1821;[16] he, too, was to spread the news of Constable's brilliant effects among his friends in Paris, including Delacroix, who first saw a picture by the artist in 1823. Constable himself was to become directly aware of this foreign interest when, in November 1822, a Paris dealer, John Arrowsmith—French in spite of his name—visited the British Institution exhibition where *The Hay Wain* was again on view, priced then at 150 guineas. The dealer offered £70 for it, but Constable would not part with the work—of which Fisher anyway had first refusal—at such a low figure. When Arrowsmith re-turned to London in the spring of 1824, however, Constable eventually agreed to sell it, together with a painting of similar size which he called *The Bridge* (Plate 80) and a small view of Yarmouth, for £250. Later, in May, he was introduced by Arrowsmith to a colleague, Charles Schroth, who immediately ordered three works and afterwards increased his commission to nine. During his association with these two dealers, lasting only until the end of 1826, by which time the

fortunes of both men had foundered, he sold them over twenty works, many more than he was able to dispose of throughout the rest of his career within the London art trade.

The other aspect of this reassuring and rewarding episode was no less significant. After Arrowsmith's purchases arrived in Paris, Constable was able to report to Maria that they 'have caused great stir; the French critiks by profession are very angry at the French artists for admiring them. All this is funny enough,—and very amusing, but they cannot get at me on this side of the water.' (II: 356) When, later in 1824, the pictures were shown at the Salon, in the Louvre, they were again greatly admired, and among those who commented enthusiastically upon them were writers as eminent as Stendhal[17] and Thiers.[18] In December 1824, Constable reported to Fisher:

'A gentleman told me the other day that he visited the Louvre—he heard one say to his friend—"look at these English pictures—the very dew is upon the ground". They wonder where the *brightness* comes from. Only conceive what wretched students they must have been to be so surprized at these qualities—the fact is they study (& they are very laborious students) art only—and think so little of applying it to nature . . . My wife is now translating for me some of their criticisms. They are very amusing and acute—but very shallow and feeble. Thus one—after saying, "it is but justice to admire the *truth*—the *color*—and general vivacity & richness"—yet they want the objects more formed & defined &c, say that they are like the rich preludes in musick, and the full harmonious warblings of the Aeolian lyre, which *mean* nothing, they call them orations—and harangues—and high-flown conversations affecting a careless ease—&c &c &c—Is not some of this *blame* the highest *praise*—what is poetry?—What is Coleridges Ancient Mariner (the very best modern poem) but something like this? However, certain it is they have made a decided stir, and have set all the students in landscape thinking—they say on going to begin a landscape, Oh! this shall be—a la Constable!!!!' (VI: 185-6)

Among those who were most affected by the appear-

ance of these pictures was Delacroix, who saw them on Arrowsmith's premises before the exhibition and under their influence made certain changes in his own *Massacre de Scio*.[19] In January of the following year Constable was informed that 'on the French King's visit to the Louvre, "he was pleased to award me a Gold Medal, for the merit of my landscapes . . .".' Later that year, when he showed *The White Horse* and another work, probably his *Stratford Mill*, at Lille, he was awarded a second gold medal.

The financial return which came from his brief association with Arrowsmith and Schroth was certainly welcome at a moment when the expenses of his family life were mounting, but his French successes sharpened his sense of frustration at the coolness with which he and his art were generally treated in his own country. Having become an associate of the Academy so belatedly in 1819, he waited year by year for advancement to full membership, until, when it ultimately came, the election seemed rather an act of charity upon the part of his fellows than a matter of enthusiastic recognition.

As so frequently in Constable's life success was attended by a cause for concern. His wife's health was now so vulnerable that the family's life was being constantly disrupted by it. In May 1824, he had had to send her and the children to Brighton, where she remained until the end of the year, and in 1825 she had to be there again, between August and December. In these periods and whenever they were separated thereafter he sent her an account of his doings in the form of a journal.

'My life', he wrote to Henry Hebbert in August 1825, 'is a struggle between my "social affections" and my "love of art". I dayly feel the remark of Lord Bacon's that "single men are the best servants of the publick". I have a wife . . . in delicate health, and five infant children. I am not happy apart from them even for a few days, or hours, and the summer months separate us too much and disturb my quiet habits at my easil.' (IV: 99) He was, at that moment, about to take his family to Brighton for a second time and, on his immediate return to Charlotte Street, he wrote to

Fisher, 'I am now thank God quietly at my easil again. I find it a cure for all ills besides its being the source "of all my joys and all my woe". My income is derived from it, and now that after 20 years hard uphill work—now that I have disappointed the hopes of many—and realized the hopes of a few (you can best apply this)—now that I have got the publick into my hands—and want not a patron—and now that my ambition is on fire—to be kept from my easil is death to me.' (VI: 204) The journals written for his wife show how much his work was interrupted by callers and domestic distractions of every kind.

Each year as the date of election to the Royal Academy approached he was forced into the degrading routine of canvassing his fellows for their support. In February 1828, he wrote this sombre account of his position to the portrait painter, Thomas Phillips.

'May I be allowed under your candour to say a little about myself since I have been in the Academy?

'During that period I have painted about ten pictures (as considerable as my limited powers would go) —all of which made their first appearance on its walls. Only one of them (the Lock) found a purchaser among English collectors . . . Two or three were bought by my friend Archdeacon Fisher—from affection . . . and two have found a home in France (bought of me by a dealer at 100 guineas each)—one of which he sold in Paris for 400 guineas. The others are still mine. In truth I have never yet had the good fortune to see the face of an English patron of art.

'Do not my dear Phillips beleive for a moment that I speak this in the spirit of complaint. My ambition has been to form if possible an original feature in English landscape, and to do any little good in my power to that Institution which has so far honoured me—and for which I am gratefull for my education—and I have not been without my reward. To do this however I have sacrificed the best part of my life—and not a little of paternal property. I am now past the age of fifty—Mrs Constable has most delicate health—and has seven infant children, who have to look for me only for every thing in the world.' (IV: 280)

Five weeks later his father-in-law died, leaving him

£20,000 and giving him for the first time that financial independence which his painting could not, and never would, provide, and relieving him from concern about the future security of his children. Already, however, his wife's illness had reached a terminal state and in November she died, bringing upon him the most devastating emotional crisis of his life. In January of the following year he wrote to Leslie, 'my greivous wound only slumbers . . . God grant that the remainder of my life may be passed under the influence of her who is now an angel in heaven.' (III: 18) He wrote in similar terms to his brother Abram:

'Hourly do I feel the loss of my departed Angel. God only knows how my children will be brought up. Nothing can supply the loss of such a devoted, sensible, industrious, religious mother who was all affection. But I cannot trust myself on that subject. I shall never feel again as I have felt, the face of the world is totally changed to me, though with God's help I shall endeavour to do my next duties.'[20]

Seven weeks later, on 10 February 1829, he was elected to full membership of the Royal Academy by one vote, ahead of Francis Danby, and when he made his official call upon Sir Thomas Lawrence, the President, Lawrence 'did not conceal from his visitor that he considered him peculiarly fortunate in being chosen an Academician at a time when there were historical painters of great merit on the list of candidates.' (Leslie, p. 173.)

Coming at this time, the event was, as he said, 'deprived of all satisfaction'. He said that a few weeks after the vote he was still 'smarting under his election' (III: 20) because, as he remarked on another occasion, 'It has been delayed until I am solitary, and cannot impart it.'

The nine remaining years of his own life, involving the care of seven children, whose ages at their mother's death ranged from eleven years to eleven months, was to be a quite distinct part of his career and one in which his art, especially when the project in hand was most ambitious and demanding, gave him greater concern and anxiety than ever before. That 'the face of the world was totally changed to him' was to be borne out

by the pictures. The period was also marked by two enterprises, both of which demanded a great deal of him, being new in his experience. One was the publication in five parts, each containing four prints, of a sequence of mezzotints made by David Lucas after a selection from his studies and finished pictures. The work was known as *Various Subjects of Landscape characteristic of English Scenery* (hereafter referred to as *English Landscape Scenery*; see Appendix II and Plates 19, 138, 139 and 143). He hoped to achieve by this means what he must have felt his paintings had failed to gain, public recognition for his ideal of landscape and for his manner of re-creating it.[21]

A similar purpose encouraged him to give public lectures on the history of landscape painting. He delivered the first of these addresses at Hampstead in 1833, and the ultimate version of them was given in 1836 at the Royal Institution, where his son had been 'a pupil of Faraday's . . . in chymistry'. Here was an opportunity not only to express his appreciation of his great predecessors, but to talk generally about the branch of art he had chosen and, in a scientific ambience, to justify his conviction that a painting should be 'understood, not looked on with blind wonder, nor considered only as a poetic aspiration but as a pursuit, *legitimate, scientific and mechanical*'. (*Constable's Discourses*, p. 69.)[22] In this period, too, as a result of his election, he was required to teach as a Visitor in the Life Academy at the R.A., and on one occasion brought in green cuttings of foliage to provide a natural background against which the models could pose in the drawing classes, thus demonstrating his belief that the human figure should always be studied in a setting.

In 1832 the death of Archdeacon Fisher had ended a precious friendship. 'This makes a sad gap in my life & worldly prospects. He would have helped my children, for he was a good adviser though impetuous —and a truly religious man. God bless him till we meet again—I cannot tell how singularly his death has affected me . . .' (III: 79) He found in these years, however, a new and faithful confidant, the young American-born painter Charles Leslie, who was to be his first biographer.[23] Towards the end of his life he discovered in the countryside around Arundel, in Sussex, not only a new source of subjects, but a region of landscape whose sights deeply impressed him. At this time the painting of small oil studies or sketches direct from the motif, which had been one of the most characteristic aspects of his practice, largely gave way to the making of studies in watercolour, often more substantial and vigorous than they had been before; but the succession of large, finished compositions was continued until the end. He was working upon the last of them, *Arundel Mill and Castle* (Plate 168), on the day of his death, which came without warning during the night of 31 March 1837, after a final hour more tranquil than many of those he had spent so painfully in an anxious life.

None of Constable's observations is more familiar than some words he wrote to Fisher in 1821: 'Painting is another word for feeling.' If this simple but elusive statement had not survived, there is plentiful evidence elsewhere in his letters from which a similar concise apologia for his art could be deduced. Here is the evidence that he regarded his pictures not simply as a re-creation of the eyes' experience, as the rendering of an ideal of landscape, or as giving him sensual pleasure and a vision of truth. His words imply that the paintings were fed from a deeper, emotional, source and were thus always to be conditioned or complicated by the stream of his placid or agitated consciousness. For that reason the physical body of his pictures, the marks and substance of the paint upon the canvas, as well as the imagery he derived from nature, can only be understood in relation to the growth of his mind, to borrow those words which Wordsworth used in the subtitle of his autobiographical poem, *The Prelude*; and in that process of growth, what he himself called his 'social affections'—his attachment to certain people and his need for human intimacies—was as momentous as that strong sense of his own personal uniqueness which led Constable to call himself egotistical. In spite of his determination to approach nature 'scientifically', he was one of the least objective of painters, one of those least capable of knowing objectivity or detachment as a

working state. He has sometimes been presented as a passive and modest victim of circumstance, one of those artists given a heroic status by modern criticism as a victim of fixed, traditional ideas and conventional judgements. The truth of this conception can only be gauged if the identity of the victim is understood.

Few artists can have been as warmly enwrapped in family affection and concern as Constable, and few have been so disinclined in adult life to stand apart or escape from the place and the community in which they were reared as well as deny the demands of their dependants. It is indicative that he should have called the kind of landscape, anywhere in England, that most satisfied him 'home' scenery: he complimented the Dutch painters for being 'stay-at-home people'. The routines of domestic life, however distracting, could always claim his concern and always provided a sort of happiness. His family was not just permanently established somewhere—in the Stour valley—but was rooted in the soil of the place and, collectively, was as responsive as a barometer to the changes in the weather and the cycle of the seasons. His closest relatives had an impressive and undisguised moral steadfastness. His father stood by him as he probably stood by every commitment and seems never to have withdrawn his sympathy and encouragement once his son's calling and affections had been assigned. His advice was given out of a continuing sense of responsibility:

'Your present prospect & situation I consider as far more critical than at any former period of your life; as a single man I fear your rent and outgoing, on the most frugal plan will be found quite equal to the produce of your profits. Suppose you were to take a helpmate with a small income & your house became furnished like poor sturgeons [some East Bergholt neighbours] what would your situation then be? . . . If my opinion was requested, it would not be to give up your female acquaintance in toto; but by all means to defer all thoughts of a connection until some removals have taken place, & your expectations more certainly known. My further advice recommends a close application to your profession & to such parts as pay best. At present you must not choose your subject or waste your time by invitations not likely to produce further advantages. When once you have fixed on a subject, finish it in the best manner you are able, & not through despair put it aside & so fill your room with lumber.

'I fear your too great anxiety to excell may have carried you too far above yourself; & that you make too serious a matter of the business & thereby render yourself less capable; it has impaired your health & spirits. Think less & finish as you go (perhaps that may do). Be of good cheer John; as in me you will find a parent & a sincere friend.' (I: 73-4)

At the root of his father's concern was not just paternal affection but a strong sense of expediency. 'Thank God', wrote Ann Constable in 1813, 'your father is purely, & often talking of you, both when awake & sleeping—so you must be convinced, how near your welfare is to him. His earnest wish, is to have you what he terms, *earn money*.' (I: 90)

Constable's mother added to this a most humane tenderness; she, quite simply, mothered him, as the following passages from her letters show:

'In truth, permanent happiness is much more generally to be found in the near & dear connection of one's own family—there is no disguise—no flattery, which is so very empty . . . How thankful I am that you do much injoy the invaluable blessing of health. It is I trust the kind gift of providence rendered the more permanent by your own prudence & good conduct—long may you injoy it on such terms is my prayer . . . do not hesitate letting me know wherein I can serve you—& tho I should be glad to see you here, yet do not let it take from your store two or three guineas, more essential to a piece of broad cloth . . .' (I: 30-1)

'Be very careful of that precious blessing, health— and let us know when you are comfortably settled which I hope you will be. I am ready to assist with anything you may want of furniture . . . Pray take care of yourself, and keep your feet warm and dry, as from sitting in wet & damp stockings & shoes often proceed, sore throats, inflammation of the lungs and tooth ache. Also pray keep a good fire. I cannot send you a waggon of coal—if I could you could not give them storage—

so I enclose what will procure them in a retail way & hope you will regard it as my Warm Recollection . . .' (I: 54) 'I *want you* and all your performances, to be nothing short of *perfection*.' (I: 93)

To this parental constancy was added the goodwill of his brothers and sisters, and it is important to recognize that until he was fifty-two the painter depended for the major part of his income upon the family business and property at East Bergholt, maintained and administered after his father's death by his brother Abram.

Outside the circle at Bergholt was another supporting force of relatives, their attachment to him typified by his maternal uncle, David Pike Watts, who earnestly practised benevolence in his public life, sponsored his nephew's visit to the Lake District in 1806, and for some years thereafter pressed upon him comprehensive advice.

'You do not expect to pass thro' Life always on a smooth stream unruffled. If you do it is impossible on Earth; nor is it for the real good of man any more than constant calm without agitation is good for the whole system of Nature . . . My opinion is that cheerfulness is wanted in your landscapes; they are tinctured with a sombre darkness. If I may say so, the trees are not green, but black; the water is not lucid, but overshadowed; an air of melancholy is cast over the scene, instead of hilarity . . . in this Boat Landscape [Plate 32], where there is much to admire, there is this sad Trait to lament, namely hurry and slight of *Finish*. This is the unfortunate Sign of an hurried Mind and consequently perplex'd pencil; in short of that fatal habit *Procrastination*'. (IV: 38)

His marriage to Maria Bicknell, so arduously gained, brought supreme rewards, and Constable's devotion to his children had a rare, joyful intensity, so that both their presence and their absence caused exuberant feeling—delight in their company, and a nagging unease when they were away. He was never without a stock of precious friendships and some of the most significant associations came into his life at just the right time. There were the artists who nursed his talent, helped him widen his experience or were simply appreciative of his work: Joseph Farington, J. T. Smith, Benjamin West, John Jackson, David Wilkie, David Lucas, Charles Leslie. Sir George Beaumont was not only a generous friend; his feeling for art also made him an ideal contrast to the sort of connoisseur that Constable abominated. His most important friendship, however, was that with Archdeacon Fisher, who, as a man similarly duteous, loving and unpretentious, was the confessor he constantly needed and who was all the more helpful on account of his emotional stability and charitable detachment. With their differences went important sympathies, pleasures and interests developed in common: they both enjoyed happy marriages, a conservative view of affairs, a similar feeling for nature and country life, a sense of art, and a resolute Anglican Christianity, which made Constable sure that his works, like his friend's pastoral exercises, were a product of godly inspiration and consent. Fisher's benevolence was not only sincere but adroit. He offered his vicarage as a honeymoon retreat, bought in 1819 the first of the large pictures on which his friend's ideals and expectations were then fixed, and would lend it for exhibition when to do so was likely to be useful. It was Fisher who surrendered his claim to *The Hay Wain* when Arrowsmith's interest in the picture was obviously going to be more rewarding. He was a life-line stretching from the heights to the depths of his friend's experience.

This circle of loving relationships must also have helped to have formed both the egotism and the vulnerability which Constable recognized so clearly as being inescapable parts of himself. When he was exposed to anything less than affection and loyalty, a most tender creature, like the hermit crab out of its shell, was revealed and he seems never to have managed to avoid hurt by adopting an attitude of detachment or stoicism; as did the struggle like the struggle he experienced in resolving the equation of nature and art, his life invariably presented itself to him in dialectic terms as a problem of resolving the hardly reconcilable claims of his private and public worlds. The main obstacle to his marriage was a clergyman who judged him a social inferior when the same son of a

tradesman was being amicably received in the palace of a bishop. Pictures found insufficient for high honour in his own national Academy, where he had been trained, were thought worthy to win a medal from a foreign King. The impression given by his words and behaviour, and indeed by his work also, in the years which followed the intolerable loss resulting from his wife's death, present a man in whom distress and disappointment had risen to a toxic level. The contemporaries who reported their memories of him after his own death can be divided into two distinct groups. Those with experience only of the public man and his behaviour in their professional world were, it seems, powerfully impelled, as soon as he was dead, to insist upon his vanity and conceit, his 'always talking of himself and his work', his being 'unceasing in his abuse of others',[24] and his sarcasm; and his letters contain evidence enough to prove that these charges were justified. His judgements could be brutally harsh; he could be defiantly argumentative;[25] he was at times self-righteously self-assertive. Those intimate friends, however, who knew the private man and enjoyed his affection, reported with no less conviction his honesty and his capacity for love and charity, and it is certain that the spiked and showy defences which he erected against the world were seldom used more maliciously than the hedgehog's prickles. His kingdom, personal and artistic, had to be defended. He separated himself from his early friend, J. T. Smith,[26] and believed him to have been disloyal, but when the man died in penury he acknowledged his early obligation and immediately—and privately—sent his widow money. His love of children was not an emotional indulgence, but rather typified his powerful compulsion to embrace all that he could trust in life, and in the natural world also, with extraordinary wholeheartedness. His most composed, blithe and technically stable works were inevitably produced in the years from 1817 to 1824, when the world was behaving most kindly, when his marriage was relatively undisturbed by his wife's ill health, when the reviewers were being most sympathetic, when French interest in his art was strong, and when he was able to enjoy his friendships—with

Fisher and Beaumont, for example—to the full. Then he could say, 'I have a kingdom of my own both fertile and populous . . .'

He was, besides, not a naïve countryman without verbal and rational defences, not an eloquent sensitive peasant of John Clare's type, any more than he was an intellectual, in the sense that Reynolds may be called an intellectual artist; but he was a person of sharp and inquisitive intelligence who would never hesitate to use the theoretical sources or literary attachments of his art. He was a reader of literature, for part of his life at least, with a ready stock of poetic references and images alive in his memory. If he trusted his eyes most, he had certainly read many of the most respected works of artistic theory then available in English. His demand that the painter should have precise knowledge of the natural world and his idea of landscape painting as a kind of science encouraged him to read anything—be it Gilbert White's *Selborne* or Forster on *Atmospheric Phaenomena*[27]—which would increase his understanding. He plainly enjoyed encouraging the scientific interests of his eldest son and was able to do so intelligently. He disliked in other artists, not just the failure to be observant, inquisitive and knowledgeable, but the kind of pretentiousness which comes from a superficial exploitation of easily received ideas or experience. In this, as in everything else, he was a natural and insistent moralist.

In relation to his work the most important of those traits which are strongly revealed in his letters was an enslavement, more often than not self-imposed, to anxiety. The very words, anxious and anxiety, come naturally to his pen. From youth he was prone to suffer from toothaches and the headaches associated with them, and in the last eight years of his life, particularly, he was frequently ill, but he recognized that some of his physical pains were psychosomatic. '. . . the truth is', he wrote to Henry Hebbert, 'could I divest myself of anxiety of mind I should never ail any thing.' (IV: 99) At all times in his life Constable could, of course, point to well-founded reasons for this state. He could be anxious with just cause about his choice of vocation because his talent developed slowly, was not

generally acclaimed, and brought him little material reward or security. He would be anxious about the progress of his relationship with Maria Bicknell before they married and about the condition of her health afterwards, and about his capacity to support his children. As each new year arrived and in the dark days of winter—away from nature or at any rate from the inspiriting greenness of the spring and summer landscape—and as he strove to finish and assemble his works for the exhibitions ahead, he could be anxious about their completion and the response they would draw from colleagues and reviewers: 'I am writing this hasty scrawl [in the] dark before a six foot canvas which I have just launched with all my usual anxieties.' (VI: 190)

Constable's family had observed the trait of anxiety in him many years before. 'I fear', his father wrote, 'your too great anxiety to excell . . .' (I: 74) And his uncle, Watts, was more outspoken; 'I am sorry to see too visible traits in your whole person of an inward anxiety which irritates your nervous system and in its effects doubtless deranges the digestion and secretions, vitiates the Blood and undermines the Health . . . You must avoid the excess of Anxiety, that extreme solicitude to *finish* which sometimes at a single touch takes away a mark'd trait . . .' (IV: 30) When, in a letter of January 1833 to David Lucas, he gave a numbered list of the conditions of his current difficulty, number 2 was 'An anxiety that ought not to be with me', number 11 'A great Anxiety and disturbance of mind' and number 15 '. . . above all consider the weight on the mind.' (IV: 405–6)

It was the weakness with which Fisher most often urgently confronted him. 'Whatever you do, Constable, get thee rid of anxiety. It hurts the stomach more than arsenic. It generates only fresh cause for anxiety, by producing inaction and loss of time . . .' August 1825. (VI: 203) '. . . any freak of imagination or anxiety distracts you. Now come and work & don't *talk* about it.' 1829. (VI: 252) 'We are all given to torment ourselves with imaginary evils—but no man had ever this disease in such alarming paroxysms as yourself. You imagine difficulties where none exist, dis-

pleasure where none is felt, contempt where none is shewn and neglect where none is meant.' November 1825. (VI: 209)

To that Constable's reply was, 'I have related no imaginary ills to you—to one so deeply involved in active life as I am they are realities and so you would find them. I live by shadows, to me shadows are realities.' (VI: 211) He may have despised his more rigorous critics and certainly seems to have tried to keep their writings out of his studio, but in the end their fierce judgement of his methods gave an additional complication to his practice and enhanced his uncertainty. His letters to David Lucas show a man grimly, sometimes hysterically, concerned to protect himself against false report.

Although Constable was slow in gaining confidence and technical command, he was quick to define to himself and to his confidants the sort of artist he wanted to be and to determine with equal certainty those accomplishments to which he would not aspire. His confessed wish to be original and to avoid 'mannerism' were expressions of the same ideal. For him originality meant speaking in his own voice and language from a direct experience of nature, and not imitating the language and vision of others. He passionately desired what Coleridge called 'the true voice of feeling'. 'It is always my endeavour however in making a picture', he wrote to James Carpenter[28] in 1828, 'that it should be without a companion in the world, at least such should be the painter's ambition . . .' (IV: 139) His devotion to certain earlier masters was coupled with an angry contempt for those contemporary artists who plagiarized their work and for the connoisseurs who encouraged them to do so by creating a taste which rested upon art rather than a response to natural reality.

'I looked on *pictures* as *things* to be avoided. Connoisseurs looked on them as things to be *imitated*, & this too with a deference and humbleness of submission amounting to a total prostration of mind and original feeling, that must obliterate all future attempts —and serve only to fill the world with abortions . . .' (III: 94) 'Good God, what a sad thing it is that this lovely art—is so wrested to its own destruction—only

used to blind our eyes and senses from seeing the sun shine, the feilds bloom, the trees blossom, & to hear the foliage rustle—and old black rubbed-out dirty bits of canvas to take the place of God's own works.' (III: 94–5)

His view was exactly the contrary of that principle which had had such widespread acceptance in the eighteenth century and which had been put so succinctly by Addison in one of his *Spectator* essays, that the arts should 'deduce their Laws and Rules from the general sense and Taste of Mankind and not from the principles of those Arts themselves; or in other words that the Taste is not to conform to the Art, but the Art to the Taste.'

Constable voiced his distrust of connoisseurship as acrimoniously as Hogarth had done, and, no doubt, declared his opinion to connoisseurs as openly as he did to his friends. The same spectre of grimy old canvases that obsessed Hogarth haunted[29] him. 'I ask, did Titian paint his pictures *with 300 years on their heads*— did Claude paint his pictures *with 200 years on their heads* . . . do the Water Color Society, dirty their paper before they use it? Do the house-painters mix up the new color to match the old rancid hues of the room or stairs, &c, &c, &c.?' (V: 185)

Because the subjects—to use a plain term in its narrow sense—of Constable's pictures were with few exceptions so limited, consistent and similar throughout his career, it is easy to neglect or discount the variety of their content and style, especially as that variety did not appear with an order and continuity which can be defined or explained without difficulty. The nature of Constable's practice was not only very personal to himself, but resembled some twentieth-century artists more than any of his predecessors or contemporaries.

Before considering the content and imagery of his landscape, the subjects should be established, not only the identifiable places he chose to paint, but also the natural ingredients which formed the type of scenery he preferred. The dominant subject was, of course, that area about his birthplace which is now called the Constable country,[30] that is, the valley of the Stour, the river itself, the villages of Dedham, Langham, and East Bergholt, and the land in the vicinity. Then there was Hampstead, a second family home, with the Heath and the prospects from its heights; and there were those scattered southern localities, in Surrey and Dorset, Sussex and Wiltshire, where similar motifs could be found, where the contours of the ground, the colour and effects of light, were compatible with the landscape of his inner vision, the ideal world that came to rule his choice of them. There were also the coastal sites at Yarmouth and Hastings and more numerously in the Brighton district and around Weymouth Bay, where the sea and beach offered no spectacular dramatic arrangement of rocks and breakers but where, behind a flat shore and low cliffs, the shape of the land seemed to repeat the form of the ocean, where large skies were revealed above a low horizon, and where the clouds and the shadows they cast upon the ground seem to be rhyming with the movement of the waves. Within his landscapes the buildings and other signs of human life have a like simplicity. The windmills, watermills and locks, cottages and barns belonged to the essential life and economy of the countryside, and they were never less than familiar to him, like the buildings along the Stour belonging to his father's business or Parham Mill at Gillingham, Dorset, a type of structure whose form and use he understood so well (Plates 113 and 114). Even some of the more formal subjects were justified and enriched for Constable by affecting personal associations. Salisbury Cathedral was Bishop Fisher's church, and the Close, the city and its environs his home and the place where the painter stayed with the Bishop's nephew (Plates 81–87).

In his appreciation of what was historical, Constable was not, like Turner, reacting to the drama of great occasions. He was never once induced to paint a wholly invented landscape nor one which formed a stage for heroic or tragic events from the past. His enjoyment of old places and objects was inspired by a feeling that through long use they had taken on a patina which projected his own sense of personal association far back into the past. The scenery of the Lakes and similar places was unacceptable because, for one

reason, these regions were remote from human society, and places where the life and work of men could have little influence. Only when he needed a subject sufficient to contain and communicate his distress or despair was he tempted to reach for such a plainly evocative symbol as sites like Hadleigh Castle (Plates 120–123), Stonehenge (Plates 144 and 145) and Old Sarum (Plates 142 and 143) or for such an affective phenomenon as a rainbow.

He was constantly critical of other painters, especially contemporaries who worked under the dictates of Taste or painted that with which they had no intimate association. These artistic tourists, temporarily pitching their easels anywhere from the Seine to the Ganges, were in his opinion being seduced by places not just geographically distant, but spiritually and socially remote from their experience. He could be equally contemptuous of those townee painters who dealt in rustic images. 'The Londoners', he wrote to Fisher, 'with all their ingenuity as artists know nothing of the feeling of a country life (the essence of Landscape)—any more than a hackney coach horse knows of pasture.' (VI: 65) Thus he seldom painted, especially on a large scale, any subject which was not within his experience. He did not like Brighton as a community, but the large six-footer picture of the Marine Parade and Chain Pier (Plate 117) is mainly about sea, sky and beach. It is not surprising that his picture devoted to the opening of Waterloo Bridge (Plate 154), conceived at a time when the need to secure his fame was particularly urgent, should have taken him thirteen years to complete, and then should have been finished, probably as an act of will, when his sense of purpose was less affected than it had been earlier by an awareness that it was not in his rural mode.

Although the pictures of Malvern Hall and Wivenhoe Park seem so fluent and expressive of the character of those places, they were made on commission —no doubt with the same reservations that he was to apply to Beckford's Fonthill. 'A gentleman's park is my aversion. It is not beauty because it is not nature.' (VI: 98) When the painting of Englefield House, also a commission, was dismissed as merely a view of a house,

he insisted that it was 'a picture of a summer morning, including a house'.

Constable maintained that subject did not matter, but however much he may have contradicted contemporary prejudice in this respect—and he certainly knew himself to be holding an unpopular opinion—his choice of common motifs was not seen in its historically original perspective. Among his favourite masters, Jacob Ruisdael and Cuyp, and of course numerous other Dutch painters of the seventeenth century, had painted their home scenery and, in establishing that mode of landscape painting, had founded a secure tradition, which many English painters in the eighteenth century had also joined. In the years of Constable's youth, the appreciation of this type of rustic landscape had been developing into a sophisticated taste through the enthusiasm and advocacy of writers such as Uvedale Price and Richard Payne Knight,[31] who found in such places the particular visual qualities and effects to which they assigned the term Picturesque, offering these as an agreeable and artistically legitimate alternative to the dramatic visual qualities implied by the word Sublime and to more conventional concepts of beauty in nature and art.

'In hollow lanes and bye roads, all the leading features, and a thousand circumstances of detail, promote the natural intricacy of the ground; the turns are sudden and unprepared; the banks sometimes broken and abrupt; sometimes smooth and gently, but not uniformly sloping; now wildly overhung with thickets and trees and bushes; now loosely skirted with wood; no regular verge of grass, no cut hedges, no distinct lines of separation; all is mixed and blended together, and the border of the road itself, shaped by the mere tread of passengers and animals, is as unconstrained as the footsteps that formed it. Even the tracks of the wheels (for no circumstance is indifferent) contribute to the picturesque effect of the whole; the varied lines they describe just mark the way among trees and bushes; often some obstacle, a cluster of low thorns, a furze bush, a tussock, a large stone, forces the wheels into sudden and intricate turns; often a group of trees or a thicket, occasions the road to separate into two parts

leaving a sort of island in the middle. . . . In many scenes of that kind, the varieties of form, of colour, and of light and shade, which present themselves at every step are numberless; and it is a singular circumstance that some of the most striking among them should be owing to the indiscriminate work of the peasant, nay to the very decay that is occasioned by it. When opposed to the tameness of the pinioned trees (whatever their age) of a gentleman's plantation, drawn up strait and even together, there is often a sort of spirit and anima-tion . . .'

That passage occurs in Uvedale Price's *Essays on the Picturesque*, published in 1794. But the acceptance of this kind of landscape as a recognized source of art did not mean that it received anything like the approba-tion and respect that Constable, with his feelings for its importance and beauty, would have regarded as adequate. No painter in England elected to full mem-bership of the Royal Academy before Constable had specialized, like him, exclusively in such motifs. The rustic landscapes of Gainsborough, directly derived from Suffolk places and painted in a Dutch manner, belong to his provincial period, and Wilson's views of similar English scenes formed a small part of his out-put. The draughtsmen we associate with the progress of the same tradition, such as Michelangelo Rooker or Thomas Hearne, were held in relatively low esteem, in company with the animal and marine painters. If the type of landscape which Constable preferred was, in his lifetime, being widely appreciated in terms of the Picturesque and analysed—in nature and in painting—with reference to the ideas of the Picturesque, it is improbable that he, as essentially an opponent of theory, would himself have enjoyed it in these terms. The word occurs only occasionally in his correspon-dence, where it is anyway casually used. It is signifi-cant that in writing the text of *English Scenery*, so ex-plicitly an apology for his art, he did not employ the word at all and indeed did not choose to relate either his experience or his pictures to any established aesthe-tic concepts.[32] Constable's historical position, the public and critical attitude to his professional career, the identity of his large compositions and his own

commitment to them, none of these matters will be understood unless it is recognized that he was striving, against the ascendant principles of taste, to establish rustic landscape on the same level of respect as the historical or 'classical' landscapes of Wilson and Turner and the traditions to which these modes be-longed. He was the first English painter both to specialize in this sphere of art and to be accepted as an Academician. When Lawrence told him in 1829 that he was lucky to be elected, the comment, however un-feeling at that moment in Constable's life, does not have to be explained as a maliciously contrived insult. It was not much more than a gloss upon the eloquent facts: that a man of fifty-three, a former student of the institution, recipient of two gold medals from the French, could by only one vote defeat a man sixteen years younger than himself, Francis Danby,[33] who had never studied in the Academy but had been elected Associate member only three years (not like Constable, seventeen) after starting to exhibit there. Danby was a painter of historical landscape, and it was proper that such should be preferred.

What distinguishes Constable's use of nature's material is not just the degree to which he specialized in that, almost to the exclusion of everything else—setting apart his portraiture—but the manner in which he committed himself to it. The range of landscape painting in England between the first quarter of the eighteenth century and the middle of the nineteenth—a range of expression from precise topography to the extremes of imaginative invention—was not equalled in any other part of Europe. The unfolding of that artistic achievement is at innumerable points attached to the Englishman's dependence upon the compact, insular territory he inhabited, to the social, economic, ideological and sentimental connections which have still to be adequately defined and explained. Only in Palmer's work of his Shoreham period did a particular landscape claim such possession of a painter's percep-tions and imagination, and so deeply pervade his con-sciousness with a similar effect, and direct his practice so powerfully.

Constable called his pictures his children, and the

word accurately expresses the psychology of the relationship not only between himself and the paintings as the products of his art, but as images created through that intimate relationship with nature which he felt he enjoyed. Moreover, in bringing the landscape to which he was so deeply committed—the Stour valley especially—before the public and insisting upon its human significance, he was exhibiting himself, and so any severe attack upon his work was taken as more than a criticism of his talent or even of his professional status. For him the quality, as distinct from the subject, of a painter's experience was the criterion by which all art should be judged. If the practice of painting was an exercise of feeling then the painter's involvement with his subject should be at the level of feeling also. The 'sentiment of landscape', to which he often referred, was something more to him than the *genius loci*, for it involved the power of any scene to affect the emotions of those who experienced it directly or through the mediation of art.

In 1814, in a letter to Maria, Constable mentioned his pleasure in reading Archibald Alison's *Essays on the Nature and Principles of Taste*,[34] and in particular the last part thereof:

'. . . "of the Final Cause and of the Constitution of our Nature", is by far the most beautifull thing I have ever read. He considers us as endowed with minds capable of comprehending the "beauty and sublimity of the material world" only as the means of leading us to *religious sentiment*—and of how much consequence is the study of nature in the education of youth—"as it is at least (amid all trials of society) securing to themselves, one gentle and unreproaching friend, whose voice is ever in alliance with goodness and virtue, who is alone able to soothe misfortune"—have we not my beloved Maria both felt this?' (II: 131)

Alison's book, published in 1790, was a late and influential example of those writings concerned with a particularly important subject of eighteenth-century speculation and theory in the psychology of artistic experience, the relationship between the material world, whether it be nature or the creations of human ingenuity, and man's emotions and consciousness. At the centre of this inquiry and debate was the concept of association considered as the psychic mechanism or process by which the outer world and man's inner consciousness were linked. In the letter just quoted, Constable said that he preferred Alison's book to Burke's more famous *Philosophical Inquiry into the Origin of our Ideas of the Sublime and Beautiful*.[35] Perhaps, among other things, he may have found unsympathetic Burke's belief that painting as an art must be inferior to poetry, on account of the necessary clarity and precision of a painted image, and the more detached, intellectual treatment, in his book, of spiritual matters.

Constable found the link of association between natural landscape, the artist's personal feelings, and the work he created, in what he called the 'chiaroscuro of nature', a general term for those qualities of 'light, bloom, freshness . . . no one of which . . . has yet been perfected on the canvas of any painter in this world.' (III: 96) Chiaroscuro, thus understood, was also the chief source of the 'sentiment of nature', and his obsessive concern to embody it truthfully was the most important spiritual source of his pictorial originality. Chiaroscuro, as the vehicle of his feelings about landscape, could convert any place, however insignificant, from being a mere subject, and perhaps a trivial one, into something of deeper content and meaning; it could convert the modest scenery which he most enjoyed into a source of affecting images.

In considering Constable's painting, it is therefore particularly important to recognize that natural landscape presents the artist particularly with two distinguishable, if indivisible, elements. There is the permanent or, at least, stable material of which it is composed, the earth and vegetation, the creatures and objects which inhabit the scene, while affecting their appearance and behaviour are those impalpable, volatile elements—light, an enveloping atmosphere, the moving air—which modify the local colours and the tones, determine the level and character of a scene's illumination, and direct the action and movement of everything able to move. If the stable elements in nature can be treated, metaphorically, as being the

landscape's body, the chiaroscuro and the moving air can be considered as the source of its changing mood or sentiment, as being the landscape's spirit. From that period in the history of European art when natural landscape became an independent and sufficient subject for painting, this duality, and all its expressive implications, had to be recognized. Whatever the philosophical and religious problems occasioned by the idea of a body-mind/spirit duality in relation to man and his experience of the universe, an artistic dualism, if only for its practical consequences, had to be accepted as an unavoidable condition of the painter's practice. Perception of the physical world depends upon light and in depicting nature light and form have to be differentiated. In the evolution of landscape painting a most significant stage was reached when the duality of form and light, from being an objective phenomenon and a matter of technique and style, became deeply involved in the painter's sense of reality and in the current of his feelings. The subtle and elusive union of light and form gradually gained control over Constable's work, and his attempt to present landscape in terms of chiaroscuro and the aerial movement which enhances its effects distinguishes him from the artists of the seventeenth and eighteenth centuries, even those in whose pictures light had such an important function. They had exploited their interest in light through the established conventions of painting; Constable's obsession drove him to methods more unconventional than any the art of landscape had yet known.

He may well have been the first painter, at any rate in England, to apply a word—Chiaroscuro—hitherto used in relation to art, to the appearance of nature. Moreover, although the Constable documents do not, I believe, contain any specific use of the word in relation to his or anyone else's emotional state—so connecting the range from light to darkness with the emotional gamut from joy to despair—there is at least the evidence provided not only by his pictures but in certain remarks such as his words to Fisher, 'I live by shadows, to me shadows are realities.' So light, shadow, and grades of tone were not merely the means by which

some object was pictorially modelled or given relief, not just an attribute of something seen, an element within the painter's control which could be a resource for dramatizing human behaviour or enriching the sentiment of a subject as Caravaggio or Rembrandt had used it.[36] The natural chiaroscuro of landscape in its commonest aspects could transform the significance of a place. The three aspects of chiaroscuro—as a natural phenomenon, as a pictorial device and as a metaphor for the range of human emotions—were at last, in such works as *Hadleigh Castle*, to be so instinctively combined by Constable that for him landscape became, to an unprecedented degree, an instrument of self-confession.

About 1802 Constable was defining to himself the concept of landscape which should thereafter be his concern. What was then home scenery in a strict sense, the region where he was born, was of course to be enlarged to include other places that he wished his fellow countrymen to regard as being peculiarly English. This identification of himself and the sort of landscape in which he felt at ease with his strong sense of nationality was never exactly defined, but it was certainly a part of his self-confessed 'egotism'. Apart from a single reference, in a letter to Fisher of April 1822 ('My brother is uncomfortable about the state of things in Suffolk. They are as bad as Ireland—"never a night without seeing fires near or at a distance".' (VI: 88) there are no comments to be found upon any of the conditions which were altering the identity of the English scene in his lifetime—the expansion of towns and cities, the mounting effects of industrial development, or the physical changes that were to result from the transport revolution of the early 1800s. There is no evidence of his feelings about the building of railways or the spread of the capital, then creeping northwards towards his Hampstead home. Except for some London views, there is very little in his art which shows a world significantly different in appearance from the land he could have painted a century before. His art reflects physical and climatic, not historical change. The country was changing however, and not

just topographically. Its historical character and associations were threatened. The book which Constable's friend, J. T. Smith, devoted to the antiquities of London is marked by a spirit more distinctive than simple nostalgia or antiquarianism, a sense of the past being dismantled and of the need to establish its ancient identity. It can have been no more than a coincidence that, although some parts within Constable's own domain were altered by processes of statutory enclosure in appearance and land-use, the area of the country within which he chose to work so exclusively —east of a line drawn from the Wash to Weymouth Bay—was the region least affected by recent or contemporary enclosure and thus was a landscape of antique form and appearance. He was not only conservative by temperament in his attitude to society but seems—quite unlike Turner, who was deeply responsive to the dynamics of historical change—to have been unaffected by the transformations occurring in his contemporary world. His art was conservative in subject and revolutionary in form.

Among the works painted about 1802 are several in which Constable began to study the expressive effects of light, but in choosing that evening glow which drapes a scene just after the reddened sun has gone below the horizon and adds the calming influence of lengthened shadows he was taking a familiar theme. He had yet to enlarge the calendar and time-table of landscape and recognize that the traditional motifs, dawn and evening, day and night, and the conventional attributes of the seasons, would no longer satisfy his experience and purpose. The detailed observation of atmospheric change, combined with a study of the small, unregarded particulars of his own countryside, were to be Constable's chief occupation during the next twelve years.

When he painted the *Boat-building* of 1815 (Plate 39), entirely out of doors it seems, he evidently had two serious intentions—to prove to himself and others that he could 'finish' a finite, elaborate work by executing it within the conventions of an artistic tradition to which he was still closely attached, while not failing conscientiously to invest the picture with that truthful look and originality which was the profit he believed had been gained from his local experience and study. If he had just looked to Claude for advice, his purpose could only be to do Claude again after nature. Here is a bright midday of late summer, the sun's steady warmth cooled by the slight breeze stirring the leaves, the colour of grass and foliage fully matured as the season nears its end. Those elements of the boat-builder's craft he chose to include were sufficient to give the picture reality, but were not so assertive as to make the landscape merely a stage; the human activity and the objects associated with the craft are so unobtrusive they might be a part of nature. Only the picture's emphatic greenness, albeit a green kept in control by a grey overtone, distinguishes the form of this picture, as an image of rural scenery, from the rustic landscapes of earlier painters, Dutch and English, and indeed from the works of some contemporaries. Pictures made earlier than this may now appear to be more expressive: the *Stour Valley and Dedham Church* (Plate 41) of 1814–15, with its informal composition, is more lively and suggestive; and the *Dedham Vale with ploughmen* (Plate 38) of about 1815, which includes that chilly rain-shower blowing briskly away on the breeze, is more evocatively atmospheric.

The *Flatford Mill* of 1817 (Plate 58) developed the traditional aspects of the *Boat-building* and its stable design even further, perhaps because the perspective of the retreating river holds the composition in a firmer grip, perhaps because it must have been painted mainly in the studio and thus the picture's lighting was even more fixed and carefully contrived. Another four years was to elapse before the character of these compositions was, with the painting of *The Hay Wain*, to be significantly changed. Meanwhile, in *The White Horse* (Plate 53) and *Stratford Mill* (Plate 55), Constable enlarged the scale and increased the rhetoric of his Stour valley theme and thus converted the place that was once home, the land in which he had developed the resources of his art, into a symbol of English scenery which could, he hoped, influence the feelings of his fellow countrymen and take its place alongside the representative landscapes of European painting. *The*

Hay Wain was not only the most richly atmospheric of the finished landscapes he had by that date exhibited, but the first major work in which his personal style was unmistakably evident. In helping Constable achieve the qualities displayed in the picture, the cloud studies of 1820–2 (Plates 60–67) combined with the Hampstead sketches (Plates 75 and 76) of the same period were a fundamental influence.

Dr Kurt Badt has shown how important the investigation of the sky during the first half of the nineteenth century was to be in changing the sense of landscape and its spiritual connection with human experience. Given the pictorial studies of Constable, Dahl and Blechen, the scientific researches of Luke Howard, the writings of Goethe, Carus and Ruskin—not to mention a similar attention to clouds in the work of other artists and authors—it would be no exaggeration to suggest that, through a more responsive and dynamic treatment of the sky, not merely the iconography but the expressive scope of landscape painting was greatly extended.[37] Constable's cloud studies, inspired as much by his instinctive sentiments as by the intellectual curiosity which caused him to annotate them with the dates and times of painting, are the most impressive works in European art occasioned by this widespread interest and study. He had realized that his earlier rendering of clouds was insufficient to satisfy his growing obsession with effects of light and atmosphere. The painting of *Wivenhoe Park* (Plate 51), made in 1816 for General Rebow, shows how his earlier instinct for truthful observation had brought difficulties which he was then unable to resolve. The commission was of a kind which he approached with some hesitancy. He did not enjoy painting gentlemen's estates and thus joining a tradition which, in England, went back to the seventeenth century. The place was likely to be, by his standards, unnatural, and so conducive to an equally affected performance on the painter's part. As always on the few occasions when he made such works, he used every device at his command to convert a portrait of a place into something expressively less limited. Within the bounds of his practice at the time, the atmospheric elements of the picture are uncommonly strong; they override the house, which is barely visible at the centre of the scene, and disguise whatever formalities of design the park contained. Indeed, the chief element in the landscape as he conceived it is a vigorous parade of massive clouds; they not only dramatically control the upper part of the composition, but by the shadows they cast give the whole painting a very powerful energy. With the passage of time its tonality has matured into a coherent state and is, anyway, agreeable to a latter-day taste, but the problem which such an exercise presented then can be readily imagined: when the picture was new the clouds and their shadows must have been falsely dominant. As Constable's compositions grew in scale and became more substantial, the necessity of making his skies natural, strong and expressive grew also. In *Hadleigh Castle* and *Salisbury Cathedral from the meadows* the clouds were to be pictorially as substantial as the ground beneath them.

He would have encountered in Alison's book on taste the statement that there is an analogy between 'the lovely sensations of sunshine and the cheerful emotion of joy . . . between the lustre of morning and the gaiety of hope'. The artistic connections between Constable and Wordsworth have become a cliché of criticism, but among the reports of experience which certainly do link the two men in a spiritual companionship there is none more evocative than the following words from *The Prelude*, 'The sky never before so beautiful, Sank down into my heart and held me like a dream . . .'[38] Constable's appreciation of the sky was inspired more by a practical sense of its artistic use than by any desire for a transcendental vision, but if he did give both the clouds and the blue infinity beyond a very strong material presence in his pictures, and one which grew stronger as the years passed, he was also more frequently impelled to project his anxieties into his treatment of the sky and thus into the sentiment of the landscape as a whole; its forms became dominated by his emotions. The best sky studies of 1820–2 (Plates 60–67) are among Constable's more perfectly resolved works, for they combine an exact and impassioned observation with that simple, concen-

trated and apparently effortless execution which he could command when his besetting anxieties were apparently absent and when his involvement with nature was as immediate as he always wished it to be.

The six-footers painted between 1819 and 1828 were all, except for the Brighton picture shown at the Academy in 1827 (Plate 117), of Stour valley subjects, and all but one of these included a part of the waterway. Only in the *Dedham Vale* of 1828 (Plate 108) is the human element in the scene quite incidental and suitably described by the conventional term 'staffage'. Although we may associate many of Constable's larger compositions with human detail, as titles such as *The Hay Wain* and *The Leaping Horse* imply, the figures and their actions seldom have a memorable identity and he seems to have taken very little interest in characterizing them. The same indeterminate dog was brought from *The Hay Wain* (Plate 72) into *The Cornfield* (Plate 119) and thence, eight years later, into the foreground of *Salisbury Cathedral from the meadows* (Plate 150), becoming a little less actual with each remove. In fact, the most expressive figures to be found in his work appear before 1823, which is not to say that they were more elaborately realized. A particular weakness of invention, which limited the effectiveness of such details, also affected his portraits. Indeed Constable, who felt so deeply and said so much about nature and the countryside, and who rejoiced in being a born countryman, made no comment of any interest, in words or pictures, about the human life of rural England.

The series of Stour valley compositions began with four tranquil images expressive of benign summer weather, indicated by the sluggish passage of the barges in *The White Horse* (Plate 53) and the picture he called *The Bridge* (Plate 80), by the boys idly fishing in the *Stratford Mill* (Plate 55) and the midday rest of the waggoner and his horse in *The Hay Wain*. The next two subjects, *The Lock* (Plate 100) and *The Leaping Horse* (Plate 99) in their various versions, have not only the strongest subjects of any pictures painted before *Hadleigh Castle* (Plate 121) but a new energy of style, which could be attributed, speculatively, to

various causes. One was the desire to diversify the Stour valley theme, which some people, including Fisher, were beginning to find monotonous, and to do so, however emphatically, in the only way that his convictions would allow—by altering the atmospheric conditions within the landscape and making the human details respond to that change. By 1825 his failure to gain full membership of the Academy, which would have improved his chances of winning financial security, was becoming serious and he may well have considered that, when landscapes with a strong applied subject were the most esteemed, he should move his own work in that direction. The declining health of his wife was by then bringing to an end a phase of contentment and optimism: the disturbance in the heart of these landscapes certainly reflects his anxiety, even if it was not a deliberate expression of his unease.

In both *The Lock* and *The Leaping Horse* the wind blows gustily across the fields and every movable thing submits to its influence. A man strives to open the lock, while his companion contends with an unruly sail as his boat rocks in the surge of water erupting from the bottom of the gate; a bargeman, pressing upon the pole, steadies his craft in the strong current while, on shore, the sturdy horse, which will soon take up the rope's strain again, is jumped over an obstacle on the tow-path. And in both pictures a race of turbulent water in the foreground echoes the turbulence of a grey, cloud-filled sky. The quality of style which was soon to dominate the *Hadleigh Castle* (Plate 121)—an irregular and powerfully assertive handling of the paint, which was to become quite overwhelming in some works of the 1830s—was emerging here, although the picture's *matière* was still a fluent and controlled expression of the subject's chiaroscuro.

The last two works in the Stour valley sequence, *The Cornfield* (Plate 119) and *Dedham Vale* (Plate 108), introduced another, more radical change, and they now seem, in their different ways, to be the most contrived of Constable's exhibition pieces. Painting them on upright canvases gave both subjects a monumental design and formality which none of the earlier pictures had

had, the spirit of both scenes being determined by traditional tall trees creating a vertical thrust and by a deep, flat perspective establishing the horizontal balance to it.

The Cornfield was to be the picture acquired by private subscription for the National Gallery after the artist's death and so may be supposed to have pleased contemporary taste. Even if we apply to it the aesthetic criteria of the time rather than the sensibility of today, it must still be considered Constable's most artfully ingratiating work. He confessed to Fisher that he had given it—and he must presumably have been referring to the handling—a coat of 'eye-salve' to enhance its general appeal. He took advice from a botanist friend about the authenticity of the plants. The symbols scattered through the scene, the cornfield itself, the broken gate, the inactive plough at the field's edge, the donkeys browsing at the hedge, the procession of sheep, the shepherd boy drinking in the stream—all combine to satisfy the popular feeling for a sense of rural life, and if the work's affinity with Gainsborough's *Market Cart* (Plate 176) was accidental or, at least, not very consciously contrived, then this is certainly a work in which an eighteenth-century sense of rusticity was persisting if not being deliberately revived. *The Cornfield* shows Constable yielding, a little, to one prevailing temptation. And the *Dedham Vale* presents his response to another, that of allowing the rhetoric which was anyway a natural and sincere element in his exhibition pieces to become imperiously grand: it is his *Crossing the Brook* and not only his most academic conception but one in which he faced the claims of tradition with the greatest confidence and command. For the first time, he extended his gaze towards a grand infinity, as if to insist that the Stour valley was not a private retreat but a part of the great universe, as well as having its place in the history of art. Previously, when his pictures had contained a distant horizon, as in some of the Hampstead subjects, the physical breadth of the scene in view had been more interesting to him than its depth; he had easily resisted the temptation to set up formal containing barriers on either side of the design so as to promote a sense of space. But

here, in this picture, the viewer is taken through a carefully designed anteroom into the open plain beyond.

The next large composition (Plate 121) marked an even more abrupt change in the painter's practice, and its identity is easily explained by his wife's death in the autumn of 1828. It was a bitter paradox that his most tragic work, the picture most strongly charged with an unequivocal and fierce passion, should have been based on a place which cannot, constantly, have engaged his feelings. The place so freely re-created in the picture—Hadleigh, on the Essex side of the Thames estuary—had, apparently, no great significance in the artist's life, although he had mentioned the ruin to Maria in a letter when he visited it in 1814. The solitary, shattered castle must, however, have impressed him then to be firmly fixed in his memory so many years later. At this time of despair, he would not select a cherished spot in the Stour valley or near his Hampstead house or in Fisher's part of Dorset, anywhere, indeed, associated with the joys of his childhood, courtship and marriage, places of which he was hardly ever to paint a dark interpretation. He wanted, presumably, a remote subject which would not, through fond memory, aggravate an emotional wound, but could nevertheless symbolize his sense of desolation. If a sketch of the castle seen from a point further to the north was made at this period, a view in which the isolation of the ruin is more striking and the perspective of the river stretching eastwards less positive, he may have chosen to alter his original concept of the work quite fundamentally in favour of the version he developed. Certainly that view, based literally upon a tiny pencil note of 1814 (Plate 123), the only extant source, was changed in two significant details between that moment when he converted the original study into an oil sketch and the period when the two larger versions were made. Into the heart of the ruin he planted a wind-blown, emaciated tree and, besides strengthening the light silvering the horizon, he brought the darkest of the clouds nearer to the edges of the canvas. In its final version this harsh picture is the most elemental in composition, in feeling the most intense, and in its handling the most turbulent of all

the large Academy pieces made by that date. It also embodies the most poignant expression in all Constable's painting of an idea which affected, consciously or unconsciously, so much of the artistic imagery of the period and which is suggested by Goethe's remark that 'Man sees the natural and the spiritual in a constant and indissoluble relation.' Furthermore it introduces a general theme which was to be quite common in his later works, that of light dispersing darkness or irradiating a shadowed world, as if it were possible through art not only to symbolize a state of consciousness but to ameliorate it.

Whatever course his affairs might have taken had his wife lived, the imagery of his painting and the conduct of his practice was greatly changed after 1828. He could still paint a simple landscape lying under a calm sky and render its tranquillity in a poised, uncomplicated manner; a work of this kind is the *Watermeadows near Salisbury* (Plate 149), made in 1829 during one of his last visits to Fisher and when his friend was, on the evidence of their letters, trying to bring him back to a state of equable feeling and self-possession. The picture was accidentally rejected by the Academy selection committee, but he could still consent to show this aspect of himself and his vision to the public, as he did again by exhibiting the *Cottage in a cornfield* (Plate 135) in 1833; this was an earlier work which was 'licked', as he said, into a condition for showing, but was not deprived thereby of the fresh qualities of a happier period. The practice of his last nine years was not conducted with that consistency of purpose and development shown in the 1820s. Only one of the larger exhibited pictures, *The Valley Farm* (Plate 160), presented a Stour valley theme; the rest were devoted to subjects as diverse as his prejudices would allow: *Helmingham Park* (Plate 127), the image of a shadowy, secluded retreat; *Whitehall Stairs* (Plate 154), a glittering piece at last finished, by an effort of will, thirteen years after its first conception; *Salisbury Cathedral from the meadows* (Plate 150), which he had treated with such an affecting simplicity in the sketches of the 1820s, here being the inspiration of his most unquiet images; the *Cenotaph* in the park at Coleorton

(Plate 156), uncommonly an autumn picture, the season in tune with an elegiac work, for it celebrated a dead artistic hero, Sir Joshua Reynolds, and a dead friend, Sir George Beaumont, and was perhaps influenced, too, in its sentiment by Wordsworth's sombre poem inscribed on the memorial which Beaumont had raised in the portrait painter's honour. Constable's practice as a whole was affected in these years by more frequent use of an explicit symbolism like that which had controlled the Hadleigh picture, and this too reflected the darker aspects of his experience and feelings. The isolation of Stonehenge and Old Sarum, both abandoned relics, was, like the broken Essex castle, dramatized by storm clouds and turbulent winds. Even optimism or renewed purpose, which alternated with periods of distress, was to find an ambivalent symbol in the rainbow, for all its brightness a transient apparition, created by the collision of sun and storm. He called the last version of a repeated Hampstead view (Plate 158) 'one of my best bits of Heath, so bright, dewy and sunshiny', but this painting was furnished with a rainbow and its uneasy brilliance depends more upon the contrast of darkness than upon a condition of light; indeed Constable's words seem to suit neither its subject nor its mood, but to fit an earlier kind of painting. Formerly the idea of chiaroscuro had been simply attached to nature and its effects but now it seems to refer more truthfully to aspects of himself.

The technical qualities of his later painting will be considered below, but, in terms of the content of his landscapes, the radiance to be found in the *Salisbury Cathedral from the meadows*, for example, was a shallow iridescence scattered over a sombre base. In these circumstances it is not surprising that he was content to see the chiaroscuro of early works transformed into the dense shadows and piercing lights of Lucas's mezzotints, which gave some early, lyrical sketches an ominous force and spirit of foreboding. In the history of art there are few other prints of an essentially reproductive purpose which so profoundly transform the original work.

'I must tell you that as a painter I am becoming more

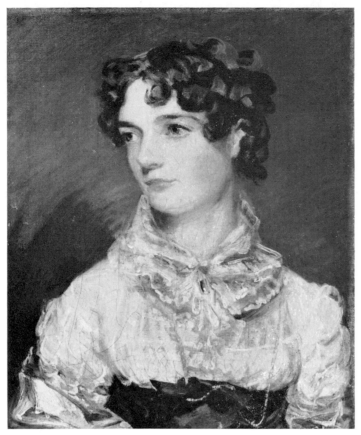

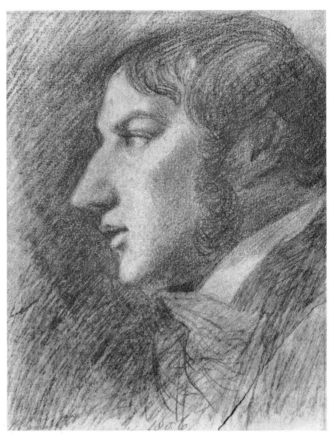

Figure 1. Maria Bicknell (later Mrs Constable), painted in 1816, the year of their marriage. Oil on canvas, $11\frac{7}{8} \times 9\frac{7}{8}$ in. (302×251 mm.) London, Tate Gallery

Figure 2. Self-Portrait. Dated 1806. Pencil, $7\frac{1}{4} \times 5\frac{1}{2}$ in. (184×140 mm.) Collection Colonel and Mrs J. H. Constable

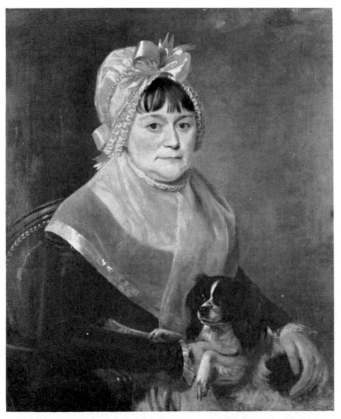

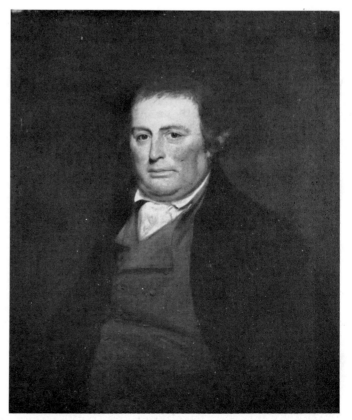

Figure 3. Ann Constable, the painter's mother. c.1801. Oil on canvas, 30×25 in. (762×635 mm.) Collection Colonel and Mrs J. H. Constable

Figure 4. Golding Constable, the painter's father. 1815. Oil on canvas, $29\frac{3}{4} \times 24\frac{3}{4}$ in. (756×629 mm.) Collection Colonel and Mrs J. H. Constable

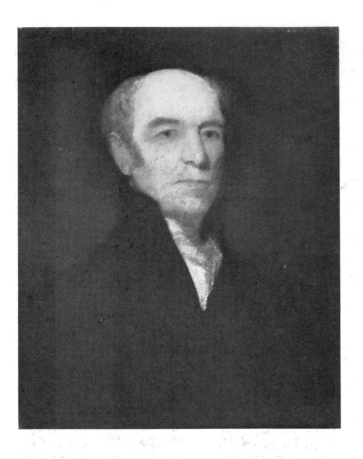

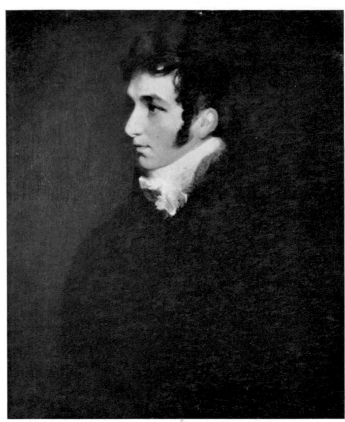

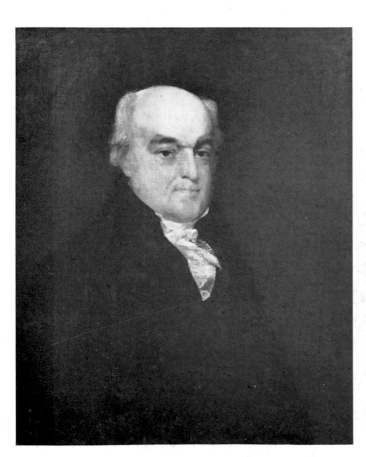

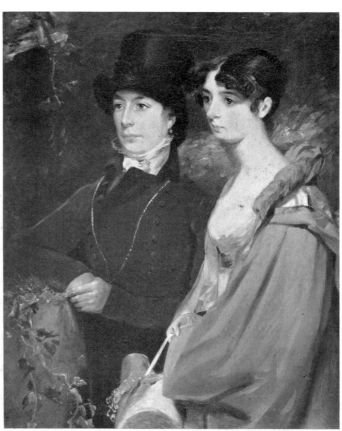

Figure 5. (*far left*) David Pike Watts, the painter's maternal uncle. 1812. Oil on canvas, $24\frac{3}{4} \times 19\frac{3}{4}$ in. (629×502 mm.) Collection Colonel and Mrs J. H. Constable

Figure 6. (*left*) Abram Constable, the painter's brother. 39×25 in. (760×635 mm.) Ipswich, Christchurch Mansion

Figure 7. (*far left*) Charles Bicknell, the painter's father-in-law. Date unknown. Oil on canvas, $31\frac{1}{2} \times 26\frac{1}{4}$ in. (800×667 mm.) Collection Colonel and Mrs J. H. Constable

Figure 8. (*left*) Ann and Mary Constable, the painter's sisters. Oil on canvas, $15 \times 11\frac{1}{2}$ in. (381×292 mm.) San Marino, California, Henry E. Huntington Library and Art Gallery

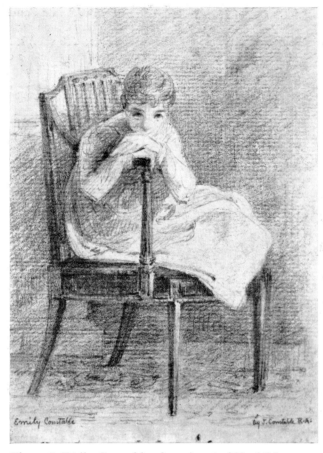

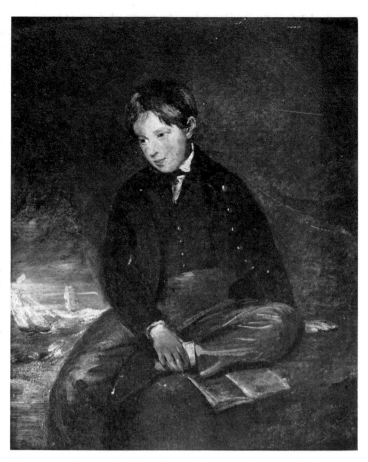

Figure 9. Emily Constable, the painter's fifth child, born 1825. *c*.1830. Pencil, 6 × 4½ in. (152 × 114 mm.) Collection Colonel and Mrs J. H. Constable

Figure 10. Charles Golding Constable, the painter's third child, born 1821. Oil on canvas, 14¾ × 11¾ in. (375 × 298 mm.) Collection Benjamin Britten

Figure 11. The artist's children playing the coach driver. Pen and ink and watercolour, 4¼ × 7¼ in. (108 × 184 mm.) Inscribed 'all this is entirely his own invention—a little mite inside'. The children are probably the eldest two, John Charles, born 1817, and Maria Louisa, born 1819. Private Collection

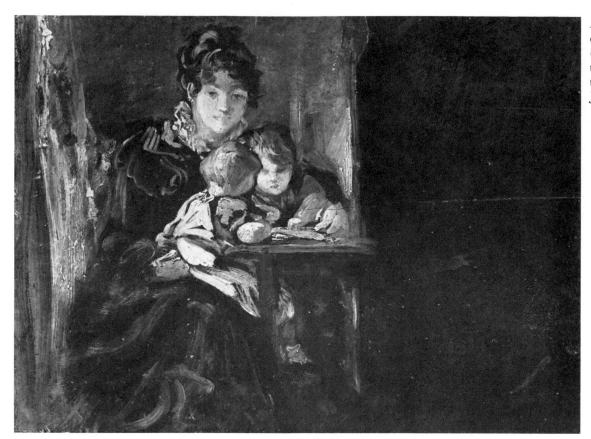

Figure 12. Mrs Constable with two of her children. Oil on panel, 6½ × 8½ in. (165 × 216 mm.) It is not known which two of the painter's children are shown in this group. Collection Colonel and Mrs J. H. Constable

Figure 13. Archdeacon John Fisher. Exhibited 1817. Oil on canvas, 14 × 12 in. (356 × 305 mm.) Cambridge, Fitzwilliam Museum

Figure 14. Constable late in life, by Daniel Maclise, R.A. (1806–70). Pencil, 5½ × 4¼ in. (140 × 108 mm.) London, National Portrait Gallery

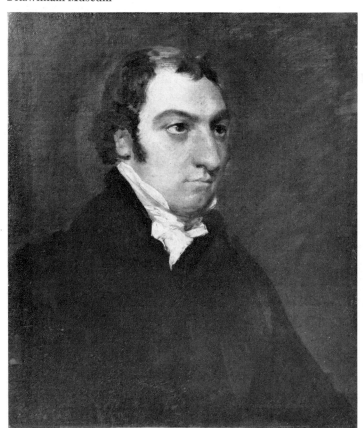

clear-sighted in front of nature, but that with me the realization is always very difficult.' These words might, on both pictorial and verbal evidence, have been uttered by Constable, but they are, of course, not his. They were written in 1906 by Cézanne.[39] Not only is the bearing of that sentence in accord with Constable's response to *his* motifs, but the central word, realization, is the ideal term by which to characterize his whole endeavour and especially his efforts after 1815. A most appropriate image of Cézanne as landscape painter would show a man standing in the open air at his easel, directing his scrutiny back and forth between the canvas and the motif, striving to transfer to the one the chromatic intensity and physical presence of the other, so that the forceful impression, the impact of the sense-data he received from the landscape should be re-created with sufficient dynamism through the coloured marks put upon the picture surface. Cézanne, who spoke of being 'passionately fond of the contours of this country [his native Provence]', said that in a picture there should not be 'a crevice through which may escape the emotion, the light, the truth'. A comparable image could be formed of the painter of *The Hay Wain* and *The Leaping Horse*: the artist in his studio, a place filled with studies vividly recalling his direct observations of light and colour, his inner eye possessed by an equally intense and persistent vision of nature, seeking through colour to bring those impressions, in all their vitality, to the work before him. 'I have filled my head with certain notions of freshness—sparkle—brightness till it has influenced my practice in no small degree.' (VI: 258) The isolation which Cézanne—himself certain that 'art addresses itself to an excessively small number of individuals'— enjoyed in the landscape of his native region was matched in Constable's case by *his* evident sense of being apart in a place of his own, by *his* certainty that his painting was necessarily separated from the understanding of the educated majority. Both painters found a certain imperious self-satisfaction in their search for truth, in the mental hardships of their calling and in being perpetual students.

It may be argued that for every serious painter there must be a problem of realization, whether his concern be a sunlit meadow or Christ nailed to the Cross, but most painters—and certainly this was so before the nineteenth century—managed to acquire a pictorial language and method, and then develop and extend it, without unending travail and besetting anxieties. Bonington, to instance a contemporary whose talent Constable coolly judged,[40] was also a student of light and atmospheric effects in nature, but he quickly attained an assured, closed method for the treatment of such effects and everything else he painted. Turner, like Picasso in our time, was one whose way of working was always free, open, and exploratory, but whose experiments were evidently pursued without persistent anxiety, even in the face of virulent criticism.

Constable was nearly forty before he emerged from artistic immaturity and a sense of apprenticeship, and even by that age his practice was not clearly directed. However ardently he applied himself, the way he worked in his studio can never have been methodical. A disciplined working practice would have meant an orderly progress towards a predetermined goal, and, with such a routine, alternative solutions emerging along the way, false starts and distractions, uncertainties and disappointments, could have been regulated in the interests of a final composition. Such a process had been one of the conditions of traditional practice learnt in the workshops and in the Academies which replaced them as the main source of artistic training and knowledge. These routines were gradually supplanted, from the eighteenth century onwards, by different and more personal working habits, according to the temperament of the individual. In the history of artistic practice Constable has a very distinctive and important place, for in a fundamental way he stands apart from the Academic tradition, not only through the character of his most personal works but also through the conduct of his professional life. According to his friend and colourman, George Field,[41] Constable once said, in conversation with a French visitor, that he had no method, and the observation is supported by much evidence. There was the obstacle of his volatile temperament, standing in the way of a

free, confident, decisive procedure, and particularly when the artistic problems and the circumstances of domestic life were at all challenging, when the work was due for public attention or, by its size, demanded lengthy treatment. There was the confused variety of his pictures in all media, especially after 1820, this being a body of work so distinctively diverse from the *œuvre* of other painters, however impulsive or experimental. That is why, as a prelude to any interpretation of Constable's technique or stylistic development (and that cliché does not really suit him), the relation of the 'finished' paintings to the less elaborate works in various media has to be considered. Such words as 'sketch' and 'study' and others with a similar meaning in our sadly limited artistic terminology are quite inadequate in any attempt to re-create the circumstances and motives of this painter's most individual behaviour.

Dr Badt, in his account of the cloud studies, was perhaps the first writer on Constable to insist that those informal works connected by their subject with the six-footers should not simply be identified with the conventional preparatory works of others. Seurat is an apt nineteenth-century example of an experimental painter working contentedly within a traditional discipline of studio practice: Constable's behaviour was absolutely different. I suggest that the little *Hay Wain* pochade reproduced in Plate 70 should not be treated as a progressive state in the development of that composition or even as an incidental product in which a particular problem of composition was worked upon away from the main canvas. It is more likely to have been made as the expression of an indefinite impulse and one which cannot, therefore, be rationally explained. It should be linked to the involuntary workings of Constable's feeling and intuitions, not to the rational logistics of an evolving composition.

The large unfinished versions of *The Hay Wain* (Plate 74), *The Leaping Horse* (Plate 96) and other exhibition pieces which we may also by habit call sketches are equally problematic. Were they rejected solutions abandoned early, full-scale modelli, alternative versions kept in progress with the others, in which alternative possibilities could be tested? Did they all have the same use or does each case have to be considered separately, as some of the documentary evidence suggests? Regrettably Constable's letters do not help us to answer these questions. The only certain conclusions are that we *cannot* establish the function of these paintings with any certainty, and that together with the other works they constitute an *œuvre* without precedent in the history of painting.

Badt has also rightly insisted that none of the six-footers should be treated as exercises, devised coolly, even unfeelingly, to secure approval by the rulers of the Academy and by connoisseurs with a conservative taste. He invokes Wordsworth's idea of art as being 'emotion recollected in tranquillity' to explain the difference between them and the more spontaneous or simple pictures. (Apart from the important distinctions between the processes of poetic and pictorial composition, there was never much tranquillity or ease of mind available to Constable for the production of his larger works.) There is a passage in one of his letters to Fisher—not quoted by Badt—which might at a first reading seem to support this idea, but which, like the compositions themselves, points in a different direction. The letter (VI: 142) was written from Sir George Beaumont's house after Constable had been copying a Claude. 'Perhaps a sketch would have answered my purpose, but I wished for a more lasting remembrance of it and a sketch of a picture is only like seeing it in one view. It is only one thing. A sketch (of a picture) will not serve more than one state of mind & will not serve to drink at again & again—in a sketch there is nothing but one state of mind—that which you were in at the time.' The six-footers were treatments of a subject in more than one 'view' and one state of mind, but not an essentially different view and state of mind, not expressive of a different mode of feeling. Badt suggests that the sketches have the qualities of poetry and the exhibition pieces those of prose. Certainly most of Constable's modern interpreters, preferring the one type of picture to the other, have shared that opinion and prejudice, but the judgement does not, I believe, conform with either the artist's valuation or his priorities.

To appreciate the physical identity of the major landscapes and understand the painter's ways of making them, the question of finish is, in terms of historical criticism, paramount. The very concept of finish, which so constantly interested nineteenth-century writers on contemporary painting, has ceased to be a critical issue for so long that it is difficult now to recover any feeling for its former significance. The conflict which throughout his career Constable experienced in both mind and practice gives him and his work a very important, even crucial place in the technical history of the matter. He was faced by the following alternatives: to consider finish as an objective standard by which a picture's entire identity as well as its visible surface was to be judged, or to give his works the *matière* necessary to convey the 'original' feeling to which he often referred as well as those elusive attributes of nature which he most valued.

For almost the whole of his working life, Constable was involved in a conflict between these two alternative concepts with which he was confronted by friends and opponents alike. In his early years as a painter, some of his relatives presented him with the problem as one not merely affecting his professional practice, but as nothing less than a moral issue. His father naïvely and kindly did so, and his censorious uncle, David Pike Watts, also, but in his case with more sophistication and fervour. Commenting upon a picture shown in the Academy exhibition of 1814 (Plate 32), he wrote, 'in this Boat Landscape, where there is much to admire, there is this sad Trait to lament, namely hurry and slight of *Finish*. This is the unfortunate Sign of an hurried Mind and consequently perplex'd pencil; in short of that fatal habit *Procrastination*.' Fisher, years afterwards, treated it almost as a matter of mental health; achieve a '*finished polished picture*' and his friend would have defeated that corrupting demon, anxiety. So the problem continued not merely to affect his pictorial technique but also to involve that formidable moral censor who, like an inquisitor, presided over Constable's artistic consciousness. He confessed later that the surface of his pictures had prevented his ideal of landscape from being gener-

ally understood and accepted. He lamented that he had 'cut his throat' with the palette knife he used so much after 1822. In the end he was even inclined to chide himself with having become that most ignoble sort of painter, a mannerist, and thus to have betrayed one of his strongest convictions.

His characteristic finish, that broken and sometimes tortured surface which Lawrence called 'ferocious' and which, if we will submit our attention closely to the pictures themselves, is still in the later works disturbing and difficult to ingest, was then liable to be further aggravated by distracted emotions and become the outward sign of an anxious, divided and distressed spirit. At the outset, the originality of Constable's handling had been simply caused by his pursuit of 'chiaroscuro' and by the aims he outlined to Fisher in that letter of 1821. When he said elsewhere that what he was seeking had not been 'perfected in the canvases of any painter in the world', the claim was certainly justified and not only his originality but the developing character of his execution and style can only be understood by a precise comparison with the methods of earlier artists and the conventions in which they worked. Previously in the history of landscape the expression of light, atmosphere and aerial movement had been achieved under the rule of certain pictorial unities, and these obviously shaped the effects of painters who deeply touched Constable's affections: the luminous perspectives of Claude (Plates 174 and 175), that resonant glow which suffuses the sun-lit pictures of Cuyp (Plate 169), and the cool grey light of Jacob van Ruisdael's woodland prospects (Plate 172). These unities were strictly observed, though not, in the literature of art, defined with the same theoretical precision as those that had been applied to dramatic form or as the metrical rules that had controlled poetry. In painting they were unities of illumination, tone, space, notation and touch, some of these being subject to a more rigorous and exact usage than others. They formed, moreover, a body of pictorial conventions which Constable had inherited as a student, to which he was faithful in his more elaborate pictures before the early 1820s and from which thereafter he could

only depart with a consciousness that he was claiming a provocative freedom.

Unity of illumination had meant treating the natural scene, however indefinite its actual boundaries, as if it were an enclosed and finite space, a kind of natural chamber lit consistently throughout either from one or from a limited number of concentrated light sources. Consequently shadows in landscape could also be regulated by the same laws of geometric perspective that were applied in other subjects. No conflict need exist, therefore, between light and shade as a means of suggesting mass and relief, and as a condition of sunlight or any other particular atmospheric or seasonal state. The sunshine which breaks in upon a Cuyp river landscape from an invisible source just beyond the edge of the canvas gives solidity to the trees, figures and animals while bathing them in a liquescent, golden atmosphere; his problem had been to reconcile the sense of mass, texture and enveloping sunlight. Unity of tone meant an ordered composition of the picture's spatial illusion by an atmospheric perspective which determined the placing and strength of the tones, in a regulated sequence from foreground to horizon. Such a unified system of tone is very evident, for example, in the work of J. R. Cozens, among Constable's favourite masters, and although few artists used colour so austerely as he, the local hues of landscape had always been regulated by that tonal unity just described. Unity of notation required that the natural forms of landscape, in the earth, water and vegetation, should be represented by graphic symbols consistently applied—symbols for leaves, for grass, or the ripples of a stream, for example, and for everything else in nature which had a distinctive and finite shape. And these symbols were, like the picture's tone, controlled by the system of perspective, diminishing in scale towards the horizon. This use of a regular and conventional notation was combined with a necessary unity of touch or handling. The substance of the paint, the plasticity of the individual strokes, was regulated also, so that the painter's handling would not be so obtrusive as to interfere with the other unities. The imaginative achievement of such masters as Claude or Cuyp was to work within such a rational system, but to use it with so much freedom and sensitivity that its conventions never became obtrusive nor acted as a constraint upon their vision and feeling, any more than the laws of musical structure constrained Mozart or Beethoven. In the landscapes of 1802, Constable was using his particular inheritance of a tradition in a quite elementary and unoriginal manner, redeemed there by the charm of the subjects and the first evidences of his own genius for sensitive observation.

The finished pictures constructed within the conventions just described do not, of course, account for all the landscapes made in the seventeenth and eighteenth centuries. There are those works—Rubens's landscape sketches in oil colours being among the finest of them—which were created privately, as it were, in response only to the artist's personal demands and necessities and carried out by more informal and irregular means (Plates 170 and 171); they had qualities of colour, notation and touch which would have been thought out of place elsewhere although they were even then esteemed within the terms of this distinct informal mode of painting. They were warmly accepted, indeed, because the painter had proved his capacity to behave elsewhere with a proper decorum. Much of what Constable produced in the fifteen years after 1802 were works of this sort, made while his friends and relatives were urging upon him the need to be conscientious and industrious in surrendering to the disciplines of finished pictures, and thus in bringing his art to public attention and in claiming public respect. And thus it was in the succession of finished works which form a prelude to the compositions of the 1820s that he proved to himself and to others that he could observe the unities. Not long before he started to work upon the *Boat-building* (Plate 39) in Suffolk he had written to his friend Dunthorne that he was 'determined to finish a small picture on the spot for every one I intend to make in future.' About the same time he discussed the same problem with Farington, who had to report that his progress within the Academy was being obstructed by his insufficiency with respect to finish. In attempting to reconcile his determination

to keep that grasp of natural effects which he had gained through his quick studies on the spot with the traditional demands of a disciplined and elaborated composition, Constable looked to Claude for guidance. The consequences of this study and determination so evident in the *Boat-building* are even more obvious in the *Flatford Mill* (Plate 58), exhibited at the Academy in 1817 and executed mainly in the studio. The difference between these works and earlier attempts to achieve something beyond a sketch—the views of his father's garden (Plates 36 and 37), the *Dedham Vale* in the Proby Collection (Plate 18), the *Stour Valley* in Boston (Plate 41)—indicate a painter putting himself under restraint. Here are more formal images of landscape. The space is more exactly defined and contained within the boundaries of the canvas, the transitions of tone less abrupt, the lights and the shadows more carefully placed, the touches of pigment, whether or not they indicate an object such as a leaf, less obtrusive. The same disciplines were to control the execution of the first large compositions: *The White Horse*, *Stratford Mill*, and *The Bridge*. By 1822, however, his interest in the chiaroscuro of nature had become so consuming and his experience of it had crystallized into such a powerful interior image, and one to be defended so passionately, that the disciplines he had been following must have seemed an intolerable restraint upon his sense of originality; from then the quest for vitality, freedom and fluency which naturally belonged to the sketches, their strength of colour and irregular improvised handling, began to invade everything he composed. His criticism of the watercolourist and drawing master, John Varley, was no doubt prompted by his conviction that Varley taught his pupils the conventions before they had learnt to observe the reality of landscape.

This was also a period when Constable's painting of oil studies became even more purposeful than it had been earlier, and was concentrated upon a narrow objective. The experience he gained in his cloud studies and in the group of Hampstead Heath sketches of the same time—in which he treated the influence of light and aerial movement upon the broken ground and grass, bushes and trees of quite nondescript sites—was then of very immediate relevance to the development of his studio pictures. An ideal example of his most advanced methods is a small Hampstead study of this date in the Mellon collection (Plate 69).[42] The kind of natural conditions which must have occasioned it will be familiar to anyone observant of weather effects. A spring or summer storm is just breaking or passing away from the locality. The sky colour is vivid and uneasily transient. Sunlight strikes irregularly through a confusion of shifting clouds. A boisterous wind is gusting and slackening with irregular force. In the tree-tops the movement of the large masses of foliage is accompanied by a wild dance of the leaves at the surface; the trunks and branches sway in a bold undulation. The ground is broken below into shards of light and shadow. In the picture, a rapidly improvised image, these strong effects have been realized with an exceptional freedom of colour and handling. At some points—in the formation of the clouds, for example, and in the large areas of foliage—the marks of the brush are quite descriptive; elsewhere there is only an evocative scribble suggesting general attributes of light and motion. The handling of the paint is irregular and spontaneously inventive, in one place casually slipped off the point of the brush, in another appearing as a web of hair-like strokes as the bristles have been pressed with the fingers into a thin fan and just touched with the colour. Compare this sketch and others of the time with the Suffolk studies of ten years before (Plates 21, 25 and 26), and the advance in freedom and individuality is obvious, although Constable's spontaneous interest in atmospheric effects had been the same in the earlier works. Simple areas of colour summarized the larger elements in the scene or distinctive areas of light and shade, the colour was strong but moderated by a controlling harmony of tone which regulated the whole study; the flecks, spots or strokes of bright colour which suggested the light and its reflection or simply enlivened an expanse of colour were put in vividly enough, but with a conventional reserve. The difference between one procedure and another is also

evident in the development of Constable's way of drawing with a pencil. The summary method he was using in his sketchbooks of the 1810s was nevertheless based upon a set of graphic conventions consistently used—a more sophisticated use of the loops and strokes and hatchings than that which had shaped the cottages he had sent to Smith—but in many later drawings not only do the outlines cease to describe shapes and forms but the subject is conjured into being by an impulsive, vigorous scribble that is almost free of any consistent graphic conventions; there is no clear distinction here between line and tone.

Thus, in his late forties, from approximately the time that *The Hay Wain* was on the easel, a conflict without precedent in the history of landscape developed between Constable's artistic vision and his technical practice; it could, perhaps, only have happened at this moment in the development of painting when similar forces of tradition and innovation were opposed in art as they were in human society, and when every institution was under review. In Constable's case it was the conflict between those long-established unities and conventions regulating the type of landscapes that were in principle the antecedents of a work such as *The Leaping Horse* and that increasingly possessive personal vision of a natural world, controlled by chiaroscuro and aerial movement, that had taken hold of his imagination together with those methods of painting that he had formed as his means of offering a truthful illusion of it. As the years passed his determination to establish both imagery and style acquired an evangelical strength, so that he could insist upon his purpose in a suitably dynamic metaphor: 'I imagine myself driving a Nail. I have driven it some way—by persevering with this nail I may drive it home . . .' (VI: 181)

By an extraordinary act of unconscious, certainly uninformed, prophecy, his uncle, David Pike Watts, had defined the terms of this conflict in a letter to the painter written some ten years before '. . . until your Mind is great enough to govern your *Habit*, this trait of the artist *will be seen in his art*—a struggle between Mind and *Self*. This Victory may be obtain'd as Reason prevails and Passion subsides—as Age matures the Intellectual Powers and Youth resigns the Sensual Phantoms; resigns them only to the guidance of Intellect, not extinguishes them.' (IV: 38) Every particular term of that diagnosis, with only one element missing—that is, the factor of anxiety which aggravated his feelings and complicated his passions and which was so powerfully to influence the imagery and the physical form and substance of his work—defines the chief creative problem of Constable's practice after the early 1820s. During this period he was striving to unite the intellectual part of painting, all that concerned the conventions and unities of traditional modes of representation, with that passionate, egotistical self which derived both its subject and its language from the most transient, volatile conditions of nature and which sought to establish the reality and effect of that subject through what he called a 'language of the heart'. The phrase 'painting is another word for feeling' implies a yearning desire that his emotional response might find a suitable form without being tempered by the interference of some rational intermediary. Since then some products of twentieth-century painting have shown an attempt to narrow the gap between feeling, intuition, or the images coming from the unconscious, and the ultimate forms put down upon the canvas. The historical necessities which were operating in the first half of the nineteenth century could not then allow any artist that freedom of creative action permissible in the twentieth; Constable's large works, more than the sketches, have, with the passage of time, lost their ferocity, to use Lawrence's word again, and also much of their original strength of colour and consequent tonal contrast. The painter himself anticipated this and wished that the critics, who responded so unfavourably to his technique, would do likewise, but all the same, the contrast these works present even now to most landscapes painted before the middle of the nineteenth century can still be impressive and unmistakable if the pictures are seen in their historical context. The immediate visual effect of *The Leaping Horse* or *Hadleigh Castle*, the *Waterloo Bridge* or the

more benign, less advanced works such as *The Hay Wain* or *The Cornfield* can be simply defined. After a hundred and fifty years the colour of these pictures, their surface and *matière* is, overall, forceful and assertive, and their dynamic countenance is most impressive if we put them beside earlier pictures with similar rustic subjects. The word 'overall' is important, for every square inch of the painted surface, every mark of the brush, seems to be claiming the same degree of attention and to have the same physical vitality. This is particularly so in the later pictures— *Hadleigh Castle*, the final *Waterloo Bridge*, *Salisbury Cathedral from the meadows* are typical cases—when the impasto had become denser and the brush strokes more assertive and rhythmical.

In earlier painting, the surface had not had the same convulsive intensity, except in pictures by such artists as Magnasco or Ricci, in which a very mannered style of execution or some decorative purpose had overwhelmed the subject. The visual impact of the picture's *matière* had varied from passage to passage across its surface. So, individual forms were not given the same solidity or relief; distant passages were less strongly realized than those in the foreground; the dynamics of colour and tone were controlled like the instrumental voices in a balanced orchestration; the impasto varied from point to point, not only in accordance with the texture, illumination and weight of the object depicted, but also with its position within the picture's perspective.

In a sketch such as the one reproduced in Plate 69 this principle of composition obviously could not be applied—as had been done in the *Boat-building*, for example—because its rapid execution would have allowed Constable no time to calculate his effects and compose the image as he might do in a studio work. Given the differing strengths of tones and colours— allowing, that is, for red being more assertive than blue and parts of the tonal scale more emphatic than others—most passages in this sketch will command our visual attention equally. We do not expect such a quick and excited improvisation to provide a coherent illusion of form and space; its nature was to be suggestive

rather than descriptive, provisional not systematic. After the early 1820s, Constable's larger compositions acquired the same kind of physical character, and ask to be similarly interpreted. Because the colour has dimmed, the shadows darkened and the light passages become more transparent, now the most assertive and vigorous elements in the pictures are necessarily the fierce marks of his personal and irregular notation and his impasto. The change can be experienced, even in reproduction, by comparing the details taken from the *Flatford Mill* (Plate 136) and *The Leaping Horse* (Plate 137). In the first example the notation of the foliage was still consistent and exact, controlled by the leaf forms and by a traditional treatment of tonal and linear perspective, but in the other work these controls have been abandoned and the notation is not simply irregular, by the standards of earlier conventions, but has ceased to be descriptive. Here the marks on the canvas suggest a world of diffused, vibrant light and aerial motion, no longer a structure of stable forms consistently lit from a single source.

A hundred and fifty years later, when our habits of seeing have been educated by Impressionism and further influenced by painters such as Soutine or Kokoschka, we are not constrained to read such marks as if they formed a descriptive system, but Constable's contemporaries—and especially sophisticated connoisseurs—were bound not merely to judge but to interpret his method of execution as an errant version thereof. They called his scattering of white touches his 'snowstorms', and we should not assume that this was merely a knowing joke. It would have been difficult for an early nineteenth-century eye not to see the device as such, not to read it literally, as a shower of flakes which obscured a separate and more conventional image lying behind a veil.

The application of these white touches, about which even Constable, at last, became uneasy, was forced upon him by the limitations in his use of colour, given his determination that the pictures should be sparkling and vibrant. Whatever view we take about the historical necessities which may or may not determine the development of style, or indeed of the knowledge

which contributes to painting, Constable did not exploit the principles of optical mixture used fifty years later by such artists as Monet and Seurat to give their works that luminous intensity we associate with Impressionism and Pointillism. In his compositions, apart from introducing accents of red to animate his greens in a conventional way, he went no further in experiment than he had done in his rapidly painted studies, animating an area of colour—the same green for example—by forming it with touches of different hues and by strengthening the shadows in terms of the object's local colour, that is, by a direct use of a darker shade of that same tint. It has been falsely assumed that the most important and distinctive aspect of Constable's originality was his use of colour; the reviewers, in fact, seldom commented critically upon it, and many of his contemporaries, let alone some earlier painters, had taken greens from the palette quite as strong and 'natural' as his. He was bound to discover that his use of colour, especially in a large composition, dominated by the natural hues of sky and vegetation, did not lead to the vivid luminosity he was seeking, and that, in fact, the apposition of strong colours may create a total effect less vivid than the quality of its parts. For this reason white, having a unique, indestructible brilliance in any chromatic context, became, as a last resort, the device by which pictures worked into a strong but not necessarily luminous state could be given the elusive brightness which controlled his artistic impulses.

No picture demonstrates more expressively Constable's problems and dilemmas, the reason for the anxieties he suffered at work—as distinct from those provoked by his 'social affections'—than the *Waterloo Bridge*, which took so long to complete and must have become more difficult to finish with every passing year as the demands of his inner vision became increasingly insistent. The fulfilment of it required not only a strong visual memory, but that indefinable gift by which, in extension of memory, the elusive image in the mind's eye is embodied in visible form. Constable was evidently not well endowed with this talent, an inventiveness possessed by many artists of inferior achieve-

ment; perhaps he could only consent to bring his image of the subject before the public when their memory of the event had faded and its associations with a historic victory had diminished. *Waterloo Bridge* was the only one of his major pictures in which, as he admitted, he moved away from his own 'rural' sphere and he cannot have felt secure in that foreign territory.

The subject was structurally complicated. Its colour ranged from the brilliant uniforms in the foreground—red, blue and gold—to the greys of the far-away city; in actuality it deserved the description Constable gave to the painting, a 'Harlequin's jacket'. There were the strong, determinate shapes of the buildings and the boats, and the imprecise, shifting forms of water and sky. There was the linear perspective, denoted by the architecture and the shape of the receding river, and the aerial perspective which reduced the distant bridge, otherwise the focus of the pageant, to a phantom. There were the topographical facts that could not be neglected, details, proportions, intervals not freely to be changed. And there was, of course, that inner world of his own vision, volatile and luminous, which had also to be accommodated in the image, if the picture was to bear the necessary stamp of his own self-conscious originality.

Not long before the last spell of work upon the exhibited version Constable saw some Italian studies by Charles Eastlake[43] and wrote this to Leslie: 'excellent of their kind and done wholly for the *understanding* bald and naked—nature divested of the "chiaroscuro", which she never is under any circumstances—for we can see nothing without a medium. But these things have wonderfull merit & so has watch making—they are so good they drive me mad.' (III: 47) The Waterloo Bridge subject was one which eighty years earlier Canaletto might have treated, bringing all its complexities under the control of his precise, immaculate, pictorial system, in which there was an established notation for every physical detail, a way, both rational and sensuous, to reconcile the conflicting attributes of colour, light and space, to harmonize the conventions of linear and atmospheric perspective. This, too, was a sort of

watchmaking, albeit more masterly than Eastlake's skill.

Constable's simile is a very appropriate one as an indication of his own artistic problems in a work of this kind. The watchmaker forms a machine to convert a rational conception of that elusive quality, time, into an exact and equally rational image, whose language is precisely clear. Constable started with something equally impalpable, his 'chiaroscuro of nature', and strove to invent, empirically, upon the canvas an image which would faithfully evoke that equally elusive quality. How was he to contrive a pictorial 'machine' which would not destroy or corrupt the vision which obsessed him and which would also endow the work with the pulse of his own feelings? That was the problem which prompted his constant anxieties.

The surviving notes of his lecture on the history of landscape painting suggest that Constable did not bring his account of it up to date by reference to his contemporaries. John Robert Cozens and Thomas Girtin, both dead by the time his own practice was starting, were the most recent artists he considered. The comments about his fellow painters in the letters, except for respectful, occasionally generous, allusions to Turner, are mainly dismissive, critical, at best moderately approving, except when a particular work may have evoked a few words of unlimited praise. The response to living painters was always informed by a judgement of their character and personal pretensions, and was, anyway, as volatile as his reactions to all experience, depending upon the state of *his* affairs. Constable could hardly have failed to regard Callcott or Collins, Glover or Hofland[44] primarily as rivals, since the reviewers, treating them as men of genius, so often compared, and even preferred, their achievements to his, and since some of them were publicly honoured so long before him. (Callcott, three years younger than Constable, gained membership of the Academy nineteen years before he did: Collins, eleven years younger, nine years before.) Apart from a cordial relationship with De Wint, Constable's artist friends were not landscapists. Whereas he judged the painting of the past with a liberal enthusiasm, his assessments of modern work were as limited as the natural world he

preferred, his simple, exacting criteria being those implied in the quotations below: was the work corrupted by some unworthy or unnecessary subject? was it informed by an understanding of nature and expressive of natural reality? had the artist resisted the temptations offered by connoisseurship?

The first quotation comes from a letter written in Brighton and follows a criticism of the place as a source of subjects:

'. . . these subjects are so hackneyed in the Exhibition, and are in fact so little capable of that beautifull sentiment that landscape is capable or which rather belongs to landscape, that they have done a great deal of harm to the art—they form a class of art much easier than landscape & have in consequence almost supplanted it, and have drawn off many who would have encouraged the growth of a pastoral feel in their own minds—& paid others for pursuing it.' (VI: 171)

The second passage occurs in a letter to Leslie:

'Tis true—tis strange—passing strange to say that I have never seen anything in landscape yet with which I was satisfied. All that I have seen of even the greatest names, are either "pictures" or nothing. . . . What must I feel when I knock my head against the clouds and (waves) of poor Callcott—or breathe the stagnate sulphur of Turner—or smell the —— of a publick house skittle ground by Collins—or be smothered in a privy by Linnell or Mulready—but let them alone, is best of all.' (III: 85)

Until quite lately Constable's implicit estimate of himself as a painter uniquely responsive in his own time to 'pastoral feel' would have been widely confirmed. He was cherished, and often sententiously interpreted, as a solitary spokesman of the truth about the common realities of English landscape, with only the painters of the Norwich School—the Cromes, Stark, Vincent and the rest—noted as worthy companions. (Incidentally, he probably knew little of their art in its provincial isolation, and there is no comment in his letters on any of them.) Recent study of his period, however, has brought into sight again work that, although not very difficult to find or recover, had been neglected since before 1900. In the first three decades of the nineteenth

century, a large body of pictures was made which not only treated the type of subject Constable favoured but shows a sensitive and exact appreciation of it, just that 'keen eye' which for him was the mainspring of good landscape painting: the pictures of the young Linnell, the early landscapes of Mulready, modest paintings by artists of minor reputation (such as Havell, Delamotte, G. R. Lewis), the watercolours of Cornelius Varley, John Varley (when working in his more descriptive way), Hills and Cristall.[45] These artists did not constitute a movement, let alone a school, but they did share habits of devoted observation and a distinctive vision, separating their work from the rustic art of the eighteenth century, from which it had unobtrusively developed, and from that mid-nineteenth-century sentiment to which some of them, in their later years, surrendered. By its lyrical naturalism their art can evoke even more suggestively than Constable's an ancient rural England, which was by then precariously fragile and about to be transformed by the new forces of an industrial society. Their treatment of the distinctive light, colour and textures of English scenery are no less valid than his, in spite of showing different emphases and being rendered in a more traditional, regulated and reticent style.

Whereas the artists just mentioned, by painting small pictures and speaking in a quiet voice, accepted the humble position that such work continued to occupy in the hierarchy of artistic genres, Constable, from the same modest situation, declaimed the attractions and virtues of home scenery with a much more forceful and aspiring eloquence. The scale and vigour of *The Hay Wain* or *The Cornfield* are now accepted as being natural in every sense of the word, but once their presence and visual effect seemed defiant and excessive. Constable did for village England, for its heaths and meadows, downland and narrow waterways what Courbet, soon afterwards, was to do for the Auvergne peasants in his challenging picture, the *Burial at Ornans*—that is, convert their modest life and social status into something artistically heroic. *He* did not clothe his villagers as gods or princes, and Constable did not convert his home scenery into an ely-

sium, however strongly he may have infused it with his own sentiments.

In a most significant way, Constable, who, in our time, has seemed a less radical and original artist than Turner, provided a greater challenge to the taste and tolerance of his contemporaries. Turner's radical use of colour and pigment was exercised in subjects which were inherently violent or extravagant by reason of their sublimity or the violent events they included and which could be supposed to justify or at least provoke the painter's recourse to extreme effects; but Constable's ferocious manner was applied to subjects associated since the seventeenth century with a more modest and regulated style.

In his later years, and in one instance at least, to his great annoyance, some young artists were beginning to imitate his methods.[46] Among them were F. R. Lee and F. W. Watts,[47] who became adept at interpreting, in a nerveless manner, the aspects of his style represented in *The White Horse* and *The Hay Wain*. They were to be unworthy followers, merely the most competent of the painters who, through the middle years of the nineteenth century, extended the rustic tradition, modernizing it with superficial elements of Constable's handling and colour which a more conservative contemporary artist such as Creswick did not attempt to use. Constable was to have no English successors of any significance—the best landscape painting of the mid-century is connected with Pre-Raphaelitism—and not until fifty years later, when the influence of Impressionism upon English art and taste became effective and his informal works began to enter public collections, joining the few large compositions already there, did he win his modern reputation.

Constable's connections with French nineteenth-century art have been wishfully exaggerated by writers seeking to prove the historical influence of English painting, and from a technical standpoint often misunderstood. His immediate influence in France has been made to seem more uniquely significant than it was. Certainly, in the 1820s, his reputation in Paris was substantial; but so was that of other English painters whose strong colour, vivid rendering of

atmosphere and light as well as their free and vigorous handling supported the purposes of young Frenchmen then seeking to revive the Rubéniste tradition in their own school, Rubens being at the time a vital influence in English art also. Delacroix was the most eminent of those who found inspiration and some technical guidance in *The Hay Wain* and the other pictures which Arrowsmith and Schroth took to Paris, but it was *paysagistes* such as Huet, Troyon and Théodore Rousseau whose art specifically proves his influence there. The connection between Constable and painters of the next generation, members of the Impressionist circle—Monet, Pissarro, Sisley—as well as those who less adventurously followed their course, is tenuous and probably accidental. There is little evidence to establish that some of these artists, Monet among them, had first-hand experience of his painting, but no grounds for suggesting that their practice would have been different if they had *not* seen it.

The idea that Constable was himself an Impressionist has helped to misdirect the understanding of his methods. If the word is used, as it was by British critics such as Stevenson and MacColl, to characterize a pictorial tradition extending back to the seventeenth century, and even to the Venetian art of the Renaissance, then Constable is perhaps as much an Impressionist as Velazquez and Rubens, Watteau and Goya, Delacroix and Corot, belonging like them to a line of colourists working in a free, painterly manner and concerned with atmospheric effects. If the term is more strictly used to characterize works by the artists who contributed to the Impressionist exhibitions of the 1870s and 1880s and those who emulated their methods, then the idea of Constable as an Impressionist has little foundation. The landscape motifs favoured by Monet, Pissarro and Sisley, for example, were often comparable with his in a geographical sense, northern France and south-eastern England being quite alike. These artists obviously shared Constable's interest in light and aerial movement, but the results of this concern were very different. Whereas Constable had limited his work to spring and summer views, the French pictures describe every season of the year, if

they do not show the stormy turbulence which controls *The Leaping Horse* or *Hadleigh Castle*. However deeply committed the Impressionists were to the world they painted, their art has an emotional detachment and presents no response to what Constable had called the 'sentiment of nature'. Monet found Turner too 'romantic', and would, no doubt, have felt uneasy, too, at Constable's compulsion to project his most intense and intimate feelings into the behaviour of nature. The pictorial methods of Impressionism were at once more advanced and more traditional than his. They extended the optical and suggestive power of colour far beyond his limited use of it, but never applied the paint in that free, ferocious, irregular manner which confounded *his* critics even if, like Constable, they frequently had to bear the charge that their pictures lacked finish. Monet combined a revolutionary management of colour with a touch as elegant, and essentially controlled, as Gainsborough's. In short he had a method and Constable, at least in his most ambitious works, had not. He was to develop his apparently submissive regard for nature into a sort of Expressionism.

Whether we are looking at Constable's more elaborate pictures, attending closely to their substance, or reading his private and public writings, we are bound to be constantly aware of a person divided between compelling alternatives: tradition and originality; permanence and change in matters physical and emotional; the claims of art and nature; and those of nature and his own egotistical self. Both the content and the significance of these internal debates were felt all the more intensely by a man who was instinctively a moralist and consciously a teacher, that is, a prophet of his own vision. It is the impress which these debates made upon the form of his painting and their influence upon its spiritual centre which made him so modern an artist in his time and has kept him so ever since, even when the external features of subject and style have become conventional. Two aspects of the internal debate are particularly important in establishing his modernity: the conflict he sensed between art and nature, and that between nature and self.

Constable could look at the works of Claude or

Ruisdael, we may be sure, with tears in his eyes: he objected to the concept of a National Gallery because it contained pictures and certified the heresy that the art of painting could be advanced through connoisseurship, which fixed nature in a rigid artistic mould. His sense of this conflict was, of course, extended into matters more immediate and practical to himself than this. One of the two important changes in the painting of landscape which was to occur between then and this century was to be the abandonment of the scenic prejudice. Landscape painting had hitherto been dominated by a scenic approach to nature, whose physical and temporal infinitude had been composed into a finite scene. The very term 'landscape' implies something different from the word nature, the one being boundless and indefinite, the other organized and confined; and the English sightseers and landscape fanciers of the eighteenth century had instinctively, compulsively, transferred their appreciation of what was natural into the sphere of art by immediately converting what they saw into scenes, views, prospects, carrying an artistic seal of approval.

When we stand surrounded by Monet's *Nymphéas* in the oval basement gallery of the Jeu de Paume, in Paris, we are not at the centre of a panoramic scene like those which some of Constable's contemporaries devised to delight the mind as much as tease the eye; we are, vicariously, in the midst of nature. Constable did not, of course, at any time dispense with the scenic vision, for his exhibition pieces were traditionally composed within conventions from which he could not escape; they do, however, predict its dismissal. As traditional compositions they are permeated always, sometimes disturbed, and in the end shattered, fragmented, by qualities which are hostile to scenic composure—the attributes of light and motion which contradict permanence and stability, and the physical marks of the pigment upon the canvas which embody that natural impermanence. Wordsworth demanded that language should be the incarnation of thought, not its clothing. Constable was quite evidently seek-

ing, with a similar purpose, to incarnate nature in the material of his art.

The desire to close the traditional gap between nature and art, not letting the example of landscape pictures, as it were, disrespectfully intervene, is repeated in his wish to bring nature and the human self closer to one another; that is the second path of change to which I referred. A passionate art of feeling had, in the century before and still in his own time, meant a recourse to what was statutorily Sublime. Constable claimed that all nature could be equally productive of emotional association and be so without claiming the benefit of intellectual guarantees. Common nature received that artistic status by its attachment to all that was human; and this could in turn be the voice of human feeling. The finest fulfilment of this idea in Constable's art is, I believe, the *Hadleigh Castle*, a work neither green nor pleasant, neither ingratiating nor benign. It fulfils, in fact, all his demands of the Sublime, so artfully satisfied by Wilson, in his *Niobe* for example, and by Turner in so many of his historical landscapes, but it does so in a peculiar, personal and forward-looking way which makes it one of the most advanced works of its time. It manifests a sense of the relationship between art and nature which was authentically new and which is ideally conveyed in the words which Keats applied to Wordsworth, 'the egotistical sublime'.

He used the term in criticism of Wordsworth's tendency to overwhelm the simplicities of Nature with a rhetoric generated by his own portentous emotions. Constable, as the *Salisbury Cathedral from the meadows* proves, could be tempted by a similar extremity of passion, but in him the artistic egotism which he was happy to acknowledge and an instinctive rather than an intellectual sense of sublimity most often worked together to create images of landscape so deeply interfused with instinctive human feelings, whether joyful, anxious or distraught, as to make them among the most truly impassioned works of the nineteenth century.

1. One of Constable's maternal aunts, Jane Watts, married Thomas Allen, a brewer with residences in London and Ipswich. The first volume of the Beckett edition of Constable's correspondence provides, in the appendixes, a sequence of relevant family trees.

2. J. T. Smith's *Nollekens and his Times* was first published in 1828.

3. J. T. Smith, *The Antiquities of London and its Environs*, 1791–1800, was followed in 1815 by *Ancient Topography of London*.

4. J. T. Smith, *Remarks on Rural Scenery; with twenty etchings of Cottages, from Nature; and some observations and precepts relative to the picturesque*, 1797.

5. Count Francesco Algarotti (1712–64). The *Essay on Painting* by this Italian philosopher and connoisseur of art and music had been published in English in 1764. A new translation of Leonardo's *Treatise of Painting* was published in 1796. Solomon Gessner (1730–88), Swiss painter and poet. The work by Gessner which Constable read was an essay on landscape, forming an appendix to the English translation, published in 1776, of his *Neue Idyllen*. Gessner's writing had at the time a great appeal for minds much more considerable than his own; it is unlikely that Constable would ever have valued his pictures.

6. John Cranch (1751–1821), a largely self-taught artist, was a painter of historical subjects, but in this context of more consequence, also of rustic genre.

7. 'I have lately copied Tempesta's large Battle.' (II: 8) Constable first mentioned Ruisdael in a letter to J. T. Smith in January 1796 (II: 9). A copy, in pen and ink, after a Ruisdael print, *The Wheatfield*, dated 1818, is in the Victoria and Albert Museum (258–1888).

8. Evidently encouraged by Smith, Constable made efforts to discover all he could at first hand about Gainsborough's early life and practice in Suffolk, recognizing the compatibility between his own artistic ideals and the early work of his predecessor. Later his uncle, David Pike Watts, was to buy the famous picture commonly known as *Cornard Wood* (Plate 177), now in the National Gallery, London. Constable could also have studied Gainsborough intimately in the collection of his patroness, Lady Dysart.

9. Joseph Farington, R.A. (1747–1821), although a competent landscape draughtsman and painter, is now chiefly remembered for his influential activities within the society of his time, especially in the management of the Royal Academy, and above all for the Diary he kept between 1793 and 1821, the most important and substantial contemporary document for the artistic history of the period. The references to Constable are almost always instructive. Apart from bringing him into close contact with the traditions of English topographical draughtsmanship, Farington would have informed him about Richard Wilson, whose pupil Farington had been and whom Constable admired.

10. John Dunthorne, a plumber and glazier who lived near the Constable family house at East Bergholt, was among the painter's earliest local friends, and the relationship affected his will to be a painter, for Dunthorne was a sedulous if not sophisticated amateur artist. Their friendship remained firm until 1816, when Constable terminated it, evidently under the influence of Maria; the man's independent, free-thinking attitudes had not helped in the difficult association with Dr Rhudde. Dunthorne's son, also named John, was to become Constable's assistant in London and in 1829 he set up an independent practice as a picture restorer. His skill and close attachment to Constable is one of the factors which anyone seeking to establish the authentic corpus of Constable's work would have to bear in mind.

11. An account of this episode in Constable's life will be found in Beryl and Noel Clay, 'Constable's visit to the Lakes', *Country Life*, Vol. LXXXIII, 1938, pp. 393–5.

12. The pictures are reproduced in the Shirley edition of Leslie's *Life*, in plates 25 and 34.

13. The friendship was probably founded during Constable's visit to Salisbury to stay with the Bishop in September 1811. The first significant surviving letter which passed between them is dated May 1812 (VI: 15). The younger John Fisher was Constable's junior by twelve years; he was ordained priest in 1812. He became Archdeacon of Berkshire in 1817 and later received from his uncle the additional living of Gillingham, Dorset.

14. Bishop John Fisher made slight watercolour drawings in a conventional eighteenth-century manner and some of these can be seen in public collections. His brother George, better known as Sir George Bulteel Fisher, was a more aspiring and capable amateur artist, although Constable did not like his efforts.

15. Charles Nodier (1780–1844) was essentially a man of letters, but it was in a small travel book, entitled *Une Promenade de Dieppe aux Montagnes d'Ecosse*, based upon a tour in Britain and published in 1822, that the first appreciative notice of *The Hay Wain* in French, and indeed of the artist's talent in general, was published.

16. Théodore Géricault (1791–1824) was, with Delacroix, the greatest painter to emerge in France during the years following the Napoleonic régime. He had come to England in 1820 to exhibit his *Radeau de la Méduse* and in 1821, at Lawrence's invitation, had been a guest at the Royal Academy banquet.

Constable was only one of several English artists whose work he greatly admired.

17. Stendhal (Marie-Henri Beyle) had been in England in 1821 and had previously, in 1817, published, in two volumes, his history of Italian painting.

18. Louis Adolphe Thiers (1797–1877), statesman and historian. His first published work was a series of notes on the Salon of 1822 and his appreciation of *The Hay Wain* appeared in the *Constitutionnel*, with which he was intimately associated.

19. For an account of the relationship between *The Hay Wain* and Delacroix's *Massacre de Scio*, see M. Florisoone, 'Constable and the Massacre de Scio', *Journal of the Warburg and Courtauld Institutes*, Vol. 20, pp. 180–5.

20. This passage was quoted by Shirley in his edition of Leslie's *Life*, p. 234, but the whereabouts of the original text was not then identified and has not since been discovered by Beckett.

21. The history of the partnership between Constable and Lucas, the mezzotints which resulted from their association—conceived, executed, revised, sometimes abandoned according to Constable's passionate whims—, and the development of the publication during and after the painter's lifetime is too complicated even to summarize in this book and the reader is referred to Andrew Shirley, *Mezzotints by David Lucas after Constable*, 1930. As the enterprise was commercially a failure and not in other respects successful, its most important effect was to complicate his working life and enhance his sense of public failure.

22. *John Constable's Discourses*, edited by R. B. Beckett, 1970.

23. Charles Robert Leslie, R.A. (1794–1859) was the son of American parents and became a painter primarily of subject pictures. He was to be Professor of Painting at the Royal Academy and, apart from his biography of Constable, he published *Autobiographical Recollections* (1860) and a *Handbook for Young Painters* (1855). He first met Constable in 1816 and they had become intimate friends by 1820.

24. These comments were made by the painter David Roberts in a note he contributed to Walter Thornbury's life of Turner. Another artist who commented upon the same trait was Richard Redgrave, who said that Constable 'uttered sarcasms which cut you to the bone'.

25. In a letter to Leslie, for example, written in April 1832 (III: 66) Constable said, 'I thought you might like to have Callcott's opinion—especially as it was the only one in which we did agree during the evening.'

26. Constable believed that, in 1828, Smith deliberately supported another artist, George Arnald, against him in the Royal Academy elections. See a letter to Leslie (III: 16).

27. 'The mind & feeling which produced the *Selborne* is such an one as I have always envied', Constable told Fisher. Thomas Forster's *Researches about Atmospheric Phaenomena*, published in 1812, was reprinted in 1815 and 1823.

28. James Carpenter was a noted bookseller, a collector of pictures and the father of William Carpenter, also a bookseller and a closer friend of Constable's. James was perhaps the first individual previously unknown to the artist to buy one of his pictures in an exhibition, the Royal Academy of 1814.

29. Not only in prints such as *Time smoking a Picture*, but in his published comments upon connoisseurs and connoisseurship, Hogarth's attitude was markedly similar to Constable's.

30. The term is not a recent invention of travel agents, but was being applied to the district in the artist's lifetime, as indeed he reported.

31. The publications of Sir Uvedale Price (1747–1829), such as *An Essay on the Picturesque* . . . (1810), and Richard Payne Knight (1750–1824)—*The Landscape, a Didactic Poem* (1794) and *An Analytical Enquiry into the Principles of Taste* (1806)—were, together with the numerous writings of the Revd William Gilpin, the most important literary influences which shaped the appreciation of the Picturesque as an aesthetic category and a quality to be sought in nature and art.

32. The occasional use of the word 'picturesque' or 'Picturesque' in Constable's personal writings, and the application of it to his pictures by contemporary reviewers and others, has always to be considered critically, for, although the term could be applied quite specifically in accordance with the meanings found in theoretical writings on the matter (see note 31), it was also, no less then than now, a term implying nothing more than a suitability for pictorial use.

33. Francis Danby, A.R.A. (1793–1861) was a landscape painter whose range of subjects was wide; he painted modest rustic scenes, especially during his residence in Bristol, but his contemporary reputation was gained by historical landscapes, sometimes as melodramatic in content and style as those of John Martin. The success of these accounts for his rapidly achieved fame and for the fact that, as a young man, he ran Constable so close in the Royal Academy election of 1829.

34. Archibald Alison (1757–1839), *Essays on the Nature and Principles of Taste* (1790). Further editions appeared in 1811, 1812, 1815; this indicates the fame of the book.

35. Edmund Burke (1729–97), *A Philosophical Inquiry into the Origin of our Ideas of the Sublime and Beautiful* (1757).

36. The tradition of painting which stemmed from Caravaggio and in which subjects were dramatized through the influence of artificial light, moonlight or other extreme effects of chiaroscuro, also had a place in the development of English

painting, from the time of Joseph Wright's experiments in this genre, beginning in the 1760s, until the middle of the nineteenth century. Just as Constable showed no interest in winter landscapes or spectacular subjects, so his interest in chiaroscuro never led him to treat such themes.

37. Johan Christian Dahl (1788–1857), a Norwegian landscape painter who worked mainly in Dresden, was encouraged by the scientist and amateur Carl Gustav Carus, who in 1831 published a book on landscape painting—*Nine Letters on Landscape Painting*—to follow Goethe's injunctions, inspired by the writings of Luke Howard, that artists should carefully study cloud formations. In turn the German painter Karl Ferdinand Blechen (1798–1840) was prompted by Dahl to pursue a similar course of study. The relationship between these individuals and others involved in the investigation of cloud forms is thoroughly discussed in Kurt Badt's *John Constable's Clouds* (1950).

38. *The Prelude*, Book II, lines 178–80 (1805 edition).

39. The quotations from Cézanne are taken from the translation of the artist's letters by Marguerite Kay, edited by John Rewald (1941).

40. Constable was suspicious of Bonington's precocious talent. ('It is not right in a young man to assume great dash—great completion—without study, or pains.' (IV- 141)), but he may have been influenced, in painting his large Brighton picture, by some of the young man's Normandy beach scenes, such as the *Dieppe Fish Market* in the Mellon Collection.

41. George Field (1777?–1834), who supplied Constable with colours, was interested in much more than the practical chemistry of the pigments he developed and dispensed. His scientific and philosophical concerns were wide, and among his publications was *Chromatography, or a Treatise on Colour and Pigments and their Powers in Painting* (1835). His career and its relationship to the art of the period deserves further study.

42. In spite of an inscription of uncertain origin suggesting that this study was made in 1830, I have no hesitation in ascribing it to the date given here.

43. Sir Charles Eastlake, P.R.A. (1793–1865), painter chiefly of subject pictures, was also a learned student of the history of art, a writer on artistic matters and Director for five years of the National Gallery.

44. Sir Augustus Wall Callcott, R.A. (1779–1844); William Collins, R.A. (1787–1847); John Glover (1767–1849); Thomas Christopher Hofland (1777–1843).

45. Joshua Cristall (*c.* 1767–1847); William Delamotte (1775–1863); William Havell (1782–1857); Robert Hills (1769–1844); George Robert Lewis (1782–1871); John Linnell (1792–1882); Cornelius Varley (1781–1873); John Varley (1778–1842).

46. Constable suspected, in the 1830s, that William Wells, the collector, was interested in some of his works only for the assistance they might give to the latter's protegé, F. R. Lee.

47. Frederick Richard Lee (1798–1879); Frederick Waters Watts (1800–62).

The plates

THE PLATES have been arranged subject to the demands of design and production in a chronological sequence. The dates are recorded according to the following principles:

'1820' indicates that there is undoubted documentary evidence for assigning the picture to that year.

'?1820' or 'c.1820' indicates that this date has been assigned to the picture on stylistic grounds.

'Exhibited 1820' indicates the date of a picture's first public showing.

If the picture is treated in a note, the number of that note is given at the end of the caption.

1. *Cottage at Capel.* 1796. Pen and ink, $7\frac{1}{8} \times 11\frac{3}{4}$ in.
(180 × 299 mm.) London, Victoria and Albert
Museum. See Note 1

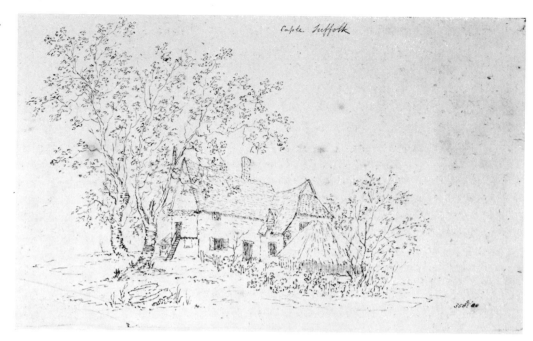

2. *Dedham Church and Vale.* 1798. Pen and ink and watercolour, $13\frac{5}{8} \times 20\frac{3}{4}$ in. (346 × 527 mm.) Manchester, Whitworth Art Gallery. See Note 2

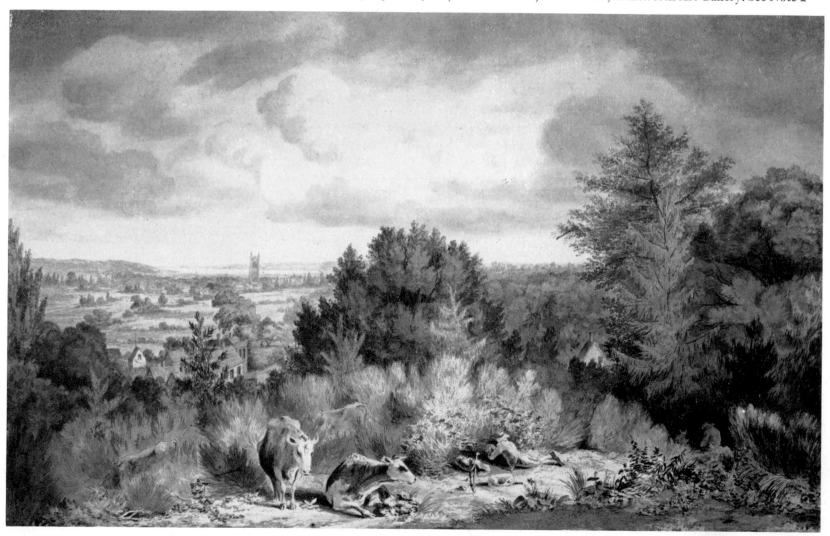

3. *Old Hall, East Bergholt.* 1801. Oil on canvas, 28 × 42 in. (711 × 1,067 mm.) England, Private Collection. See Note 3

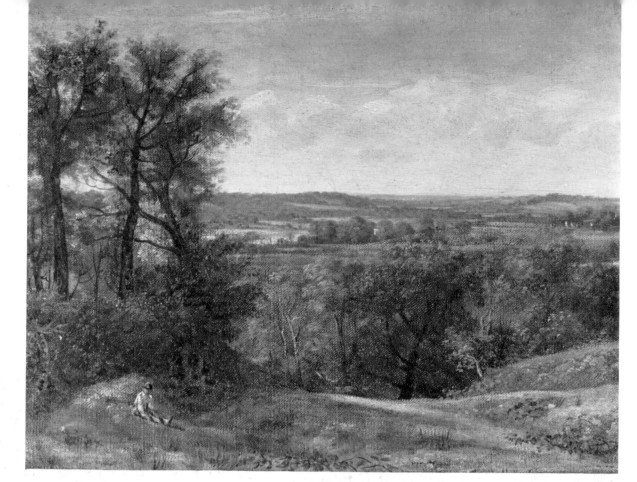

4. *Dedham Vale*. ?1802. Oil on canvas, $13\frac{1}{8} \times 16\frac{3}{8}$ in. (335 × 415 mm.) From the collection of Mr and Mrs Paul Mellon. See Note 4

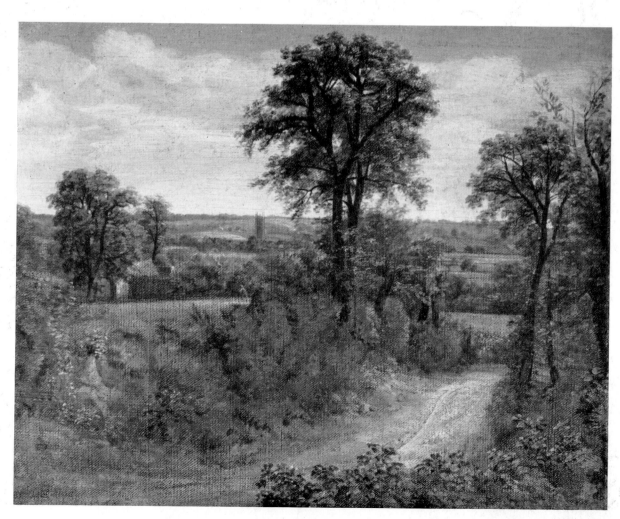

5. *Road near Dedham*. ?1802. Oil on canvas, $13\frac{1}{8} \times 16\frac{3}{8}$ in. (335 × 415 mm.) From the collection of Mr and Mrs Paul Mellon. See Note 4

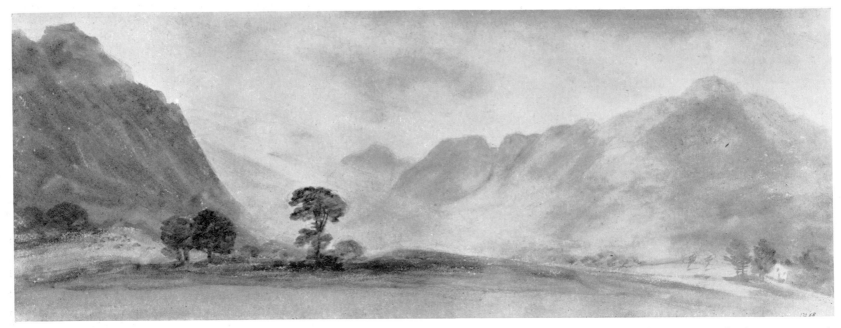

6. *View in Borrowdale*. Inscribed 'Borrowdale 2nd Sep^r. 1806 morning previous to a fine day'. Pencil and watercolour, $7\frac{1}{8} \times 18\frac{7}{8}$ in. (181×480 mm.) London, Victoria and Albert Museum. See Note 5

7. *Keswick Lake*. 1806–7. Oil on canvas, $9\frac{1}{2} \times 16\frac{1}{2}$ in. (241×419 mm.) Melbourne, National Gallery of Victoria. See Note 5

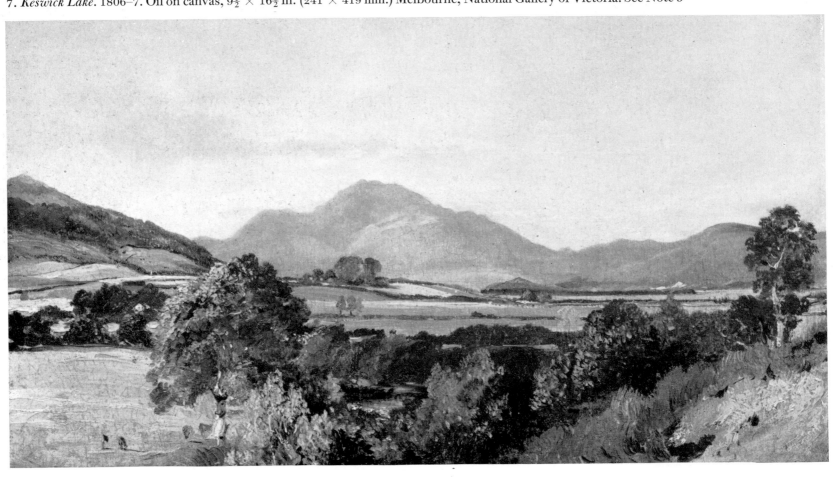

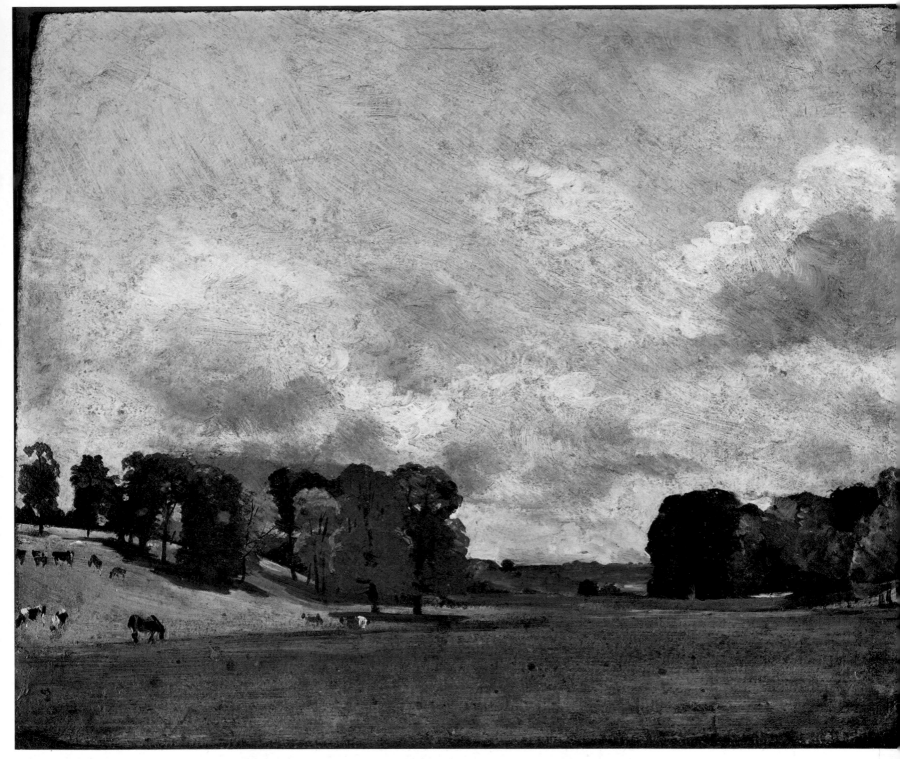

8. *View at Epsom. c.*1809. Oil on millboard. 11¾ × 14⅛ in. (298 × 359 mm.) London, Tate Gallery. See Note 6

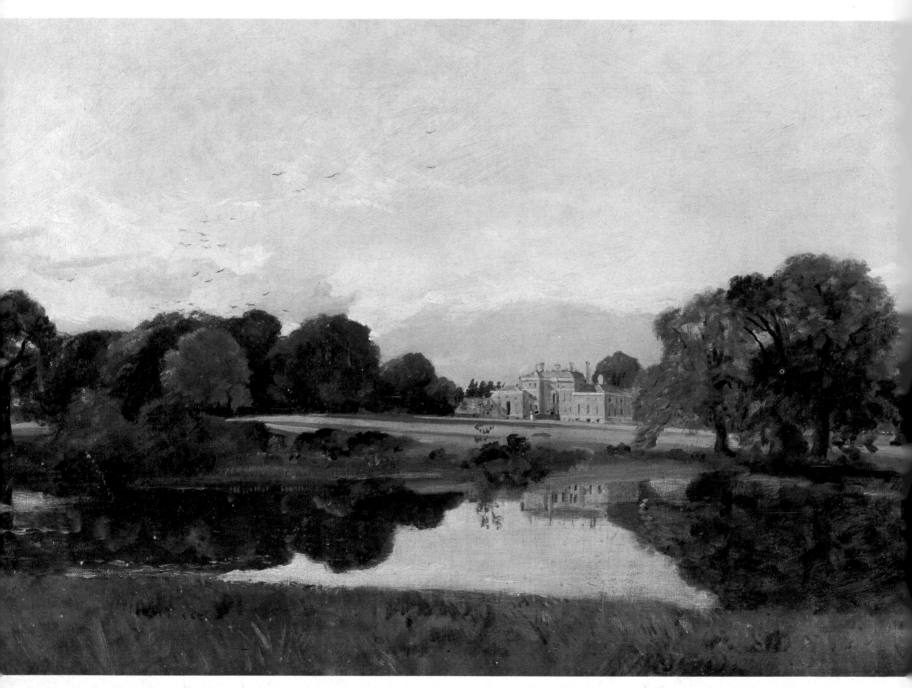

9. *Malvern Hall, Warwickshire.* ?1809. Oil on canvas, 20¼ × 30 in. (514 × 762 mm.) London, Tate Gallery. See Note 7

10. *Golding Constable's house, East Bergholt. c.*1811. Oil on millboard laid on panel, $7\frac{1}{8} \times 19\frac{7}{8}$ in. (181 \times 505 mm.) London, Victoria and Albert Museum. See Note 8

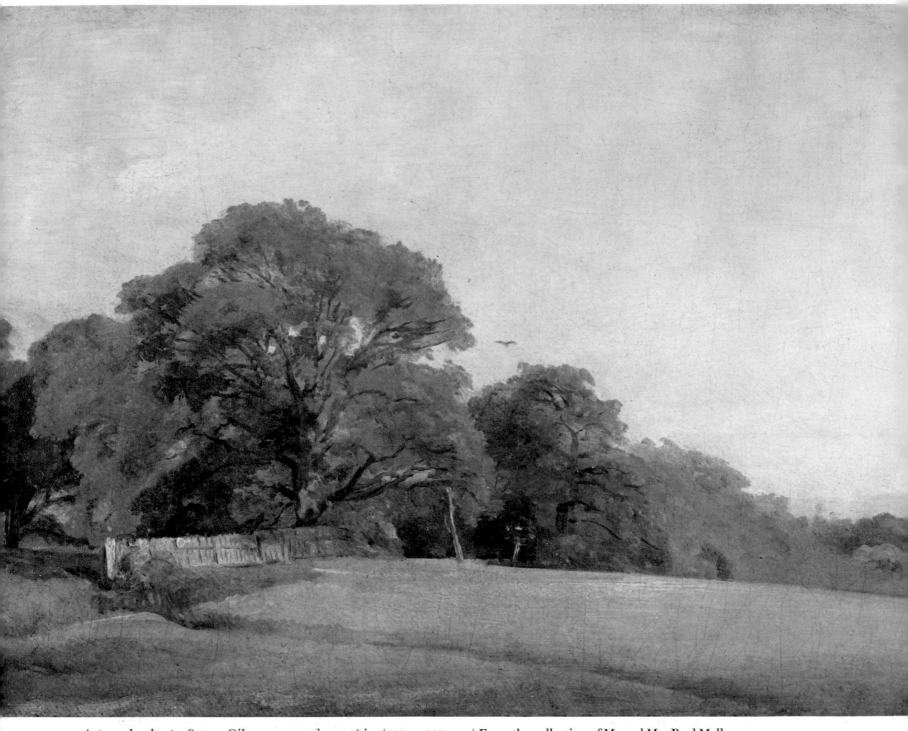

11. *Autumn landscape.* ?1811. Oil on canvas, $8\frac{3}{8} \times 11\frac{1}{4}$ in. (212 × 285 mm.) From the collection of Mr and Mrs Paul Mellon

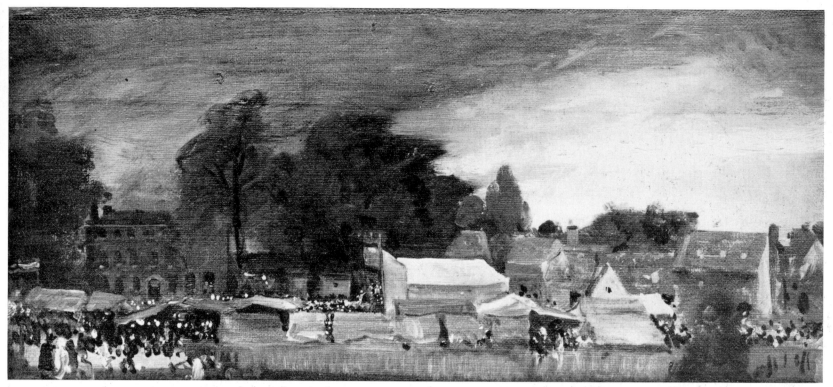

12. *A village fair, East Bergholt.* 1811. Oil on canvas, $6\frac{3}{4} \times 14$ in. (172 × 355 mm.) London, Victoria and Albert Museum. See Note 9

13. *West Lodge, East Bergholt.* *c.*1811. Oil on canvas, $6\frac{1}{2} \times 11\frac{1}{4}$ in. (165 × 286 mm.) From the collection of Mr and Mrs Paul Mellon. See Note 9

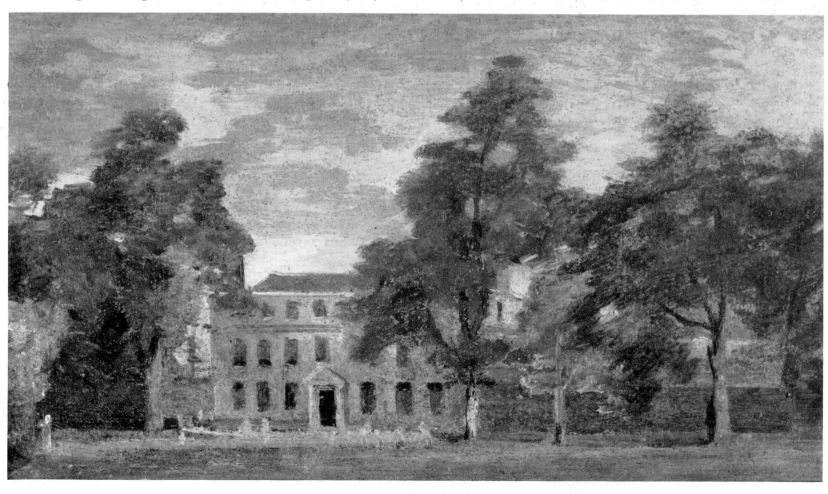

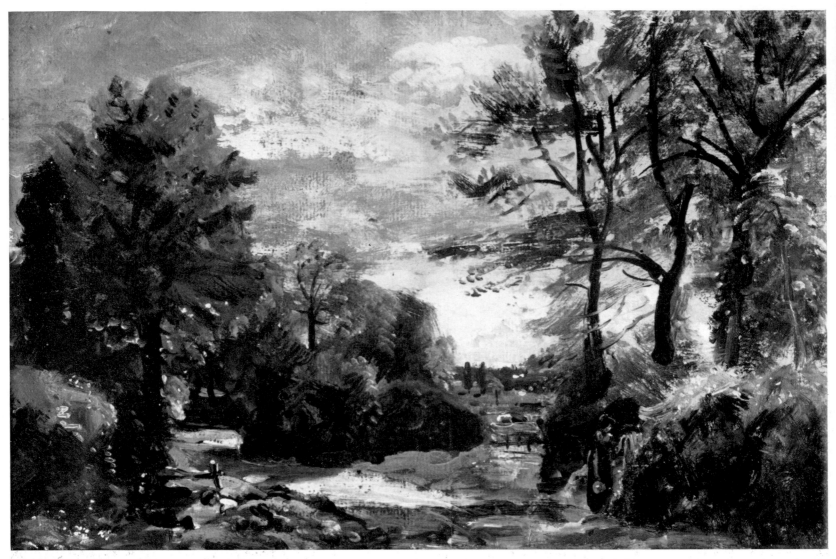

14. *A country lane. c.*1809–14. Oil on paper, 8 × 11¾ in. (203 × 298 mm.) London, Tate Gallery. See Note 10

15. *East Bergholt Church*. Signed and dated 1811. Watercolour, 16 × 24 in. (406 × 610 mm.) Port Sunlight, Lady Lever Art Gallery. See Note 11

16. *Landscape near Dedham.*
1815–20. Oil on panel,
$5\frac{1}{2} \times 8\frac{3}{4}$ in. (140 × 220 mm.)
From the collection of Mr and
Mrs Paul Mellon

17. *Landscape near Dedham.* ?1815–
20. Oil on canvas, $8\frac{1}{4} \times 13\frac{1}{4}$ in.
(210 × 335 mm.) From the
collection of Mr and Mrs Paul
Mellon

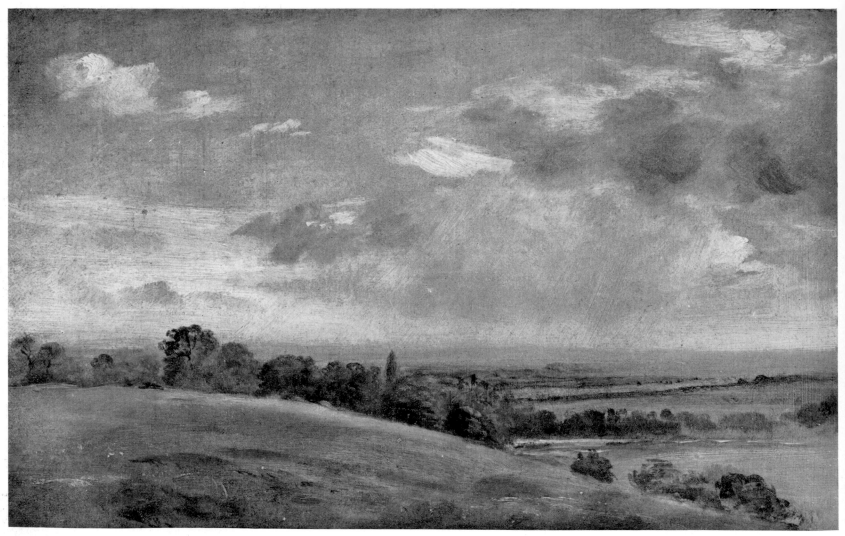

18. *Morning in Dedham Vale*. Signed and dated 1811. Oil on canvas, 30½ × 50¼ in. (775 × 1,275 mm.) Elton Hall, Major Sir R. G. Proby, Bt.
 See Note 12

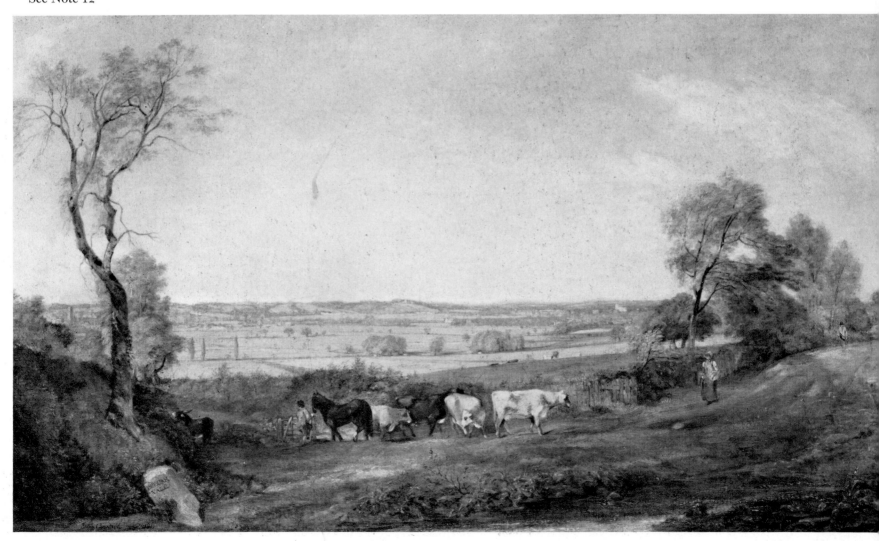

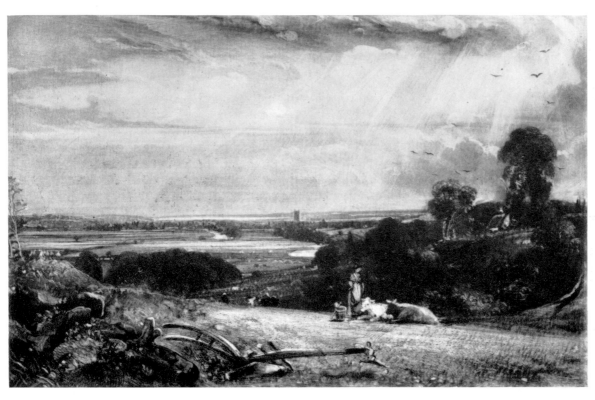

19. *Summer morning*. 1831. Mezzotint by David Lucas after *Dedham Vale from Langham* (Plate 20)

20. *Dedham Vale from Langham*. Inscribed '13 July 1812.' Oil on canvas, 7½ × 12⅝ in. (190 × 320 mm.) Oxford, Ashmolean Museum. See Note 13

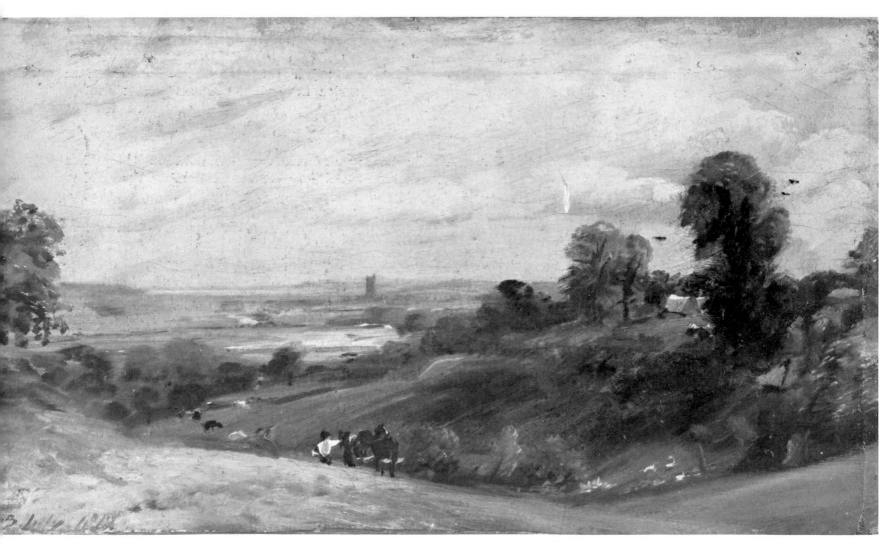

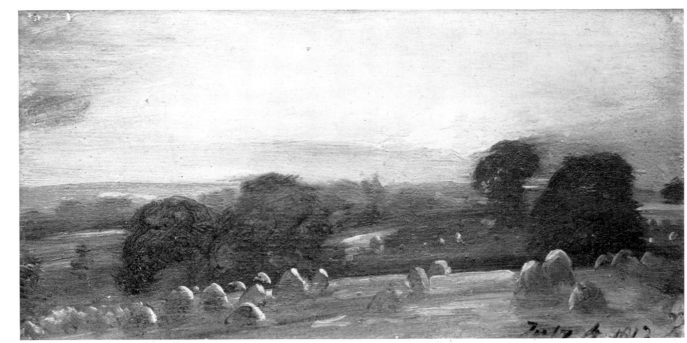

21. *A hayfield near East Bergholt at sunset.* Inscribed 'July 4 1812.' Oil on paper, $6\frac{1}{4} \times 12\frac{1}{2}$ in. (160 × 318 mm.) London, Victoria and Albert Museum. See Note 13

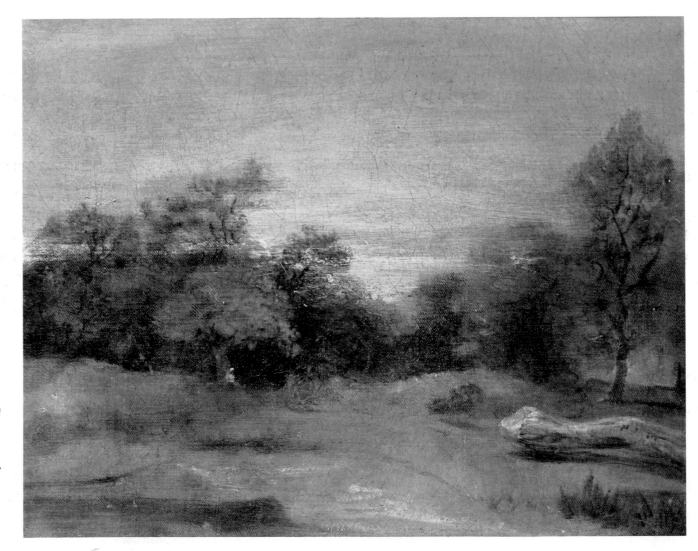

22. *Wooded landscape at sunset, with a figure.* *c*.1802. Oil on canvas, $13 \times 16\frac{1}{2}$ in. (330 × 420 mm.) From the collection of Mr and Mrs Paul Mellon. See Note 4

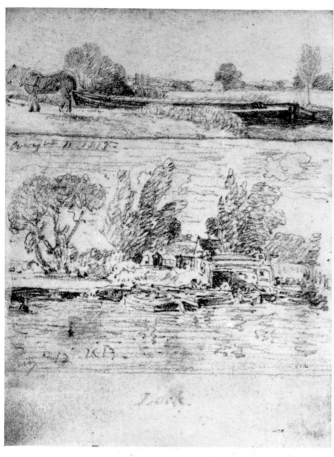

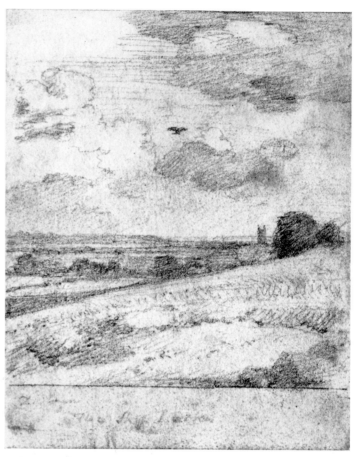

23. *Scenes on the Stour*. Dated 1813. Pencil, $3\frac{1}{2} \times 4\frac{3}{4}$ in. (89 × 120 mm.) London, Victoria and Albert Museum. See Note 14

24. *Dedham: the skylark*. 1813. Pencil, $3\frac{1}{2} \times 4\frac{3}{4}$ in. (89 × 120 mm.) London, Victoria and Albert Museum. See Note 14

25. *Landscape, with trees and cottages under a lowering sky*. Inscribed 'Augt 6. 1812.' Oil on canvas laid on millboard, $3\frac{5}{8} \times 9\frac{1}{2}$ in. (92 × 241 mm.) London, Victoria and Albert Museum. See Note 13

26. *Dedham from Langham. c.*1813. Oil on canvas, $5\frac{3}{8} \times 7\frac{1}{2}$ in. (137 × 190 mm.) London, Tate Gallery

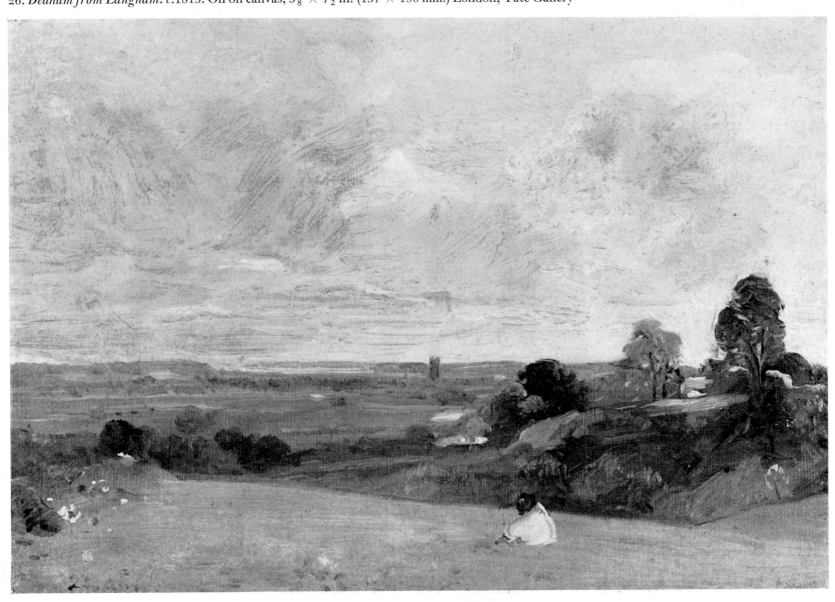

27. *Flatford Mill*. 1813. Pencil, $3\frac{1}{2} \times 4\frac{3}{4}$ in. (89 × 120 mm.) London, Victoria and Albert Museum. See Note 14

28. *A woman crossing a footbridge*. 1813. Pencil, $3\frac{1}{2} \times 4\frac{3}{4}$ in. (89 × 120 mm.) London, Victoria and Albert Museum. See Note 14

29. *Landscape study: cottage and rainbow*. Oil on paper laid on board, $5\frac{1}{2} \times 8\frac{1}{2}$ in. (140 × 216 mm.) London, Royal Academy of Arts

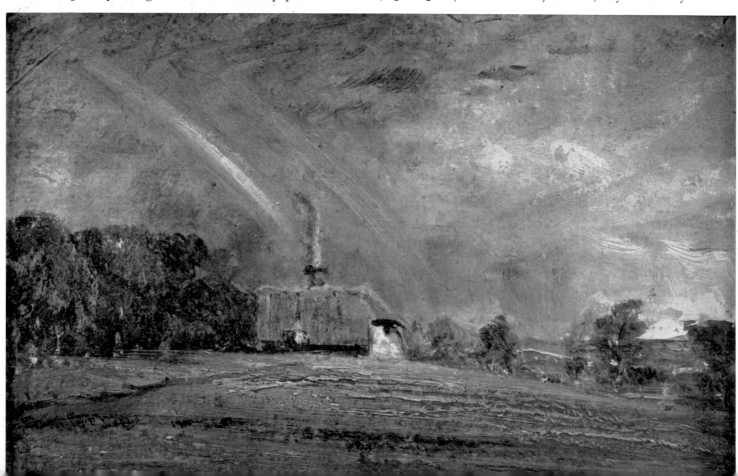

30. *Landscape and double rainbow*. Inscribed '28 July 1812.' Oil on paper laid on canvas, $13\frac{1}{4} \times 15\frac{1}{8}$ in. (337×384 mm.) London, Victoria and Albert Museum. See Note 13

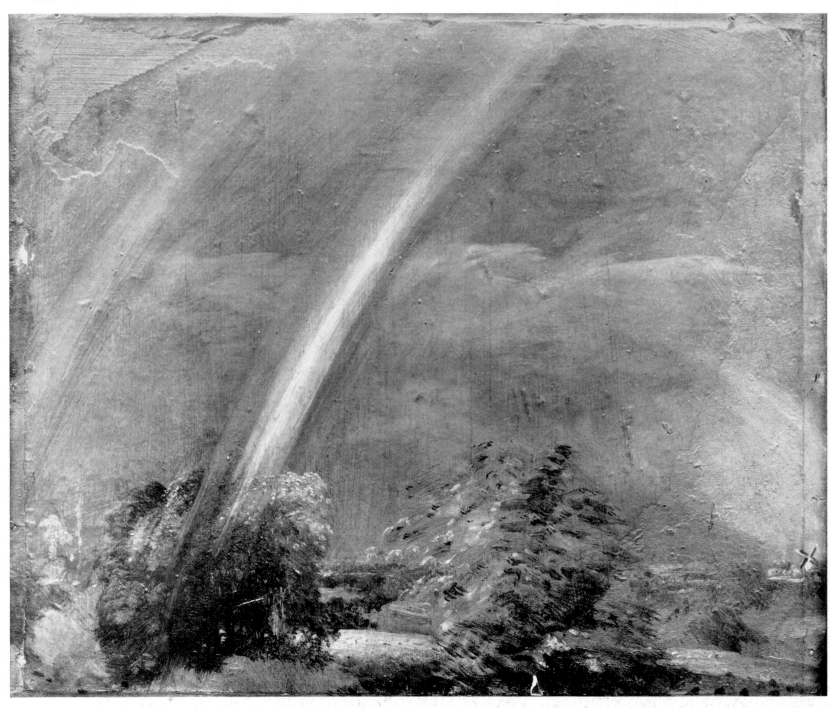

31. *The mill stream.* 1813–14. Oil on board, 8 × 11¼ in. (203 × 286 mm.) London, Tate Gallery. See Note 15

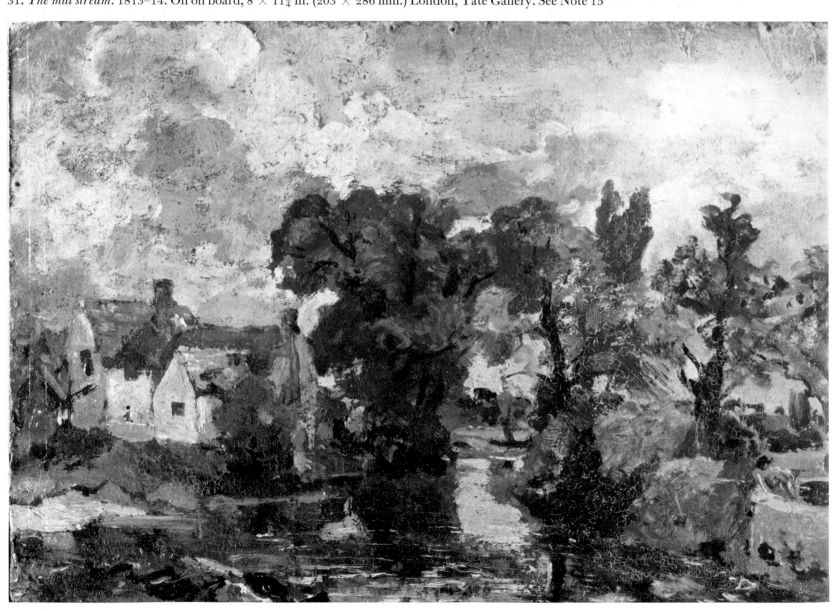

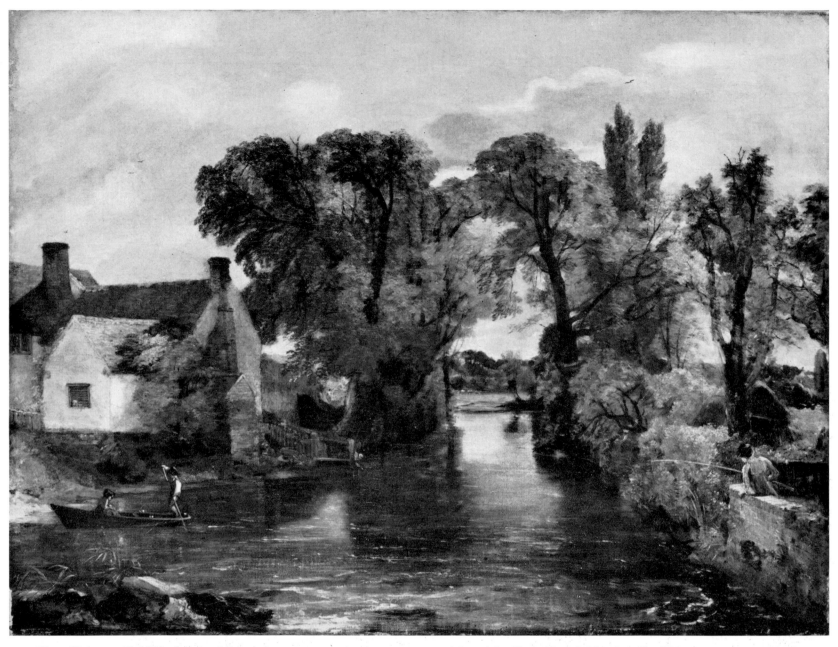

32. *The mill stream*. Exhibited 1814. Oil on canvas, 28 × 36 in. (711 × 914 mm.) Ipswich, Christchurch Mansion. See Note 15

33. *Flatford Mill from a lock on the Stour*. *c.*1811. Oil on canvas, 9¾ × 11¾ in. (248 × 298 mm.) London, Victoria and Albert Museum. See Note 16

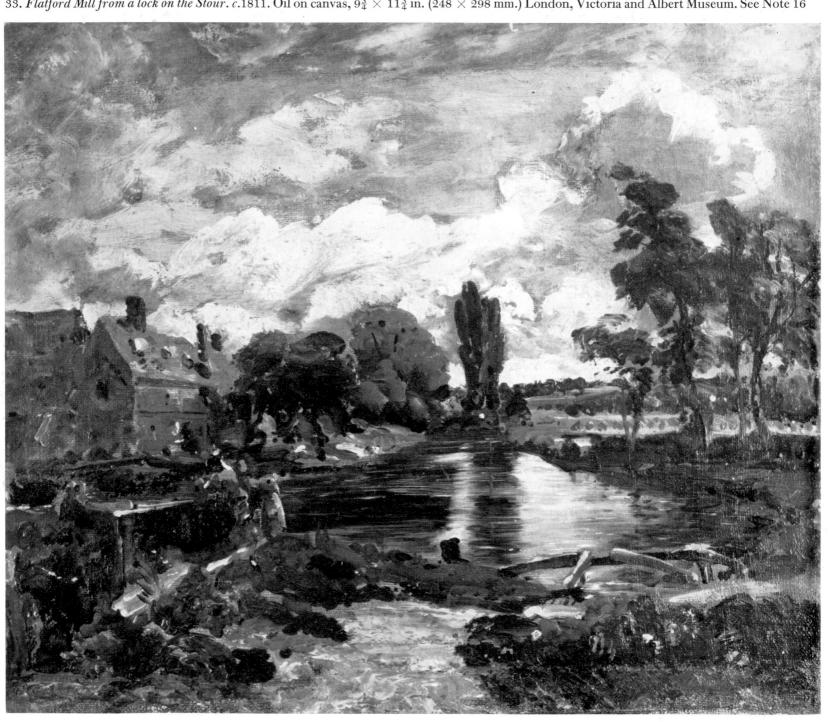

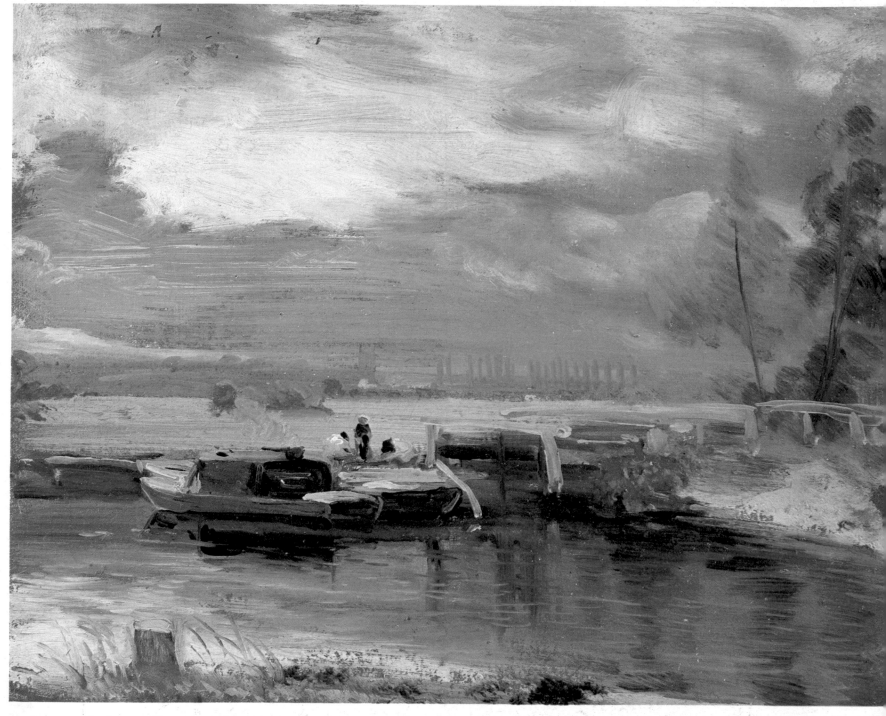

34. *Barges on the Stour, with Dedham Church in the distance. c.*1811. Oil on paper laid on canvas, $10\frac{1}{4} \times 12\frac{1}{4}$ in. (260 × 311 mm.) London, Victoria and Albert Museum

35. *Autumn sunset. c.* 1812. Oil on paper and canvas, $6\frac{3}{4} \times 13\frac{1}{4}$ in. (171×336 mm.) London, Victoria and Albert Museum. See Note 13

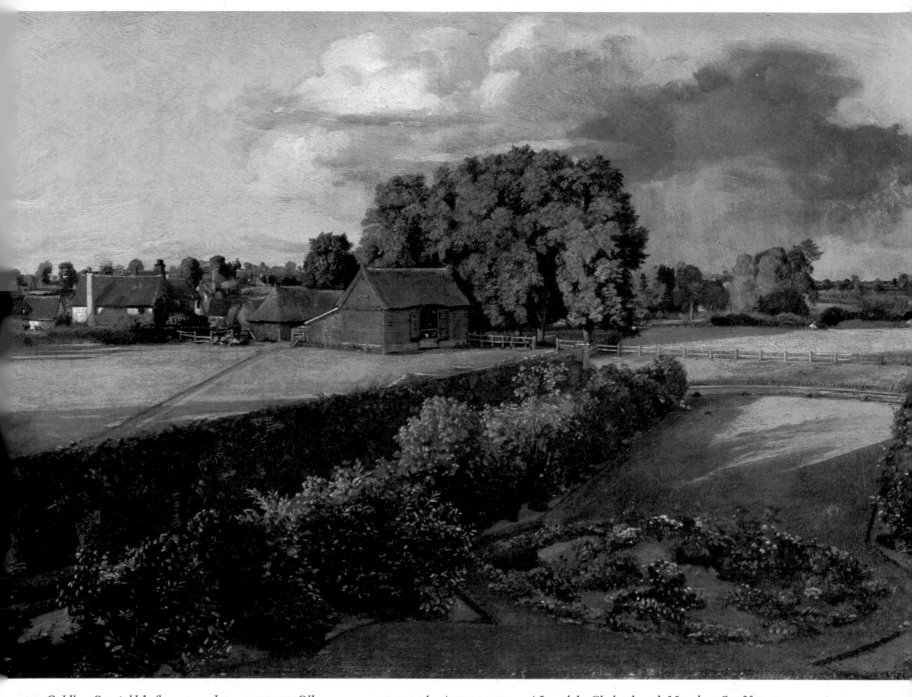

36. *Golding Constable's flower garden.* *c.*1812–16. Oil on canvas, 13 × 20 in. (330 × 508 mm.) Ipswich, Christchurch Mansion. See Note 8

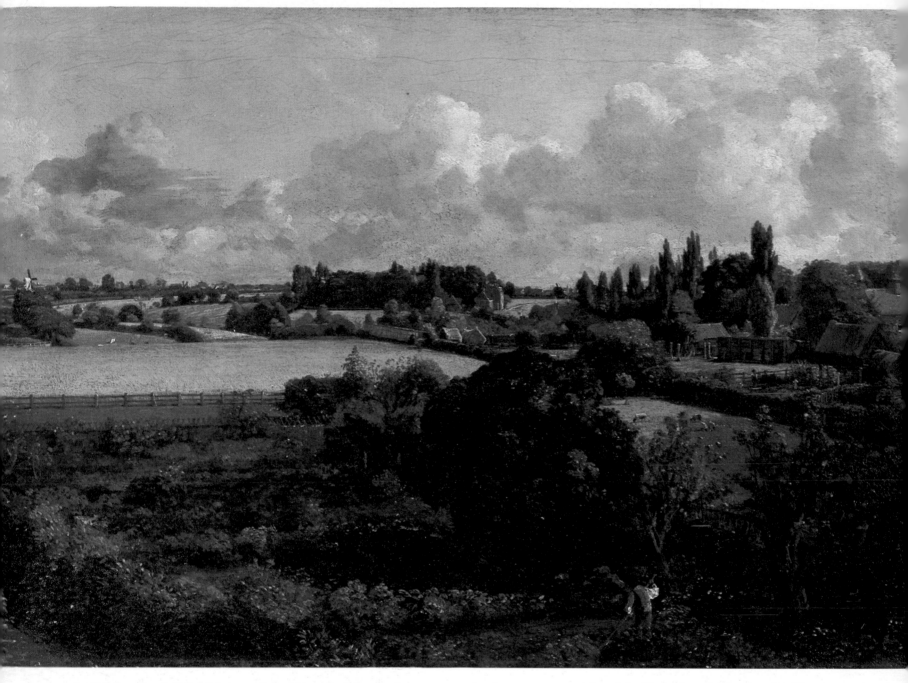

37. *Golding Constable's kitchen garden*. *c*.1812–16. Oil on canvas, 13 × 20 in. (330 × 508 mm.) Ipswich, Christchurch Mansion. See Note 8

38. *Dedham Vale with ploughmen.* *c*.1815. Oil on canvas, 16¾ × 30 in. (425 × 760 mm.) From the collection of Mr and Mrs Paul Mellon. See Note 17

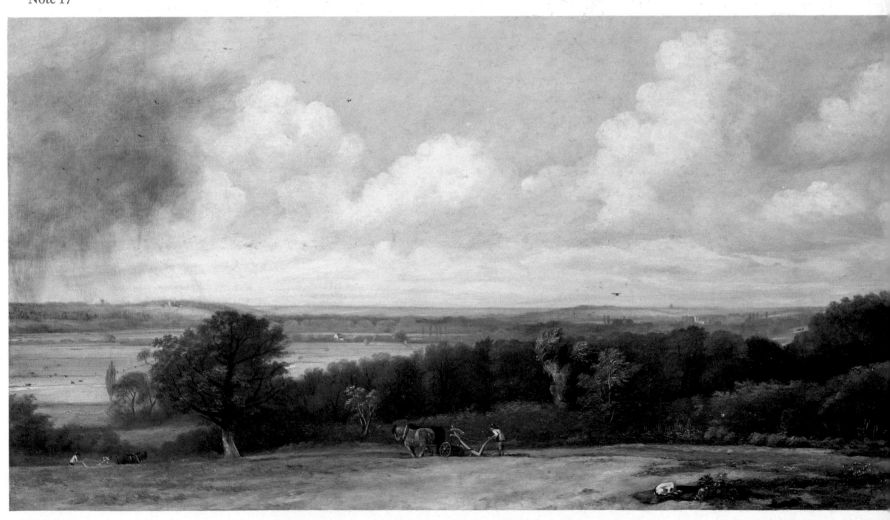

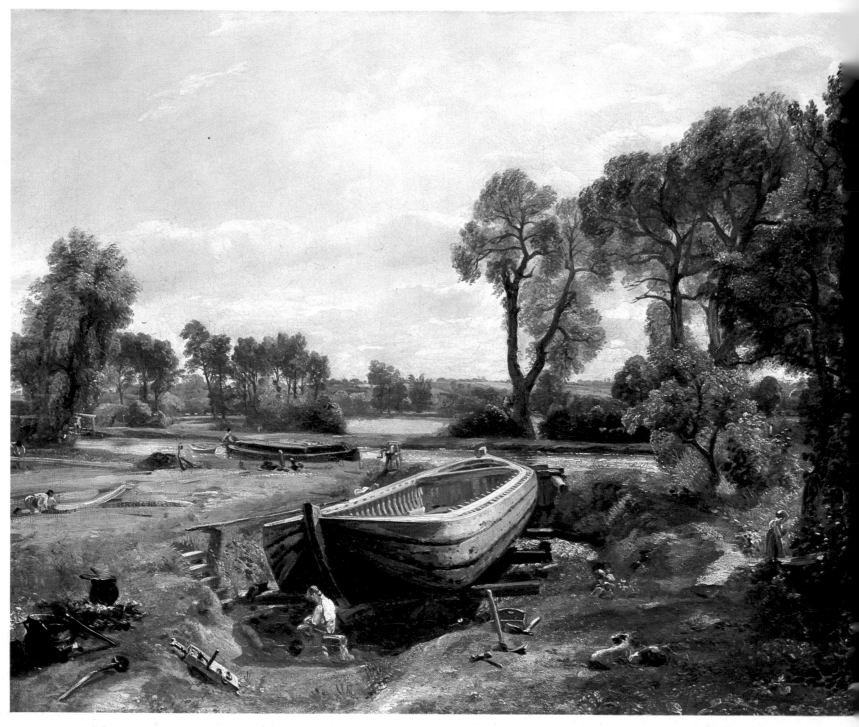

39. *Boat-building near Flatford Mill.* 1815. Oil on canvas, 20 × 24½ in. (508 × 616 mm.) London, Victoria and Albert Museum. See Note 18

40. *The Stour Valley and Dedham Church.* Dated 1814. Oil on canvas, 15½ × 22 in. (394 × 559 mm.) Leeds, City Art Galleries. See Note 19

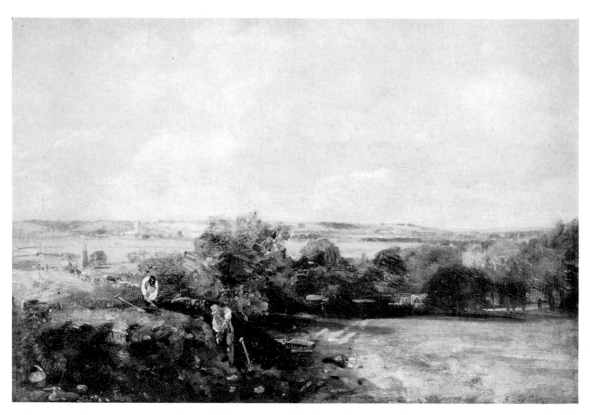

41. *The Stour Valley and Dedham Church.* 1814–15. Oil on canvas, 21¾ × 30¾ in. (552 × 781 mm.) Boston, Museum of Fine Arts. See Note 19

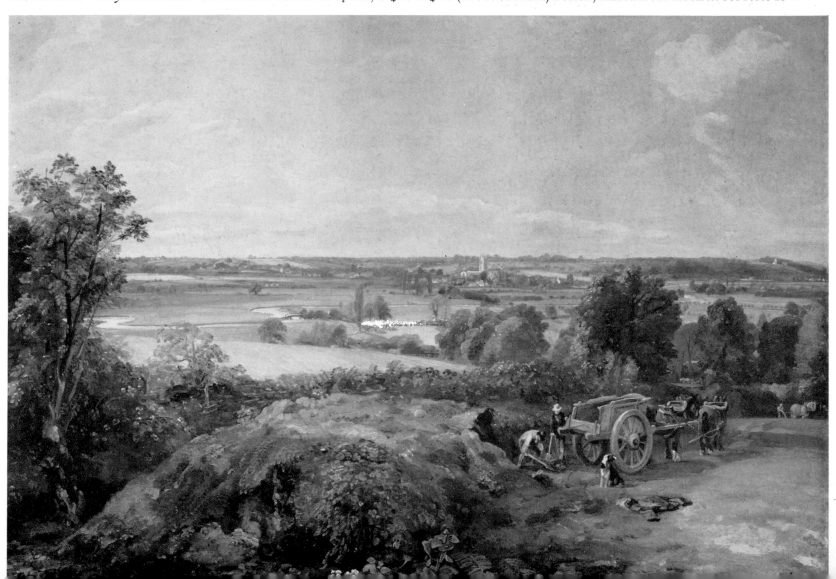

42. *Coast scene. c.*1816. Oil on millboard, 7⅛ × 13 in. (180 × 330 mm.) Oxford, Ashmolean Museum

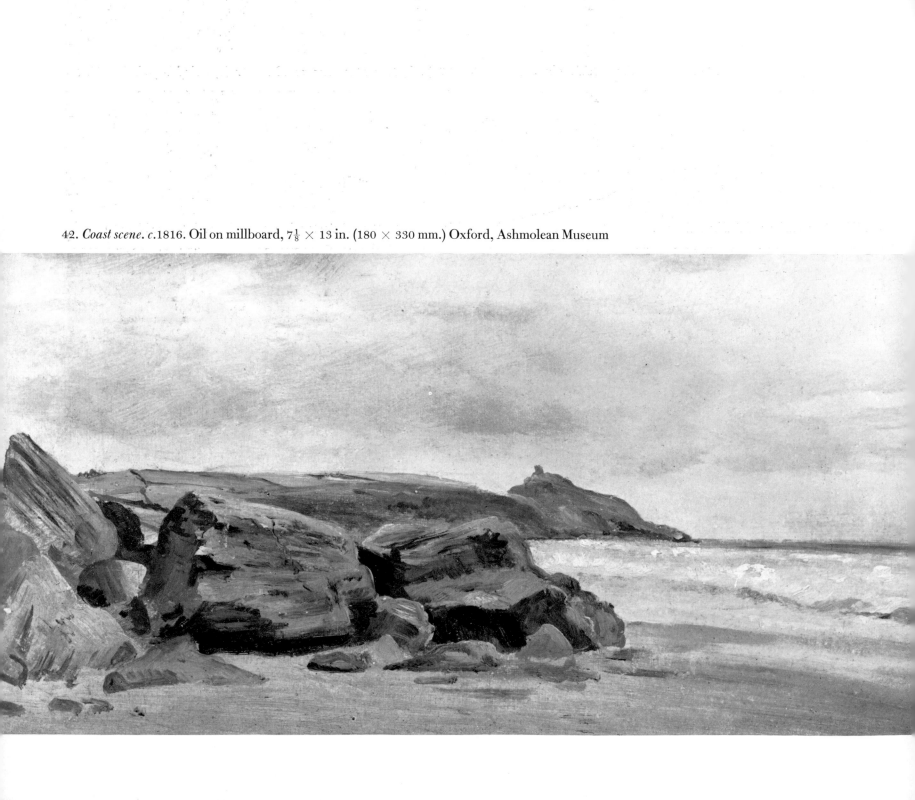

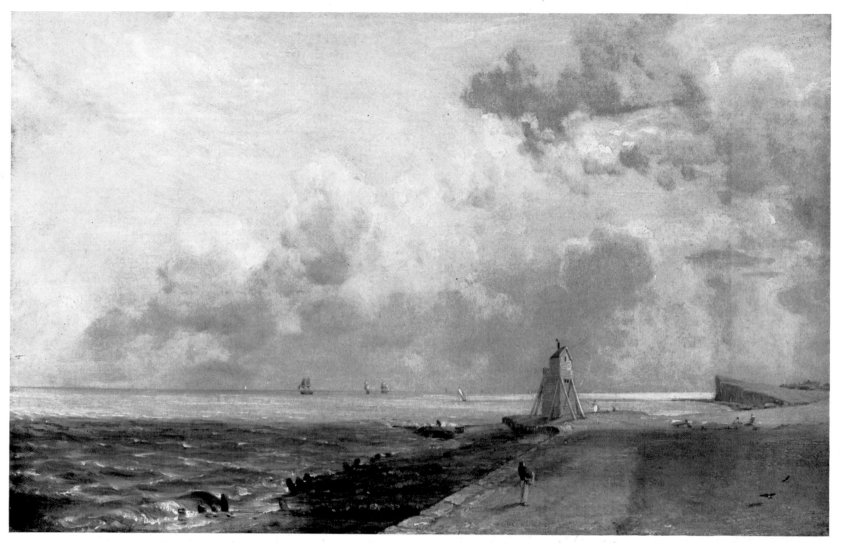

43. *Harwich: the Low lighthouse and Beda Beacon Hill. c.*1819. Oil on canvas, $12\frac{7}{8} \times 19\frac{3}{4}$ in. (327 × 502 mm.) London, Tate Gallery. See Note 20

44 *Near Stoke-by-Nayland*(?) *c.*1820. Oil on canvas, 14 × 17½ in. (356 × 444 mm.) London, Tate Gallery. See Note 21

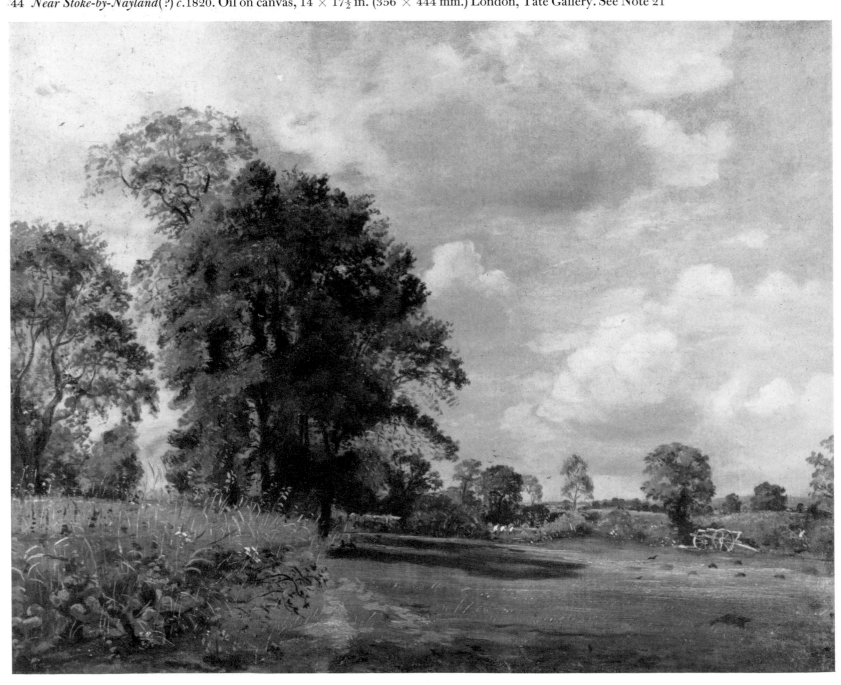

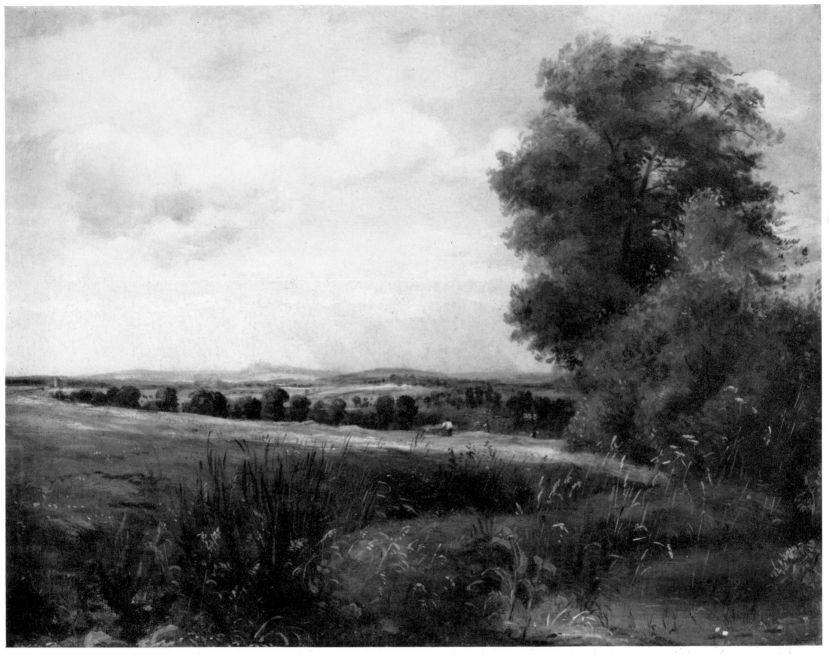

45. *Looking over to Harrow.* c.1820. Oil on canvas, 13½ × 17 in. (343 × 432 mm.) From the collection of Mr and Mrs Paul Mellon. See Note 21

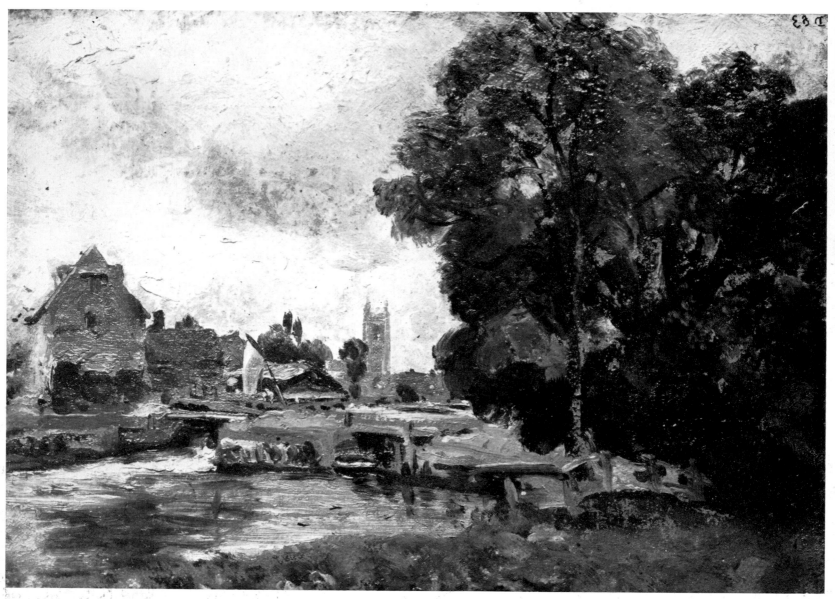

46. *Dedham Lock and Mill. c.*1810–15. Oil on paper, $7\frac{1}{8} \times 9\frac{3}{4}$ in. (181 × 248 mm.) London, Victoria and Albert Museum. See Note 22

47. *Dedham Lock and Mill*. Signed and dated 1820. Oil on canvas, $21\frac{1}{8} \times 30$ in. (537 × 762 mm.) London, Victoria and Albert Museum. See Note 22

48. *Hampstead Heath. c.*1820. Oil on canvas, 15 × 26⅛ in. (381 × 664 mm.) London, Tate Gallery. See Note 23

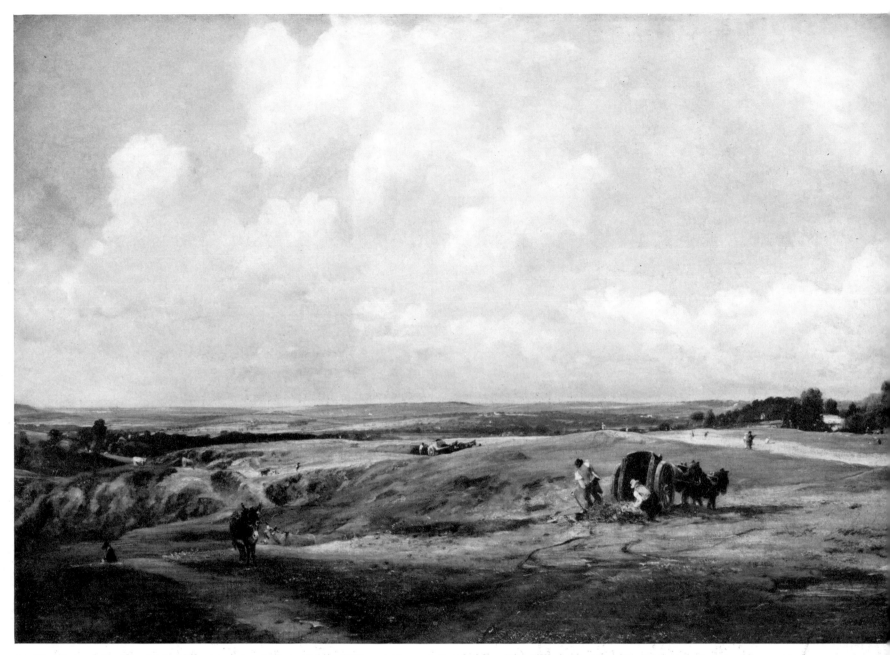

49. *Hampstead Heath. c.*1820. Oil on canvas, 21¾ × 30¼ in. (552 × 768 mm.) Cambridge, Fitzwilliam Museum. See Note 23

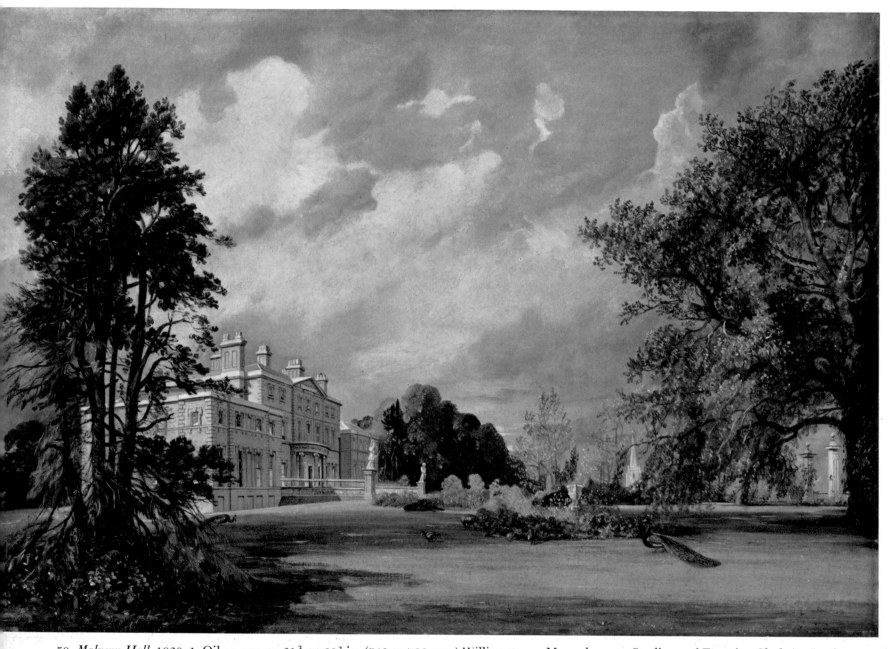

50. *Malvern Hall*. 1820–1. Oil on canvas, $21\frac{3}{8} \times 30\frac{3}{4}$ in. (542 × 782 mm.) Williamstown, Massachusetts, Sterling and Francine Clark Art Institute.
See Note 7

51. *Wivenhoe Park, Essex*. Exhibited 1817. Oil on canvas, $22\frac{1}{8} \times 39\frac{7}{8}$ in. (561 × 1,012 mm.) Washington, D.C., National Gallery of Art (Widener Collection). See Note 24

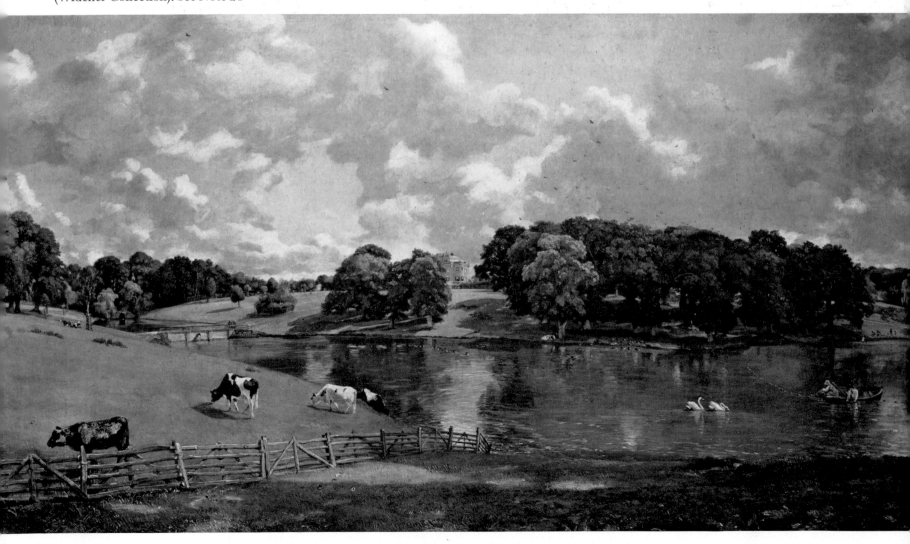

52. Detail from *The White Horse* (Plate 53)

53. *The White Horse*. Signed and dated 1819. Oil on canvas, 51¾ × 74⅛ in. (1,314 × 1,883 mm.) New York, The Frick Collection. See Note 25

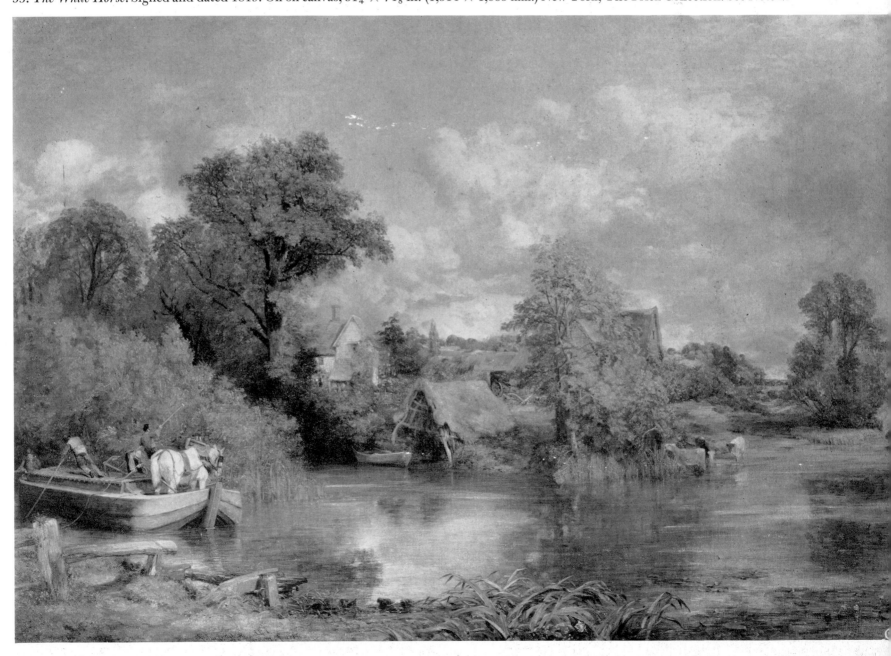

54. *Landscape sketch* ('*Stratford Mill*'). 1819–20. Oil on canvas, 12 × 16½ in. (305 × 420 mm.) England, Private Collection. See Note 26

55. *Stratford Mill*. Exhibited 1820. Oil on canvas, 50 × 72 in. (1,270 × 1,829 mm.) England, Private Collection. See Note 26

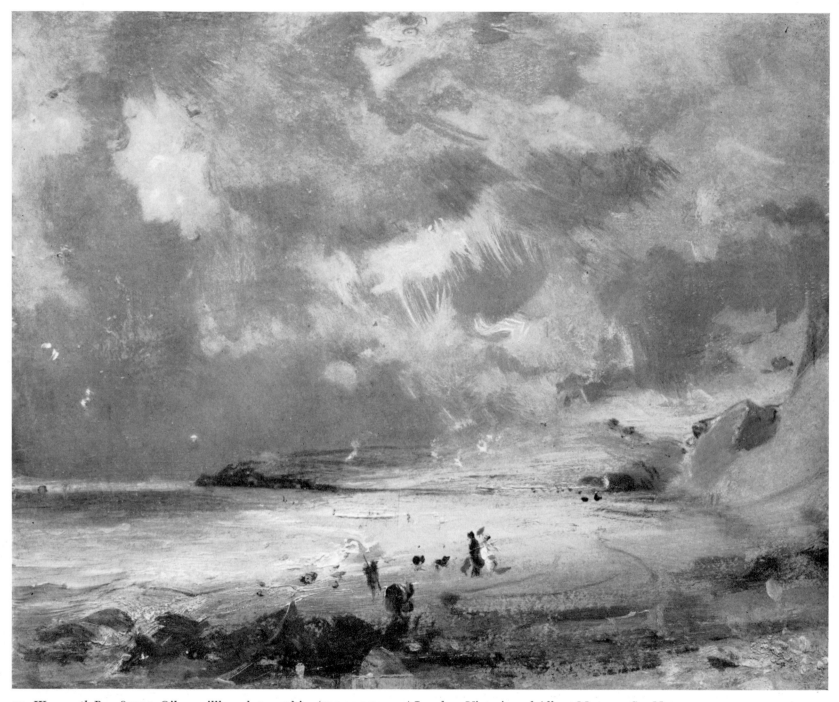

56. *Weymouth Bay*. ?1816. Oil on millboard, 8 × 9¾ in. (203 × 247 mm.) London, Victoria and Albert Museum. See Note 27

57. *Weymouth Bay.* *c.*1817. Oil on canvas, 20¾ × 29½ in. (527 × 749 mm.) London, National Gallery. See Note 27

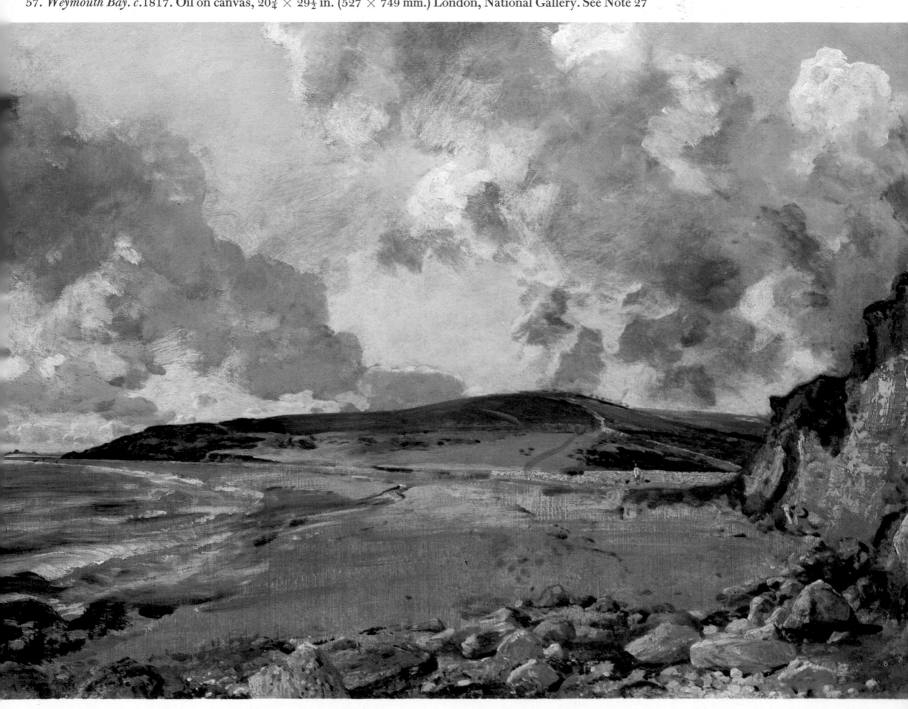

58. *Flatford Mill, on the River Stour*. Signed and dated 1817. Oil on canvas, 40 × 50 in. (1,016 × 1,245 mm.) London, Tate Gallery. See Note 28

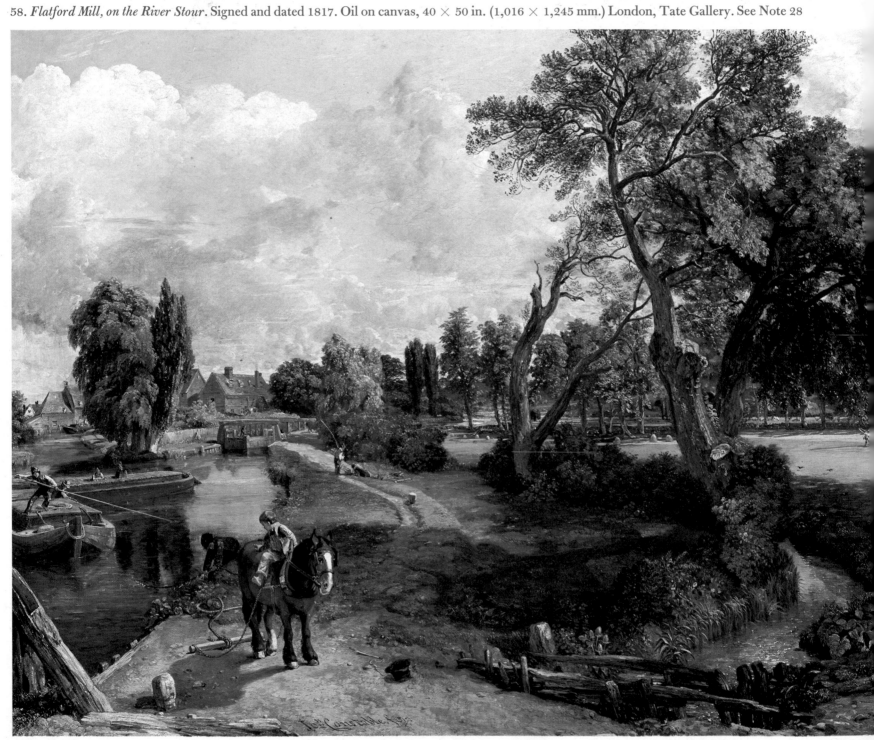

59. *Landscape study: Hampstead looking west.* 1821. Oil on paper on canvas, $10\frac{7}{8} \times 11\frac{3}{4}$ in. (276 × 298 mm.) London, Royal Academy of Arts. See Note 29

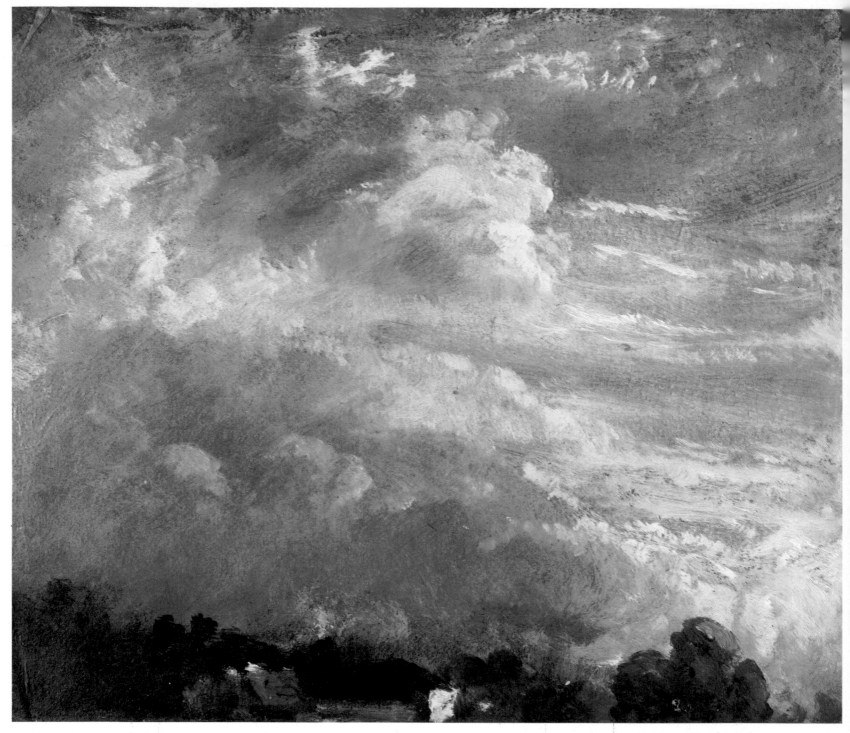

60. *Cloud study: horizon of trees.* 1821. Oil on paper on panel, 9¾ × 11½ in. (248 × 292 mm.) London, Royal Academy of Arts. See Note 30

61. *Cloud study, sunset.* c.1820–2.
Oil on paper on millboard,
6 × 9½ in. (152 × 240 mm.)
From the collection of Mr and
Mrs Paul Mellon. See Note 30

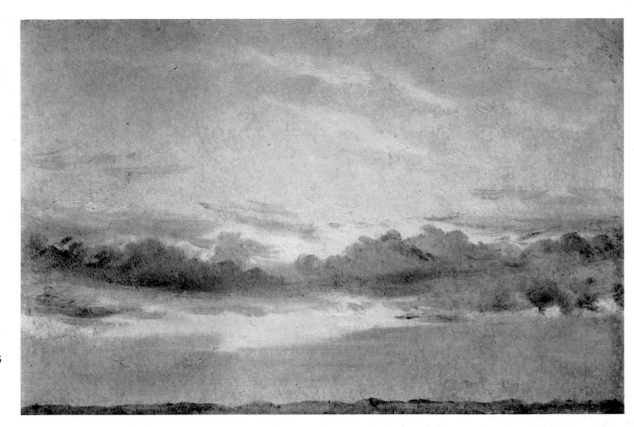

62. *Study of cumulus clouds.*
Dated 1822. Oil on paper on
panel, 11¼ × 19 in. (285 × 485
mm.) From the collection of
Mr and Mrs Paul Mellon. See
Note 30

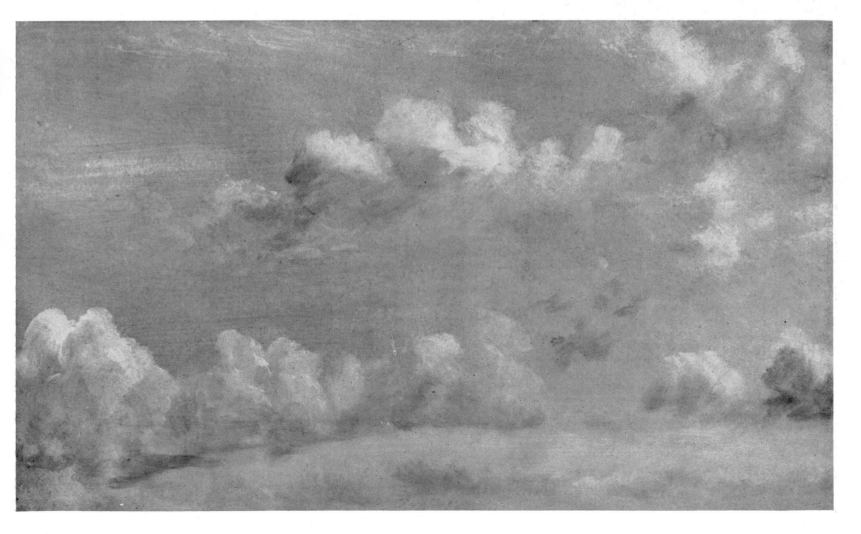

63. *Strato-cumulus cloud*. Dated 1821. Oil on paper on board, $9\frac{3}{4} \times 11\frac{7}{8}$ in. (247 × 302 mm.) From the collection of Mr and Mrs Paul Mellon. See Note 30

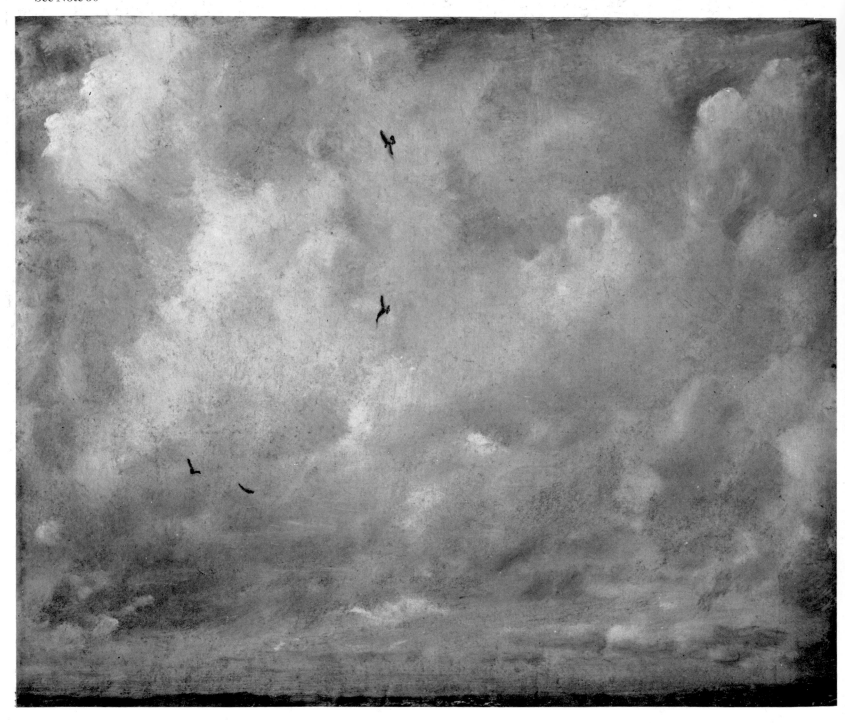

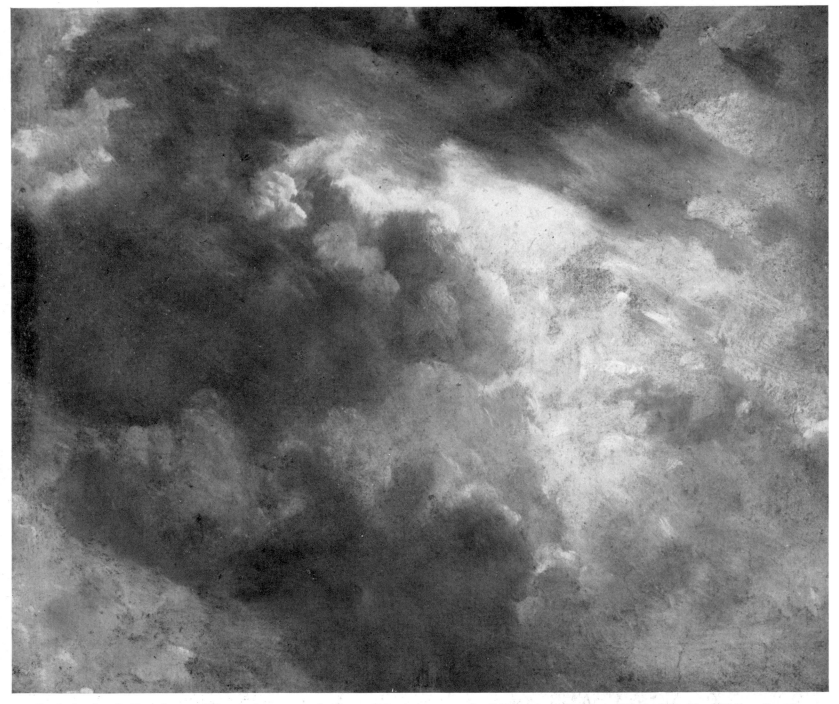

64. *Dark cloud study*. Dated 1821. Oil on paper on panel, $8\frac{3}{8} \times 11\frac{1}{2}$ in. (212 × 290 mm.) From the collection of Mr and Mrs Paul Mellon. See Note 30

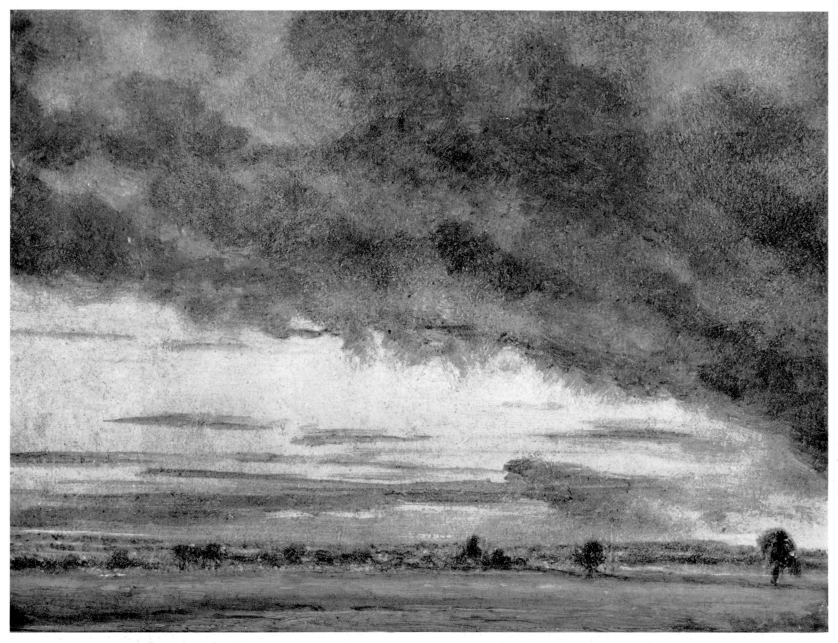

65. *Evening landscape after rain.* *c*.1820–1. Oil on paper on panel, 7 × 9½ in. (177 × 240 mm.) From the collection of Mr and Mrs Paul Mellon. See Note 30

66. *Study of cirrus clouds.* c.1822. Oil on paper,
4½ × 7 in. (114 × 178 mm.) London,
Victoria and Albert Museum. See Note 30

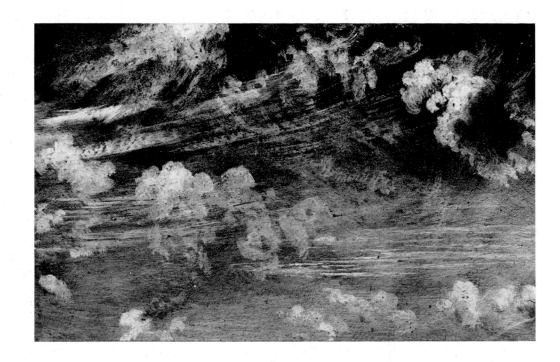

67. *Study of cumulus clouds.* Dated 1822. Oil on paper on panel, 11¼ × 19 in. (285 × 485 mm.) From the collection of Mr and Mrs Paul Mellon.
See Note 30

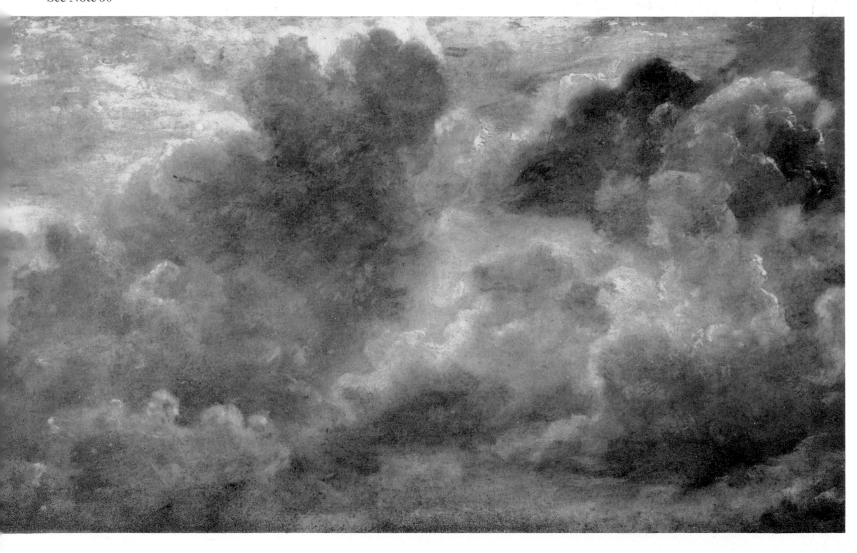

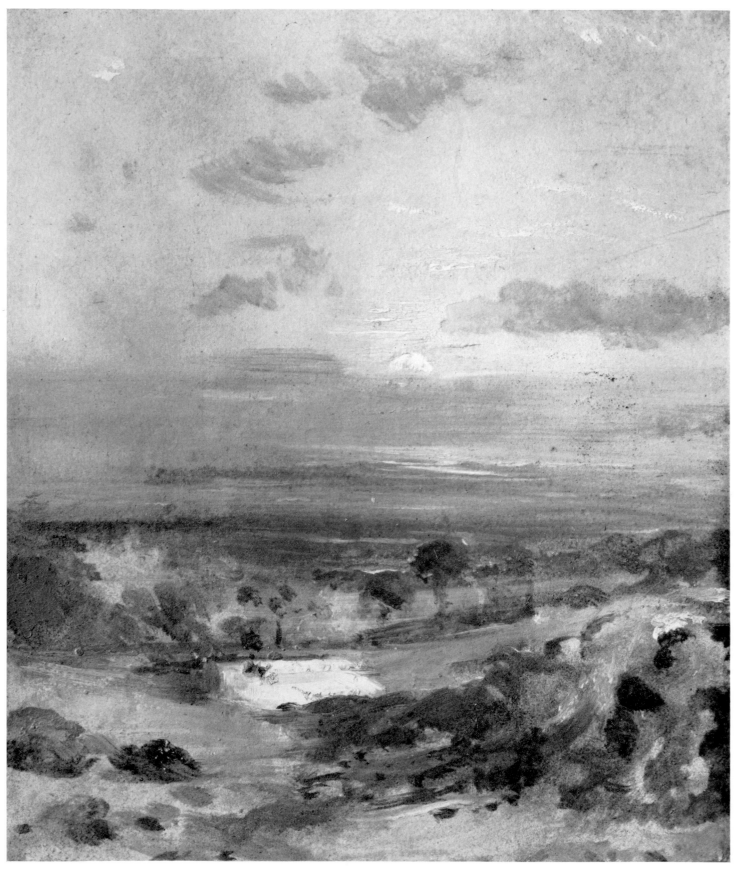

68. *Branch Hill Pond, evening. c.*1822. Oil on paper, 9 × 7½ in. (229 × 190 mm.) London, Victoria and Albert Museum.
See Note 29

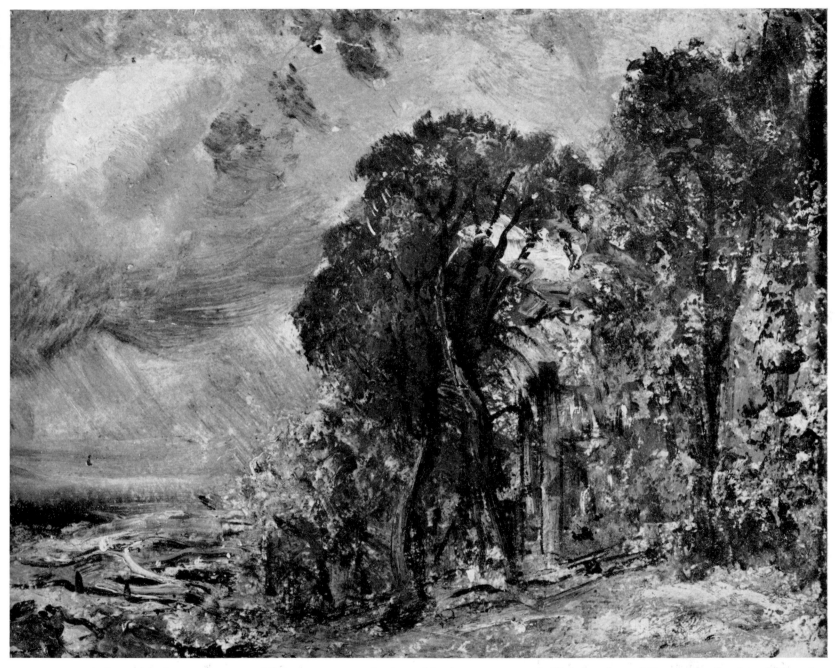

69. *Hampstead after a thunderstorm. c.*1822. Oil on paper on panel, $6\frac{1}{8} \times 7\frac{5}{8}$ in. (155 × 195 mm.) Slightly enlarged. From the collection of Mr and Mrs Paul Mellon. See Note 29

70. *Landscape sketch* ('*The Hay Wain*'). *c*.1821. Oil on panel, $4\frac{7}{8} \times 7$ in. (125 × 180 mm.) Enlarged. From the collection of Mr and Mrs Paul Mellon. See Note 31

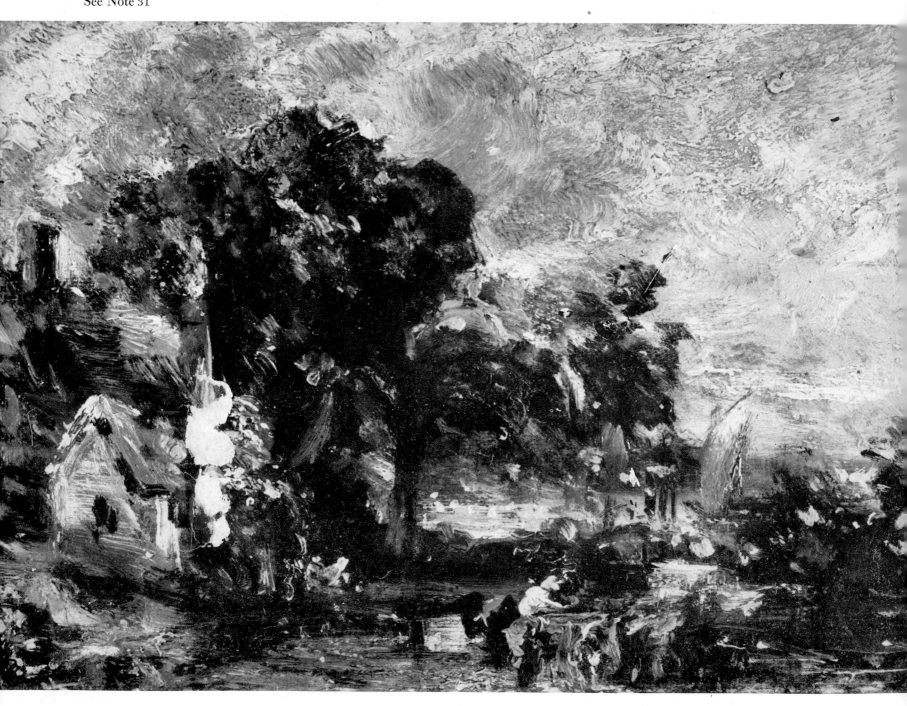

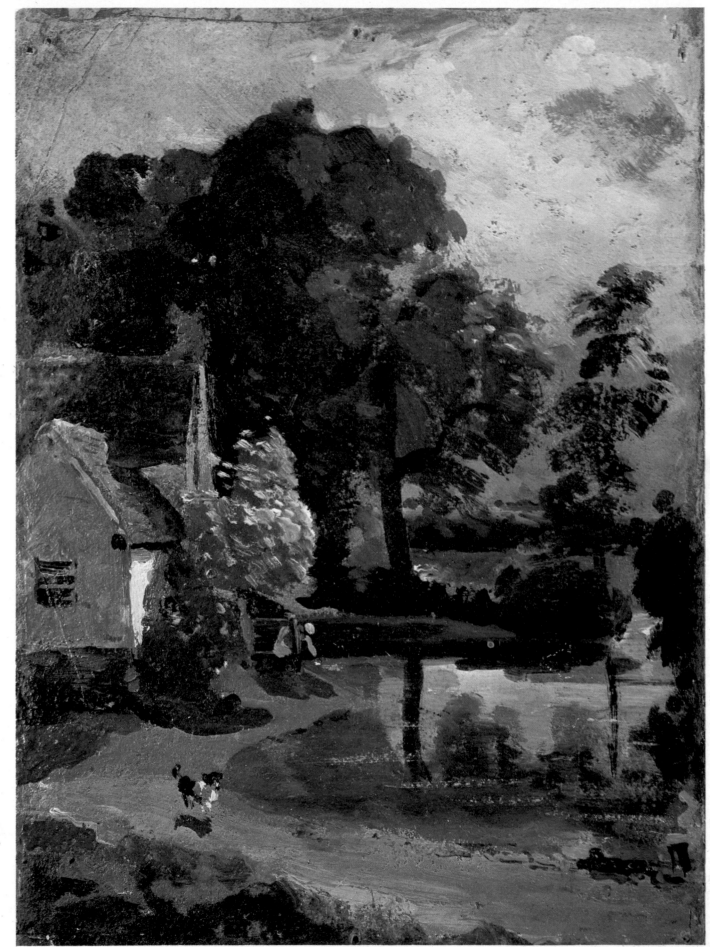

71. *Willy Lott's house. c.*1810–15. Oil on paper, $9\frac{1}{2} \times 7\frac{1}{8}$ in. (241 × 181 mm.) London, Victoria and Albert Museum. See Note 31

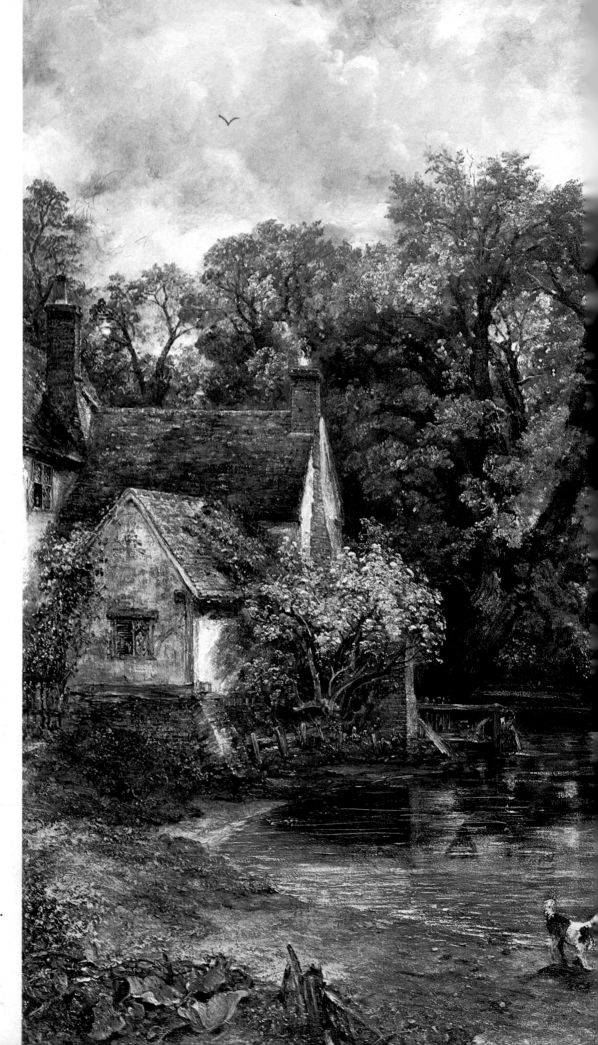

72. *The Hay Wain*. Signed and dated 1821.
Oil on canvas, 51¼ × 73 in. (1,305 ×
1,855 mm.) London, National Gallery.
See Note 31

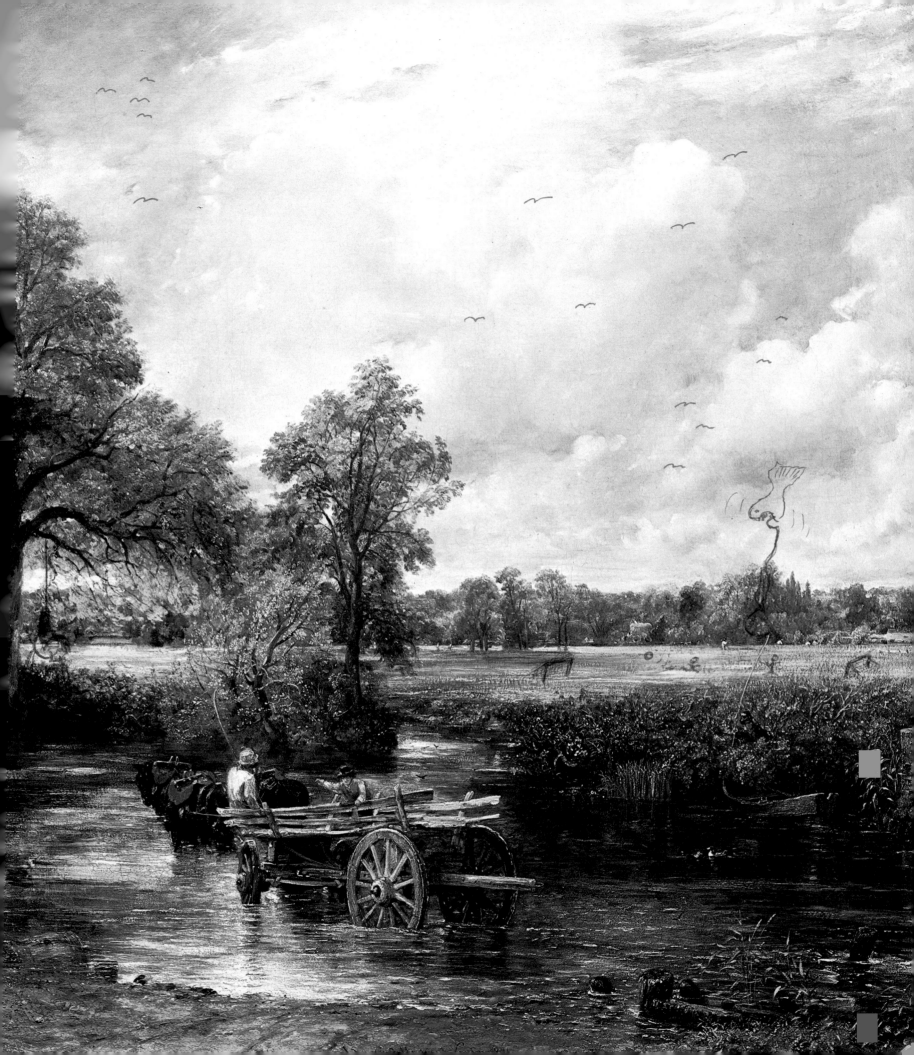

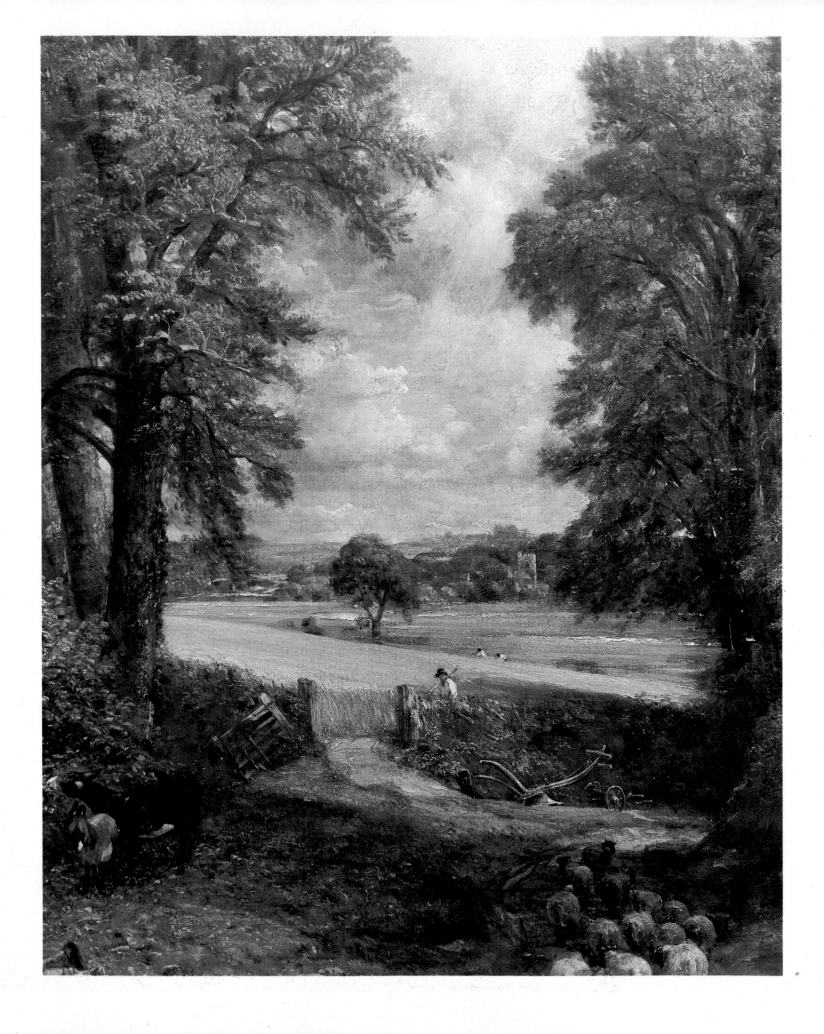

73. Detail from *The Cornfield* (Plate 119)

74. *Landscape sketch* ('*The Hay Wain*'). 1820–1. Oil on canvas, 54 × 74 in. (1,370 × 1,880 mm.) London, Victoria and Albert Museum. See Note 31

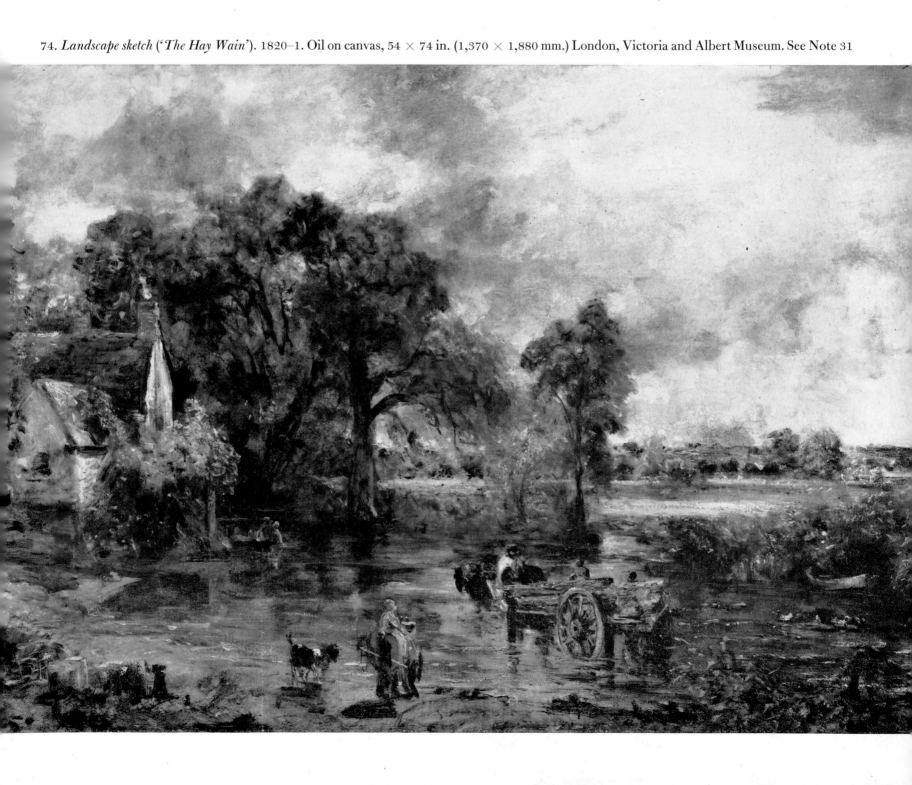

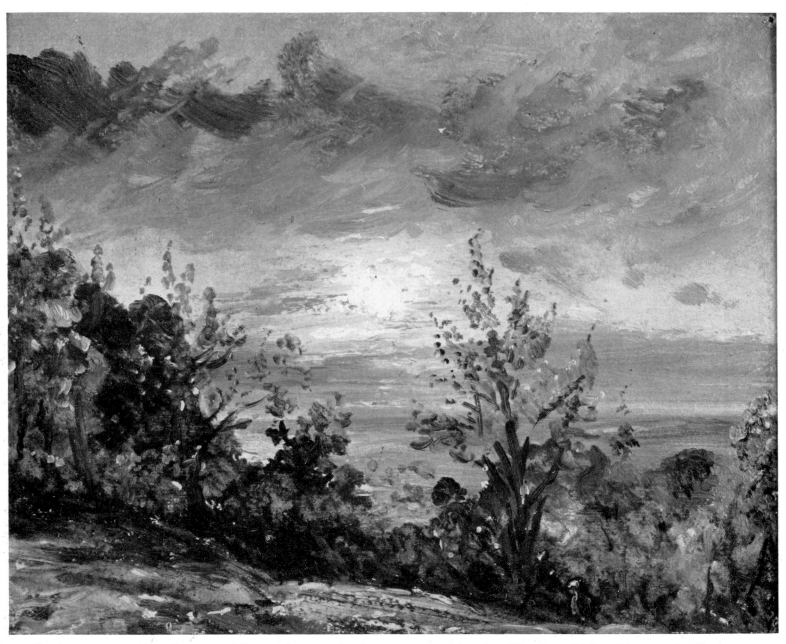

75. *Sketch at Hampstead: evening*. 1820. Oil on card, $6\frac{1}{4} \times 8$ in. (159 × 203 mm.) London, Victoria and Albert Museum. See Note 29

76. *A sandbank at Hampstead Heath.* Dated 1821. Oil on paper, $9\frac{3}{4} \times 11\frac{3}{4}$ in. (248 × 298 mm.) London, Victoria and Albert Museum. See Note 29

78. *Study of the trunk of an elm tree. c.*1821. Oil on paper, 12 × 9¾ in. (306 × 248 mm.) London, Victoria and Albert Museum. See Note 32

77. *Study of tree trunks. c.*1821. Oil on paper, 9¾ × 11½ in. (248 × 292 mm.) London, Victoria and Albert Museum. See Note 32

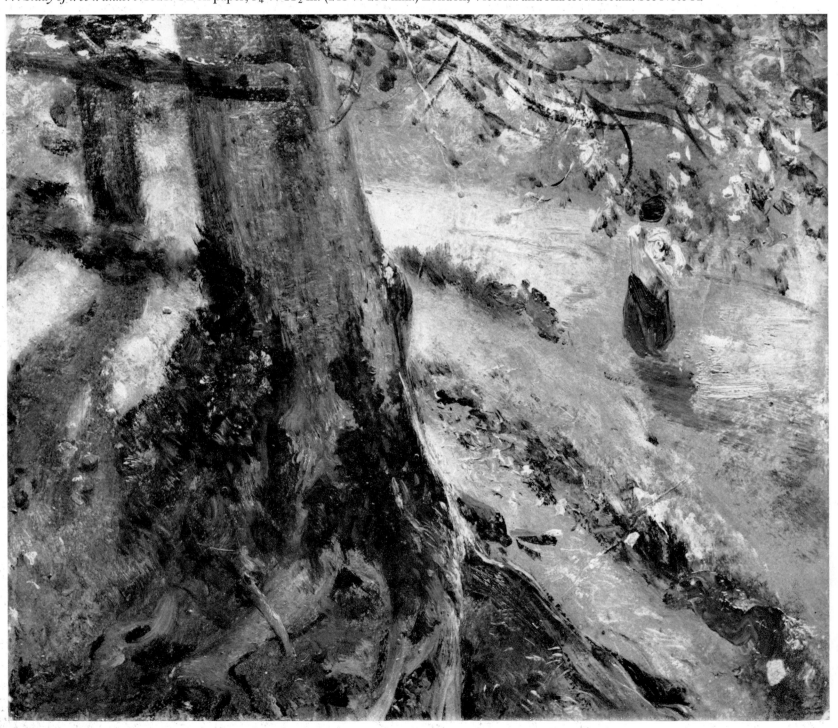

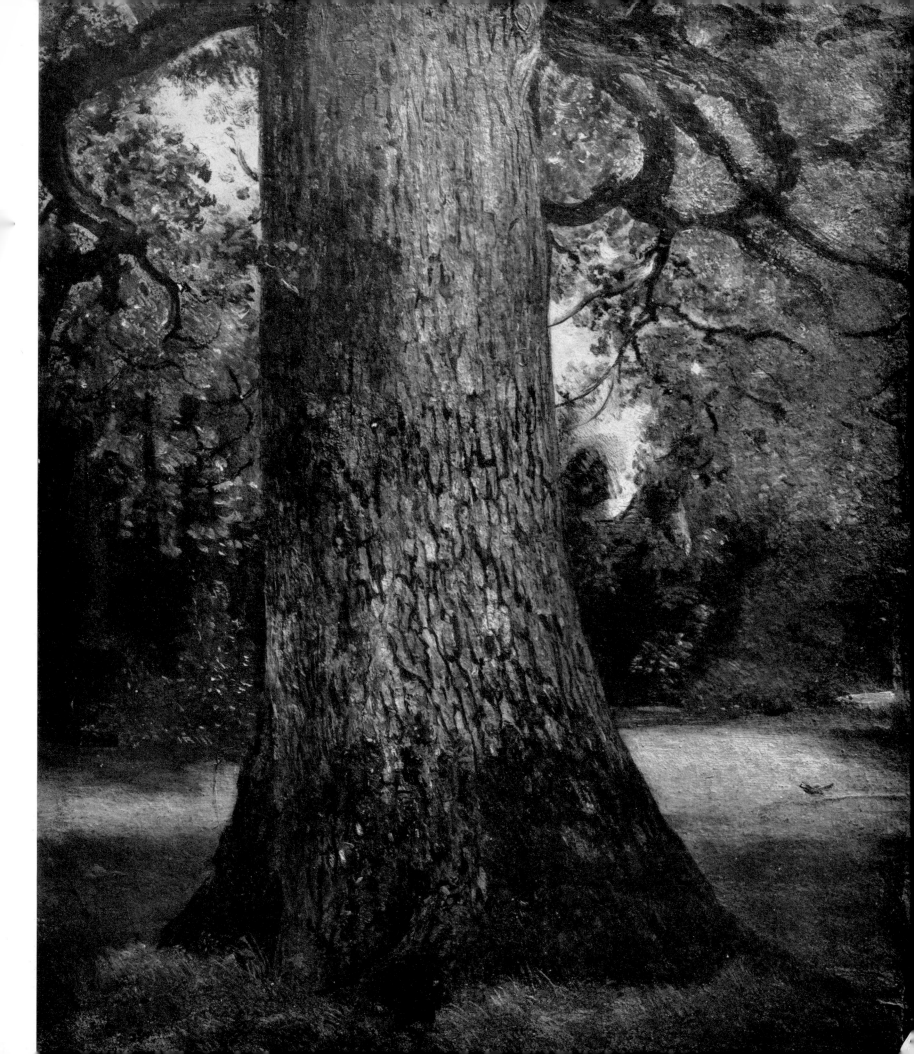

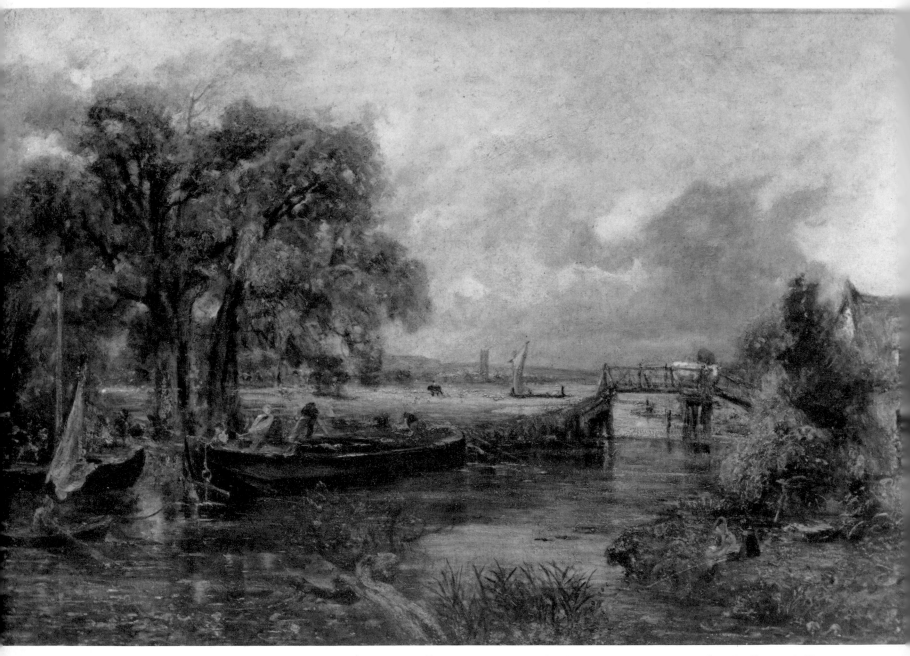

79. *Landscape sketch* (*View on the Stour near Dedham*). 1821–2. Oil on canvas, 51 × 73 in. (1,295 × 1,854 mm.) London, Holloway College.
See Note 33

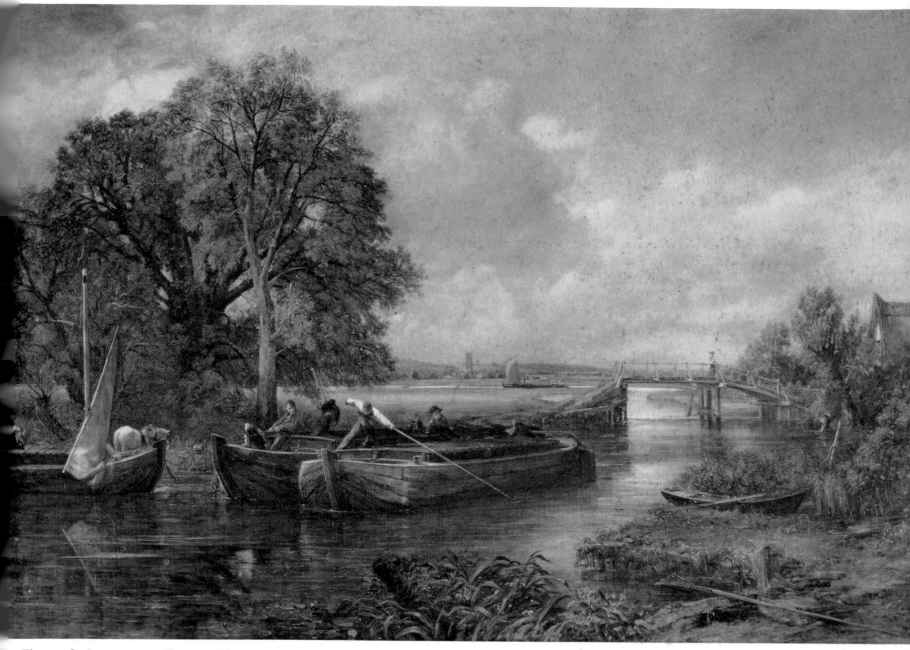

View on the Stour near Dedham. Exhibited 1822. Oil on canvas, 51 × 74 in. (1,295 × 1,880 mm.) San Marino, California, Henry E. Huntington Library and Art Gallery. See Note 33

81. *Salisbury Cathedral and the Close*. Dated 1820. Oil on canvas, $9\frac{7}{8} \times 11\frac{7}{8}$ in. (251 × 302 mm.) London, Victoria and Albert Museum. See Note 34

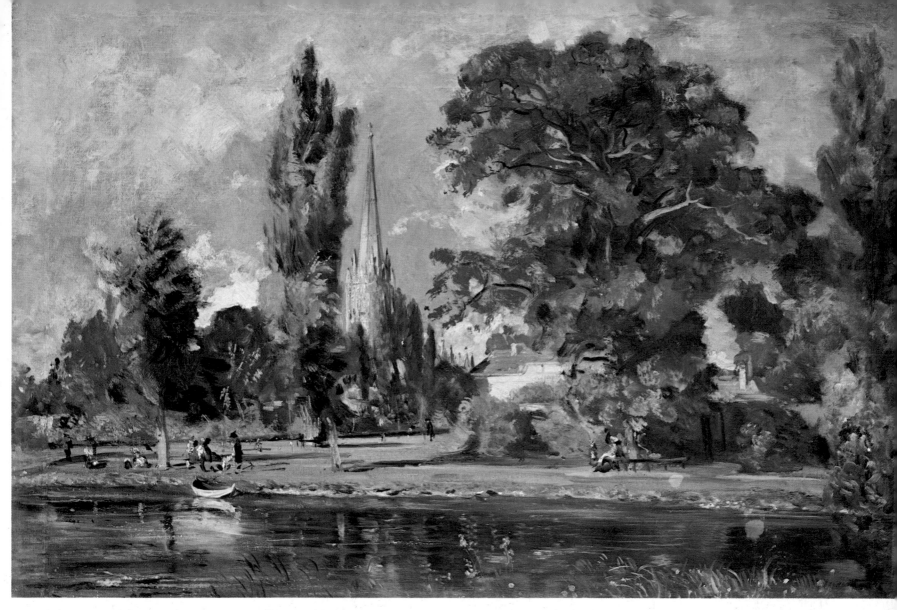

82. *Salisbury Cathedral from the river.* 1820s. Oil on canvas, $20\frac{3}{4} \times 30\frac{1}{4}$ in. (525 × 770 mm.) London, National Gallery. See Note 34

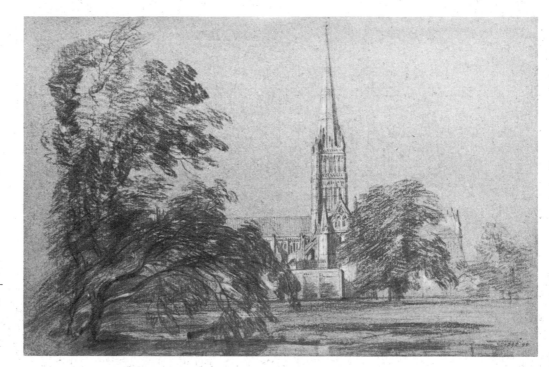

83. *Salisbury Cathedral from the south-west.* Inscribed 'Salisbury Cathedral Sept. 11 & 12—1811—S.W. view—.' Black and white chalk on grey paper, $7\frac{5}{8} \times 11\frac{3}{4}$ in. (195 × 299 mm.) London, Victoria and Albert Museum. See Note 34

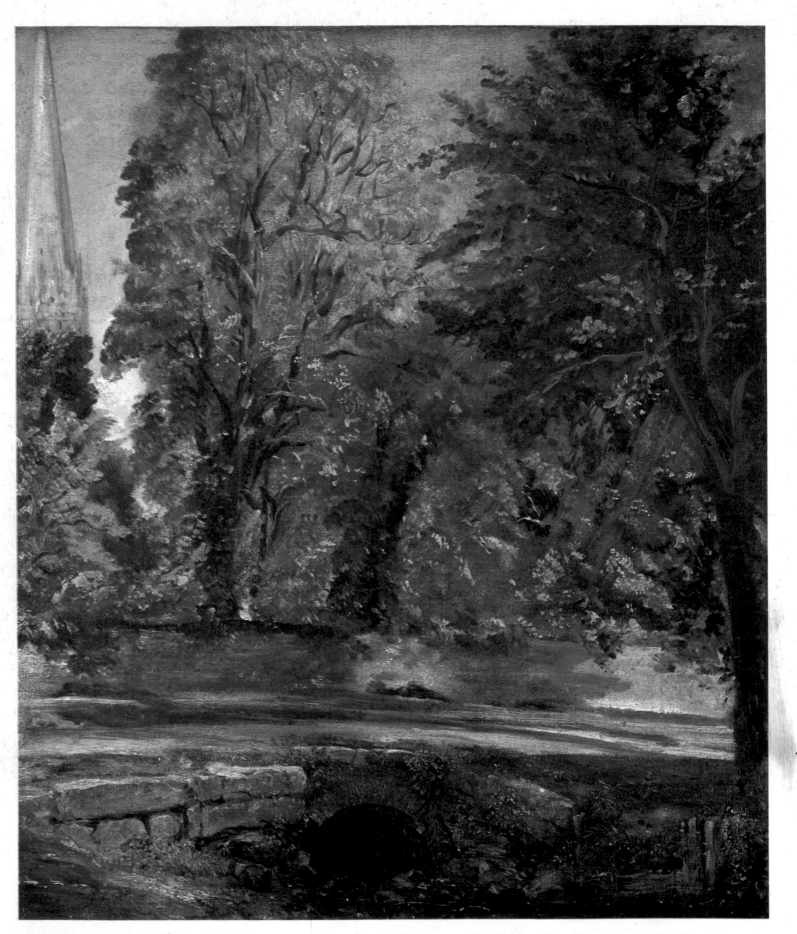

84. *Salisbury: the Close wall. c.*1821. Oil on canvas, 23¾ × 20¼ in. (603 × 514 mm.) Cambridge, Fitzwilliam Museum. See Note 34

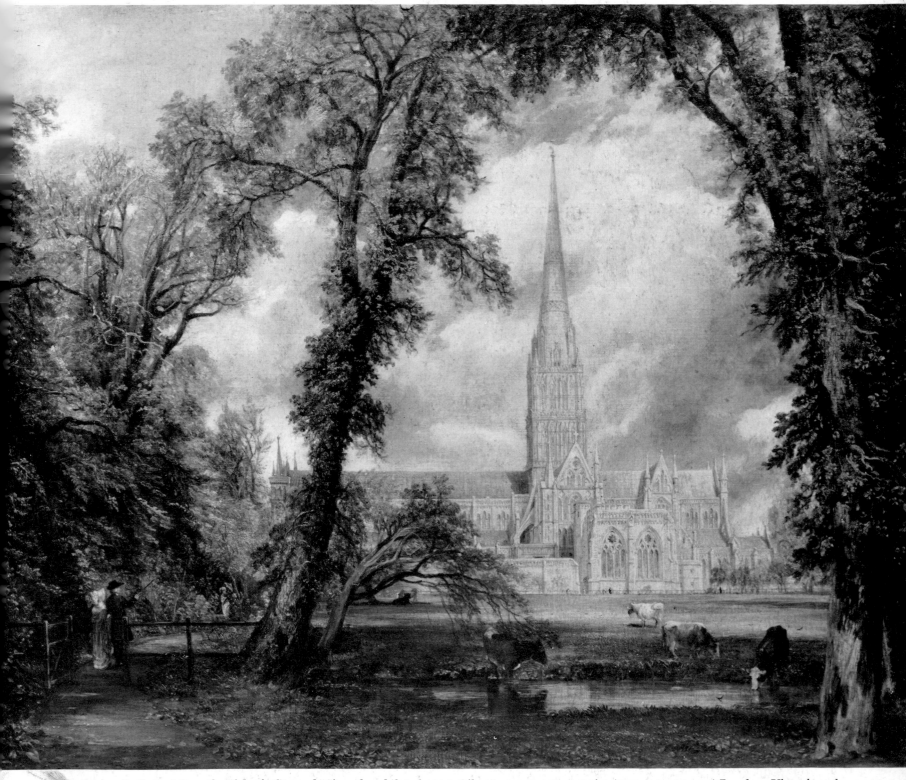

85. *Salisbury Cathedral from the Bishop's Grounds.* Signed and dated 1823. Oil on canvas, 34½ × 44 in. (876 × 1,118 mm.) London, Victoria and Albert Museum. See Note 34

86. *A view of Salisbury Cathedral.* ?1820–2. Oil on canvas, 28¾ × 36 in. (730 × 910 mm.) Washington, D.C., National Gallery of Art. See Note 34

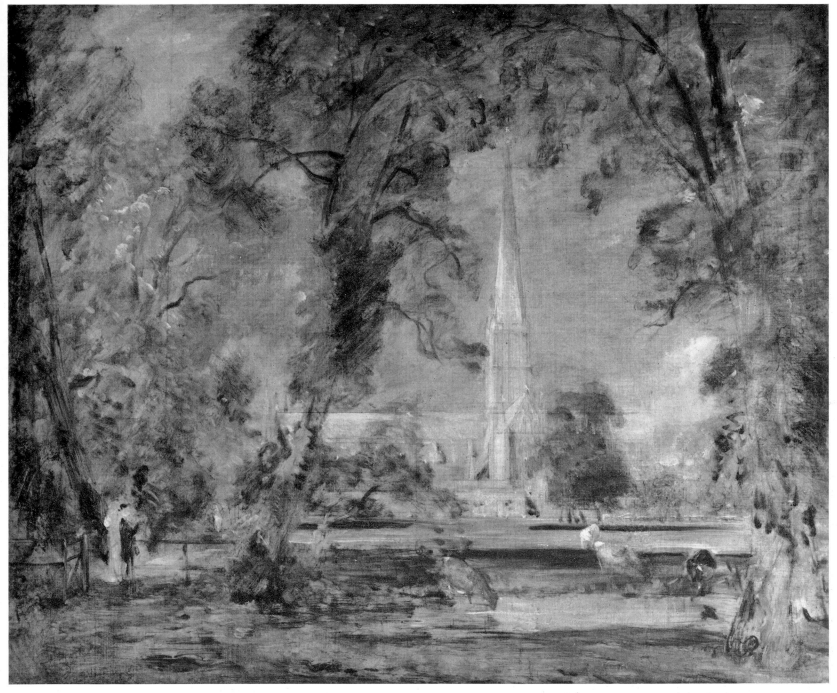

87. *Landscape sketch (Salisbury Cathedral from the Bishop's Grounds). c.*1823. Oil on canvas, 24 × 29 in. (610 × 737 mm.) Birmingham, City Museum and Art Gallery. See Note 34

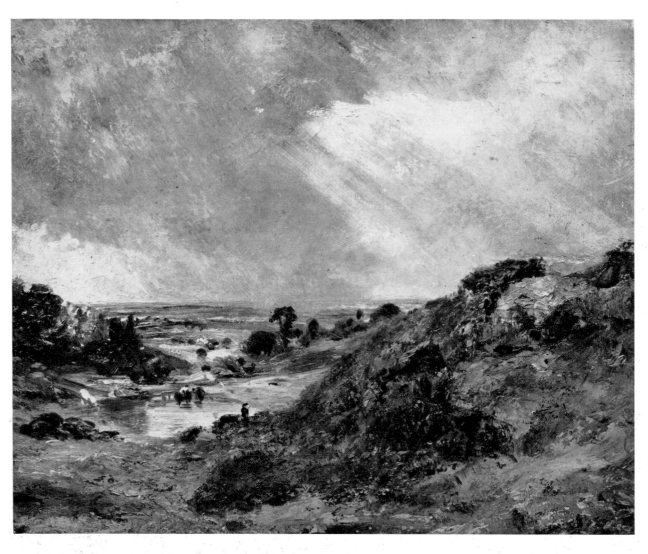

88. *Branch Hill Pond, Hampstead*. Dated 1819. Oil on canvas, $10 \times 11\frac{7}{8}$ in. (254×300 mm.) London, Victoria and Albert Museum. See Note 23

89. *Hampstead Heath at sunset, looking towards Harrow.* ?1820–5. Oil on canvas, $11\frac{5}{8} \times 19$ in. (295×485 mm.) From the collection of Mr and Mrs Paul Mellon. See Note 29

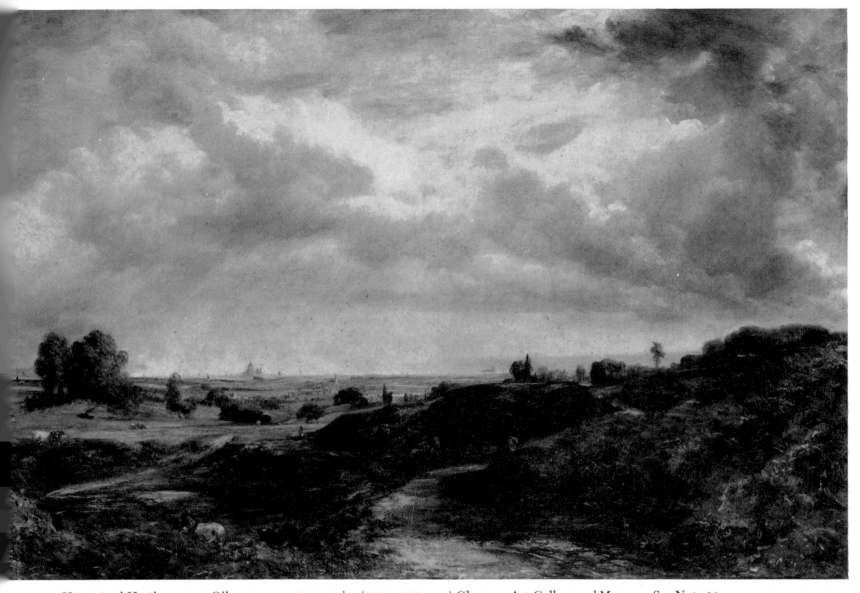

90. *Hampstead Heath*. 1820–5. Oil on canvas, 25 × 38 in. (635 × 965 mm.) Glasgow, Art Gallery and Museum. See Note 23

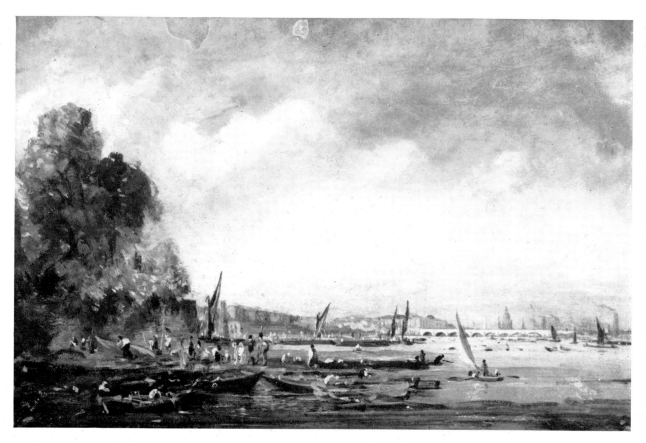

91. *Sketch of the Thames and
Waterloo Bridge.* ?1820–4.
Oil on paper on canvas,
$8\frac{1}{4} \times 12\frac{1}{2}$ in. (210 × 317
mm.) London, Royal
Academy of Arts. See
Note 35

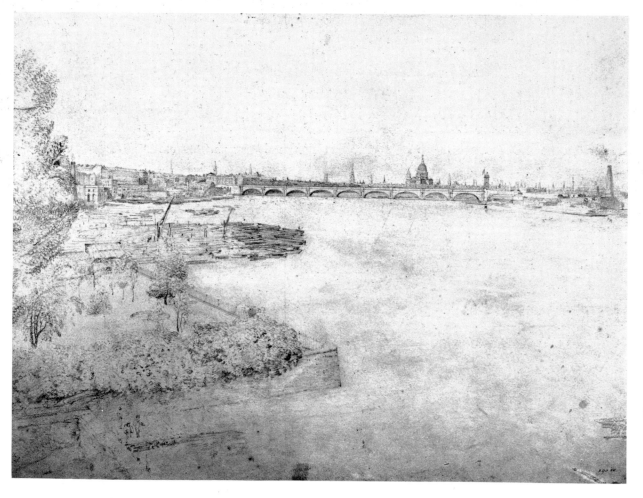

92. *Waterloo Bridge from the
west. c.*1819. Pencil,
$12 \times 16\frac{1}{8}$ in. (306 × 410
mm.) London, Victoria and
Albert Museum. See Note 35

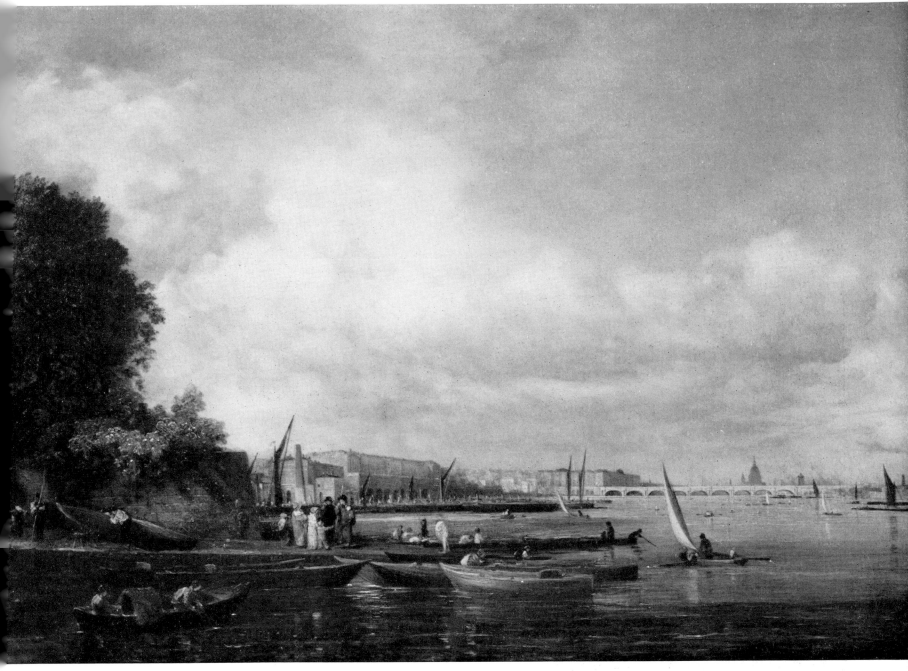

93. *The Thames and Waterloo Bridge. c.*1824. Oil on canvas, 30¾ × 21¾ in. (781 × 552 mm.) Cincinnati, Ohio, Art Museum. See Note 35

95. *Trees at Hampstead: the path to the Church.* ?1821. Oil on canvas, 36 × 28½ in. (914 × 724 mm.) London, Victoria and Albert Museum. See Note 37

94. *Summer afternoon after a shower.* c.1824–5. Oil on canvas, 13⅝ × 17⅛ in. (346 × 435 mm.) London, Tate Gallery. See Note 36

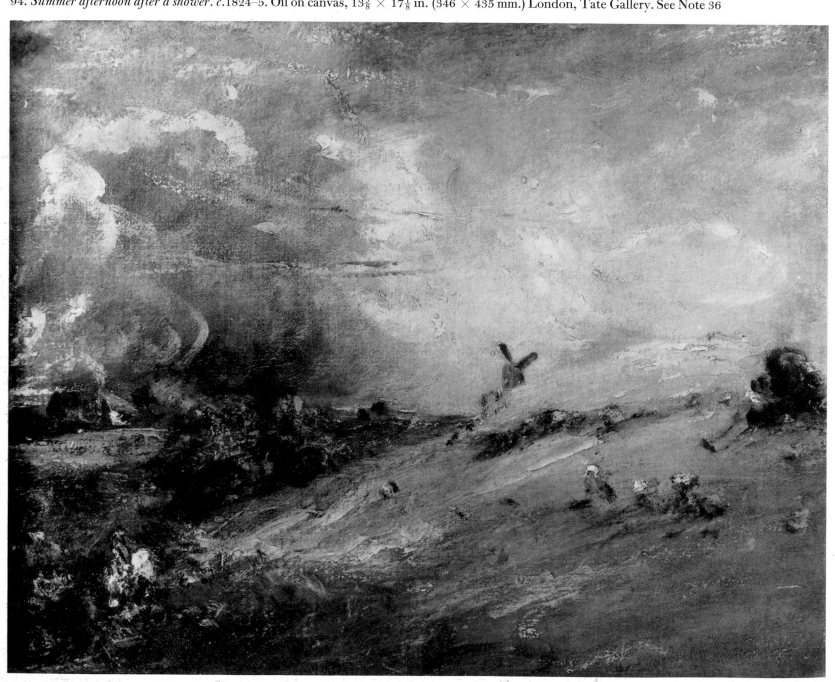

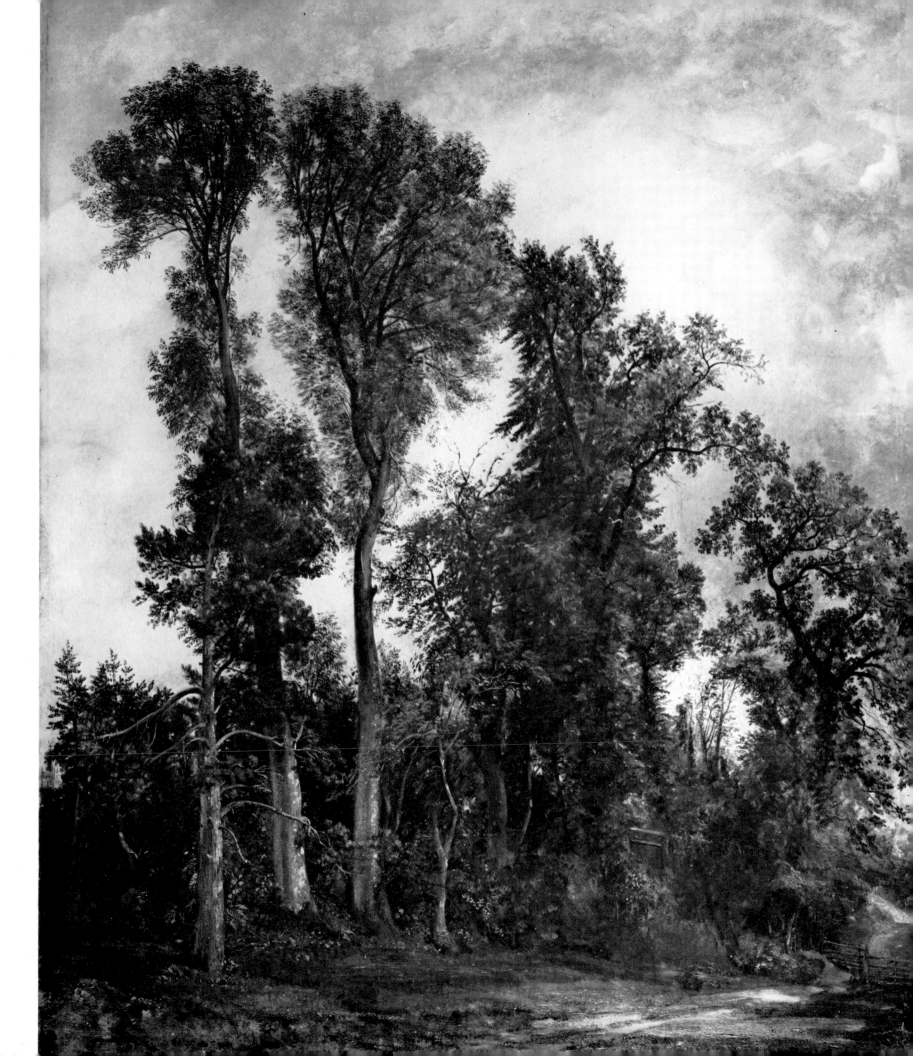

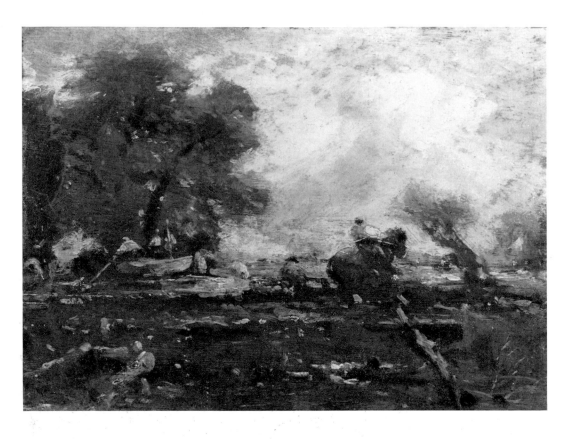

96. *Landscape sketch ('The Leaping Horse').* c.1824. Oil on wood, 6¾ × 9 in. (171 × 229 mm.) London, Tate Gallery. See Note 38

97. *Landscape sketch ('The Leaping Horse').* 1824–5. Oil on canvas, 51 × 74 in. (1,294 × 1,880 mm.) London, Victoria and Albert Museum. See Note 38

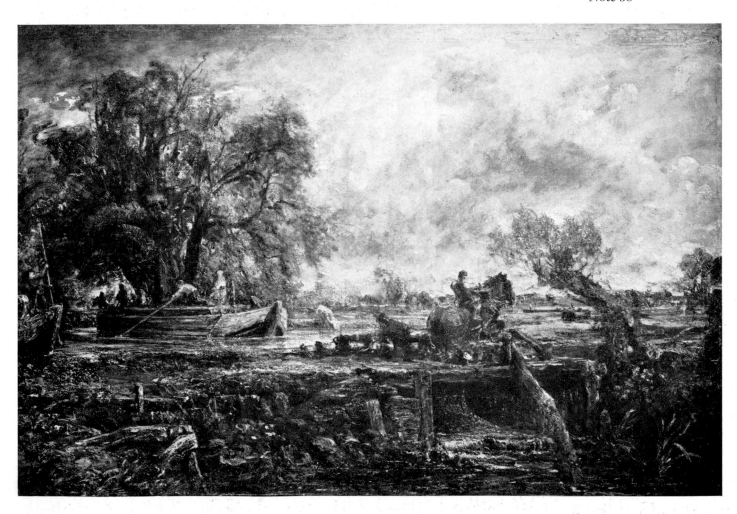

98. *Drawing for 'The Leaping Horse'*. Chalk and
ink wash, 8 × 11⅞ in. (203 × 302 mm.)
London, British Museum. See Note 38

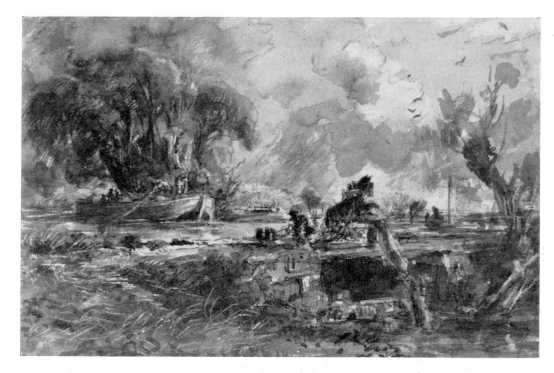

99. *The Leaping Horse*. Exhibited 1824. Oil on
canvas, 56 × 73¾ in. (1,422 × 1,873 mm.)
London, Royal Academy of Arts. See Note 38

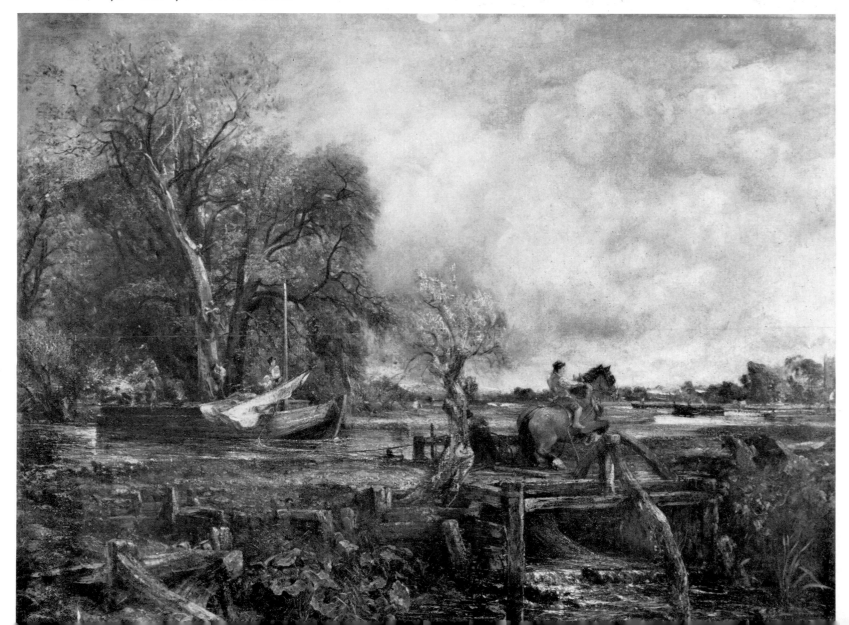

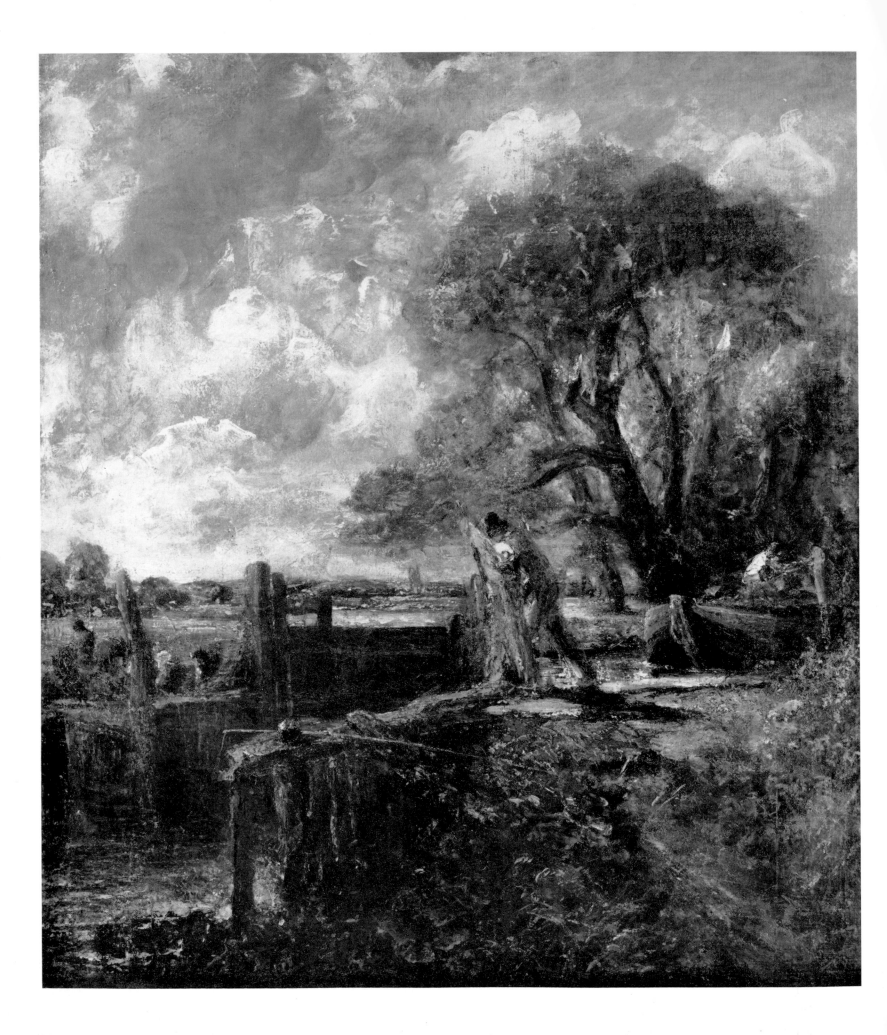

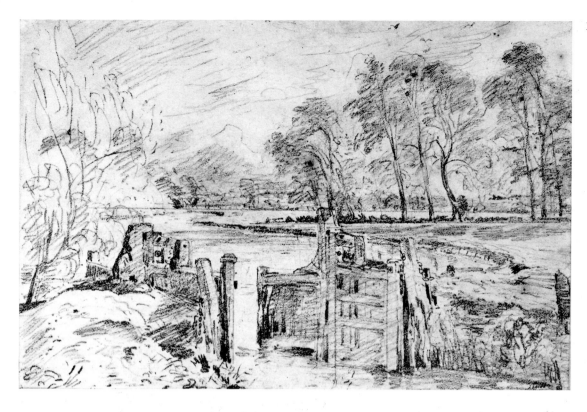

101. *A lock on the Stour*. Inscribed '11 Oct 1827.' Pencil, $8\frac{7}{8} \times 13\frac{1}{8}$ in. (224 × 332 mm.) London, Victoria and Albert Museum

102. *A boat passing a lock*. Signed and dated 1826. 40 × 50 in. (1,016 × 1,270 mm.) London, Royal Academy of Arts. See Note 39

100. *Landscape sketch* ('*The Lock*'). 1823–4. Oil on canvas, $55\frac{3}{4} \times 48\frac{1}{4}$ in. (1,416 × 1,225 mm.) Philadelphia, Museum of Art. See Note 39

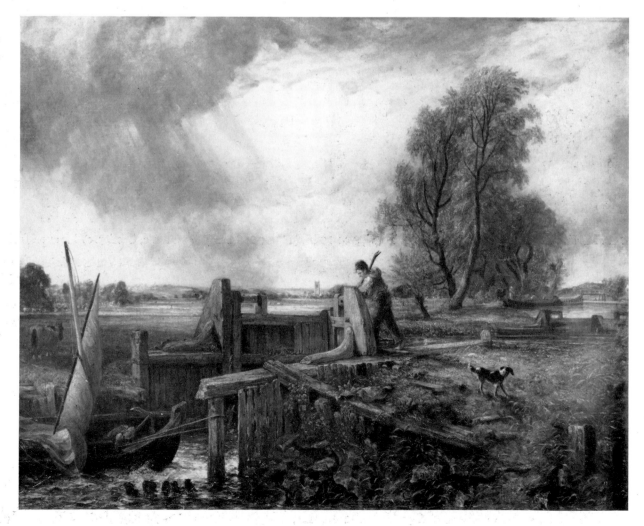

103. *Bardon Hill*. 1823. Oil on canvas on board, 8 × 10 in. (202 × 255 mm.) From the collection of Mr and Mrs Paul Mellon. See Note 40

104. *A cottage and lane at Langham* (*'The Glebe Farm'*). ?1810–15. Oil on canvas, $7\frac{3}{4} \times 11$ in. (197×280 mm.) London, Victoria and Albert Museum. See Note 41

105. *The Glebe Farm. c.*1827. Oil on canvas, $25\frac{5}{8} \times 37\frac{5}{8}$ in. (651×956 mm.) London, Tate Gallery. See Note 41

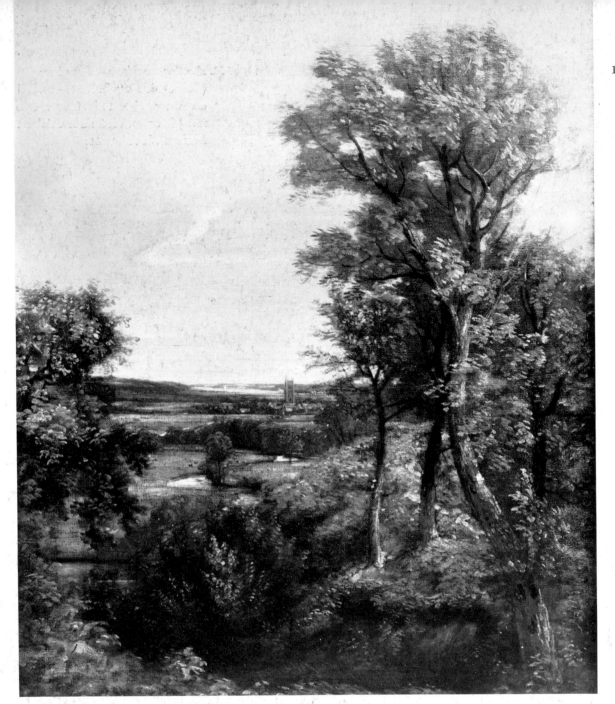

106. *Dedham Vale*. 1802. Oil on canvas,
$17\frac{1}{8} \times 13\frac{1}{2}$ in. (435 × 344 mm.)
London, Victoria and Albert
Museum. See Note 42

107. *Study of foliage*. 1820–30. Oil on
paper, $6 \times 9\frac{1}{2}$ in. (152 × 242
mm.) London, Victoria and
Albert Museum

108. *Dedham Vale*. Exhibited 1828.
Oil on canvas, $55\frac{1}{2} \times 48$ in. (1,410
× 1,219 mm.) Edinburgh, National
Gallery of Scotland. See Note 42

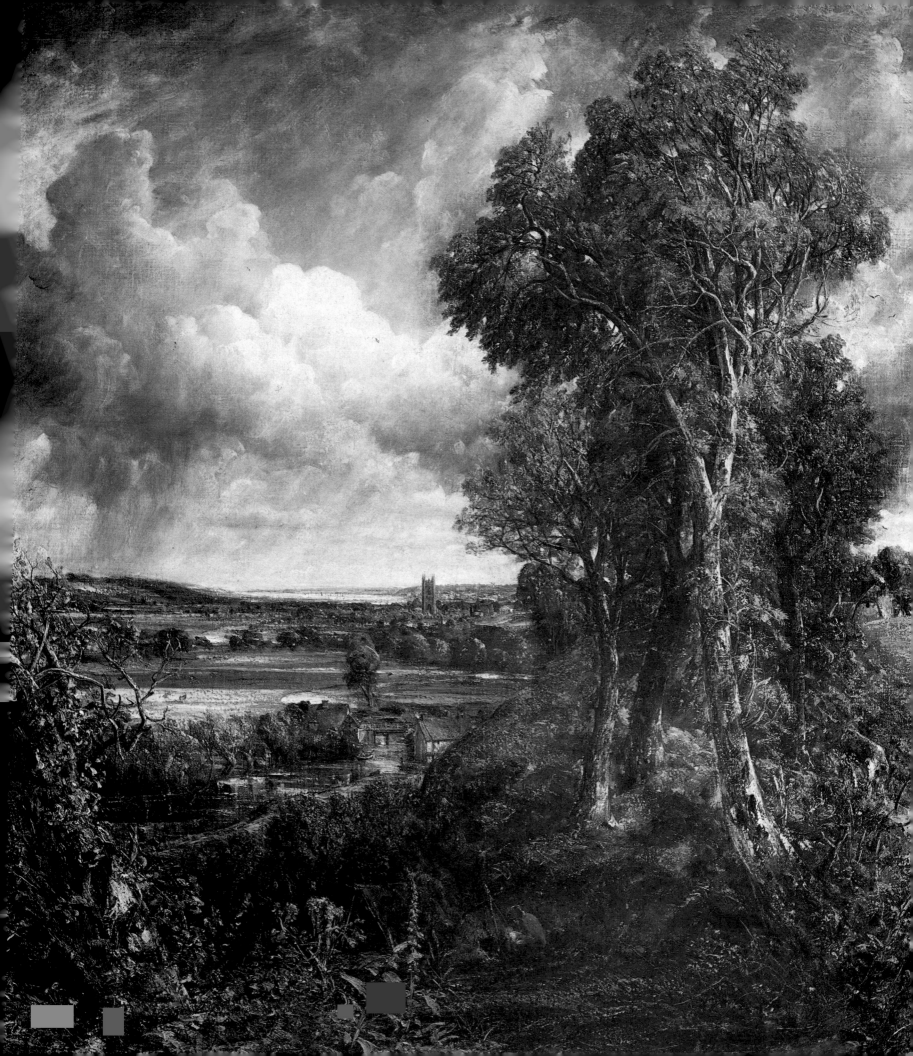

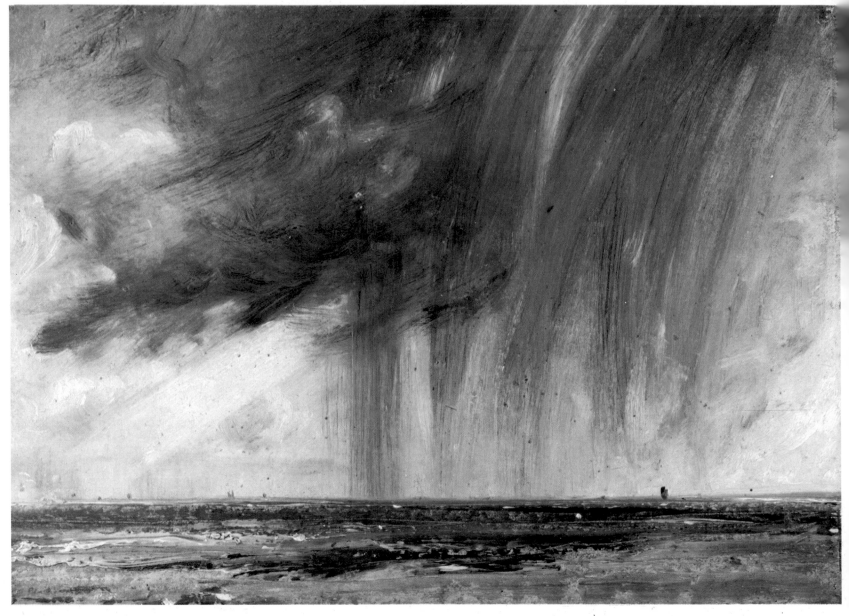

109. *Seascape study with rain clouds (near Brighton?)*. *c*.1824–5. Oil on paper on canvas, $8\frac{5}{8} \times 12\frac{1}{4}$ in. (220 × 310 mm.) London, Royal Academy of Arts. See Note 43

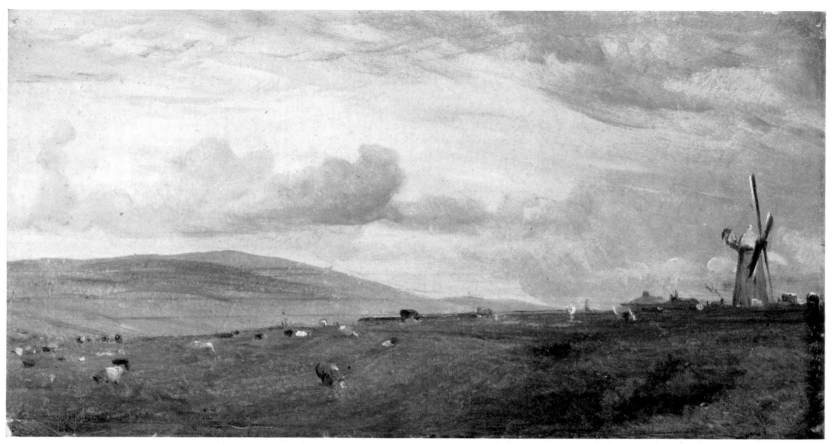

110. *A windmill near Brighton.* Dated 1824. Oil on paper, $6\frac{3}{8} \times 12\frac{1}{8}$ in. (162 × 308 mm.) London, Victoria and Albert Museum. See Note 43

111. *Brighton Beach, with colliers.* Dated 1824. Oil on paper, $5\frac{7}{8} \times 9\frac{3}{4}$ in. (149 × 248 mm.) London, Victoria and Albert Museum. See Note 43

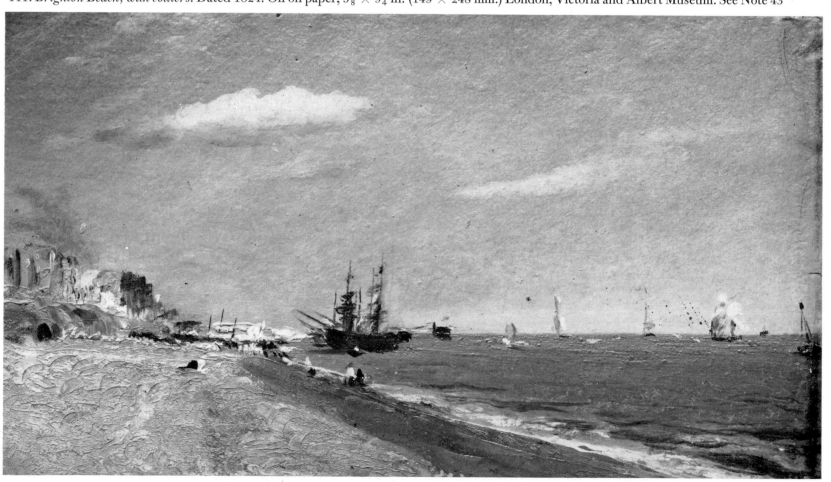

112. *The road into Gillingham,*
Dorset. 1820. Pencil,
$4\frac{1}{2} \times 7\frac{1}{4}$ in. (115 ×
185 mm.) London,
Victoria and Albert
Museum. See Note 44

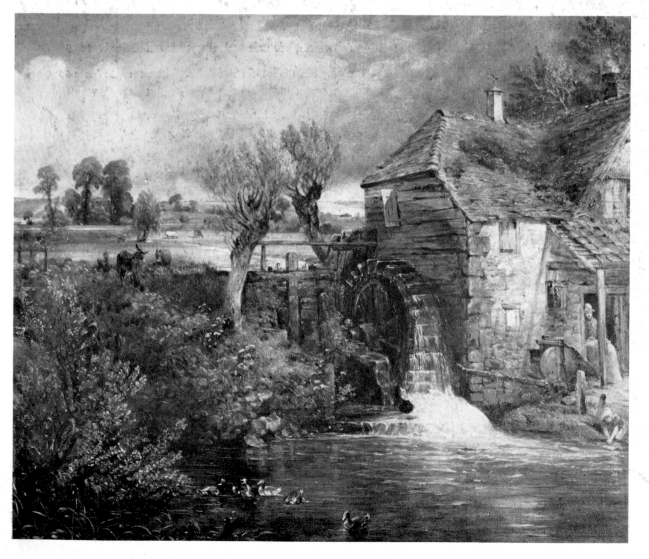

113. *Parham Mill, Gillingham.*
1826. Oil on canvas,
$19\frac{3}{4} \times 23\frac{3}{4}$ in. (500 ×
605 mm.) From the
collection of Mr and Mrs
Paul Mellon. See Note 44

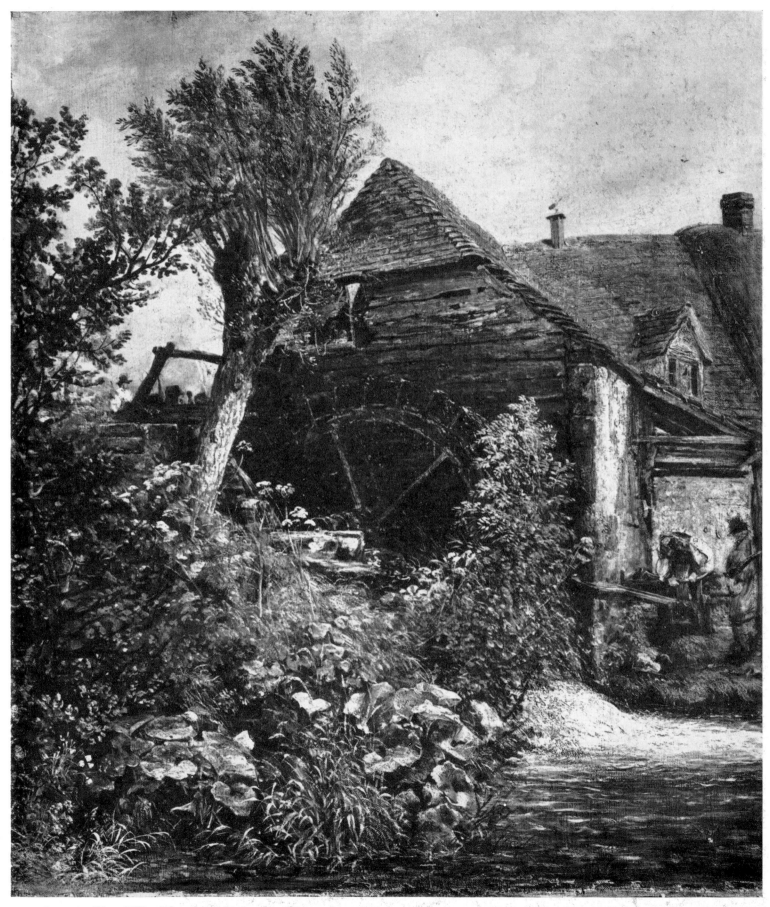

114. *A watermill at Gillingham*. Exhibited 1827. Oil on canvas, 24¾ × 20½ in. (630 × 520 mm.) London, Victoria and Albert Museum.
See Note 44

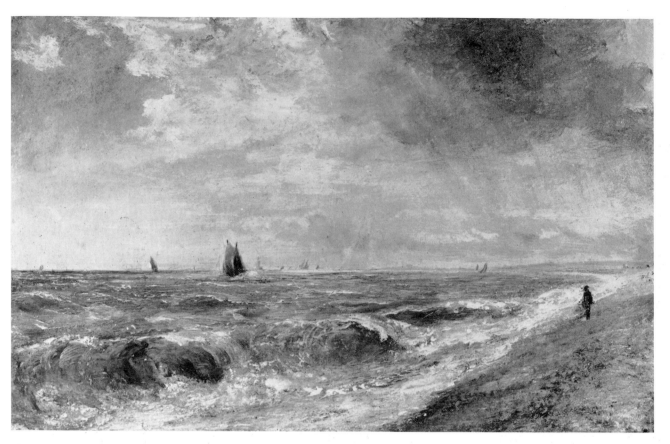

115. *Hove Beach. c.* 1824.
Oil on paper laid on
canvas, $12\frac{1}{2} \times 19\frac{1}{2}$ in.
(317×495 mm.)
London, Victoria
and Albert Museum.
See Note 43

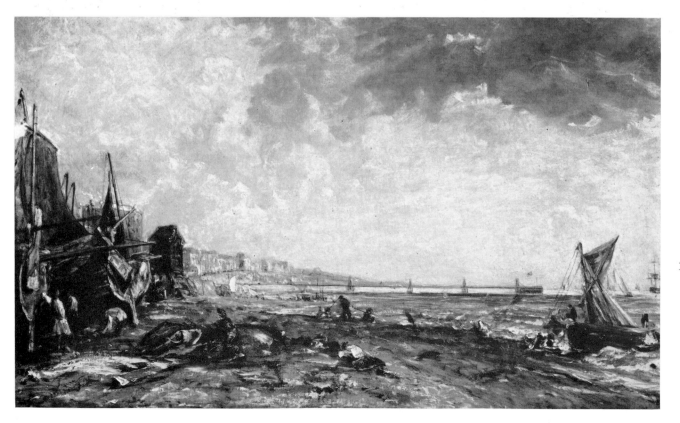

116. *Sketch ('The Marine
Parade and Chain
Pier, Brighton').
c.* 1824. Oil on
canvas, 24×39 in.
(610×991 mm.)
Philadelphia,
Museum of Art.
See Note 45

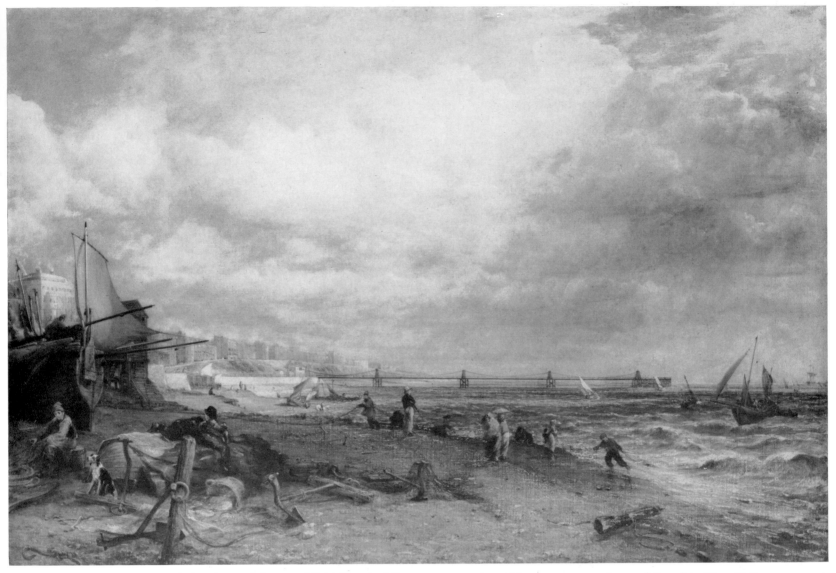

117. *The Marine Parade and Chain Pier, Brighton*. Exhibited 1827. Oil on canvas, 50 × 72¾ in. (1,270 × 1,848 mm.) London, Tate Gallery.
See Note 45

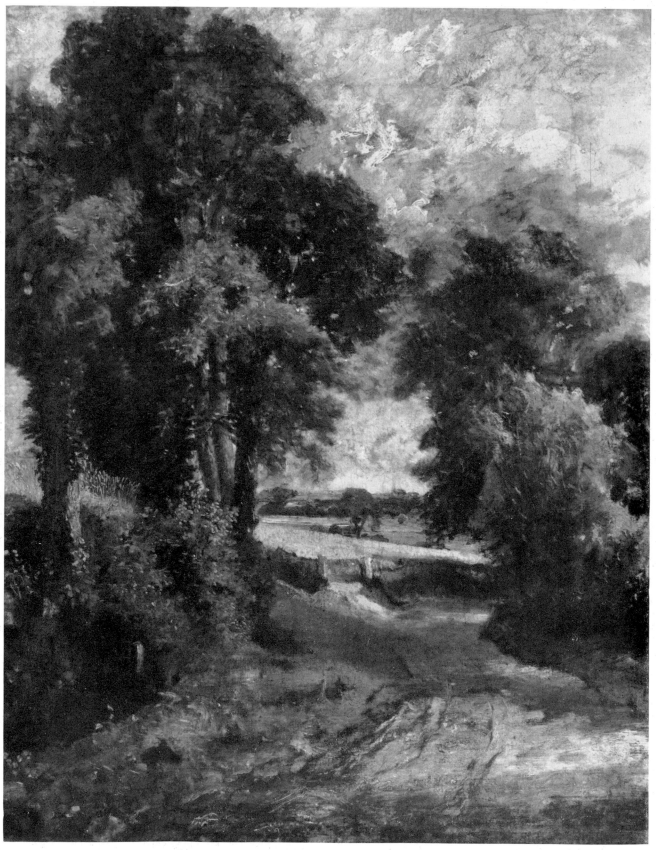

118. *Landscape sketch* ('*The Cornfield*'). 1825–6. Oil on canvas, $23\frac{1}{2} \times 19\frac{3}{8}$ in. (597 × 492 mm.) Birmingham, City Museum and Art Gallery (on loan). See Note 46

119. *The Cornfield*. Signed and dated 1826. Oil on canvas, $56\frac{1}{4} \times 48$ in. (1,429 × 1,225 mm.) London, National Gallery. See Note 46

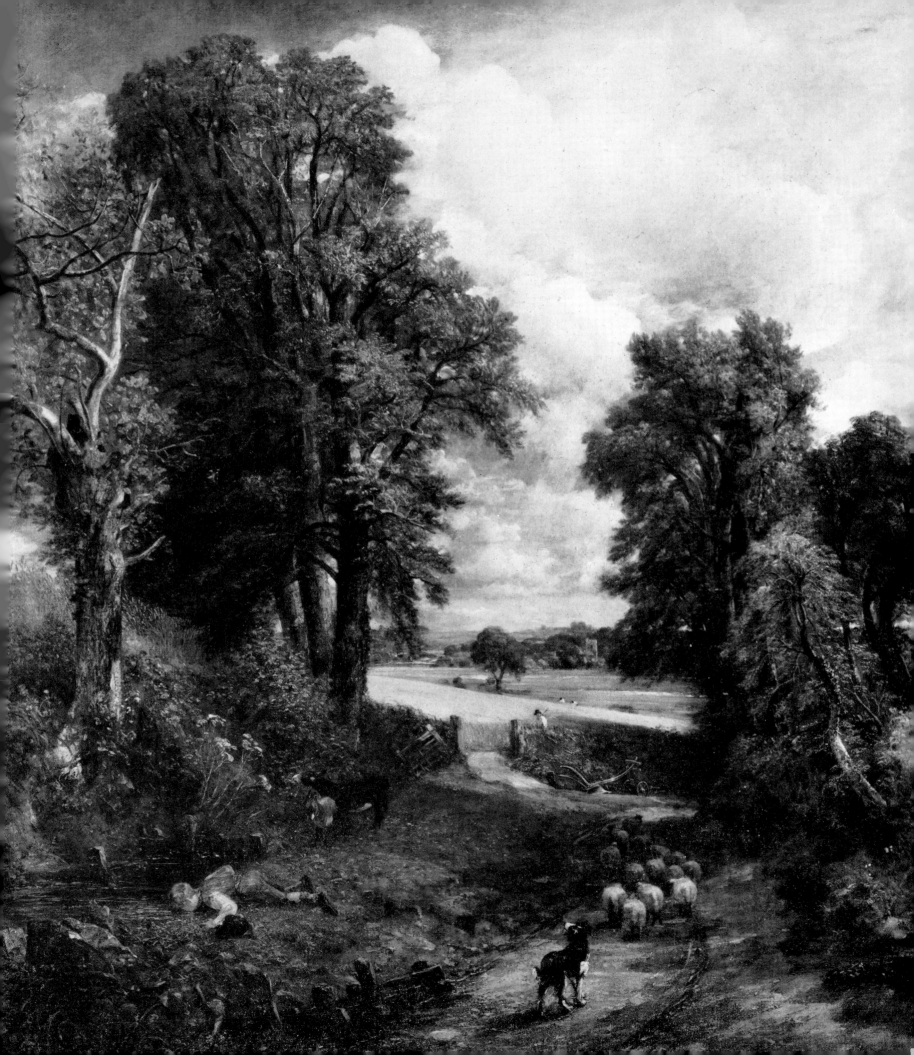

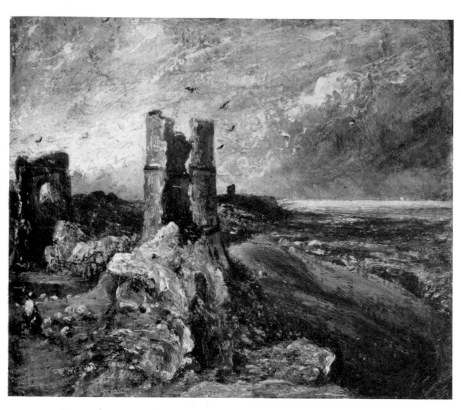

120. *Landscape sketch* (*Hadleigh Castle*). ?1828–9. Oil on cardboard, $7\frac{7}{8} \times 9\frac{1}{2}$ in. (200 × 240 mm.) From the collection of Mr and Mrs Paul Mellon. See Note 47

121. *Hadleigh Castle*. Exhibited 1829. Oil on canvas, $48 \times 64\frac{3}{4}$ in. (1,220 × 1,645 mm.) From the collection of Mr and Mrs Paul Mellon. See Note 47

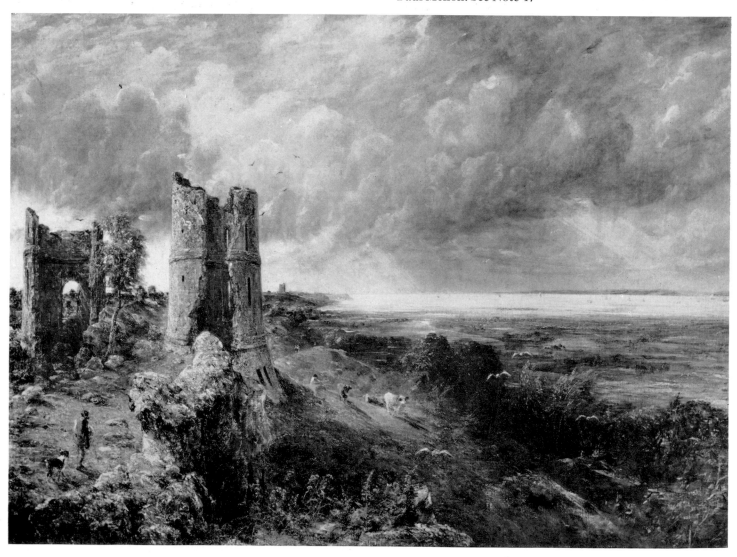

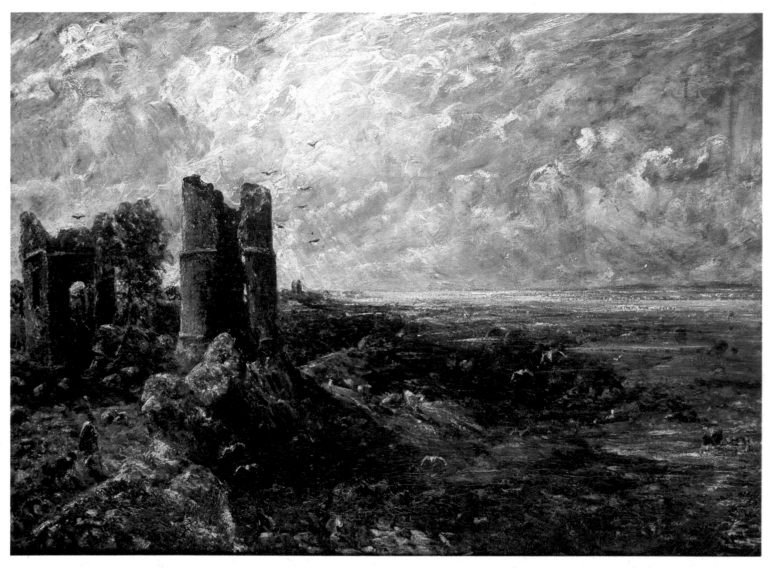

122. *Landscape sketch (Hadleigh Castle)*. ?1828–9. Oil on canvas, 48½ × 65¾ in. (1,232 × 1,670 mm.) London, Tate Gallery. See Note 47

123. *Hadleigh Castle*. 1814. Pencil, 3¼ × 4⅜ in.
(81 × 111 mm.) London, Victoria and Albert
Museum. See Note 47

124. *Coast at Brighton, stormy day*. Inscribed 'Brighton, Sunday Evening, July 20, 1828.' Oil on canvas, $5\frac{3}{4} \times 10$ in. (145 \times 255 mm.) From the collection of Mr and Mrs Paul Mellon. See Note 45

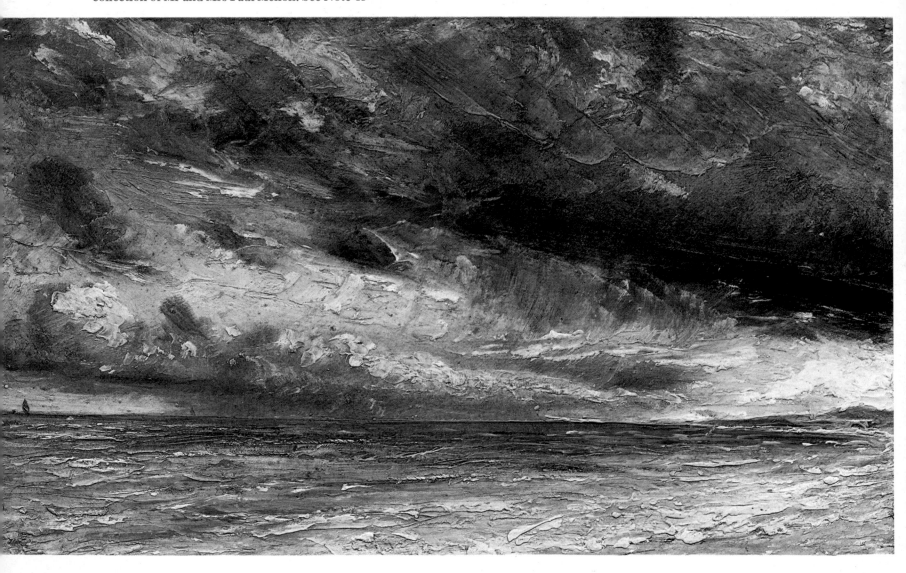

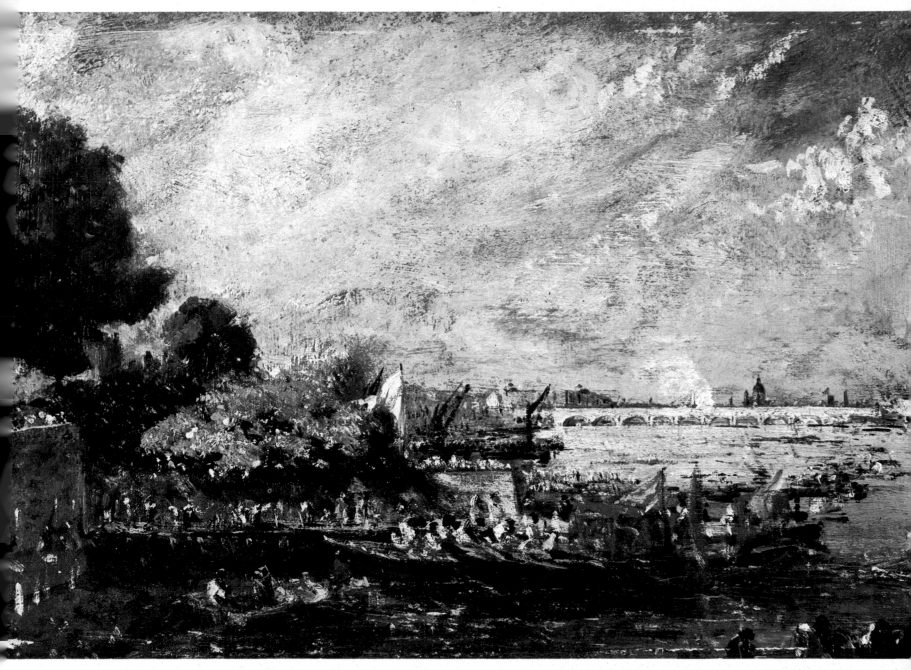

125. *Waterloo Bridge from Whitehall Stairs. c.*1819. Oil on millboard, 11½ × 19 in. (292 × 483 mm.) London, Victoria and Albert Museum. See
Note 35

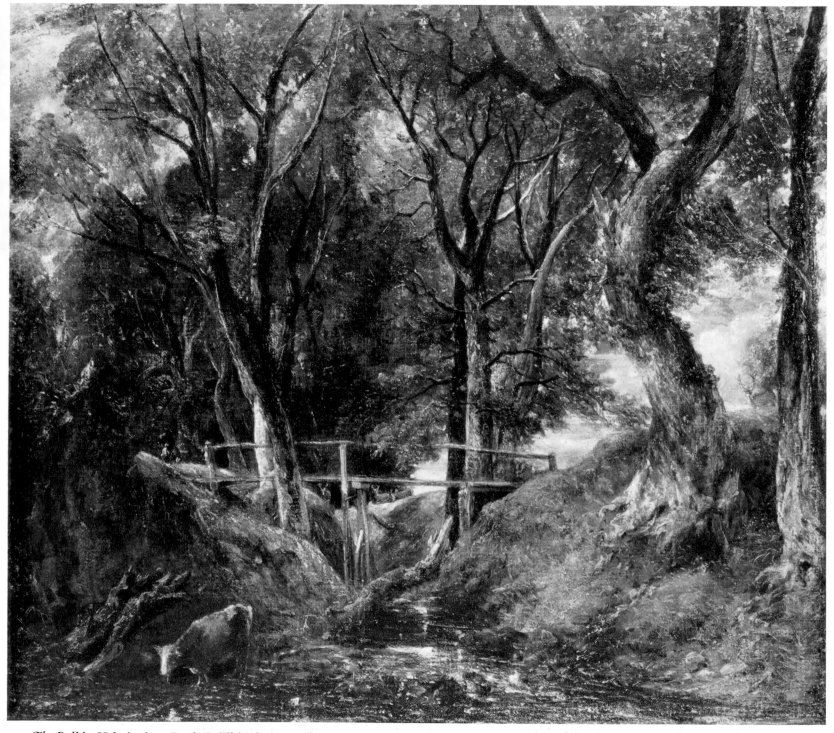

127. *The Dell in Helmingham Park*. Exhibited 1830. Oil on canvas, $44\frac{5}{8} \times 51\frac{1}{2}$ in. (1,133 × 1,308 mm.) Kansas City, Missouri, Nelson Gallery–Atkins Museum. See Note 48

126. *Trees and a stretch of water on the Stour* (?). c.1830–6. Pencil and sepia wash, $8 \times 6\frac{3}{8}$ in. (205 × 162 mm.) London, Victoria and Albert Museum

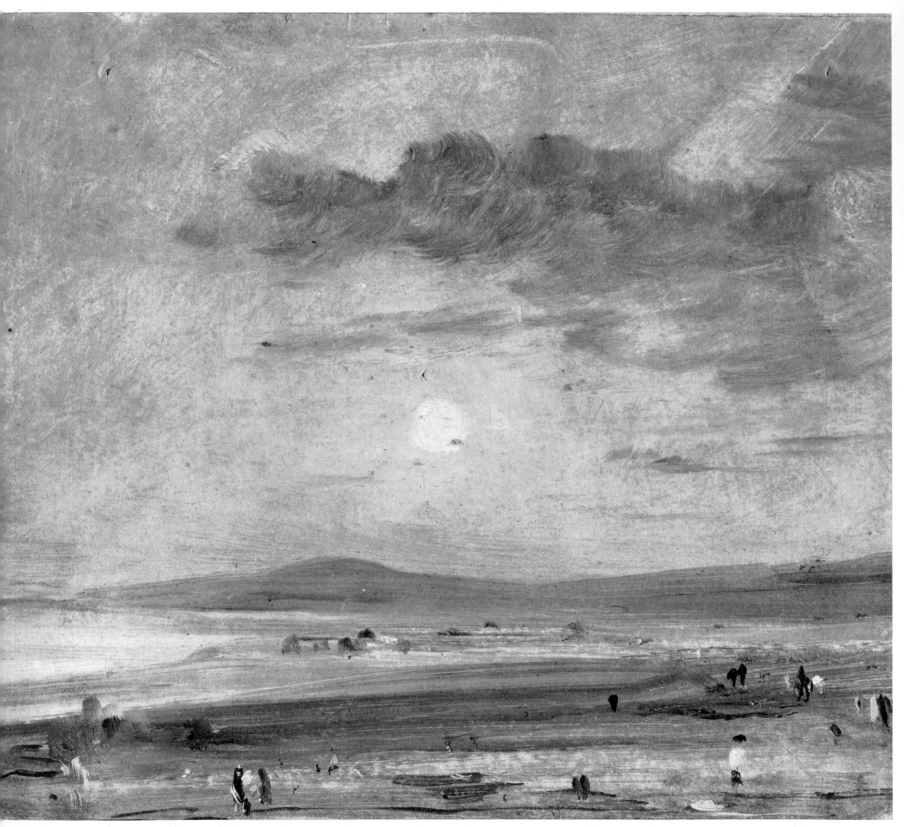

128. *Coast scene, Brighton*(?): *evening. c.*1828. Oil on paper, $7\frac{7}{8} \times 9\frac{3}{4}$ in. (200 \times 248 mm.) London, Victoria and Albert Museum. See Note 45

129. *The sea near Brighton*. 1826. Oil on paper, 6¾ × 9⅜ in. (171 × 238 mm.) London, Tate Gallery. See Note 45

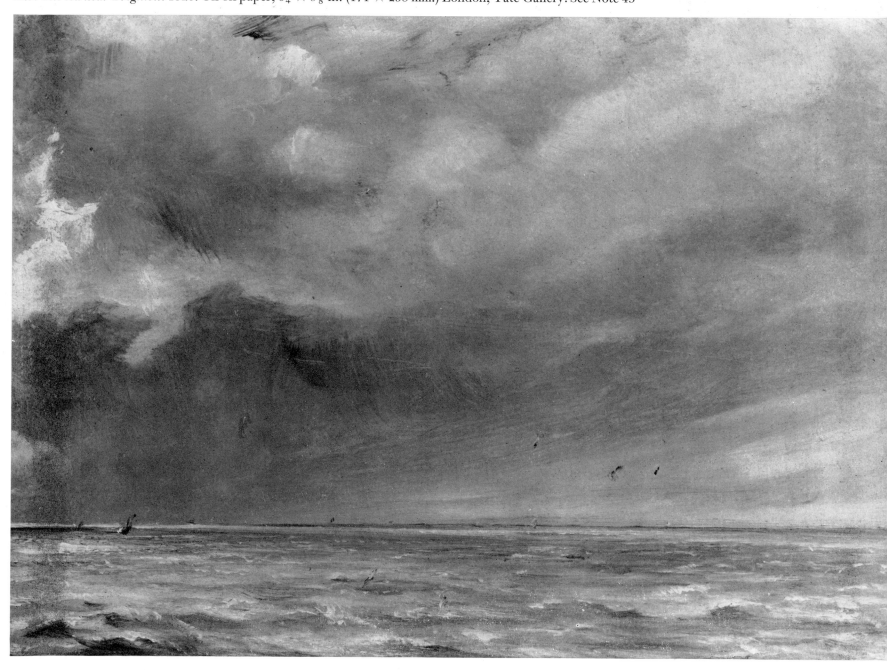

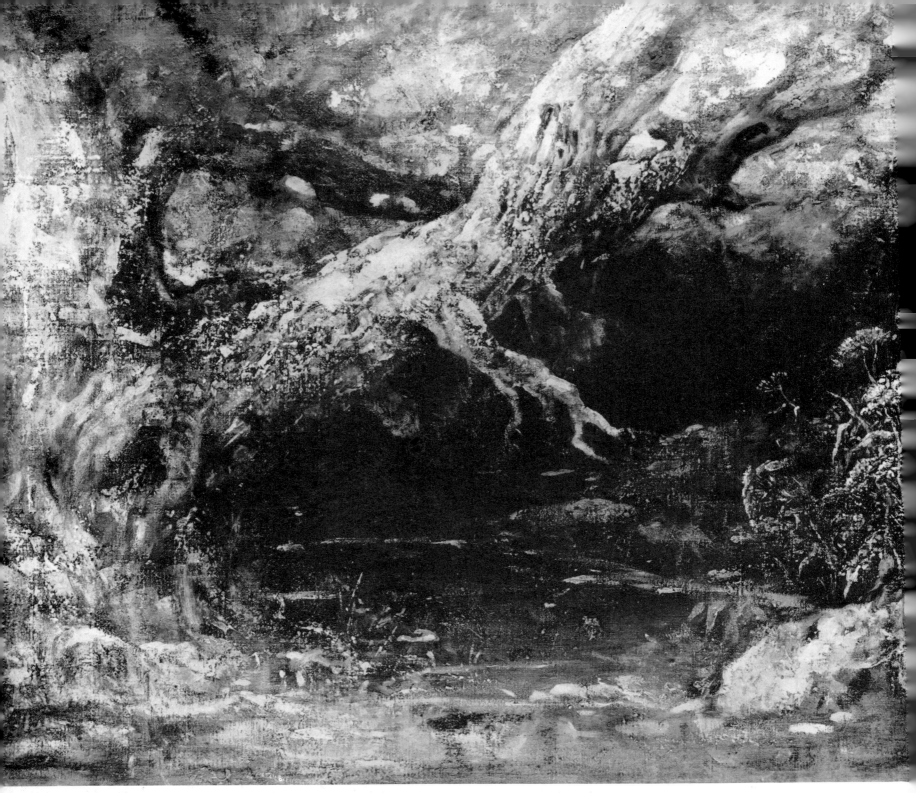

130. *The Dell in Helmingham Park*. ?1830. Oil on canvas, 25 × 29⅞ in. (635 × 759 mm.) London, Tate Gallery. See Note 48

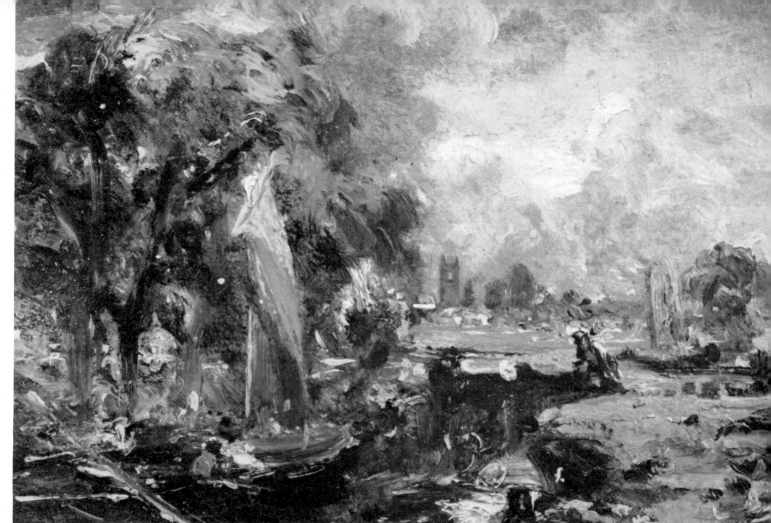

131. *Dedham, a lock.* 1820–30. Oil on paper on panel, 4½ × 6½ in. (115 × 165 mm.) Enlarged From the collection of Mr and Mrs Paul Mellon. See Note 49

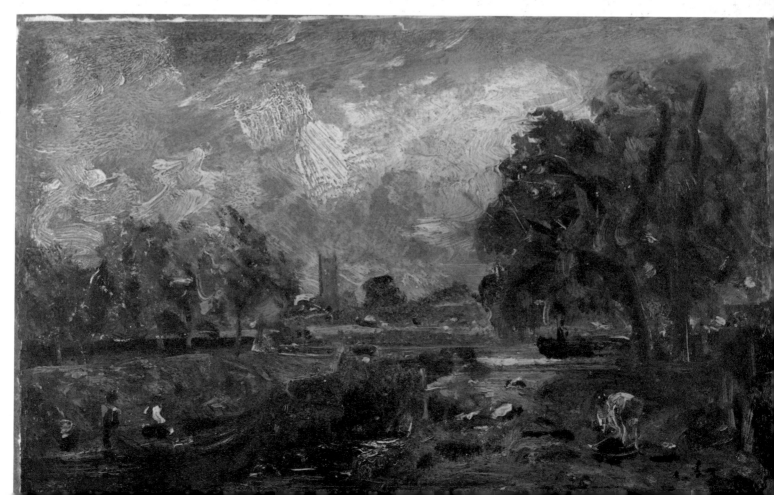

132. *Dedham, a lock. c.* 1828. Oil on paper, 6½ × 10 in. (165 × 254 mm.) London, Tate Gallery. See Note 49

133. *Hampstead Heath in a storm*. Watercolour, $7\frac{3}{4} \times 12\frac{3}{4}$ in. (197 × 324 mm.) London, British Museum

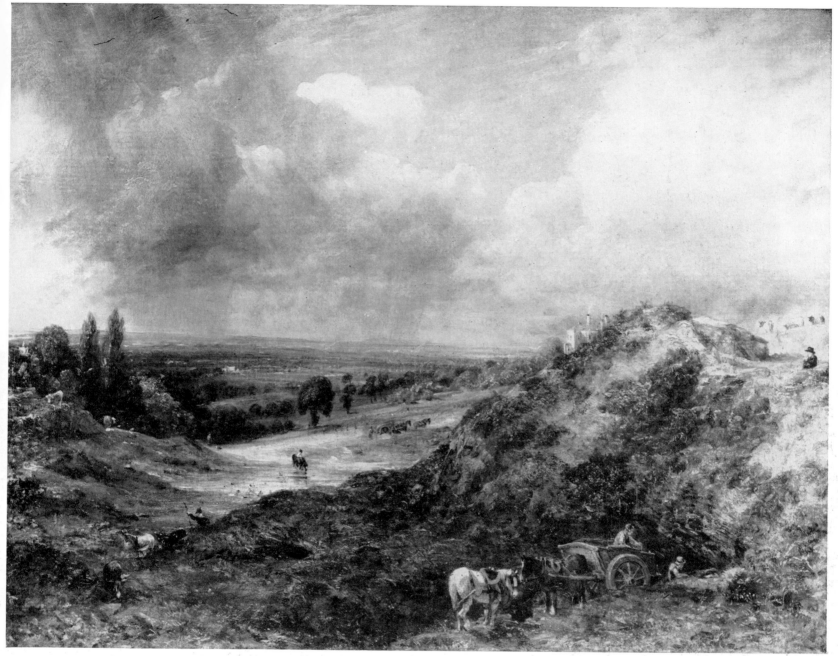

134. *Hampstead Heath: Branch Hill Pond.* 1828. Oil on canvas, $23\frac{1}{2} \times 30\frac{1}{2}$ in. (596 × 776 mm.) London, Victoria and Albert Museum. See Note 23

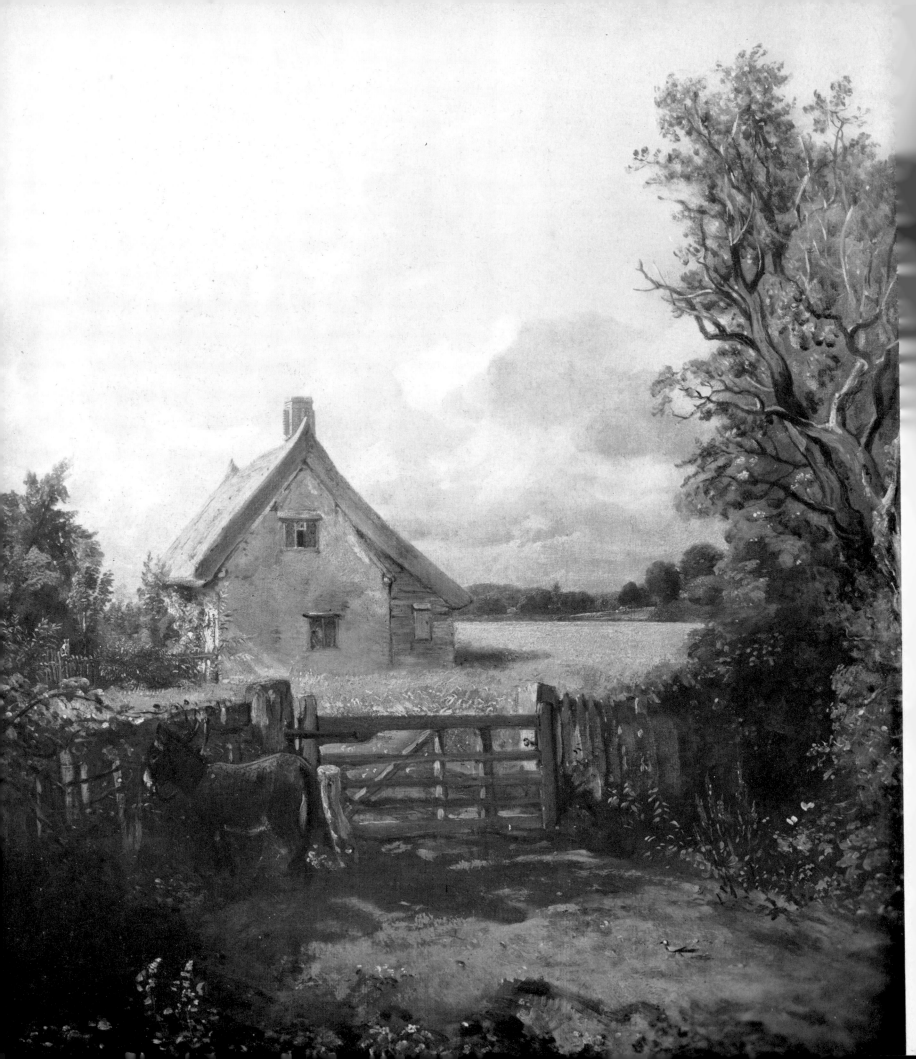

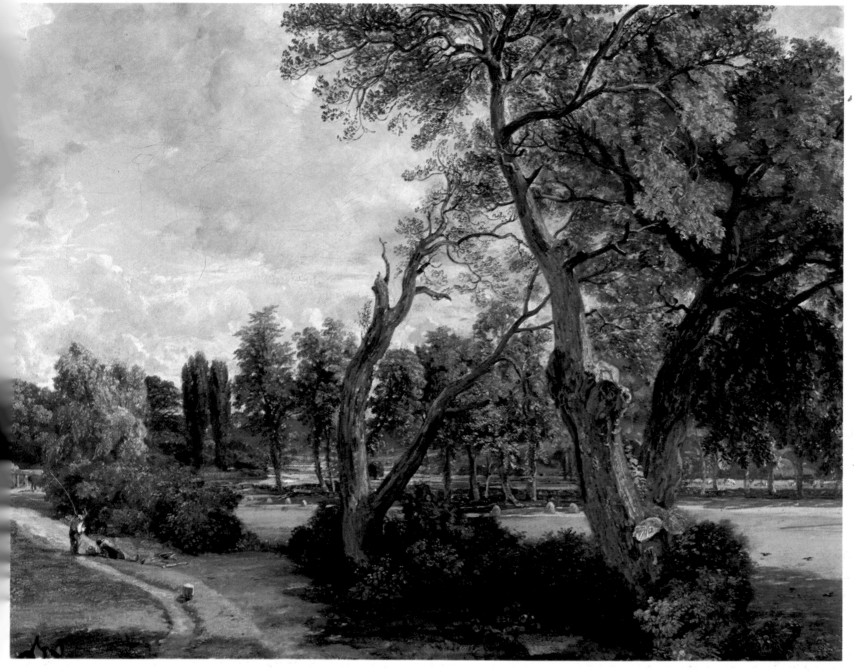

136. Detail from *Flatford Mill* (Plate 58). See Note 28

135. *The cottage in a cornfield*. Exhibited 1833. Oil on canvas, $24\frac{1}{2} \times 20\frac{1}{4}$ in. (620 × 515 mm.) London, Victoria and Albert Museum. See Note 50

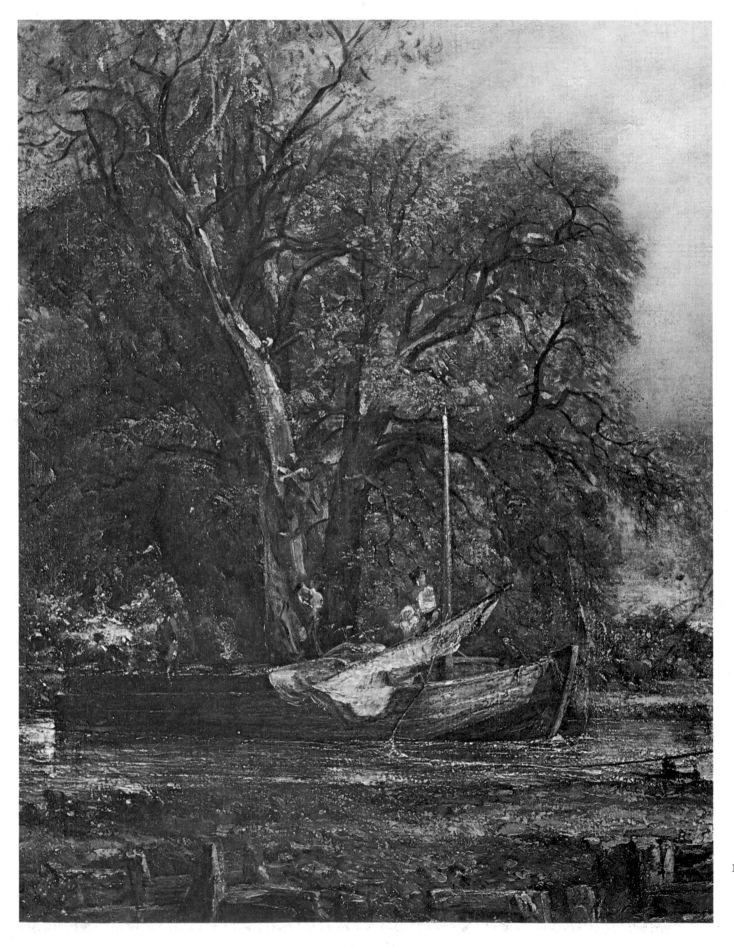

137. Detail from
*The Leaping
Horse* (Plate
98). See Note 38

138. Text to 'Spring', from *English Landscape Scenery*, corrected by Constable. See Note 66

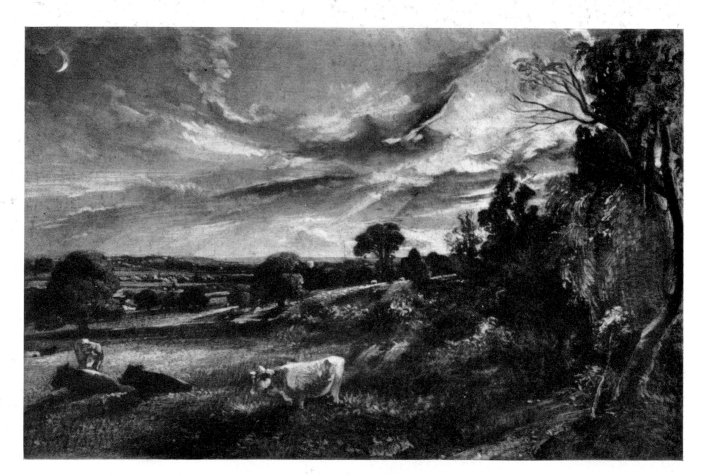

139. *Summer evening.* Mezzotint by David Lucas after Constable

140. *A view at Salisbury, from the library of Archdeacon Fisher's house.* Dated 1829. Oil on paper, $6\frac{3}{8} \times 12$ in. (162 \times 305 mm.) London, Victoria and Albert Museum

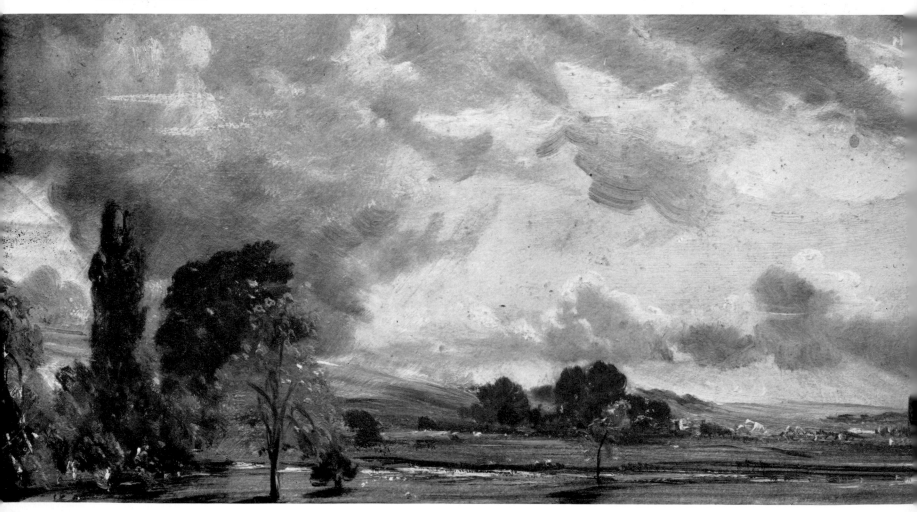

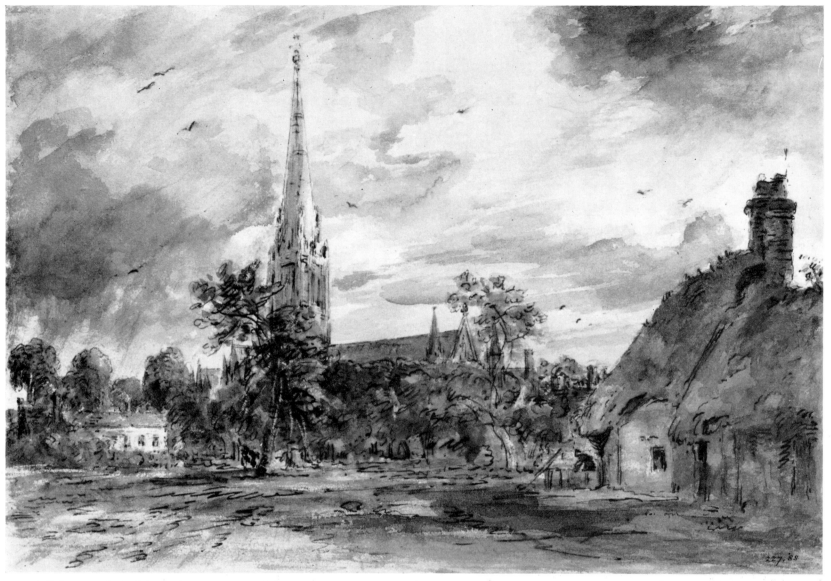

141. *Salisbury Cathedral from the north-west, with cottages.* 1829. Pen and bistre ink and watercolour, $9\frac{1}{4} \times 13\frac{1}{4}$ in. (234 × 337 mm.) London, Victoria and Albert Museum

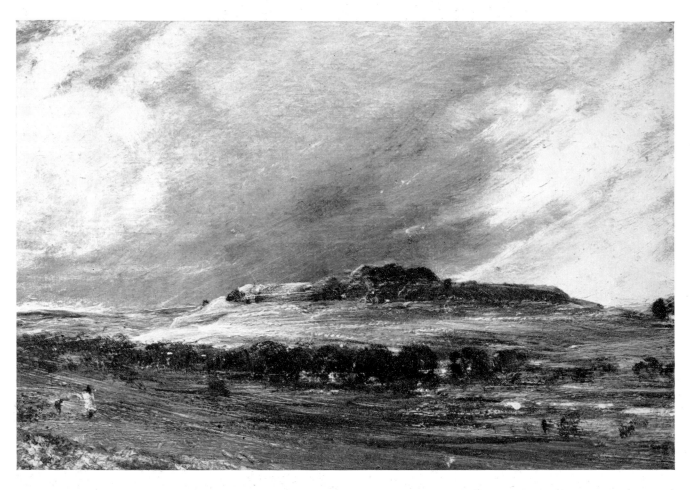

142. *Old Sarum*. 1829.
Oil on thin card,
$5\frac{5}{8} \times 8\frac{1}{4}$ in.
(143×210 mm.)
London, Victoria
and Albert
Museum. See
Note 51

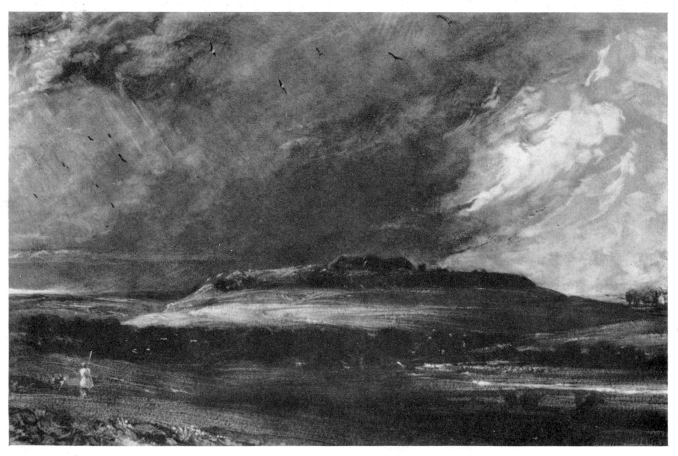

143. *Old Sarum*.
Mezzotint by
David Lucas after
Old Sarum (Plate
142). See Note 51

144. *Stonehenge*. Watercolour over black chalk, 6⅝ × 9⅞ in. (168 × 249 mm.) London, British Museum. See Note 52

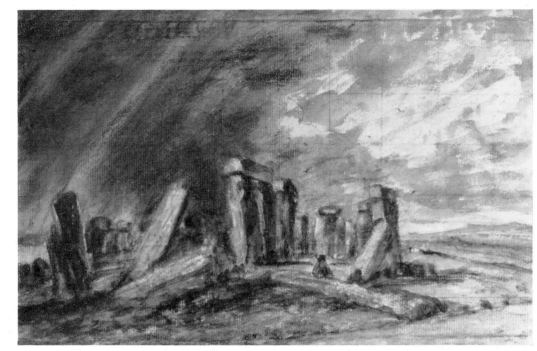

145. *Stonehenge*. 1836. Watercolour, 15¼ × 23¼ in. (387 × 591 mm.) London, Victoria and Albert Museum. See Note 52

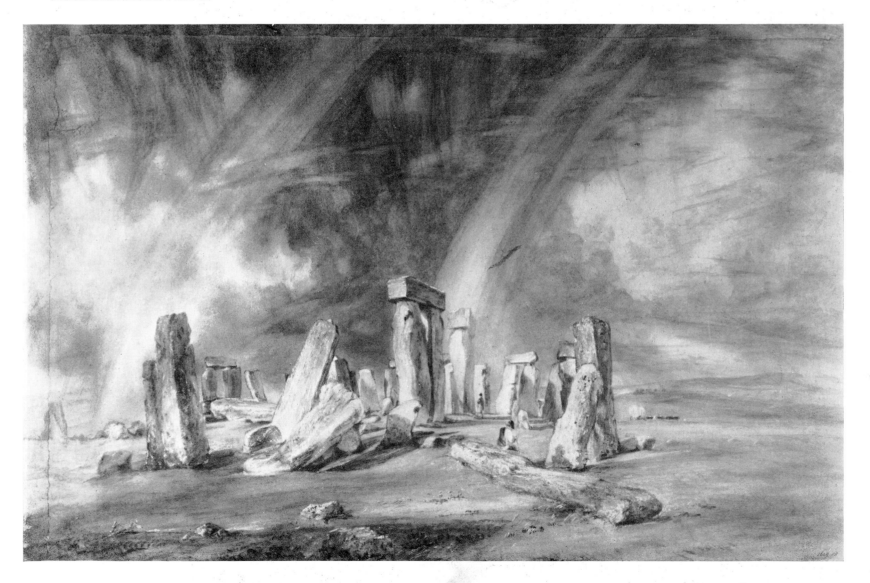

146. *Stormy effect, Littlehampton*. Inscribed 'Little Hampton July 8 1835.' Watercolour, $4\frac{1}{2} \times 7\frac{1}{4}$ in. (114 \times 184 mm.) London, British Museum. See Note 53

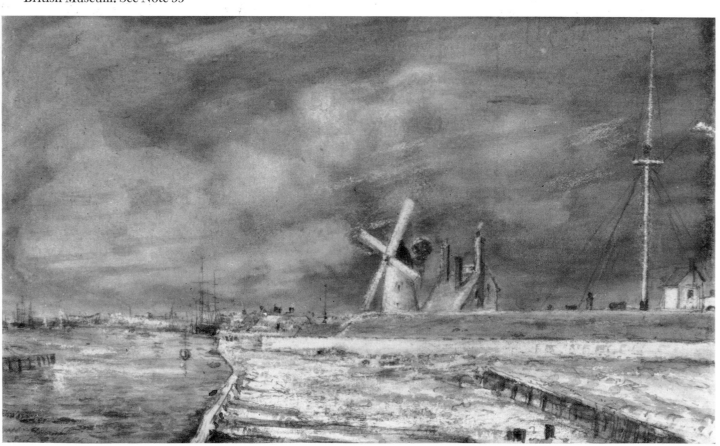

147. *Tillington Church*. Inscribed 'Tillington September 17 1834.' Pencil and watercolour, $9\frac{1}{8} \times 10\frac{1}{2}$ in. (232 × 267 mm.) London, British Museum. See Note 53

148. *Landscape sketch (Salisbury Cathedral from the meadows).* Oil on canvas, 53½ × 74 in. (1,359 × 1,880 mm.) London, Guildhall Art Gallery. See Note 54

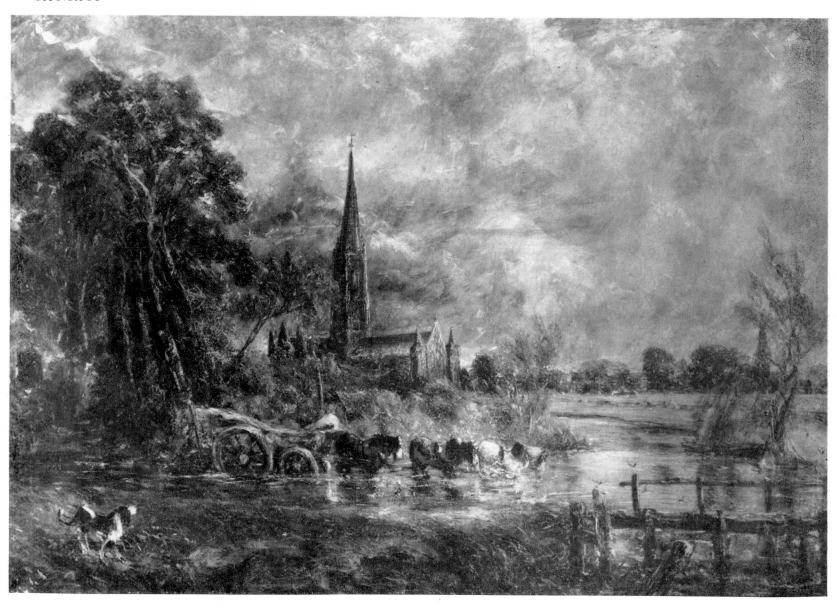

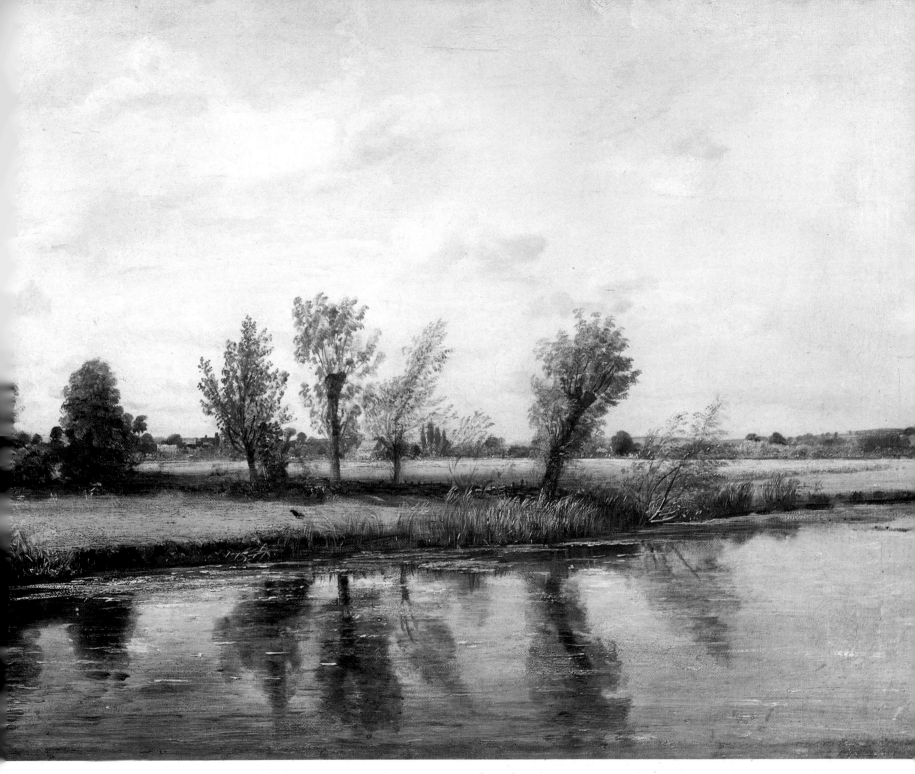

149. *Water-meadows near Salisbury.* 1829. Oil on canvas, 18 × 21¾ in. (457 × 553 mm.) London, Victoria and Albert Museum. See Note 55

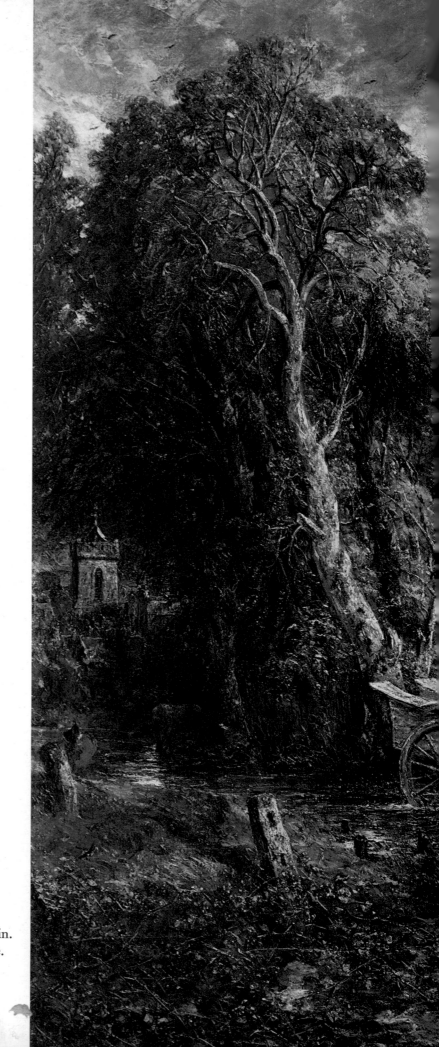

150. *Salisbury Cathedral from the meadows*.
Exhibited 1831. Oil on canvas, $59\frac{3}{4} \times 74\frac{3}{4}$ in.
(1,518 × 1,899 mm.) Lord Ashton of Hyde.
See Note 54

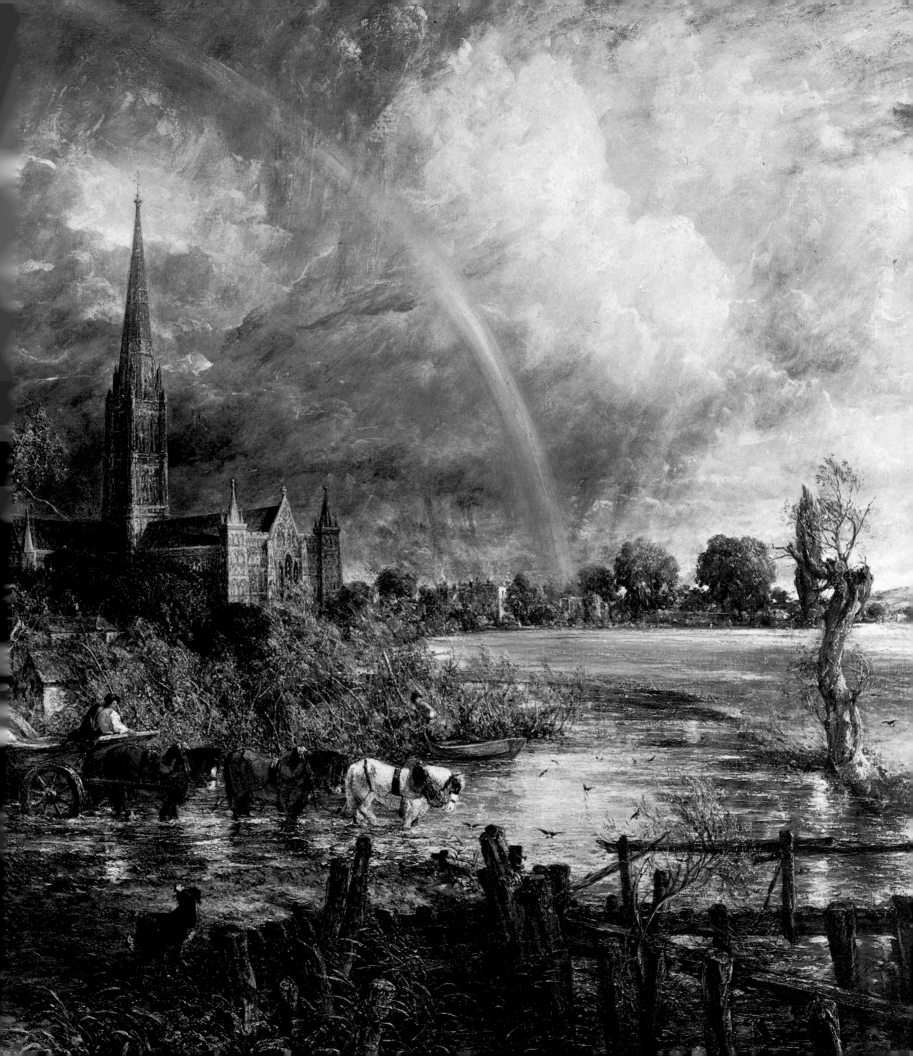

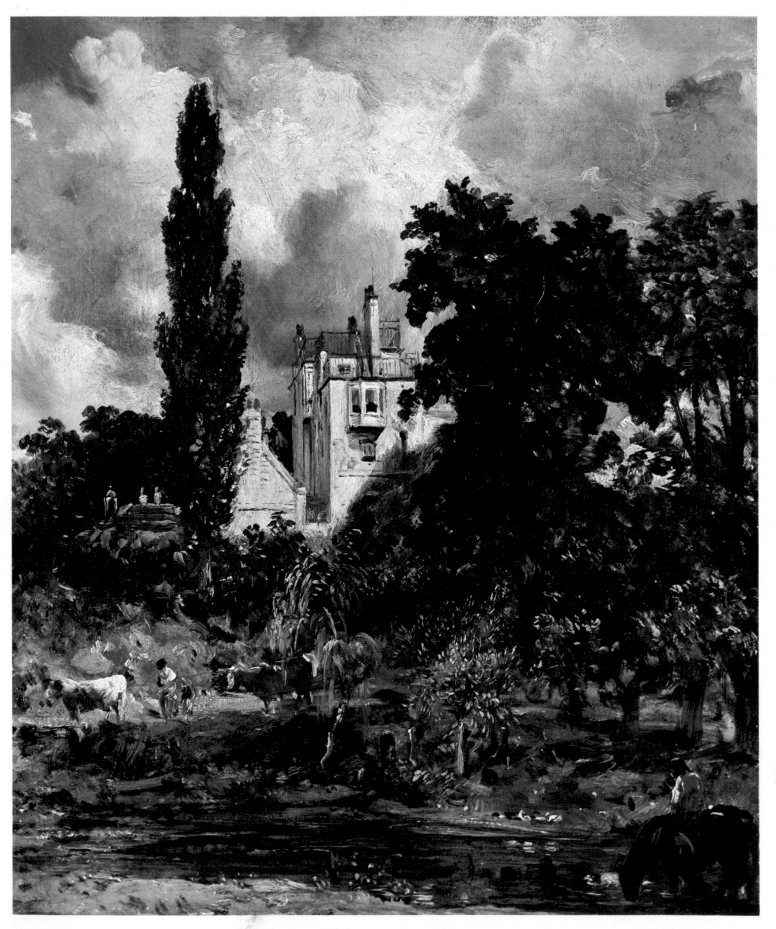

151. *The Grove, Hampstead* (*The Admiral's House*). Exhibited 1832? Oil on canvas, $14 \times 11\frac{7}{8}$ in. (356×302 mm.) London, Tate Gallery. See Note 56

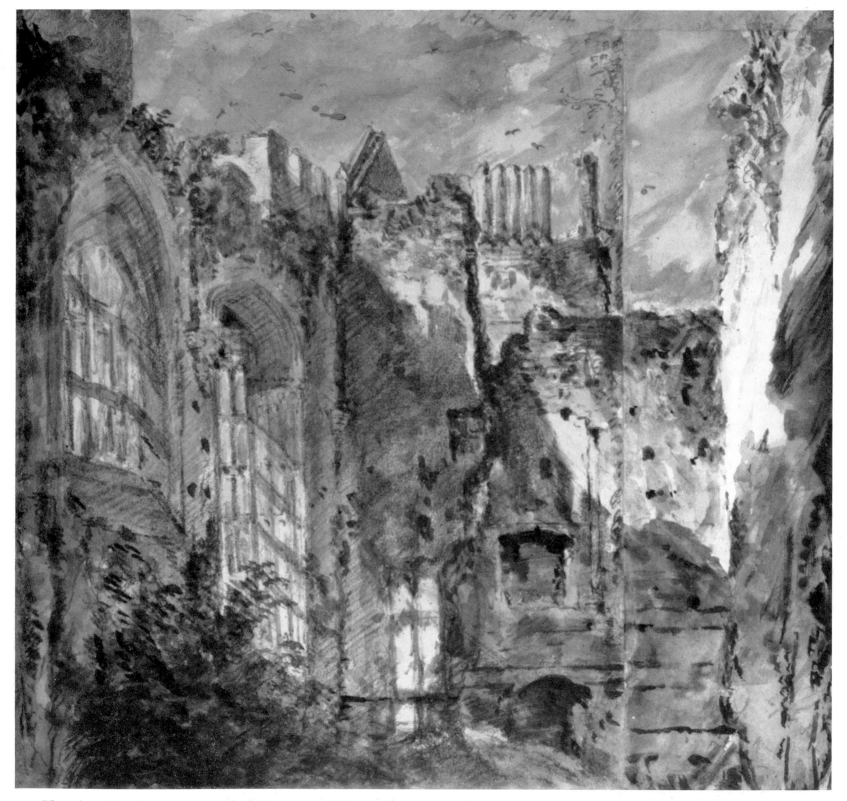

152. *The ruins of Cowdray Castle*. Inscribed 'Sep 14 1834.' Watercolour over pencil, $10\frac{1}{2} \times 10\frac{7}{8}$ in. (267 × 276 mm.) London, British Museum.
See Note 53

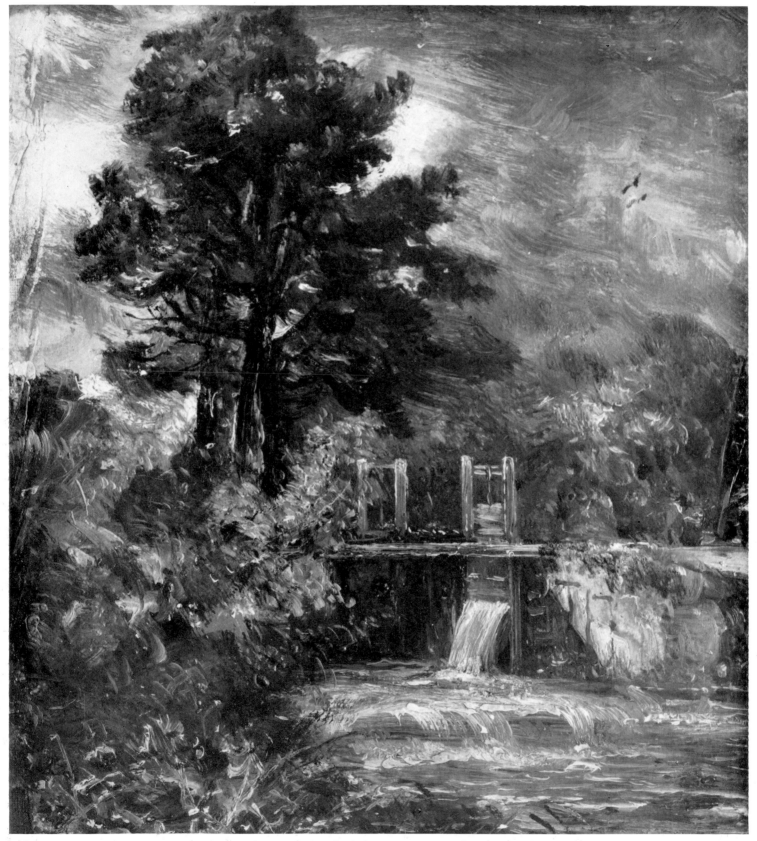

153. *A sluice, on the Stour* (?). *c.*1830–6. Oil on paper laid on canvas, $8\frac{5}{8} \times 7\frac{3}{8}$ in. (219 × 187 mm.) London, Victoria and Albert Museum. See Note 57

154. *Whitehall Stairs: the opening of Waterloo Bridge.* 1832. Oil on canvas, 53 × 86½ in. (1,346 × 2,197 mm.) Private Collection.
 See Note 35

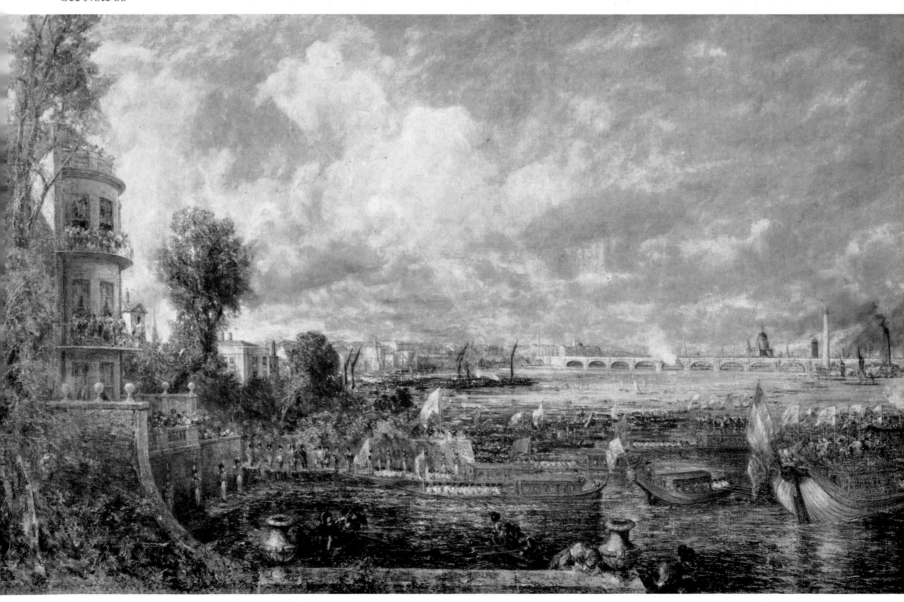

156. *The Cenotaph at Coleorton*.
Exhibited 1836. Oil on
canvas, 52 × 42¾ in.
(1,321 × 1,086 mm.)
London, National Gallery.
See Note 58

155. *The Cenotaph at Coleorton*. Inscribed 'Coleorton Hall. Novr. 28. 1823.' Pencil and grey wash, 10¼ × 7⅛ in.
(260 × 181 mm.) London, Victoria and Albert Museum. See Note 58

157. *A view of London, with Sir Richard Steele's house.* Exhibited 1832. Oil on canvas, $8\frac{1}{4} \times 11\frac{1}{4}$ in. (210 × 286 mm.) From the collection of Mr and Mrs Paul Mellon. See Note 59

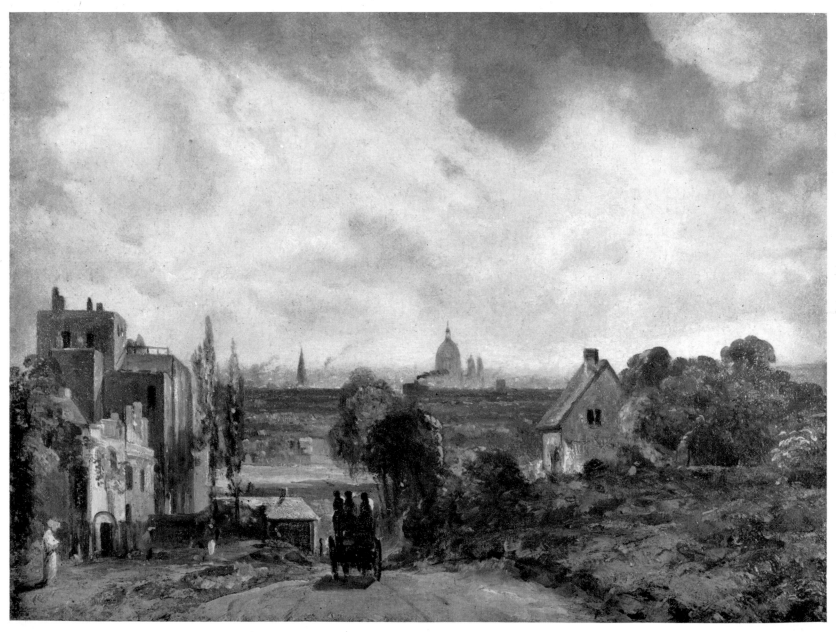

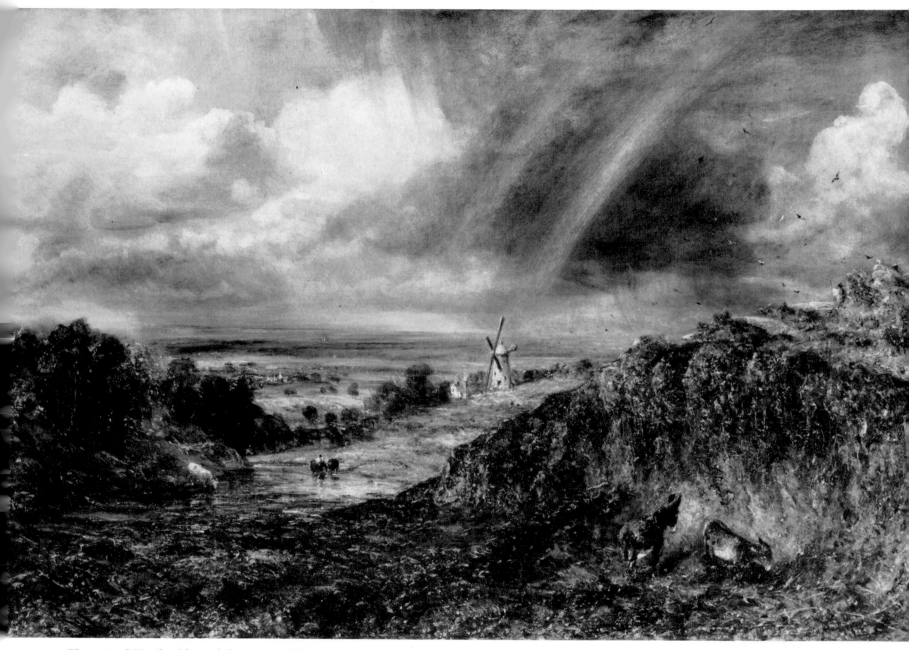

158. *Hampstead Heath with a rainbow.* 1836. Oil on canvas, 20 × 30 in. (508 × 762 mm.) London, Tate Gallery. See Note 23

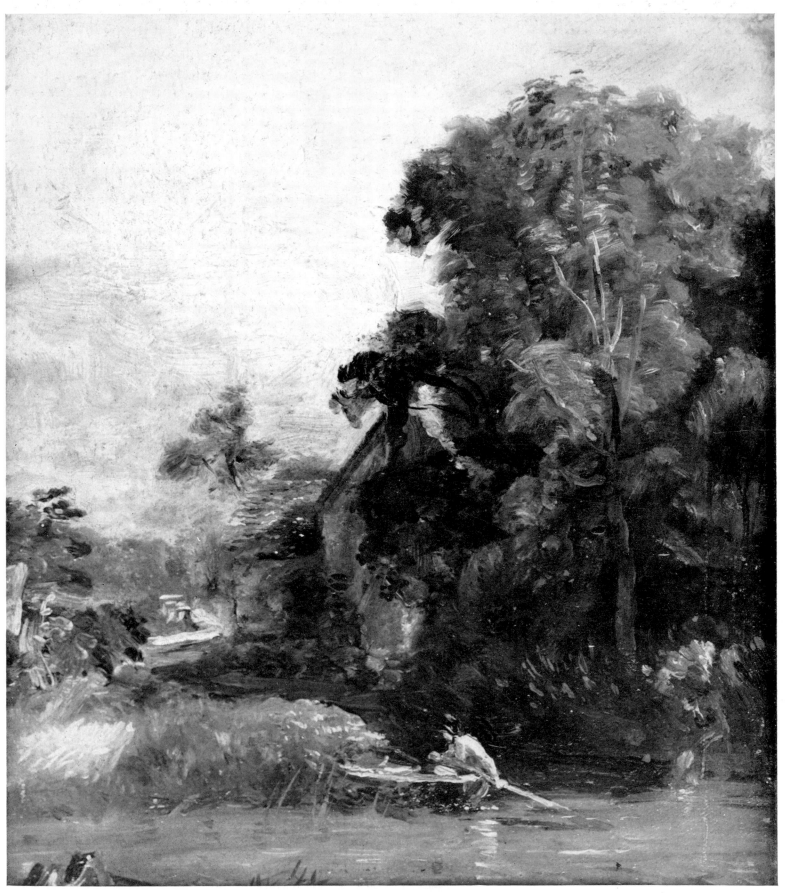

159. *Landscape sketch* (*'The Valley Farm'*). *c.*1835. Oil on canvas, 10 × 8¼ in. (254 × 210 mm.) London, Victoria and Albert Museum. See
Note 60

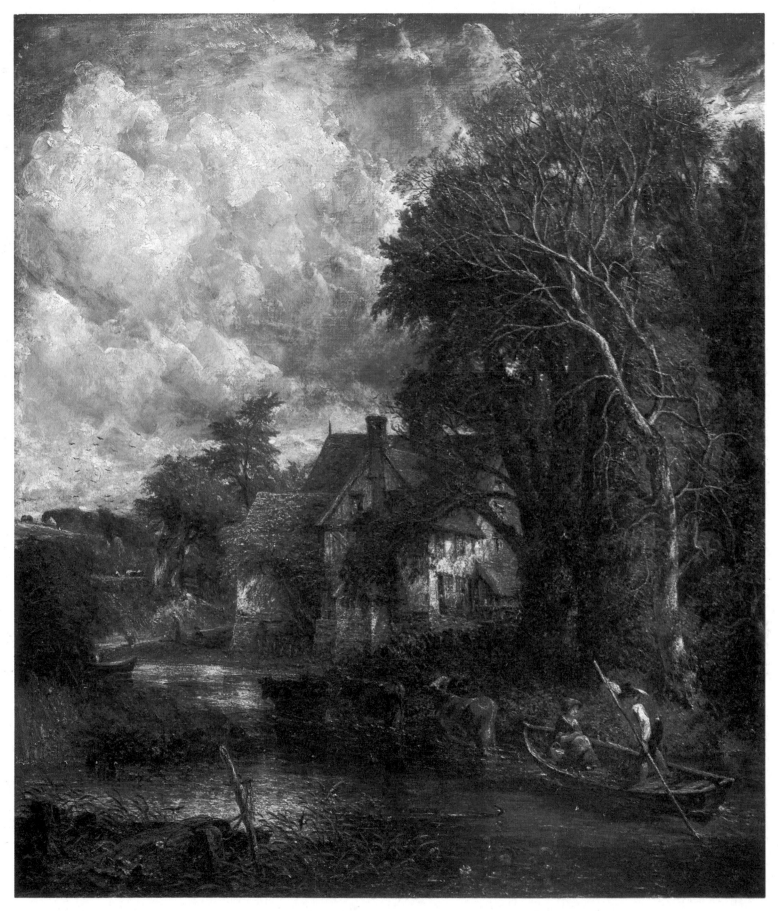

160. *The Valley Farm*. Exhibited 1835. Oil on canvas, $58\frac{1}{2} \times 49\frac{1}{2}$ in. (1,486 × 1,257 mm.) London, Tate Gallery. See Note 60

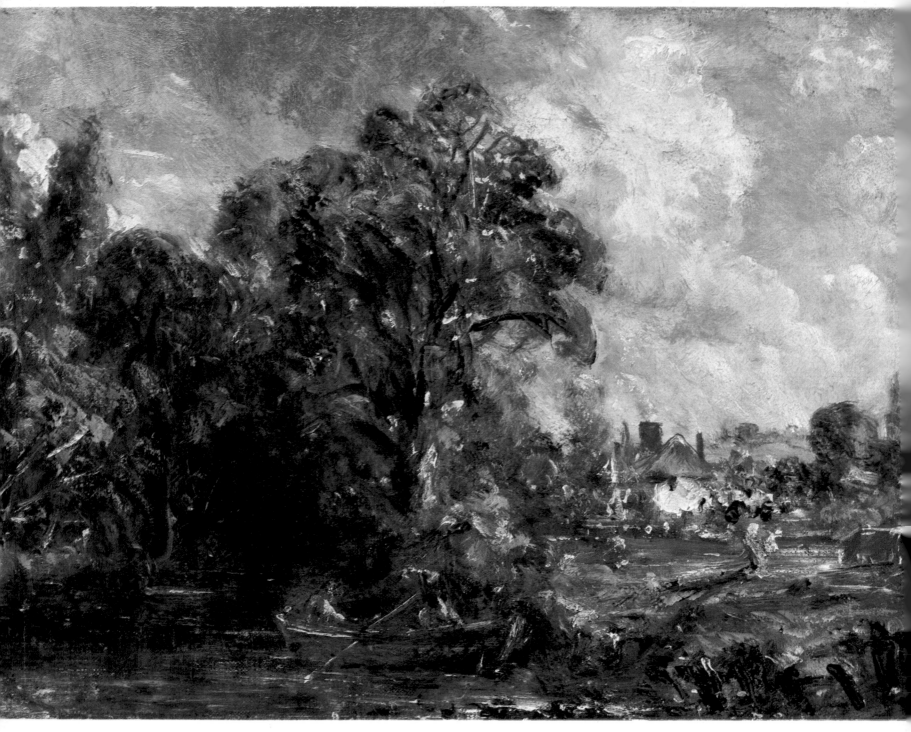

161. *A river scene, with a farmhouse near the water's edge. c.*1830–6. Oil on canvas, 10 × 13¾ in. (254 × 349 mm.) London, Victoria and Albert Museum

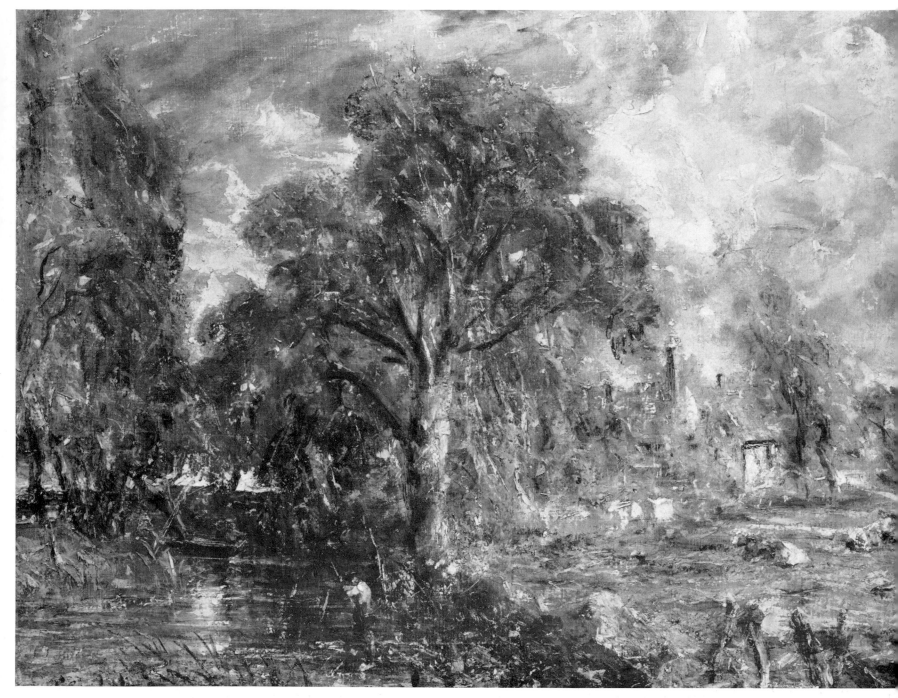

162. *On the River Stour*. ?1830–7. Oil on canvas, 24 × 31 in. (610 × 787 mm.) Washington, D.C., The Phillips Collection. See Note 61

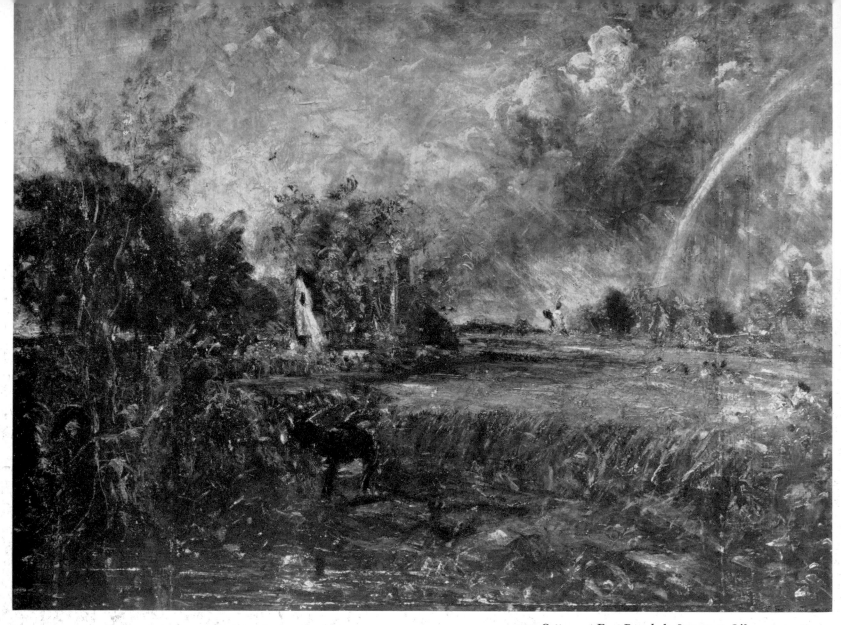

163. *Cottage at East Bergholt.* ?1835–7. Oil on canvas, 33 × 43½ in. (838 × 1,105 mm.) Port Sunlight, Lady Lever Art Gallery. See Note 62

164. *A tree in a hollow, Fittleworth.* Inscribed 'Fittleworth 16 July 1835.' Pencil, 4½ × 7⅜ in. (115 × 188 mm.) London, Victoria and Albert Museum

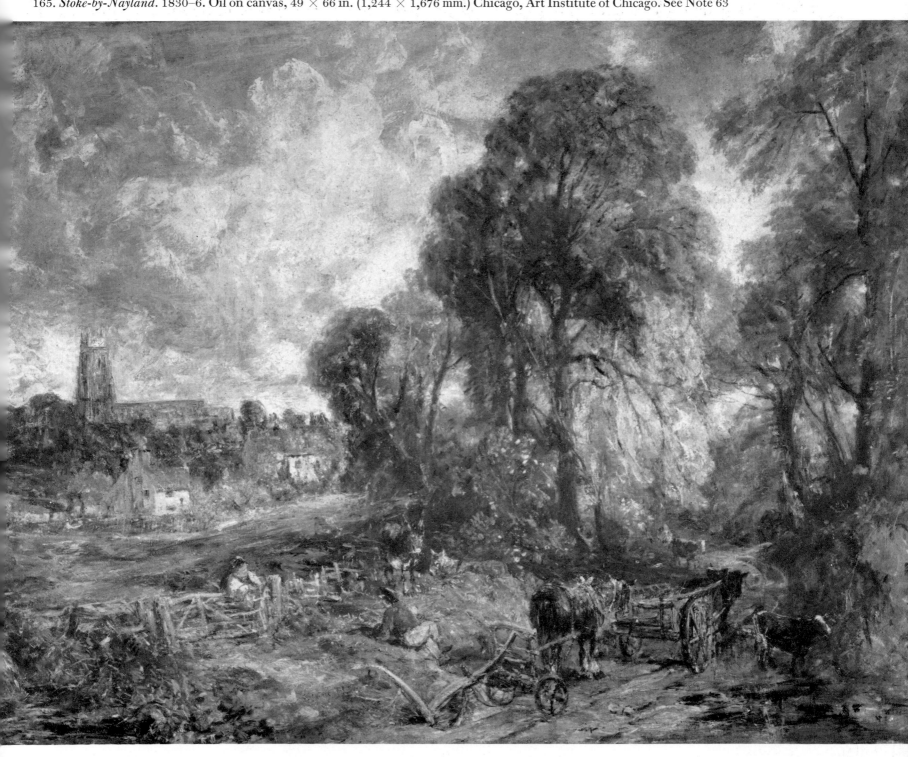

165. *Stoke-by-Nayland.* 1830–6. Oil on canvas, 49 × 66 in. (1,244 × 1,676 mm.) Chicago, Art Institute of Chicago. See Note 63

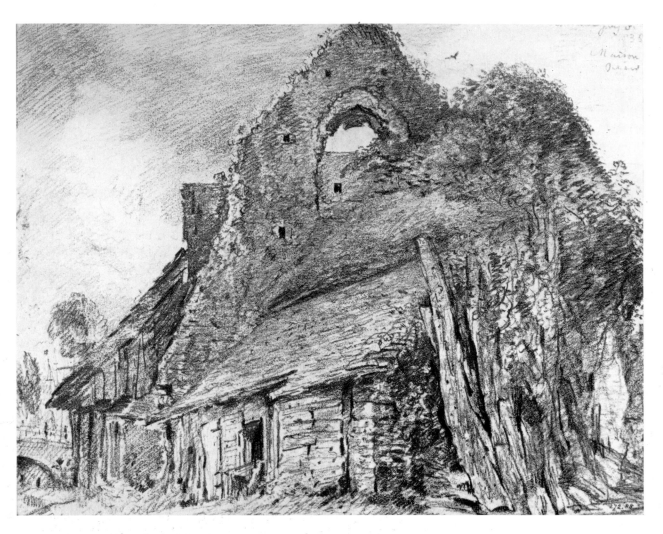

166. *The ruins of Maison Dieu, Arundel.*
Inscribed 'Arundel July 8th. 1835 Maison Dieu.' Pencil, $8\frac{5}{8} \times 11$ in. (220 × 281 mm.) London, Victoria and Albert Museum. See Note 64

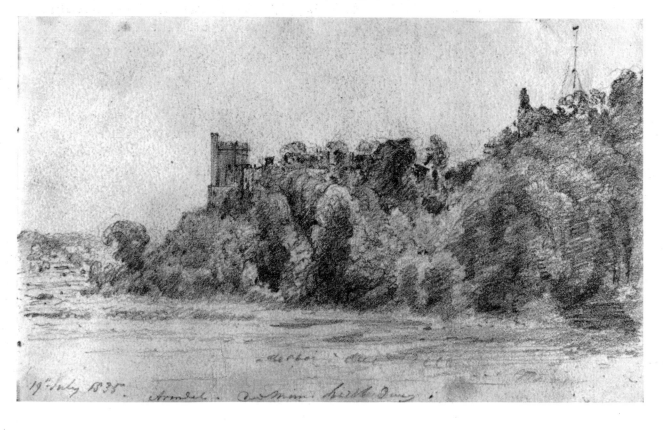

167. *Arundel Castle.*
Inscribed '19th. July 1835. Arundel—dear Minna's birthday.' Pencil, $4\frac{1}{2} \times 7\frac{3}{8}$ in. (115 × 188 mm.) London, Victoria and Albert Museum. See Note 65

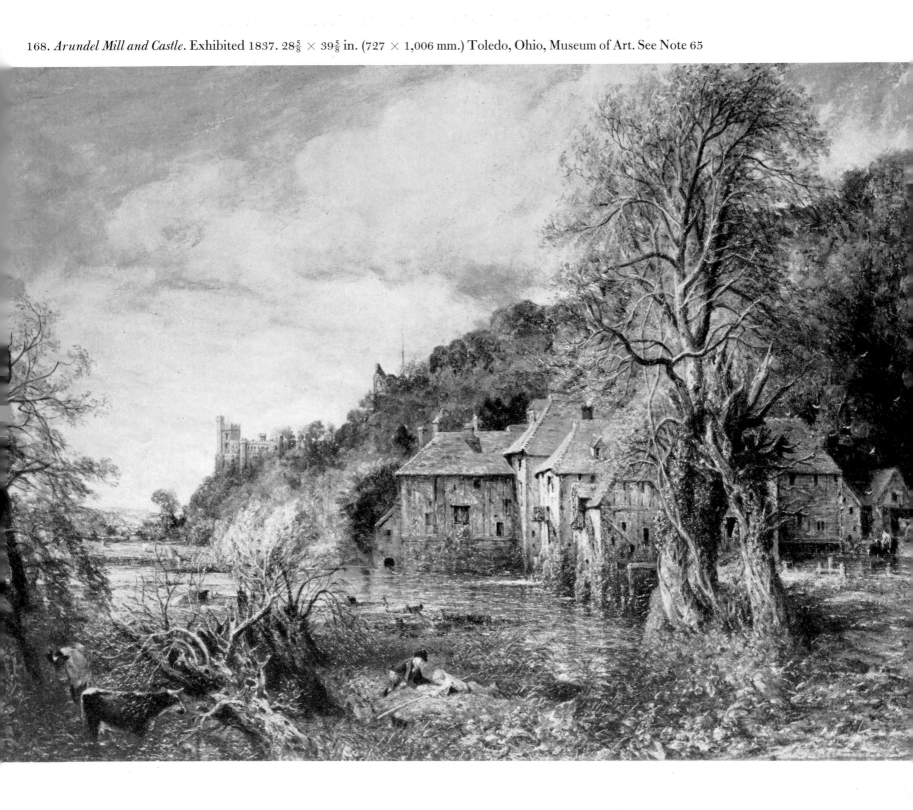

168. *Arundel Mill and Castle*. Exhibited 1837. 28⅝ × 39⅝ in. (727 × 1,006 mm.) Toledo, Ohio, Museum of Art. See Note 65

Works by earlier artists who influenced Constable

169. AELBERT CUYP (1620–91): *Hilly landscape near Ubbergen.* Panel, 17 × 20 in. (425 × 510 mm.) Cardiff, National Museum of Wales.

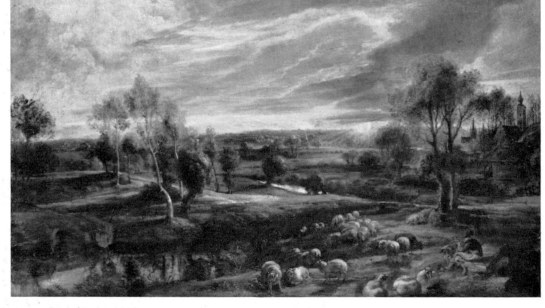

170. RUBENS (1577–1640): *A landscape with a shepherd and his flock.* c.1638. Oil on wood, 19½ × 32⅞ in. (495 × 835 mm.) London, National Gallery

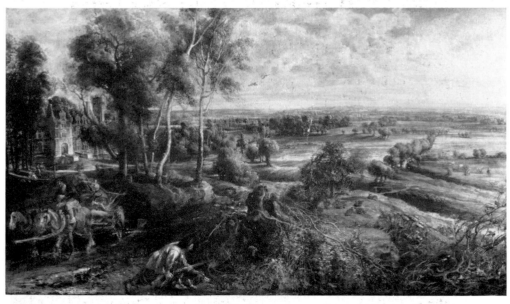

171. RUBENS (1577–1640): *An autumn landscape with a view of Het Steen.* 1636. Oil on wood, 51¾ × 90½ in. (1,318 × 2,299 mm.) London, National Gallery

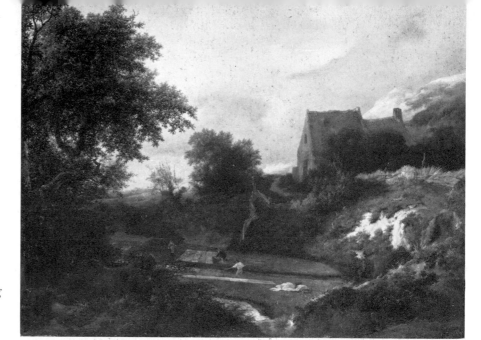

172. JACOB VAN RUISDAEL (1628/9–82): *A bleaching ground.* ?1650. Oil on wood, $20\frac{3}{4} \times 26\frac{3}{4}$ in. (525 × 678 mm.) London, National Gallery

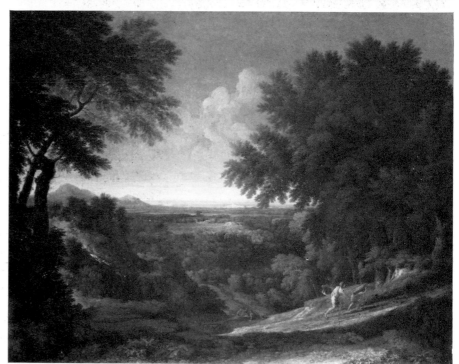

173. GASPARD DUGHET (1615–75): *Landscape: Abraham and Isaac.* Oil on canvas, $60 \times 76\frac{3}{4}$ in. (1,525 × 1,950 mm.) London, National Gallery

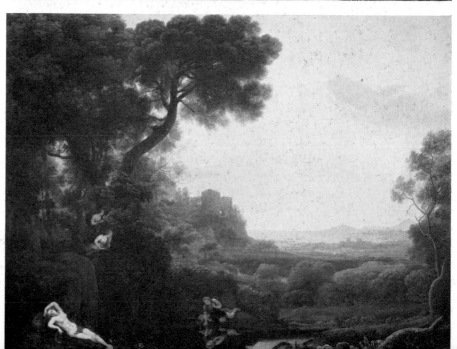

174. CLAUDE (1600–82): *Landscape: Narcissus.* 1644. Oil on canvas, $37\frac{1}{4} \times 46\frac{1}{2}$ in. (945 × 1,180 mm.) London, National Gallery

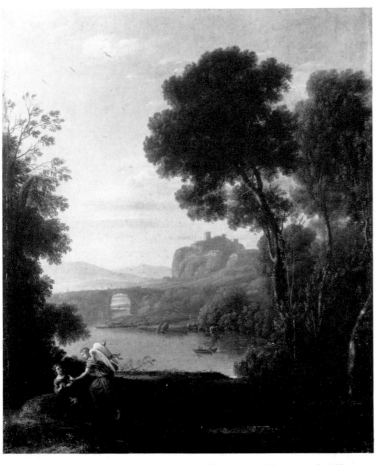

175. CLAUDE (1600–82): *Landscape: Hagar and the Angel*. Oil on canvas on wood, 20¾ × 17¼ in. (520 × 440 mm.) London, National Gallery

176. THOMAS GAINSBOROUGH (1727–88): *The Market Cart*. 1786–7. Oil on canvas, 72½ × 60¼ in. (1,841 × 1,530 mm.) London, Tate Gallery

177. THOMAS GAINSBOROUGH (1727–88): *Gainsborough's Forest ('Cornard Wood')*. c.1748. Oil on canvas, 48 × 61 in. (1,220 × 1,550 mm.) London, National Gallery

THE FOLLOWING NOTES are neither concerned with evidence relating to any picture's attribution to Constable nor its provenance, and they seldom consider problems of dating. Their purpose is, where possible, to identify the subject and to give a brief account of the work's place in the painter's life and practice. Where several pictures have the same or similar subjects or when they are the elements in a single enterprise, they may be treated together. Thus the studies and sketches connected with *The Hay Wain* are included in the note relating to that painting. Here, as elsewhere in the volume, quotations from Constable's correspondence bear a reference to the Beckett edition, so that (V: 100) indicates that the passage quoted occurs on page 100 of Volume V. The quotations from C. R. Leslie's Life of the Artist have been taken from Jonathan Mayne's edition, published by the Phaidon Press (1951).

1 *COTTAGE AT CAPEL* (Plate 1)

This is one of nine sketches of cottages made by Constable in 1796 soon after he met the antiquarian J. T. Smith, who was then preparing his publication *Remarks on Rural Scenery; with twenty etchings of Cottages, from Nature* for issue the following year. On 27 October 1796, he wrote to Smith, 'I have in my walks pick'd up several cottages and peradventure I may have been fortunate enough to hit upon one or two, that might please. If you think it is likely that I have, let me know and I'll send you my sketchbook and make a drawing of any you like if there should not be enough to work from.' (II: 5) In spite of a comment in a later letter—'You flatter me highly respecting my Cottages and I am glad you have found one or two among them worthy your needle.' (II: 8)—Smith does not seem to have used any of Constable's examples in his book.

2 *DEDHAM CHURCH AND VALE* (Plate 2)

This is one of a group of four watercolour drawings of Stour Valley subjects which Constable gave to the daughter of the curate of Langham, Essex, at the time of her marriage in 1800. They were made with the formal line and wash method which had characterized so much English landscape drawing of the eighteenth century and which influenced Constable's early practice in oil painting also (see Plates 4 and 5). It was the method which, in principle, was followed by Constable's first professional mentor, Joseph Farington.

3 *OLD HALL, EAST BERGHOLT* (Plate 3)

This picture, painted two years after Constable had been admitted to the Royal Academy schools, was probably his first important commission. It was made for the owner of the house, Mr John Reade, and Joseph Farington, consulted about the price he should charge, said, 'he could not ask less than 10 guineas.' (Farington, *Diary*, ed. Greig, vol. I, p. 309.)

4 *DEDHAM VALE* (Plate 4)
ROAD NEAR DEDHAM (Plate 5)
WOODED LANDSCAPE AT SUNSET, WITH A FIGURE (Plate 22)

These three pictures are part of a small group painted about 1802 at a time when Constable had reached a decisive phase in his thinking about landscape painting. In a letter of May, 1802, quoted more extensively on pages 11–12, he wrote to his friend Dunthorne:

'For these two years past I have been running after pictures and seeking the truth at second hand . . . I shall shortly return to Bergholt where I shall make some laborious studies from nature—and I shall endeavour to get a pure and unaffected representation of the scenes that may employ me with respect to colour particularly and any thing else . . .' (II: 32)

5 *VIEW IN BORROWDALE* (Plate 6)
KESWICK LAKE (Plate 7)

These are two products of the visit, lasting about two months, which Constable made to the Lake District in the autumn of 1806 at the expense of his uncle, David Pike Watts. The view in Plate 6 has been identified as a scene from the Watendlath path looking towards Glaramara. The other drawings of this period, most of which are now in the Victoria and Albert Museum, include views of Langdale, Derwentwater, Lodore, Helvellyn and Saddleback. Plate 7 may have been the picture exhibited at the Royal Academy in 1807 as *Keswick Lake*.

6 *VIEW AT EPSOM* (Plate 8)

This picture was probably painted by Constable on a visit in 1809 to John and Mary Gubbins, the latter being his mother's sister.

7 *MALVERN HALL* (Plates 9 and 50)

The subject of these works was the residence of Henry Greswolde Lewis. He was the brother of Lady Dysart, for

whom Constable began to work in 1807. The painter first visited the house in 1809, when he made a portrait of Lewis's ward, Mary Freer. The association was to last for at least another twenty years, and in that period, apart from views of the Hall, Constable painted other portraits, including an imaginary figure of one of Lewis's Norman ancestors.

Constable exhibited at the Royal Academy in 1822 a picture entitled *Malvern Hall, Worcestershire*, but it is possible neither to determine which of the two different aspects this presented nor which of two extant versions of both subjects it may have been. The dating of these pictures presents an even more complicated problem. The other version of Plate 50, in the Musée de Tesse, Le Mans, is signed and dated 1821; this and other evidence suggests that Plate 50 would have been painted about the same time. The version of Plate 9 illustrated here bears on its stretcher an inscription in the hand of a previous owner indicating that its original stretcher bore the date, 'apparently' in the artist's hand, 1 August 1809. As its style is compatible with work of that period it may be presumed to have been used as a source for the later work. (For a full discussion of this problem see Martin Davies, *National Gallery Catalogue of the British School*, 1959, p. 23.) [In Plate 9 it has been necessary to omit from the reproduction narrow strips from both ends of the original painting.]

8 GOLDING CONSTABLE'S HOUSE, EAST BERGHOLT (Plate 10)
GOLDING CONSTABLE'S FLOWER GARDEN (Plate 36)
GOLDING CONSTABLE'S KITCHEN GARDEN (Plate 37)

Plate 10 shows the house in which the painter was born, with East Bergholt Church on the left. A drawing in the Victoria and Albert Museum (No. 623–1888), very similar to Plate 36, helps to establish the date of the two paintings showing the gardens of the same house. As the drawing is on a sheet of paper watermarked 1811 and was inscribed by the artist on the mount *The Garden belonging to G Constable Esq.*, suggesting that it was made before his father's death, it may be presumed that the paintings were done between 1812 and 1816. The treatment of the plants is also compatible, in manner, with other works of that period. [In Plates 36 and 37 it has been necessary to omit from the reproductions narrow strips from both ends of the original paintings.]

9 A VILLAGE FAIR, EAST BERGHOLT (Plate 12)
WEST LODGE, EAST BERGHOLT (Plate 13)

Plate 13 represents the building at East Bergholt now known as Stour House, which stands opposite the original site of the Constable house on the other side of Church Street. It appears again on the left of Plate 12. A fair was held annually at Bergholt during the last week in July. Constable was almost certainly there at that time in 1811.

10 A COUNTRY LANE (Plate 14)

This sketch may have been painted in the spring or summer of 1811 as it is in exactly the same style as a similar work in the Victoria and Albert Museum (No. 326–1888) dated 17 May 1811. Such studies, made with an increasing fluency, were the most numerous products of his practice in landscape in the years before 1815.

11 EAST BERGHOLT CHURCH (Plate 15)

This is the copy of a watercolour that belonged to the artist's mother. She hoped that the presentation of it to Maria Bicknell's grandfather, Dr Durand Rhudde, Rector of East Bergholt, might encourage him to treat her son and his feelings for Maria with more sympathy. It bears on the reverse the following inscription in the writing of Constable's friend, John Dunthorne: 'A South East view of East Bergholt Church, a drawing by John Constable & presented in testimony of respect to Durand Rhudde D.D. the Rector, February 26.1811.' The Rector originally supposed the drawing to be a present from Mrs Constable, but when he discovered it came from the artist, he sent him the following note a month later:

Dear Sir,

I thank you most sincerely for your very elegant present, of a view of my Church, and beg you to believe I value the picture most highly: not merely as a Specimen of Professional Merit, but as a Testimony of your Regard.

I know not what to offer to your acceptance in Return for the very flattering Compliment you have paid me, but if you will allow me, to solicit, that you will devote the Note accompanying this, to the Purchase of some little article by which you may be reminded of me, when I am no more, you will confer a still further Obligation, on Sir,

Your very faithful Friend & Servant

D. Rhudde (II: 18)

12 *MORNING IN DEDHAM VALE* (Plate 18)

This work was exhibited at the R.A. in 1811 and is perhaps the first of those compositions which predict the character of the earlier 'six-footers', such as *The White Horse*, in so far as it presents a Stour Valley subject in a way which unites the artist's concern for atmospheric truth with careful finish and studied design. The tree in the left foreground produces a measure of formality, and Charles Leslie, a man of essentially conservative taste, found it particularly satisfying. 'There is a tree of slight form in the foreground', he wrote, 'touched with a taste to which I know nothing equal in any landscape I ever saw.'

13 *DEDHAM VALE FROM LANGHAM* (Plate 20)
 A HAYFIELD NEAR EAST BERGHOLT AT
 SUNSET (Plate 21)
 LANDSCAPE, WITH TREES AND COTTAGES
 UNDER A LOWERING SKY (Plate 25)
 LANDSCAPE AND DOUBLE RAINBOW (Plate 30)
 AUTUMN SUNSET (Plate 35)

Constable spent eight weeks at East Bergholt in the summer of 1812—between 20 June and 19 August. On 10 July, that is, only a few days after painting Plate 21, he wrote to Maria Bicknell:

'I am . . . vain of some studies of landscapes which I have done—"Landscape which found me poor at first and keeps me so." I am sure you will laugh when I tell you I have found another very promising subject at *Flatford Mill*. I do not study much abroad in the middle of these very hot bright days. I am become quite *carefull of myself*, last year I almost put my eyes out by that pastime.' (II: 80)

These studies are not only, in their kind, characteristic of the oil landscapes he was making between 1810 and 1815, studies rather than finished pictures, but their wide, loose, composition and broad handling, with a few bold accents of light, is typical of his style in this immediate period. [In Plate 35 it has been necessary to omit from the reproduction narrow strips from both ends of the original painting.]

14 *SCENES ON THE STOUR* (Plate 23)
 DEDHAM: THE SKYLARK (Plate 24)
 FLATFORD MILL (Plate 27)
 A WOMAN CROSSING A FOOTBRIDGE (Plate 28)

These drawings are from a sketchbook which Constable used when staying at East Bergholt during the summer of

1813. In March of the following year he wrote to Maria Bicknell, probably referring to this book:

'You once talked to me about a journal. I have a little one that I made last summer that might amuse you could you see it—you will then see how I amused my leisure walks, picking up little scraps of trees, plants, ferns, distances &c &c.' (II: 120)

15 *THE MILL STREAM* (Plates 31 and 32)

The building which dominates this composition is Willy Lott's house, which occurs in *The Hay Wain* (Plate 72) and *The Valley Farm* (Plate 160). The larger picture (Plate 32) was exhibited at the Royal Academy in 1814 as *Landscape: the ferry*. It provoked from Constable's uncle, David Pike Watts, the letter about the unfinished nature of his work quoted on page 42. It was painted at a time when Constable was particularly unhappy about the progress of his courtship. In conception and design it is, of all the pictures he had painted by this date, that which most clearly predicts the character of his large compositions, having a more formal and imposing design than the ploughing scene (a version of Plate 38) shown at the Academy in the same year.

16 *FLATFORD MILL FROM A LOCK ON THE*
 STOUR (Plate 33)

Although Plate 33, which shows the same aspect of the mill as Plate 58, from a point closer to it, is a free loose sketch, the elements of the scene seem, if instinctively, to have been composed more positively than was usual in Constable's works of this kind. If that interpretation of it is correct, it may have been made in the studio rather than on the spot and with the prospect of a finished picture in mind.

17 *DEDHAM VALE WITH PLOUGHMEN* (Plate 38)

Another version of this subject, slightly taller, was exhibited at the Royal Academy in 1814 as *Landscape: Ploughing scene in Suffolk*, and in May of that year, in a letter to Maria, Constable wrote, 'I am much pleased with the look and situation of a small picture there of my own—I understand that many of the members consider it as genuine a piece of study as there is to be found in the room.' (II: 122)

In February he had written to Dunthorne:

'I have added some ploughmen to the landscape from the park pales which is a great help, but I must try and warm the picture a little more if I can. But it will be difficult as 'tis

now all of a peice—it is bleak as if there would be a shower of sleet, and that you know is too much the case with my things.' (I: 101)

The picture was bought at the exhibition by John Allnutt, an enthusiastic patron of British artists, and was thus the first of his works to be acquired by a stranger. Allnutt, in a letter written to Leslie, and quoted in Leslie's biography of Constable, disclosed that he had the picture's sky 'obliterated, and a new one put in by another artist'. A little later, through a friend, he asked Constable not only to restore the picture to its original state, but to reduce its height so that it might hang harmoniously with a landscape by Callcott. Instead Constable painted a second version (Plate 38) and presented it to Allnutt in gratitude for the encouragement his original act of patronage had afforded.

18 *BOAT-BUILDING NEAR FLATFORD MILL*
(Plate 39)

The scene of this picture is a meadow near Flatford, containing a dry dock by the River Stour.

It was a year when, according to a letter to Maria Bicknell, Constable had been occupied 'entirely in the feilds and I believe I have made some landscapes that are better than is usual with me—at least that is the opinion of all here.' (II: 131)

The first evidence of his composition appears in the sketchbook drawing dated 7 September, and work on the painting, which was executed, according to Leslie, entirely in the open air, must have started soon thereafter. It is the earliest of those works which in its finish and deliberated composition may be said to anticipate those large works beginning with *The White Horse*. The picture had been influenced by the artist's determination to answer those critics who had complained at the lack of finish in his work.

In July he had called upon Farington in London. Farington had told him, 'the objections made to His pictures was their being unfinished . . . I recommended to Him to look at some of the pictures of *Claude* before he returns to his country studies and to attend to the admirable manner in which all the parts of His pictures are completed.' (Farington, *Diary*, ed. Greig, vol. VI, p. 272.) Constable followed this advice and studied the Claudes belonging to John Julius Angerstein just before leaving for East Bergholt. In spite of this and the evident influence of Claude upon the execution of this picture, Constable's work shown at the Academy

was still found by one critic to be 'coarsely sketchy' and by another 'sketches rather than pictures'.

19 *THE STOUR VALLEY AND DEDHAM CHURCH*
(Plates 40 and 41)

This picture (Plate 41), for which there is a sketch dated 5 September 1814 in the Leeds City Art Gallery (Plate 40), was made for Thomas Fitzhugh, as a wedding present to be given to his bride, Philadelphia, the daughter of Peter Godfrey, Lord of the Manor of Old Hall, East Bergholt. The Godfreys had previously shown a most sympathetic interest in Constable's career. On 25 October 1814 Constable wrote to Maria:

'I am considered rather unsociable here—my cousins could never get me to walk with them once as I was never at home' till night—I was wishing to make the most of the fine weather by working out of doors. I have almost done a picture of "the Valley" for Mr Fitzhugh—' (a present for Miss G to contemplate in London) . . . (II: 134)

Mr Ian Fleming-Williams has shown (*Burlington Magazine*, vol. cxiv, p. 386) that the mound in the foreground, on which two labourers are working, was not, as earlier suggested, part of a gravel pit, but a dunghill, known locally as a runover dungle.

20 *HARWICH: THE LOW LIGHTHOUSE AND BEDA*
BEACON HILL (Plate 43)

Golding Constable owned a property at Harwich. This is probably the picture exhibited at the Royal Academy in 1820 and based on a pencil drawing of August 1815 in the Victoria and Albert Museum (302–1888).

21 *NEAR STOKE-BY-NAYLAND* (Plate 44)
LOOKING OVER TO HARROW (Plate 45)

The stylistic similarities in these two works suggest that they belong to the same time in Constable's career. They also indicate how careful students of the artist should be in distinguishing between works made in the open air and those which, in spite of their apparent spontaneous immediacy, may have been composed. Mr Leslie Parris (in his exhibition catalogue *Constable: The Art of Nature*, No. 93) has pointed out that in the case of Plate 44 there is no physical evidence to suggest that this was studio work, and I have little doubt that the view of Harrow was made in similar circumstances.

22 *DEDHAM LOCK AND MILL* (Plates 46 and 47)

The mill represented belonged to Golding Constable and the painter worked there in his youth. Plate 46 was probably painted from nature some years before the execution of the finished composition, Plate 47, which in spite of its inscription, may have been the picture exhibited at the British Institution in 1819, entitled *A Mill*.

23 *HAMPSTEAD* (Plates 48, 49, 88, 90, 134 and 158)

From the time when Constable first took lodgings at Hampstead in the summer of 1819 the district, especially the Heath, became extremely important in the development of his practice, although it could never supplant the Stour valley in his affections. (It is significant, in that connection, that he should not have devoted any of his large compositions to a Hampstead subject.) There he could study as well as anywhere else the 'chiaroscuro of nature' and there are numerous studies made for this purpose (see Plates 75 and 76). Some of these works must have been made, like the sky studies, from a window in the house. There is also a sequence of Hampstead landscapes, which, according to his style and methods at the time, were developed more elaborately, and although some of these were evidently made for exhibition or sale, it seems not unreasonable to suppose that he used the place as a trial ground in which his creativity could be exercised, all the more effective as a site of experimental work for being so close and familiar.

HAMPSTEAD HEATH (Plate 48)

This is a view over Branch Hill Pond with Harrow Church on the horizon at the left. Of this work Leslie (*Life*, p. 72) wrote:

'I know no picture in which the mid-day heat of Mid-summer is so admirably expressed; and were not the eye refreshed by the shade thrown over a great part of the fore-ground by some young trees, that border the road, and the cool blue of water near it, one would wish, in looking at it, for a parasol . . .'

It was probably painted about 1818–20.

HAMPSTEAD HEATH (Plate 49)

The view is from the top of the Heath looking north.

HAMPSTEAD HEATH (Plate 90)

The view is from the pond near the Vale of Health, looking towards Highgate.

HAMPSTEAD HEATH: BRANCH HILL POND
 (Plate 134)

This picture was exhibited at the Royal Academy in 1828, being based upon a sketch, also in the Victoria and Albert Museum (122–188), made in 1819. It was engraved by Lucas for the third number of *English Landscape Scenery*.

HAMPSTEAD HEATH WITH A RAINBOW (Plate 158)

This work was painted in 1836 and mentioned by Constable in a letter to his friend George Constable:

'I have lately turned out one of my best bits of Heath, so fresh, so bright, dewy & sunshiny, that I preferred to any former effort, at about 2 feet 6, painted for a very old friend [W. George Jennings]—an amateur who well knows how to appreciate it, for I now see that I shall never be able to paint down to ignorance. Almost all the world is ignorant & vulgar.' (V: 35)

24 *WIVENHOE PARK, ESSEX* (Plate 51)

This estate belonged to General F. Slater Rebow, who had earlier employed Constable to paint a portrait of his daughter. He proved to be a wholly sympathetic patron, as the following passages from a letter to Maria indicate:

'The General and Mrs Rebow are determined to be of some service to me and at any rate their attentions are agreeable and add much to all that is respectable . . . I am going to paint two small landscapes for the General, views one in the park of the house & a beautifull wood and peice of water, and another scene in a wood with a beautifull little fishing house. . . . They wish me to take my own time about them—but he will pay me for them when I please, as he tells me he understands from old Driffield that *we* may soon want a little ready money.' (II: 196)

The picture was finished a month later, five weeks before the painter's marriage, and was exhibited at the Academy, with *Flatford Mill*, in the following year. The second picture has also survived and is in the National Gallery of Victoria, Melbourne.

25 *THE WHITE HORSE* (Plates 52 and 53)

The picture shows a barge horse being ferried across the River Stour at a point near Dedham where the tow-path changes from one bank to the other. It was the first of the six-foot compositions and was exhibited at the Academy in 1819 under its original title, *A Scene on the River Stour*. The drawing which Constable seems to have used in treating the central part of the composition occurs in a sketchbook used

in the summer of 1814. In finishing the picture, Constable evidently made some alterations proposed to him by Joseph Farington, who was still inclined, however, on seeing it at the exhibition, to recommend him to 'make his pencil execution more careful'. (Farington, *Diary*, ed. Greig, vol. VIII, p. 222.) It was well received by the reviewers. The writer in the *Examiner* said that the picture 'is indeed more approaching to the outward lineament and look of trees, water, boats, etc than any of our landscape painters' and in comparing Constable with Turner said that 'he does not give a sentiment, a soul to the exterior of Nature . . . he does not exalt the spectator's mind . . . but he gives her outward look, her complexion and physical countenance.' The critic of the *Literary Chronicle* was even more enthusiastic:

'What a grasp of everything beautiful in rural scenery! This young artist is rising very fast in reputation, and we predict that he soon will be at the very top of that line of the art of which the present picture forms so beautiful an ornament.'

On 2 July 1819 Archdeacon Fisher wrote to his friend:

'Will you have the goodness to tell me what price you put on your great picture now in the exhibition. . . . Did you not express a wish to have it on your easil again to subdue a few lights and cool your trees? I think you said so. Because the gentleman who meditates the purchase does not immediately want it.' (VI: 44)

Constable, who put a figure of 100 guineas upon it, indicated that he wished to work at it further before showing it again. It eventually reached Fisher's house at Salisbury in April 1820, and when it was hung he told the painter, 'My wife says that she carries her eye from the picture to the garden & back & observes the same sort of look in both.' (VI: 53)

In 1825 Constable borrowed the picture and showed it first at the British Institution and then, without seeking Fisher's approval, sent it for exhibition at Lille, where he was awarded a second gold medal. In 1829 Constable bought back the picture, paying for it the £105 he had originally received. It was subsequently engraved by David Lucas.

26 *LANDSCAPE SKETCH ('STRATFORD MILL')*
(Plate 54)
STRATFORD MILL (Plate 55)

This picture (Plate 55), which was exhibited at the Royal Academy in 1820, shows the area about a paper-mill at Stratford St Mary, upstream from Dedham. It was bought for 100 guineas by John Fisher, who presented it to his Salisbury lawyer, John Perne Tinney, in gratitude for a professional service.

In July 1821, Fisher wrote to his friend, 'Your picture is hung up in a temporary way at Tinneys till his new room is finished. It excites *great interest* & attention. The work has got much together.' (VI: 69) He later described the setting:

'The room which in it's proportions is magnificent is furnished exactly like the best parlour of an opulent pawnbroker. An enormous brass chandelier with twenty branches: a clock stuck round with gilt cupids like the chimney peice ornaments in the breakfast scene of Marriage a la mode. And to crown all, the walls covered with pannels of brown varnish yclept "old masters".' (VI: 84)

The rest of Constable's relationship with Tinney shows the artist at his most intransigent, for he expected to have a right to borrow the work for long periods in order to exhibit it. It was, in fact, shown at the British Institution special exhibition of work by living artists in 1825, and Constable probably sent it to Lille that year in company with *The White Horse*, without obtaining the owner's consent. It was engraved by David Lucas and published after Constable's death. The name given there, *The Young Waltonians*, has sometimes been attached to it since.

27 *WEYMOUTH BAY* (Plates 56 and 57)

Constable first visited this area when he spent part of his honeymoon at Osmington, Fisher's parish near Weymouth, and it seems certain that on that occasion he painted the sketch from which Plate 57 and a second version in the Louvre were composed.

28 *FLATFORD MILL, ON THE RIVER STOUR*
(Plates 58 and 136)

The buildings of the Mill, which belonged to Constable's father, are shown in the distance, lying behind the lock. The earliest reference to the picture comes in a letter to Maria, written in September 1816, a month before their marriage, from East Bergholt: 'I am now in the midst of a large picture here which I had contemplated for the next Exhibition—it would have made my mind easy had it been forwarder—I cannot help it—we must not expect to have all our wishes complete.' (II: 203) At the beginning of the following January Farington saw it in London. It was shown as *Scene on a navigable River* and in the following year at the British

Institution as *Scene on the banks of a river*. Of the two reviewers who noticed his works the writer in the *Repository of Arts* observed that his work 'now displays the most laboured finish.'

29 *LANDSCAPE STUDY: HAMPSTEAD LOOKING
 WEST* (Plate 59)
 BRANCH HILL POND, EVENING (Plate 68)
 HAMPSTEAD AFTER A THUNDERSTORM
 (Plate 69)
 SKETCH AT HAMPSTEAD: EVENING (Plate 75)
 A SANDBANK AT HAMPSTEAD HEATH (Plate 76)
 *HAMPSTEAD HEATH AT SUNSET, LOOKING
 TOWARDS HARROW* (Plate 89)

The years 1820–2, when Constable was beginning to develop his command of large-scale composition, were also a time of assiduous concentration upon effects of light, atmosphere and weather, the type of investigation, indeed, which encouraged him to regard landscape painting as a kind of science. Hampstead Heath could be an immediate source of simple motifs, ideal for the development of his observation and his ability to render such effects truthfully. The growing accumulation of such studies, and those made in Suffolk and elsewhere, provided a rich store of reference for the elaborated pictures and a means of refreshing his vision of the spring and summer seasons he preferred, when, during the dark days of winter, larger works occupied his studio easel and his inventiveness needed support. See also Note 23.

30 *CLOUD STUDIES* (Plates 60–67)

The majority of Constable's cloud studies were made in 1821–2, at a time when his interest in the 'chiaroscuro of nature' reached a climactic stage (see the letter to Fisher quoted on page 14). In the autumn of 1821 he wrote, 'I have done a good deal of skying . . .' (VI: 76), and a year later he was able to report with satisfaction to Fisher, 'I made about fifty careful studies of skies tolerably large to be careful.' Many of these were, evidently, made in oil colours on paper, and, although not all the examples which have survived still bear inscriptions noting such details as date, time and weather, probably all of them were originally annotated in this form. The particularity of the artist's observation is well typified in an inscription quoted by Leslie, who at the time of writing his biography had twenty examples in his possession.

'5th of September, 1822. 10 o'clock, morning, looking south-east, brisk wind at west. Very bright and fresh grey clouds running fast over a yellow bed, about half way in the sky. Very appropriate to the "coast at Osmington".' (*Life*, p. 94.)

In addition to the studies which show nothing but clouds, there are others made for a similar purpose in which a thin band of landscape or the tops of trees were included below the sky.

In December 1836 the painter wrote to his friend, George Constable:

'My observations on clouds and skies are on scraps and bits of paper, and I have never yet put them together so as to form a lecture, which I shall do and probably deliver at Hampstead next summer . . . If you want any thing more about atmosphere, and I can help you, write to me. Foster's book is the best book he is far from right, still he has the merit of breaking much ground.' (V: 36)

The book there mentioned was Thomas Forster's *Researches about Atmospheric Phaenomena*, first published in 1812 and reprinted in 1815 and 1823. It contained an account of the theories of Luke Howard who, in the first years of the century, had, by his studies, initiated the systematic analysis and naming of cloud forms, leading to the use of such terms as cumulus, cirrus, etc. Howard's system of classification was eventually published as the first chapter of his work *The Climate of London*. Badt (in *John Constable's Clouds*, Chapter V) has proposed that Constable must have been aware of Howard's theories and that his knowledge of them was manifested in these works of 1821–2. The evidence to support this contention is entirely circumstantial, but that he should have been ignorant of Howard seems improbable, for the latter's work was sufficiently well known for Goethe to have been aware of it by 1820; not only did he write a scientific article about it in that year but also a set of poems celebrating the English scientist's achievement.

31 *LANDSCAPE SKETCH ('THE HAY WAIN')*
 (Plates 70 and 74)
 WILLY LOTT'S HOUSE (Plate 71)
 THE HAY WAIN (Plate 72)

In this view of the River Stour near Flatford Mill (Plate 72) the building on the left is Willy Lott's house, which appears frequently in Constable's work (see also Plates 32 and 160), and, according to Leslie, the painter increased the width of the stream considerably. Apart from the two sketches for the entire composition reproduced (Plates 70 and 74) and the

study of the cottage (Plate 71), which may also have contributed to it, other sketches attributed to the artist are extant.

Farington recorded in his diary for 22 January 1821 that 'Constable came to tea and reported progress on a picture intended for the ensuing exhibition.' It was shown there as *Landscape—Noon* and passed unnoticed by some of the major journals such as *The Times* and the *Morning Chronicle*. The *Observer*, however, praised it saying that 'there is much skill shown in this performance, of which Ruysdael has evidently been the model.' The *Examiner* went further in its praise: 'a picture of Mr Constable's which we think approaches nearer to the actual look of rural nature than any modern landscape whatever . . . We challenge the Dutch Masters to show us anything better than this.'

A letter to Fisher in October indicates that Constable continued to work on the picture after the exhibition closed.

'My last year's work has got much *together*. This weather has blown & washed the *powder off*. I do not know what I shall do with it—but I love my children to[o] well to expose them to the taunts of the Ignorant—though they shall never flinch from honourable competition.' (VI: 78)

The following year the picture was exhibited at the British Institution and there seen by the French dealer, Arrowsmith, who offered Constable £70 for it. Having reported this to Fisher, the painter later wrote to his friend to say, 'I shall not let the Frenchman have my picture. It is too bad to allow myself to be knocked down by a French man.' (VI: 91). In January 1824 Arrowsmith returned to London and increased his offer, influenced no doubt by the development of Constable's reputation in Paris. Fisher, who had an option on the work, wrote:

'Let your Hay Cart go to Paris by all means . . . I would (I *think*) let it go at less than its price for the sake of the éclat it may give you. The stupid English public, which has no judgment of its own, will begin to think that there is something in you if the French make your works national property.' (VI: 151)

Constable followed this advice and sold *The Hay Wain*, the *View on the Stour* (Plate 80) and a third picture to the French dealer for 250 guineas. It was despatched to Paris in May and ultimately, after being viewable on Arrowsmith's premises, was hung at the Salon which opened in August, the novelist Stendhal being among those who gave it enthusiastic attention. In January 1825, Constable was awarded a gold medal by Charles X for his contribution to the exhibition, as were Copley Fielding and Bonington.

Arrowsmith sold the picture for £400 in 1825 to a Monsieur Boursault; it returned here, to an English private collection, in 1838.

On February 21 Fisher asked, 'And how thrives the "hay wain"?' (VI: 62) Constable later wrote to him, 'The present picture is not so grand as Tinny's [*Stratford Mill*] owing perhaps to the masses not being so impressive—the power of the Chiaro Oscuro is lessened—but it has rather a more novel look than I expected.' (VI: 65)

32 *STUDY OF TREE TRUNKS* (Plate 77)
STUDY OF THE TRUNK OF AN ELM TREE (Plate 78)

The suggestion by Reynolds (*Catalogue of the Constable Collection in the Victoria and Albert Museum*) that another very different tree study (see Plate 95 and note 37) was also made at the same period seems to the present author wholly justified.

33 *LANDSCAPE SKETCH* (*VIEW ON THE STOUR NEAR DEDHAM*) (Plate 79)
VIEW ON THE STOUR NEAR DEDHAM (Plate 80)

This picture (Plate 80), known by Constable as *The Bridge*, was exhibited at the Royal Academy in 1822, where it was generally well received by the reviewers, at the British Institution in 1823, and at the Salon des Beaux-Arts in 1824.

He began to compose it in the summer of 1821 at Hampstead, but soon transferred it to his house in Charlotte Street. On 13 April 1822 Constable wrote to Fisher:

'I have sent my large picture to the Academy. I never worked so hard before & now time was so short for me—it wanted much—but still I hope the work in it is better than any I have yet done . . . I do not know that it is better than my others but perhaps few vulgar objections can be made to it. The composition is almost totally changed from what you saw. I have taken the sail and added another barge in the middle of the picture, with a principal figure, altered the group of trees, and made the bridge entire. The picture has now a rich centre, and the right hand side becomes only an accessory. I have endeavoured to paint with more delicacy, but hardly anyone has seen it.' (VI: 87)

Arrowsmith acquired the picture for showing in Paris, paying 250 guineas for it, *The Hay Wain* and a third work.

The mezzotint by Lucas of this subject was made from Plate 79.

34 *SALISBURY CATHEDRAL* (Plates 81–87)

In August 1820 Constable showed Bishop John Fisher of Salisbury various sketches of Salisbury preparatory to painting for him, on commission, a picture of the Cathedral. On 8 October, the Bishop's daughter, Dolly, wrote to the painter, 'Papa desires me to say, he hopes you will finish for the Exhibition the view you took from our Garden of the Cathedral by the water side . . .' (VI: 58) The oil sketch for the finished composition (Plate 87) and the work ultimately exhibited (Plate 85) were based upon a drawing he had made in 1811 (Plate 83). After receiving an advance payment in November 1822 for the picture, destined for the drawing–room of the Bishop's London home in Seymour Street, Constable eventually finished the work in time for the exhibition of 1823. On 9 May he wrote to Archdeacon Fisher:

'My Cathedral looks very well. Indeed I got through that job uncommonly well considering how much I dreaded it. It is much approved by the Academy and moreover in Seymour St. though I was at one time fearfull it would not be a favourite there owing to a *dark cloud*—but we got over the difficulty, and I think you will say when you see it that I have fought a better battle with the Church than old Hume, Brogham and their coadjutors have done. It was the most difficult subject in landscape I ever had upon my easil. I have not flinched at the work, of the windows, buttresses &c, &c, but I have as usual made my escape in the evanescence of the chiaroscuro.' (VI: 115)

Later in the year Constable was commissioned to paint a smaller replica—now in the Huntington Art Gallery—as a wedding present for the Bishop's daughter, Elizabeth. In June 1824 the Bishop, who had never liked the dark cloud in the original version, asked Constable to improve it and either to paint the cloud out or make another version. Although he was forced to neglect other work Constable decided to take the latter course, but the new picture was not completed by the time the Bishop died in May 1825.

When Constable returned *The White Horse* to Fisher, he sent with it Plate 85. Fisher reported:

'The Cathedral looks splendidly over the chimney piece . . . Its internal splendour comes out in all its power, the spire sails away with the thunder-clouds. The only criticism I pass on it, is, that it does not go *out* well with the day. The light is of an unpleasant shape by dusk. I am aware how severe a remark I have made.' (VI: 222)

The amended version remained with the Bishop's de-scendants until the beginning of this century and is now in the Frick Collection, New York.

35 *SKETCH OF THE THAMES AND WATERLOO BRIDGE* (Plate 91)
WATERLOO BRIDGE FROM THE WEST (Plate 92)
THE THAMES AND WATERLOO BRIDGE (Plate 93)
WATERLOO BRIDGE FROM WHITEHALL STAIRS (Plate 125)
WHITEHALL STAIRS: THE OPENING OF WATERLOO BRIDGE (Plate 154)

Waterloo Bridge, designed by Charles Rennie, was opened by the Prince Regent on 18 June 1817. The royal party had embarked in two barges from Whitehall Stairs, next to Fife House, then the residence of the Prime Minister, Lord Liverpool, who received the Prince there, before and after the ceremony. The departure of the procession of craft is the moment depicted in the picture which Constable showed at the Royal Academy in 1832 (Plate 154). It was then thirteen years since he had, apparently, first conceived the composition, and there had been various times during that period when he had intended finishing it for exhibition.

In July 1819, Constable told Fisher he had 'made a sketch of my scene on the Thames' (VI: 45) and in April 1820 Fisher begged him not to 'part with your London and Westminster view without apprising' him. (VI: 53) In May 1822 Maria Constable told her husband that Bishop Fisher 'was quite in raptures with your Waterloo, sat down on the floor to it, said it was equal to Cannalletti . . . & wondered what you could have been about not to have gone on with it.' (II: 276) Eighteen months later, Archdeacon Fisher wrote: 'The Waterloo depends entirely on the polish & finish given it. If I were the painter of it I would always have it on my easil, & work at it for five years a touch a day.' Constable was then intending to have it finished for the Royal Academy exhibition of 1824 and on 17 January he could report to Fisher that, 'I have just completed my little Waterloo bridge. It looks very well indeed—.' (VI: 150) But this was only 'a small baloon to let off as a forerunner to the large one.' (VI: 152) By July he had decided: 'I have no inclination to pursue my Waterloo, I am impressed with an idea that it will ruin me.' (VI: 168) In October 1825, when he had restarted it, the painter Thomas Stothard came to tea and suggested 'a very capital alteration—which I shall adopt. It will increase its consequence and do every thing for it—I am quite in

spirits about it.' (II: 398) In November he reported to Fisher: 'My Waterloo like a blister begins to stick closer & closer—& to disturb my nights—but I am in a feild that knows no flinching or affection or favor.' (VI: 207) By April 1826 he had set aside the picture again, in favour of *The Cornfield*, but in July he reported that he had added two feet to his canvas. There was then apparently another hiatus until September 1829, when he suggested to David Lucas that the composition might be used for mezzotint; work on that began in the summer of 1831. In February 1832 he asked Lucas to send back to him all the sketches and drawings related to the picture 'which I am now about'.

After it had been taken to the Academy, Constable received a very unfavourable comment upon it from Stothard, and in consequence wrote to Leslie: 'I have never had more restlessness about a picture, than with the premature dismissal of this—& it has not my redeeming voice ("the rural").' (III: 68) It was to be next to a sea-piece by Turner and, according to Leslie (*Autobiographical Recollections*, vol I, pp. 202–3), after Constable had intensified the reds in the foreground of what he was to call his 'Harlequin's jacket', Turner fetched his palette and added to his grey picture a round spot of red, which 'caused even the vermilion and lake of Constable to look weak. I came into the room just as Turner left it. "He has been here", said Constable, "and fired a gun".'

The reviewers, most of whom commented on the picture's vigorous handling, were mainly appreciative of it, but the critic of the *Morning Chronicle*, as in previous years, attacked the work violently, beginning his notice, 'What a piece of plaster it is.'

Apart from the two large versions of the composition, there are three drawings and three oil paintings of various sizes, not to mention a treatment of the opening ceremony from a quite different position, closer to the bridge. The problem of relating these to the development of the ultimate composition, and, indeed, of determining the procedure by which that was ultimately achieved is made inexorably difficult by the length of time over which the painter was, spasmodically, engaged upon the project and by the lack of specific evidence in the various documents available. (Mr Denys Sutton published a lucid consideration of the evidence and its implications in *The Connoisseur*, December 1955, pp. 249–55.)

It has generally been supposed that it was always Constable's intention to include the ceremony in the composi-

tion and that the works which omit it were studies of the river to which the procession was to be added. To the present writer it seems at least equally likely that the painter originally intended nothing but a panoramic view of the Thames incorporating the new bridge, in which case Plate 93 can be regarded as the work described to Fisher in January 1824. If this was so Constable must at some time have decided to incorporate the ceremony attending the embarkation of the royal party. Was this the suggestion that Stothard, himself a painter and illustrator of dramatic subjects, offered to him in October 1825? And was it in order further to study that part of the view from which the ceremony occurred that he returned to Pembroke House in 1826? [In Plate 125 it has been necessary to omit from the reproduction narrow strips from both ends of the original painting.]

36 *SUMMER AFTERNOON AFTER A SHOWER* (Plate 94)

This subject was engraved by David Lucas in 1831 for *English Landscape Scenery*. Lucas may have had access to the present sketch as well as to a large picture mentioned in his correspondence with the painter. Leslie gives the following account of the picture:

'Immediately on alighting from the coach after one of his journeys either to or from Brighton, Constable made the beautiful sketch from which the engraving in the *English Landscape*, called "Summer, Afternoon after a Shower", was taken; it was the recollection of an effect he had noticed near Red Hill.' (Leslie, *Life*, p. 129.)

37 *TREES AT HAMPSTEAD: THE PATH TO THE CHURCH* (Plate 95)

Whether or not the present work is the one mentioned in the following passage from a letter to Fisher of September 1821, the view expressed therein is certainly applicable to it and to other detailed tree studies which have survived (see Plates 77 and 78):

'. . . and independent of my *jobs* I have done some studies, carried further than I have yet done any, particularly a natural (but highly elegant) group of trees, ashes, elms and oaks &– which will be of quite as much service as if I had bought the feild and hedge row, which contains them and perhaps one time or another will fetch as much for my children.' (VI: 73)

38 *LANDSCAPE SKETCH ('THE LEAPING HORSE')*
(Plates 96 and 97)
DRAWING FOR 'THE LEAPING HORSE' (Plate 98)
THE LEAPING HORSE (Plates 99 and 137)

The barrier which the horse is jumping was one of those placed on the Stour tow-path to prevent cattle from straying.

The picture was probably begun in November or December, 1824. On 5 January 1825 Constable wrote to Fisher:

'I am writing this hasty scrawl [in the] dark before a six foot canvas—which I have just launched with all my usual anxieties. It is a canal scene . . .' (VI: 190) Later in the month he wrote, 'The large subject now on my easil is most promising and if time allows I shall far excell my other large pictures in it. It is a canal and full of the bustle incident to such a scene where four or five boats are passing with dogs, horses, boys & men & women & children, and best of all old timber-props, water plants, willow stumps, sedges, old nets, &c, &c, &c.' (VI: 191)

After the picture had gone to the exhibition, he wrote:

'I must say that no one picture ever departed from my easil with more anxiety on my part with it. It is a lovely subject, of the canal kind, lively—& soothing—calm and exhilarating, fresh—& blowing, but it should have been on my easil a few weeks longer.' (VI: 198)

A passage in the first edition of Leslie's *Life of Constable* (p. 51) reports that Plate 97, as one of two large sketches, may originally have been intended for development as the exhibition work, but this suggestion was removed by the author from the second edition.

The main area of the composition in which variations occurred is that in the region of the horse. According to his diary for 7 September 1825, written therefore after Plate 99 had returned from the Academy, he 'took out the old willow stump by my horse which has improved the picture much.' Holmes (*Constable and his Influence on Landscape Painting*, p. 247) proposes that this alteration involved the movement of the willow from in front of the horse to its present position. Reynolds, however (*Catalogue of the Constable Collection in the Victoria and Albert Museum*, p. 172), suggests that the exhibition work had shown two trees, one in each position, and that the right-hand one was removed. He points out that in Plate 97 there is evidence of a second tree having been removed from behind the horse. In the opinion of the present writer Holmes's interpretation is to be preferred.

Those reviewers of the 1825 exhibition who gave any attention to Constable's three contributions that year treated them sympathetically, and the writer in the *Literary Chronicle* described Plate 99 as 'in itself a host . . . a charming specimen of that fresh verdant scenery peculiar to this country'. It was exhibited as *Landscape*.

39 *'THE LOCK'* (Plate 100)
A BOAT PASSING A LOCK (Plate 102)

The subject is the lock at Flatford as seen from the direction of Flatford Mill. Constable made two interpretations, the first on an upright canvas (Plate 100), of which the ultimate version is in the Morrison collection, the second on a horizontal canvas, of which the ultimate version is the work he presented as his Diploma picture on being elected to full membership of the Royal Academy (Plate 102).

In April 1824 he wrote to Fisher:

'I was never more fully bent on any picture than on that on which you left me engaged upon. It is going to its audit with all its deficiencies in hand—my *friends* all tell me it is my best. Be that as it may I have done my best. It is a good subject and an admirable instance of the picturesque.' (VI: 155)

It was exhibited that year at the Royal Academy and bought on the opening day by James Morrison of Basildon Park for 150 guineas. The reviewer of *The Literary Gazette* wrote: 'The character of his details—like those of Wilson—appear as if struck out with a single touch, but this we are all aware comes only by great practice and much previous thought and calculation.' In May, the artist wrote to Fisher:

'My picture is liked at the Academy. Indeed it forms a decided feature and its light cannot be put out, because it is the light of nature—the Mother of all that is valuable in poetry, painting or anything else—where an appeal to the soul is required. The language of the heart is the only one that is universal—and Sterne says that he disregards all rules—but makes his way to the heart as he can. My execution annoys most of them and all the scholastic ones—perhaps the sacrifices I make for *lightness* and *brightness* is too much, but these things are the essence of landscape. Any extreem is better than white lead and oil and *dado* painting.' (VI: 157)

The picture was well received by Fuseli. 'I cannot now forbear to tell you that the picture of "The Lock" was greatly esteemed by the fastidious critic Fuseli, when it was at the Academy. It was his constant visit (leaning on the porter's arm) every Sunday morning.' (V: 61)

After the exhibition, the engraver S. W. Reynolds projected a mezzotint of the work, but, although it reached the stage of proof, it was never published. It was probably in connection with this that Constable had the picture in his studio the following April, when it was mentioned again in a letter to the Archdeacon. 'My Lock is now on my easil. It looks most beautifully silvery, windy & delicious—it is all health—& the absence of everything stagnant, and is wonderfully got together after only this one year.' (VI: 200) Later that year he finished a copy, now in the Fisher collection, of which he wrote that it 'rejoices me a good deal—it is a very lovely subject.' (II: 415)

Subsequently Constable made the second interpretation —closely related to his Diploma work—in which the boat was moved to the left outside the lock, the composition of the large trees changed and a stronger sense of spaciousness contrived.

40 *BARDON HILL* (Plate 103)

This study shows a part of the Coleorton estate of Sir George Beaumont and was made when the artist was staying there in 1823.

41 *A COTTAGE AND LANE AT LANGHAM* ('*THE GLEBE FARM*') (Plate 104)
THE GLEBE FARM (Plate 105)

The composition (Plate 105) was conceived as a memorial to Bishop Fisher, as the following passage from a letter to his nephew explains:

'My last landscape [is] a cottage scene—with the Church of Langham—the poor bishops first living—& which he held while at Exeter in commendamus. It is one of my best—very rich in color—& fresh and bright—and I have "pacified it"—so that it gains much by that in tone & solemnity.' (VI: 224)

As this indicates, the church is set in an unrelated landscape, for which the origin was the sketch (Plate 104) made at least ten years earlier. Constable exhibited a version of the subject—probably Plate 105—at the British Institution in 1827, and a further version is in the Barber Institute, Birmingham University.

Plate 105 was given by the artist to C. R. Leslie. According to a note in the catalogue of the Leslie sale in 1860:

'Mr Leslie saw Constable at work on this picture, and told him he liked it so much he did not think it wanted another touch. Constable said, "Then take it away with you

that I may not be tempted to touch it again." The same evening the picture was sent to Mr Leslie as a present.'

In 1836 Constable told Leslie, 'This is one of the pictures on which I rest my little pretensions to futurity.' (III: 144)

Lucas engraved the subject in a modified form for *English Landscape Scenery*, Constable writing to him, 'I have added a "Ruin" to the little Glebe Farm: for *not* to have a symbol in the book of myself, and of the "Work" which I have projected would be missing the opportunity.' (IV: 382)

42 *DEDHAM VALE* (Plates 106 and 108)

This picture (Plate 108) was being completed, for exhibition at the Royal Academy in 1828, at a time when Constable's father-in-law, Charles Bicknell, died, leaving him a bequest of £20,000. In March, his brother Abram wrote to him from East Bergholt:

'I earnestly hope your own picture of the Valley from Langham, that well known (& to me & to you) beautiful view, will be ready for the 8th April—I am sure you must have exerted yourself, very much if you do get it done, & I know you will not send it, if it is not what you think will stand the test.—I somehow think they must elect you next time R.A. but you don't much care about it I believe.' (I: 242)

After the exhibition had opened, Constable wrote in a long letter to Fisher:

'Painted a large upright landscape (perhaps my best). It is in the Exhibition, noticed (*as a redeemer*) by John Bull [a magazine], & another, less in size but better in quality, *purchased by Chantrey* [this was a *Hampstead Heath*, now in the Victoria & Albert Museum—see Plate 134].' (VI: 236)

In making this picture Constable may have referred to the small picture (Plate 106) which he had painted in 1802. This may have been influenced by a small Claude, then in the house of Sir George Beaumont's mother at Dedham, which he had copied two years earlier.

43 *A WINDMILL NEAR BRIGHTON* (Plate 110)
BRIGHTON BEACH, WITH COLLIERS (Plate 111)
HOVE BEACH (Plate 115)

It was in 1824 that Constable took his wife—with their children—to Brighton for her health, and during the weeks he spent there himself he made numerous drawings and oil sketches, among them the three reproduced here. Some he sent to Fisher in January 1825 and when the latter returned them he promised two volumes of Paley's sermons as well, saying, 'They are fit companions for your sketches, being

exactly like them: full of vigour, & nature, fresh, original, warm from observation of nature, hasty, unpolished, untouched afterwards.' (VI: 196)

44 GILLINGHAM, DORSET (Plates 112–114)

Constable made three pictures of Gillingham mill, a place he came to know through visits to Fisher, who became vicar there in 1819. The painter spent two months with his friend during the summer of 1820 and, from the Archdeacon's house at Salisbury, went into various parts of the diocese, the drawing of the road into Gillingham (Plate 112) being one product of his travels. He was there again in 1823 and this visit must have occasioned the paintings of the mill.

The structure—an undershot mill, worked by a branch of a stream from Stourhead—was burnt down in 1825 as Fisher reported to Constable:

'The news is, that Mat. Parham's (alias Perne's) mill is burnt to the ground, and exists only on your canvas. A huge misshapen, new, bright, brick, modern, improved, patent monster is starting up in its stead.' (VI: 206). To this the painter replied: 'I am vexed at the fate of the poor old mill. There will soon be an end to the picturesque in the kingdom.' (VI: 207)

To Maria he had written of Gillingham:

'This is a melancholy place—but it is beautifull, full of little bridges, rivulets, mills & cottages—and the most beautifull trees & verdure I ever saw. The poor people are dirty, and to approach one of the cottages is allmost insufferable.' (II: 287)

Plate 113 was exhibited at the Academy in 1826 and Plate 114 in 1827. The third version, now in the Fitzwilliam Museum, Cambridge, was made in 1824 and once belonged to Archdeacon Fisher.

45 SKETCH ('THE MARINE PARADE AND CHAIN PIER, BRIGHTON') (Plate 116)
THE MARINE PARADE AND CHAIN PIER, BRIGHTON (Plate 117)
THE SEA NEAR BRIGHTON (Plate 129)

The picture (Plate 117) was painted at Hampstead from studies made earlier at Brighton. Constable's opinion of the resort was mixed. He acknowledged its health-giving air: 'This is certainly a wonderfull place for setting people up . . .' (II: 434) But he was critical of its society and of its value as a source of subjects; he perhaps chose to make a large composition of this subject deliberately so as to pacify those, Fisher among them, who complained of the sameness of his themes. 'Fisher rather likes my coast, or at least beleives it to be a usefull change of subject.' (IV: 155) He may also have been trying to show that he could produce a type of beach scene enlivened with picturesque incident then extremely popular, in spite of his criticism of such things (see p. 45).

The picture was exhibited at the National Gallery in 1827 and in the British Institution in 1828. 'My Brighton', he wrote to Fisher, in August 1827, 'was admired—"on the walls"—and I had a few nibbles out of doors. I had one letter (from a man of rank) inquiring what would be its "selling" price.' (VI: 231) But the New Monthly Magazine was critical:

'This is an attempt of Mr Constable in a new style, and we cannot congratulate him on the change. The present picture exhibits the artist's usual freshness of colouring and crispness and spirit of touch, but it does not exhibit them in connection with the objects to which they are so appropriate as they are to green trees, glittering rivulet and all the sparkling detail of morning scenes in the country. Mr Constable's style is rural and adapted to rural subjects almost exclusively. We do not mean that he cannot change it, but change he must, if he would meet with success in general subjects.'

In December 1828, soon after the death of Maria, Fisher wrote to Constable as follows:

'Evans letter was so far satisfactory that he reported you in a state of complete self-possession—I entreat you to retain it, for you have need only to look within yourself and find satisfaction. I wish if "Brighton" is not out of your possession that you would put it on an easil by your side, Claude fashion, & so mellow its ferocious beauties. Calm your own mind and your sea at the same time, & let in sunshine and serenity. It will be then the best sea-painting of the day.' (VI: 240)

COAST AT BRIGHTON, STORMY DAY (Plate 124)
COAST SCENE, BRIGHTON (?): EVENING (Plate 128)

In the spring of 1828 Maria's illness intensified and Constable later sent her to Brighton again. On 11 June he wrote to Fisher, 'My wife is sadly ill at Brighton.' Plate 124 was made there six weeks later and, besides seeming to reflect his anxious feeling, it anticipates the atmospheric effect which dominated his next major composition, Hadleigh Castle.

Reynolds (*Catalogue of the Constable Collection in the Victoria and Albert Museum*, p. 183) has suggested that Plate 128 is a Brighton subject made in the same year.

46 *LANDSCAPE SKETCH* ('*THE CORNFIELD*')
(Plate 118)
THE CORNFIELD (Plates 73 and 119)

According to the painter's son Charles, this picture represented 'the lane leading from East Bergholt . . . to the pathway to Dedham across the meadows, a quarter of a mile from East Bergholt church, and one mile from Dedham Church, as the crow flies.' (*Art Journal*, 1869.) The distant church was an invention. As Beckett points out, Constable would have walked along this lane as a boy on his way to and from school at Dedham. In composing it, he sought the advice of a botanist friend, Henry Phillips, about the plants in the foreground.

'I think it is July in your green lane. At this season all the tall grasses are in flower, bogrush, bullrush, teasel. The white bindweed now hangs its flowers over the branches of the hedge; the wild carrot and hemlock flower in banks of hedges, cow parsley, water plantain, &c: the heath hills are purple at this season; the rose-coloured persicaria in wet ditches is now very pretty; the catchfly graces the hedge-row, as also the ragged robin; bramble is now in flower, poppy, mallow, thistle, nop, &c . . .' (V: 80)

On 8 April 1826 Constable wrote to Fisher:

'I have dispatched a large landscape to the Academy—upright, the size of my Lock—but a subject of a very different nature—inland—cornfields—a close lane, kind of thing —but it is not neglected in any part. The trees are more than usually studied and the extremities well defined—as well as their species—they are shaken by a pleasant and healthfull breeze—"*at noon*"—"while now a fresher gale, *sweeping with shadowy gust the feilds of corn*" . . . My picture occupied me wholly—I could think of and speak to no one. I was like a friend of mine in the battle of Waterloo—he said he dared not turn his head to the right or left—but always kept it straight forward—thinking of himself alone . . . I do hope to sell this present picture—as it has certainly got a little more eye-salve than I usually condescend to give to them . . .' (VI: 216–17)

It was exhibited at the Royal Academy simply as *Landscape* and, in the following year, at the British Institution as *Landscape: Noon*, with the lines from Thomson's *Summer* correctly quoted:

> A fresher gale
> Begins to wave the woods and stir the streams
> Sweeping with shadowy gusts the fields of corn.

The critic of *The Times*, who thought Constable's two contributions the best landscapes in the R.A. exhibition, said that *The Cornfield* 'is singularly beautiful, and not inferior to some of Hobbema's most admired works'. It was exhibited at the Paris Salon in 1827 but apparently received no great attention. In 1837 the picture was purchased by subscription for the nation.

47 *HADLEIGH CASTLE* (Plates 120–123)

Constable visited Hadleigh in July 1814, during a visit to the Revd Walter Wren Driffield, a Suffolk man who was also a friend of his father's and who had baptized him. Driffield was then living at Feering, and the painter went there to draw his house. In a small sketchbook he made studies of various scenes along the Essex coast of the Thames estuary, the drawing of Hadleigh (Plate 123) upon which the painting is based being among them.

To Maria at that time he wrote:

'I was always delighted with the melancholy grandeur of a sea shore. At Hadleigh there is the ruin of a castle which from its situation is a really fine place—it commands a view of the Kent hills, the Nore and North Foreland & looking many miles to sea.' (II: 127)

Plate 121 was exhibited at the Royal Academy in 1829 as *Hadleigh Castle. The mouth of the Thames—morning, after a stormy night*, Constable's other name for it being *The Nore*. The picture was painted at Hampstead, and before bringing it to the exhibition Constable confessed his anxiety about it to Leslie:

'I have persevered on my picture of the Castle which I shall bring to Charlotte [Street] early tomorrow morning. Can you oblige me with a call to tell me whether I can or ought to send it to the [*Pandemonium* deleted] Exhibition. I am grevously nervous about it—as I am still smarting under my election.' (III: 20)

The title was followed by some lines from Thomson's *Summer*

> The desert joys
> Wildly through all his melancholy bounds
> Made ruins glitter; and the briny deep,
> Seen from some pointed promontory's top,
> Far to the blue horizon's utmost verge,
> Restless, reflects a floating gleam.

According to Leslie, on one of the varnishing days:

'Chantrey told Constable its foreground was too cold, and taking his palette from him, he passed a strong glazing of asphaltum all over that part of the picture, and while this was going on, Constable who stood behind him in some degree of alarm, said to me "there goes all my dew." He held in great respect Chantrey's judgment in most matters, but this did not prevent his carefully taking from the picture all that the great sculptor had done for it.' (*Life*, p. 177)

The picture divided the reviewers more than any of his previous large composition. The *Morning Chronicle* thought it 'noble' and the *London Magazine* writer mixed praise with his reservations:

'But for that accursed bespattering with blanc d'argent— or whitewash-splashing as Mr Turner will have it—how excellent. Mr Constable persists in his manner, yet, as he goes on, somehow or another, he contrives to improve; his effects are more vigorous and masterly than ever, and "excepting as before excepted", perfectly natural.'

The *Gentleman's Magazine*, however, found this practice, 'the appearance of having been scattered over, while the colouring was fresh, with a huge quantity of chopped hay . . . in execrable taste, having no resemblance to any appearance in Nature—this artist's standard of excellence.'

48 *THE DELL IN HELMINGHAM PARK* (Plates 127 and 130)

Helmingham Hall, about twenty miles north of East Bergholt, was the seat of Constable's friend and patroness, the Countess of Dysart, and the painter made several versions of the subject, the first for James Pulham in 1825; this the painter later bought back and sold to Robert Ludgate. The present work (Plate 127) was painted for William Carpenter and exhibited at the Royal Academy in 1830, but, before exhibiting it, Constable asked Carpenter to allow him to retain it in his possession and by so doing broke their association.

Constable must have known the place at least as early as 1800. He had written to Dunthorne: 'Here I am quite alone among the oaks and solitude of Helmingham Park . . . There are abundance of fine trees of all sorts; though the place upon the whole affords good objects rather than fine scenery . . .' (II: 25)

The reviewer of the *Morning Post* noticed the picture most favourably, writing that 'It has all the richness of truth of Gainsborough's best efforts without his tameness, and in brilliance and variety of colour it may vie with many of the landscapes of Rubens.' He also approved the absence of what he called the 'spottiness', but the critic of the *Morning Chronicle*, who was to attack Constable's contributions for several years to come, referred to his 'fantastic and coarse style of painting', and compared him unfavourably with Callcott and F. R. Lee. 'Effect, quocunque modo, is the idol of Constable, both in his painting and himself, and both would be more respected with less coarseness.'

A version of the subject was engraved by Lucas for *English Landscape Scenery*.

49 *DEDHAM, A LOCK* (Plates 131 and 132)

Neither of these compositions, which show Dedham Church in the distance and locks near the village in the foreground, is closely connected with any of the surviving compositions by the artist, although it is conceivable that they may have had some part in the generation of the lock subjects of 1824–6. Their placing here should not be taken as an indication of their date. Both were probably painted before 1830.

50 *THE COTTAGE IN A CORNFIELD* (Plate 135)

On 2 March 1833 Constable wrote to Leslie, 'I have licked up my cottage into a pretty look' (III: 94) and in the Royal Academy exhibition of the same year he showed a *Cottage in a Cornfield*. It has generally been supposed that this was the painting reproduced here, a work whose simple, lucid style suggests that it was executed at an earlier date; it is indeed conceivable that it may be a modified version of the picture, then entitled *A Cottage,* that he had shown at the Academy in 1817. The fact that the pencil study connected with it, now in the Victoria and Albert Museum (828–1888), was made about 1815 has little bearing upon the problem, for the artist was accustomed to draw upon his early sketchbooks for subjects many years afterwards.

A mezzotint of Plate 135 by David Lucas appears in *English Landscape Scenery*.

51 *OLD SARUM* (Plates 142 and 143)

This sketch (Plate 142) was the basis of the two plates mezzotinted by David Lucas for *English Landscape Scenery* (see Plate 143), Constable being, initially, dissatisfied with the

first but, afterwards, when a second had been made, changing his mind. In October 1831 he wrote to Lucas, 'Keep the new "Old Sarum" clear, bright and sharp, but don't lose the solemnity.' (IV: 358)

52 STONEHENGE (Plates 144 and 145)

Constable recorded this suggestive subject as early as 1820 in an austere, descriptive drawing which is also in the Victoria and Albert Museum (309–1888). By the date of the works reproduced here, the associations which the artist recorded on the mount would have reflected his sense of artistic identity: 'The mysterious monument of Stonehenge, standing remote on a bare and boundless heath, as much unconnected with events of past ages as it is with the uses of the present, carries you back beyond all historical records into the obscurity of a totally unknown period.' Plate 145, which he described to Leslie as 'a beautiful, drawing of Stonehenge; I venture to use such an expression to you', conveys as well as any of his works that personal response, of his later years, to qualities in nature and art which then and earlier would have been defined by painters and connoisseurs as Sublime.

53 STORMY EFFECT, LITTLEHAMPTON (Plate 146)
TILLINGTON CHURCH (Plate 147)
THE RUINS OF COWDRAY CASTLE (Plate 152)

These watercolours, with their dense washes of colour and broad, vigorous handling, are characteristic of those which Constable was making in the last years of his life, when he was using this medium more frequently in the kind of studies for which he might earlier have employed oil colours. Plates 147 and 152 were made during his stay with the Earl of Egremont at Petworth in September 1834 and Plate 146 the following year on one of his visits to his friend, George Constable.

54 SALISBURY CATHEDRAL FROM THE
MEADOWS (Plates 148 and 150)

The subject was probably first conceived during one of Constable's last visits to Archdeacon Fisher in 1829. In August of that year Fisher wrote to him, 'The great easil has arrived & waits his office. Pray do not let it be long before you come and begin your work.

'I am quite sure the "Church under a cloud" is the best subject you can take. It will be an amazing advantage to go every day & look afresh at your material drawn from nature herself.' (VI: 250–1)

The view shows the river Avon in the foreground with Leydenhall, Fisher's residence, on the right obscured by trees and the grounds of King's House on the left. It may be assumed that Plate 148 was painted during the development of the ultimate work (Plate 150), which was shown at the Royal Academy in 1831, the catalogue entry including the following quotation from Thomson's *Summer*.

> As from the face of Heaven the scatter'd clouds
> Tumultuous rove, th'interminable sky
> Sublimer swells, and o'er the world expands
> A purer azure, through the lightened air
> A brighter lustre and a clearer calm.
> Diffusive tremble: while as if in sign
> A danger past, a glittering note of joy
> Set off abundant by the yellow sky
> Invests the fields and nature smiles revived

This quotation caused the writer in the *Gentleman's Magazine* to question Constable's handling which he pretended to believe indicated that the landscape lay under a snowstorm. Other reviewers also commented with similar ferocity upon the artist's method of working: 'Mr Constable's coarse, vulgar imitation of Mr Turner's freaks and follies . . .' (The *Morning Chronicle*); 'A very vigorous and masterly landscape, which somebody has spoiled since it was painted, by potting in such clouds as no human being ever saw, and by spotting the foreground all over with whitewash . . .' (*The Times*)

In June Constable wrote to Leslie:

'A book, "Library of the Fine Arts" is just left here, in which they speak highly, & very properly of your pictures— & perhaps fairly, of my "chaos" as they term the Salisbury. They say (after much abuse & faults) "it is still a picture from *which it is impossible to turn without admiration*".'

Thereafter, for the next three years, Constable continued to work on the picture. It was sent to the British Institution in 1833 and before that the artist wrote to Leslie:

'I have much to do with the great Salisbury and I am hard run for it . . .' (III: 88) 'I have got the Great Salisbury into the state I always wished to see it—and yet have done little or nothing—"it is a rich and most impressive canvas" if I see it free from self-love.' (III: 89)

In August 1834, before sending the painting to an exhibition at Birmingham, he wrote to the same friend:

'I have never left my large Salisbury since I saw you.

'It would much—very much—delight me, if, in the course of today (as it goes tomorrow), you could see it for a moment. I cannot help trying to make myself beleive that there may be something in it, that, in some measure at least, warrants your (too high) opinion of my landscape in general.' (III: 113)

He was still preoccupied with the picture in the last months of his life, when he was concerned with the condition of David Lucas's large mezzotint of the subject. Although he could report to George Constable in February 1837, 'My great Salisbury print is done', a few weeks later he wrote to the engraver:

'I have had much anxiety about the bow—it has never been quite satisfactory in its *drawing* to my eye. John [Dunthorne] and I have now clearly and directly set it out— and in the most accurate manner possible, which must obviate all cavillings, & carping, from the *learned ignorant*.' (IV: 436)

On the day before his death Constable's thoughts were still on it.

'I am quite pleased to see how well you are preparing for the new bow. The proof is about what I want—I mean that you took hence. I took the centre from the elder bush—a blossom to the left—you will do possibly the same . . . We cannot fail of this plate with a proper bow.' (IV: 438)

55 *WATER-MEADOWS NEAR SALISBURY* (Plate 149)

This picture was almost certainly painted in 1829, during the visits which the artist made that summer to Archdeacon Fisher, and it was probably painted in the open air. When he sent the work for exhibition at the Royal Academy in 1829, instead of its being hung without question, Constable being an Academician, it was placed before the selection committee, who rejected it, one of the members calling it 'a nasty green thing.' When the artist, who was present as a member of the hanging committee, declared that the picture was painted by him, the President, Martin Archer Shee, insisted that it should be admitted, but Constable refused to allow the original decision to be changed. Several versions of the incident can be found: in *Richard Redgrave, A memoir*, by F. M. Redgrave, 1891, pp. 284–5; in W. P. Frith, *My Autobiography*, 1887, vol I, pp. 237–8; and by Anderdon, quoted in Whitley, *Art in England, 1820–37*, p. 330.

56 *THE GROVE, HAMPSTEAD* (*THE ADMIRAL'S HOUSE*) (Plate 151)

This is probably the picture exhibited at the Royal Academy

in 1832 as *A romantic house at Hampstead*. Another study, in the Victoria and Albert Museum (137–1888), shows the house from the side and includes a rainbow.

57 *A SLUICE, ON THE STOUR* (?) (Plate 153)

Reynolds (*Constable, the Natural Painter*, p. 223) has suggested that this was probably the lock at Dedham Mill.

58 *THE CENOTAPH AT COLEORTON* (Plates 155 and 156)

The subject of this picture is the memorial to Sir Joshua Reynolds which Sir George Beaumont erected at the end of a newly planted avenue on his estate at Coleorton. The Cenotaph bears a poem of eighteen lines by Wordsworth, written at Beaumont's request.

Constable saw the Cenotaph on his visit to Coleorton in 1823, when 'at the end of one of the walks, [he] saw an urn & bust of Sir Joshua Reynolds—& under it some beautifull verses by Wordsworth.' (VI: 143)

It is impossible to establish whether the drawing dated 28 November 1823 (Plate 155) was made at Coleorton— Leslie reports that *a* drawing was made there—or in London. Neither it nor the painting includes the bust of Reynolds which the artist said he saw. The busts of Raphael and Michelangelo are presumably an invention.

Although he had started the work at least as early as 1833, he did not show it at the Royal Academy until 1836 and then only because he wished it to be in the last exhibition in the Academy's original premises in Somerset House, in view of its connection with Reynolds. '. . . I preferred to see Sir Joshua Reynolds's name and Sir George Beaumont's once more in the catalogue, for the last time in the old house. I hear it is liked, but I see no newspaper, not allowing one to come into my house.' (V: 32)

In March 1833 he had written to Leslie: 'I have laid by the Cenotaph *for the present*. I am determined not to harrass *my mind* and HEALTH by scrambling over my canvas—as I hitherto have too often done.' (III: 96)

59 *A VIEW OF LONDON, WITH SIR RICHARD STEELE'S HOUSE* (Plate 157)

The view is painted from what is now called Haverstock Hill; Steele retired in 1712 to the small house in the right foreground. This is presumably the picture exhibited at the Royal Academy in 1832 as *Sir Richard Steele's Cottage, Hampstead*.

60 *LANDSCAPE SKETCH ('THE VALLEY FARM')*
 (Plate 159)
THE VALLEY FARM (Plate 160)

The subject (Plate 160) is a free interpretation of Willy Lott's house, which had appeared in *The Hay Wain*. It was exhibited at the Royal Academy in 1835 but had been bought beforehand, when it was still in the artist's studio, by a self-made man, Robert Vernon, who had for some years been forming a collection of modern pictures.

In March Constable wrote to Leslie:

'My picture must go—but it is woefully deficient in paint in places. Yesterday Mr Wells saw it [William Wells, another collector and among the chief victims of Constable's assaults upon the kind of connoisseur he most despised] & though he said, perhaps it is a little better, yet he added, "You know I like to be honest"—*but* fortunately for me and the art, I am sure it was not *at all* to his liking. . . . Mr Vernon came soon after with the Chalons—he saw it free from the mustiness of old pictures—he saw the daylight purely—and bought it—it is his—only I must talk to you about the price, for he leaves it all to me.' (III: 123)

In April 1835 the artist wrote to George Constable: 'Mr Wells, an admirer of common place, called to see my picture and did not like it at all, so I am sure there is something good in it. Soon after, Mr Vernon called, and bought it, having never seen it before in any state. . . .' (V: 20) According to Leslie, Vernon asked whether the picture was painted for any particular person, Constable's reply being, 'Yes, sir, it was painted for a *very particular* person,—the person for whom I have all my life painted.' (*Life*, p. 239). Vernon paid £300 for it.

The earliest appearances of the composition occur on two pages of the 1813 sketchbook in the Victoria and Albert Museum. This was almost certainly followed, perhaps only two or three years later, by a work in the Forteviot collection. The two small oil sketches in the Victoria and Albert Museum, of which Plate 159 is one, can, by reason of their colour and handling, be assigned to a time immediately before the emergence of the ultimate version. Two studies of ash trees on Hampstead Heath which contributed to the right side of the composition are in the Victoria and Albert Museum (252–1888 and 1249–1888).

The criticism the picture met with was as astringent as any which Constable received, the reviewer of *Blackwood's Magazine* being particular violent.

'It is the poorest in composition, beggarly in parts, miser-ably painted and without the least truth of colour—and so odd that it would appear to have been powdered over with the dredging box or to have been under an accidental shower of white lead—which I find on enquiry is meant to represent the sparkling of dew. The sparkling of dew! Did ever Mr Constable see anything like this in nature. If he has, he has seen what no one ever pretended to have seen. Such conceited imbecility is distressing, and being so large it is but misguided folly.'

The writer apologized in a later issue, admitting that he had 'used expressions that are too strong'.

The later stages of the work upon the final composition were at a time when Constable was in particularly low condition, for not only was he in poor health during the early months of that year but unhappily concerned about the development of *English Landscape Scenery*.

'My indisposition sadly worries me and makes me think (perhaps too darkly) on almost every subject . . .', and, obsessed by a sense of failure, 'the painter himself is totally unpopular and ever will be, on this side of the grave certainly . . .' (IV: 344)

In spite of these strictures, Constable wrote to Charles Boner in March 1836:

'It passed the ordeal of the Academy, pretty well, its ice & snow being proof against the heat of the criticism. After its return I worked exceedingly upon it—mellowing and finishing it to the utmost in my power—and it is in the very best situation in the British Gallery . . .—keeping all other landscape at a respectfull distance.' (V: 196–7)

After the exhibition Constable took the picture back to his studio and continued to work on it for several months more, as he wrote to John Chalon, 'Oiling out, making out, polishing, scraping &c seem to have agreed with it exceedingly. The "sleet" and "snow" have disappeared, leaving in their places, silver, ivory and a little gold.' (IV: 278)

61 *ON THE RIVER STOUR* (Plate 162)

This composition appears first in an ink drawing which, according to the inscription, was made on the evening of Christmas Day, 1829. The subject is again Willy Lott's house. Plate 162 must be assigned to the last years of the painter's life and, perhaps because Constable was not striving to achieve a large-scale finished and monumental composition, it must represent his late style in its most persuasive form as an extension of the treatment used in the more informal version (Plate 161) seen from the other side

of the stream from the *Hay Wain* viewpoint. [In Plate 161 it has been necessary to omit from the reproduction narrow strips from both ends of the original painting.]

62 *COTTAGE AT EAST BERGHOLT* (Plate 163)

This profoundly impassioned work, with its agitated handling and signs of impulsive improvisation (a piece of canvas was added to the right of the original support), makes this picture—an emotional transformation of a simple subject—a most characteristic product of Constable's later years.

63 *STOKE-BY-NAYLAND* (Plate 165)

The same view, with different figures and animals, appears in the second number of *English Landscape Scenery*, but the sketch from which it was made is not extant.

64 *THE RUINS OF MAISON DIEU, ARUNDEL* (Plate 166)

This drawing was probably made during the artist's summer visit to George Constable in 1835.

65 *ARUNDEL CASTLE* (Plate 167) *ARUNDEL MILL AND CASTLE* (Plate 168)

This picture (Plate 168), which Constable was working on the day he died, was intended for the Royal Academy exhibition of 1837, and was, indeed, shown there posthumously in that year. It had been started earlier, for showing in 1836, but was then set aside in favour of *The Cenotaph* (Plate 156).

The artist's association with Arundel was the consequence of his friendship, begun in 1832, with George Constable, a maltster and amateur painter (but not a relative), who had originally approached him about his *English Land-scape Scenery*. In July 1834, after the severe illness in that year, John Constable went down to Arundel with his eldest son and from there wrote the following to Leslie: 'The Castle is the cheif ornament of this place—but all here sinks to insignificance in comparison with the woods and hills. The woods hang from excessive steeps, and precipices, and the trees are beyond everything beautifull: I never saw such beauty in *natural landscape* before. I Wish it may influence what I may do in future, for I have too much preferred the picturesque to the beautifull—which will I hope account for the *broken ruggedness of my style*.' (III:111) A drawing had been made a week before and was presumably the source of the painted composition.

Another visit was to follow exactly a year later, when presumably he executed the drawing illustrated here (Plate 167), and the close relationship between the two men persisted until the painter's death. In February 1837 he wrote:

'I am at work on a beautifull subject, Arundel Mill, for which I am indebted to your friendship. It is, and shall be, my best picture—the size, three or four feet. It is safe for the Exhibition, as we have as much as six weeks good.' (V: 37)

66 Text to *SPRING*

This proof of a note for the text of *English Landscape Scenery* was first brought to attention by Leslie Parris and C. J. D. Shields in their stimulating exhibition, *Constable: The Art of Nature* (Tate Gallery, 1971). Constable's innumerable corrections to the text and his obsessional anxiety to find a suitable formulation of the ideas may not only be compared with his struggles to ensure that Lucas's mezzotints fulfilled his purpose, but make an interesting visual comparison with the characteristics of the painter's late pictorial style (cf. Plate 163).

A note on the portraits

THE PORTRAITS reproduced in this book (Figures 1 to 14) have been chosen as showing members of the artist's family and friends. Constable's portraiture has never, I believe, been systematically studied, and although it is important to take account of its significance in his professional career, the work itself is, collectively, neither individual enough nor expressive enough to affect any critical estimate of his painting. He undoubtedly thought it to be quite incidental to his main concern, landscape. In a period before the invention of photography, when a competent artist could readily secure portrait commissions, Constable's motives are quite easily recognizable—to record those who were dear to him or to gratify their needs, and to gain an income from painting as well as to justify his vocation to his family. His attitude to the matter is indicated by the fact that he did not exhibit any portraits at the Royal Academy, although that would have been a means of extending his clientele, and that in his correspondence, although certain commissions are mentioned, he does not comment upon the nature and demands of this form of art nor express his own reactions to it.

His portraits are, however, relatively numerous; the relevant files in the Witt Library show more than seventy. The most attractive quality he could achieve was a free, lively handling which gave the sitter a certain vitality and spirit, and this is most regularly found, as might be expected in so emotionally responsive an artist, in portraits of the family. Even in them, however, there is that absence of strongly characterized and eloquent forms which deprives almost all the portraits of force and presence.

THE FOLLOWING SECTIONS are intended to provide the reader with a selection of passages from the abundant material which Constable's writings, formal and informal, supply, and from which a very full understanding of his ideas and prejudices, experiences and enjoyments, is to be had.

APPENDIX I

Constable's correspondence, including the letters he received from friends and acquaintances, was assembled by R. B. Beckett, exhaustively annotated, and published in six volumes by the Suffolk Records Society. One criticism which might be made of this admirable enterprise is that the editor chose to organize the writings not in a chronological sequence, but according to the individuals with whom the painter corresponded; thus one volume is devoted to letters to and from Bishop and Archdeacon Fisher, another to those he wrote to C. R. Leslie, etc. For this reason it is difficult to obtain a consecutive account of the development of the artist's thoughts, impressions and feelings.

The following sequence of letters, written to his wife and Archdeacon Fisher in 1823, when Constable was staying with Sir George Beaumont at Coleorton, Leicestershire, has been chosen not only because they have the coherence given to them by this occasion, but also because they convey so strongly the artist's personality, affections and interests.

Beaumont, who was born in Essex in 1753 and succeeded to his father's title at the age of eight, was one of the most interesting and attractive men of his time. He was taught drawing at Eton by Alexander Cozens and at Oxford by John Malchair. He travelled in Italy with William Beckford and there he met John Robert Cozens. In the 1780s, apart from gaining the friendship of Reynolds, Gainsborough and Wilson, he began to acquire pictures—his first important acquisition being a Claude—and thereafter he was to be one of the most discerning collectors of the period and one who made his possessions freely available. In his own work as a painter—and although classed as an amateur he pursued his art with all the purposefulness of a professional—and in his opinions, he must be considered a conservative, but this did not prevent him from winning the affection and regard of a host of painters and poets. In the new hall, designed by George Dance, that he built on the family estate at Coleorton this charitable and sensitive man entertained a host of the most eminent men of the day. Wordsworth, Coleridge and Scott were among his friends. Benjamin Haydon, who stayed there with Sir David Wilkie, wrote, 'We dined with the Claude and the Rembrandt before us and breakfasted with the Rubens landscape and did nothing morning, noon or night, but think of painting, talk of painting, dream of painting and wake up to paint again.' Beaumont's association with Constable has often been considered in relation to that question which, according to Leslie, he put to the painter, 'Do you not find it very difficult to determine where to place your brown tree?' But apart from giving a false impression of his artistic sensibility, it also fails to do justice to the admiration Constable had for a man who treated him and his works with such warmth and uncondescending sympathy. They had first met at least as early as 1801 on one of those occasions when Sir George stayed with his mother in her house at Dedham, and the association was always kept alive during the next twenty years. The painter's visit to Coleorton in 1823, four years before Beaumont's death, was to be, however, the most important episode in their relationship.

APPENDIX II

In 1829, having in his own opinion failed, through painting, to have imposed upon educated taste his ideals of landscape, Constable decided to issue a publication in which carefully chosen examples of his work would be reproduced. For this task he chose a young mezzotint engraver, David Lucas, the pupil of S. W. Reynolds, who, a few years earlier, had considered reproducing some of Constable's works. The enterprise was to be arduous for both men, harassing, and commercially unprofitable. By the date of the painter's death five numbers of *English Landscape Scenery*, each containing four prints, had been published together with an introductory text and some explanatory notes. A full account of the project can be found in Shirley, *The published Mezzotints of David Lucas after John Constable R.A.* (1930) and in Volume IV of *John Constable's Correspondence*, ed. R. B. Beckett, pp. 304–463. The various texts which accompany the mezzotints were laboriously and anxiously compiled, but they contain passages which most expressively reveal the painter's ideals, and it is some of these which are republished here.

APPENDIX III

The following anthology of observations is compiled from Constable's letters, from the surviving notes on his lectures on the history of landscape painting and from Chapter XVII of Leslie's life of the artist. Here, as elsewhere in this volume, the passages from the letters are followed by a reference to the Beckett edition; thus (V: 100) means that the letters quoted will be found on page 100 of Volume V. As far as the passages from the lecture notes are concerned references are to *John Constable's Discourses*, ed. R. B. Beckett, 1970.

Appendix I: The letters from Coleorton

Coleorton Hall. Octr. 21, 1823.

My very dear Love,

I hasten to fulfill my promise to write to you on my arrival here—though Sir George and Lady Beaumont both wish me to defer it to another day, as he wants me in his painting room. But you are every thing to me and every thing I wish.

O dear this is a lovely place indeed and I only want you with me to make my visit quite compleat—such grounds—such trees—such distances—rock and water—all as it were can be done from the various windows of the house. The Church stands in the garden & all looks like fairy land.

I wish you to write to Mrs. Whalley, she will take it sisterly and kind—tell her what an adventure I had at Leicester, as I was determined not to go by without seeing Alicia. I did not chuse to dine at Northampton—but counted much on tea at Leicester. Just as it was made and almost poured out, I ran to Miss Linwood's to find unfortunately that she & all her young ladies were at the theatre (about half past 8). Thither I hastened—saw Alicia—shook hands—kissed her. She looked delightfully, her fair hair *frizzed* and beautifully parted on her fair round forehead, her cheeks rosy (owing to being surprised by a *Gentleman*), and chin dimpled, and her teeth beautifully white.

Saw three strange figures on the stage—one in pompadour pantaloons with ruffles at his knees & a tail who had just ended a strange song—and the whole theatre clapping their hands—all this took place in half a minute—hastened back to the inn to finish my tea—party broke up—coach driving off and myself nearly left behind. Will not this amuse her? Copy it, & your letter will be almost finished.

Only think that I am now writing in a room full of Claudes (not Glovers)—real Claudes, and Wilsons & Poussins &c.—almost at the summit of my earthly ambitions. I cannot help asking myself how I came here—but I think of you and am sad in the midst of all—and my ducks, my darling Isabel & my Charley boy, my Minna & my dear dear John—& last but not least in my heart, my poor Fish, *here*—but the tears are in my eyes, and I will say farewell.

J.C.

I am just returned from a walk—all round and about with Sir G. He is now painting, & I shall take my box, and do a bit of rock or tree covered with moss.

Cannot you send down Ellen, for the cat and paper for room—Mr. Haines's picture of the Lake, and give it him? Tell them poor dear Dr. Baily . . . ed to receive it. Take it yourself with John in a silk handkerchief. Had you a pleasant evening Tuesday?

Coleorton Hall. Octr. 27, 1823.

Thank you my dearest girl for your letter, it was a most acceptable guest. How glad I am to hear you are so well—and that you have been all out & that the Firths are such nice neighbours.

We find such occupation here that I can hardly say when I shall come back whether this week or not 'till the next. Sir George and Lady Beaumont are so kind to me, that I feel quite at home. I will tell you what we do and what we have done and how we pass the time making every day much too short for me.

All are early here—and I am now writing before breakfast that when the boy goes to Ashby to post at ten, I may be ready.

We breakfast at half past 8, but to day we began for the winter hour 9—this habit is so delightfull that if you please we will adopt it, but I must say you are very good.

We do not quit the table immediately but chat a little about the pictures in the room, the breakfast room containing the Claudes. We then go to the painting room, and Sir George most manfully like a real artist sets to work on any thing he may fix upon—and me by his side. At two o'clock the horses are brought to the door—and Lady Beaumont hunts us both out.

So one of these fine days I had the opportunity of seeing the ruins at Ashby, the mountain streams and rocks (such Everdingens) at Griesdieu, and an old convent there, Lord Ferrer's—a grand but melancholy spot—I could think of the Lord Ferrers who was hanged for shooting his steward.

We then return to dinner. Do not sit long—hear the news paper by Lady Beaumont (the Herald—let us take it in town)—then to the drawing room to meet the tea—then comes a great treat. I am furnished with some beautifull portfolio, of his own drawings or otherwise, and Sir George reads a play, in a manner the most delightfull—far beyond any pronounciation I ever heard—on Saturday evening it was 'As You Like It', and the Seven Ages I never so heard before.

Last evening (Sunday) he read a sermon and a good deal of Wordsworth's Excursion, it is beautifull but has some sad melancholy stories, and as I think only serve to harrow you up without a purpose—it is bad taste—but some of the descriptions of landscape are beautifull. They strongly wish me to get it.

Then about 9 the servant comes in with a little fruit and decanter of cold water and at eleven we go to bed—where I find a nice fire in my bed room—and I make out about an hour longer, as I have everything here, writing desk &c. This makes me grudge a moment's sleep here.

I shall have much to say, & I am sure this visit will form one of the epocks of my life in [taste], industry, pride, and so

on—& I will take care of myself and not let vulgar writers come and insult and intrude upon me as I have done, I will have a proper opinion of myself. A friend of ours, an R.A., is much laughed at here, and fully known—but we will talk of this matter alone.

This is a dreary morning, but I do not mind, I have so much that I want within—but I shall make a few sketches on the grounds, & I have done a little one from the window. Sir G. has kindly allowed me to make a study of a little Claude, a Grove—probably done on the spot.

If you like to stay where you are 'till I come *pray do*—never mind Roberts—did she get the money? If you return this week pray let Sarah get the fires well done in all the rooms, not forgetting my painting room.

I have nailed up the back nursery window. Let it be undone. Remove the large canvas out of the front into the back parlour but do it carefully not to let them lean it against any thing. Ask if Sarah wants money.

It rains gently—so that probably I shall get a good day's work.

Nothing can be more attentive than the servant Joseph who remembers me at E. Bergholt years ago.

Do not expect me this week. Kiss all our darling ducks.

Yours ever affectionately
J. Constable

Ask Roberts if she wants the money for her new pelisse I have promised to give her this winter, trusting in God we shall not have such another one as the last.

Thank you for writing to Mrs. Whalley—I am sure she must be pleased. I shall write from here to Mr. Lewis. Eat the venison yourselves by all means with Uncle Joe. Lady B. seems quite interested in poor Captain Parry—to be jilted is dreadfull—the Lady must be colder than the ice and snow of the North Pole.

It wants only a quarter of nine, & I expect the bell for breakfast. Nothing can be so punctual as they are. Every step from this door is a picture—the garden is beyond all description, rock, ruins, the Church, the house, the mountain &c &c.

I am anxious my dearest girl to hear from you—and very desirous of knowing if you are arrived from Hampstead and how all my darlings are, and if you got the money from the Bank.

I hope to be soon with you, as I am anxious to see all my darlings—I miss them & you so much—but nothing can be more kind and obliging in every way that can be thought of than are Sir G. and Lady Beaumont. I am only to think of a thing and I can have it, and I have now lost all that uncomfortable reserve and restraint that I first had.

Nothing would amuse you so much as to see Sir G. and myself hard painting by the side of each other. I have finished a beautifull copy of the little Claude—a sunset. They say it is a wonderfull little copy—at any rate by doing it well when I was about it it may be worth something for our children. I have begun another which I hope to complete this week, the little Grove.

What a delightfull place this is. The weather has been bad—and I do not at all regret being confined to this house. The mail yesterday did not arrive 'till many hours after the time owing to some trees being blown down and the water was out at Newport Pagnal.

I am now going to breakfast—before the Narcissus of Claude. How enchanting and lovely it is, far very far surpassing any other landscape I ever yet beheld.

Write to me. Kiss and love my darlings. I hope my stay will not surpass this week—but now that I have such an opportunity, I cannot lose it.

Ever my dear Fish yours most affectionately
J. Constable

Sunday morning, Coleorton Hall—Oct. 2nd 1823.
Pray keep good fires, and do not let the children play in the cold ante room & painting room. Let me know all that has happened, & who called.

Coleorton Hall near Ashby de la Zouch.
Novr. 5th 1823.
My very darling Love

For the want of the above direction on your last letter I was deprived of the pleasure of hearing from you 'till Sunday evening last. I wrote to you on Sunday to beg a letter: this whole scene is so very delightfull to me that I am prolonging my stay I fear beyond prudence. But 'tis such an opportunity and Sir G. and Lady Beaumont are so very liberal and kind that I can hardly tell what to do: but this week will I hope conclude what I have to do.

I have a little Claude in hand, a grove scene of great beauty and I wish to make a nice copy from it to be usefull to me as long as I live. It contains almost all that I wish to do in landscape.

You are very kind to let me remain and though I cannot now actually name the day of my departure from here depend upon it I am too anxious to see my darling Fish & my sweet babes, not to wish hasten my return—as well as to attend to my own house & business.

But I know you will make every allowance for my *present situation*—among so many Claudes &c &c—& nothing can exceed the good nature with which I am treated by all, even

the servants. If you want any money to go on with there is your 8 pounds at Spring Gardens still owing to me, and I am sure your papa will send it if you wish.

I have had another letter from Lady Dysart—the business of "importance" which she wanted me to come to London about is to see two or three pictures packed up, and sent to Helmingham. Her steward will pay me the money on my return to London, 42 pounds.

How delightfull of dear Charley to wish to show Thompson her room: I dare say you will have got the children into very nice order & good behavior on my return—& I will endeavour not to spoil them again. I hope they avoid colds & keep out of my nasty painting room. I hope the wind does not come to Roberts's bed and give dear little Isabel cold as it did poor dear Minna last winter.

Let me hear from you though my stay is so short—I almost wish I could hear from you every day. I did not write quite so often because I knew you did not request it, at least you said so—but then you had hope I should not have been here so long.

I told you I had a letter from Fisher—very kind, delightfull & friendly. I wrote to him on Sunday. Has the wretched Smith brought home any frames? What a day was yesterday— and this morning so fine. I hear of young Farnham sometimes. There is a Mr. Osbaldeston near hear who keeps a great number of dogs, and the gentlemen ride about after them by the whole day together.

Sir G. paints a good deal—we work in the same room. He is very entertaining—so full of delightfull stories about painting—& he laughs, sings, whistles & plays with his dog who is a very surly fellow, but quite friends with me. This is the most punctual house that ever was—at 9 breakfast— no lunch—dinner four—tea seven—prayers 10—bell always rings as the clock is striking those hours.

Sir G. rides out about 2, fine or foul—rises at 7—walks in the garden—the horses come under the window—he feeds the birds at breakfast—after dinner the news paper is read out, & at 7 tea & then some book, or play read by Sir G. What dreadfull accounts of the horrible murders, near Saint Albans.

You would laugh to see my bed room, I have dragged so many things into it, books, portfolios, paints, canvases, pictures &c, and I have slept with one of the Claudes every night. You may well indeed be jealous, and wonder I do not come home—but not even Claude Lorraine can make me forget my darling dear Fish—I dream of her continually and wake cold and disappointed.

Kiss and love my dear little fishes, but I shall soon see them—& God bless you.

J. Constable

It is now almost breakfast time—my hands are cold, and the boy will soon go to post. The fine morning is gone, & the fog come.

Sunday morning. Nov. 9. 1823.

How glad I was my dear love to receive your last kind letter, giving a good account of yourself and our dear babies. I am glad you are going to amuse them at the Derbys', and that you can have the carriage as you will then feel more safe.

Nothing shall I hope prevent my seeing you this week. Indeed I am now quite serious about my absence, and shall soon begin to feel alarmed about the Exhibition, though that is very secondary to meeting all I hold dear.

I do not wonder at your being jealous of Claude. If any thing could come between our love it is him. But I am fast advancing a beautifull little copy of his study from nature of a little grove scene, which will be of service to me for life, and by being nearly finished will be worth something and a peice of property—it is so well. If you my dearest love will be so good as to make yourself happy without me—for this week only—then I shall meet you again quite happy—and it will I hope be long before we thus part again.

But beleive me I shall be the better for this visit as long as I live. I am sure I shall finish my pictures so much better— and my temper will be so much improved. Sir G. is never angry or pettish or peevish—and though he loves painting so much it does not harrass him. You will like me a good deal better than ever you did, indeed I think now I shall never be cross to my poor Fish again.

Tomorrow Mr. Southey the poet is coming to stay here with his wife and daughter—Sir G. and his lady count much of his visit! and so shall I. Indeed I know you would be sorry if I did not stay to meet him. He is such a friend of Gooch's. He is on his way from the Lakes, with some book to publish in town. But the Claudes are all I can think about while here.

Only think of the wretched Smith—making the willful mistake about the frame.

I count much of seeing Southey. Write to me again when you have seen the show at the Derbys'. Did you take the print to Mr. Haines of Helvellyn? Have you seen Miss Cipriani?

I am glad to find you are as busy as a bee, for our dear children—I know you will not get them any thing they do not want. Has Roberts bought her new pelisse? Did you send to Spring Gardens for the money? I am sure you must want it, but every body will trust us—at present thank God—and I shall be sure to get on in time.

Ever yours
J.C.

I shall often write this week to tell you all I can & do you tell me of any thing particular happening. Have you heard of Mrs. Mirehouse's arrival yet in London?

The weather has been so bad that I can scarcely look out of the window, but Friday was lovely. I can hardly be able to make you a sketch of the house but I shall bring much (though in little compass) to shew you.

Thursday was Sir. G.'s birthday—the servants have a ball—I was lulled to sleep with a fiddle—69—married half a century.

Coleorton Hall. Novr. 18, 1823.

My very dearest love,

I shall finish my little Claude on Thursday and then I shall have a little job or two to do besides to some of Sir G's pictures, that will take a day or two more and then home—but I will not lose a moment in coming yet I had better not fix a day. Indeed I cannot well as there is no coach passes here in which I could take a place, I must only take my chance—but it is not always full.

I sent you a hasty shabby line by Southey but all that morning I had been engaged on a little sketch in Miss Southey's *album* of this house which pleased all parties here very much.

Has Smith sent on about another frame for the Bishop's second picture? Have you got Miss Thorley's account for rent—& was old Nightingale paid—& had the board away?

You shall have a copper and Ellen washing a little for us will be a mercy, but from hence you shall be entire manager.

Tell me any news you can think of. Sir G. is so loath to part with me that he would have me *pass the Christmas* with him. He has named a small commission which he wished me to execute here—but I have declined it as I am so desirous to come to my darlings. [Deletion.] Sir G. is so kind that I have no doubt he means this little job is to pay my expences down here—but it is a pity to stop for it.

I have worked so hard in the house that I never once went out of the door last week, so that I am getting quite nervous—but I am sure my visit here will be ultimately of the greatest advantage to me and I could not be better employed to the advantage of all of us by its making me so much more of an artist. Indeed what I see and learn here is prodigeous—and I can never expect such an opportunity again nor indeed shall I want it—the breakfast bell rings.

I now hasten to finish as the boy waits. I shall have so much to talk about on my return that I shall now only say that I really think the seemly habits of this house will be of service to me as long as I live—everything so punctual—Sir G. never omits Church, twice every Sunday—he never looks into his painting room, on a Sunday, or trusts himself with a portfolio—never puts himself into a pet, or is im-patient—never uses an oath on any occasion, or take's God's name in vain—always walks or rides for an hour or two at two o'clock. So will I with you if it is only into the Square. I shall esteem myself after this visit and not let low people get an influence over me but keep to myself much more.

Let me hear from you soon, & tell me all the news you can. Lady B. was quite pleased with Minna's asking if the gentleman on the coach could speak—she said it was an admirable natural and innocent satire and such an one as a grown person could not make.

Kiss them all from me. I almost wish I had not cut myself out so much to do here, but I was greedy, with the Claudes. But they cannot fail to help me as long as I live and I should really be loath to take £20 each for my copies.

November 21.

My dearest Love

I am as heart sick as ever you can be at my long absence, but which is now fast drawing to a close. In fact my greediness after pictures caused me to cut out for myself much more work than I ought to have taken at this time.

One of the Claudes would have been all that I wanted but I could not get at that first: & I had been here a fortnight when I began it. To day it will be done with perhaps a little to touch on Saturday morning—I have then an old picture to fill up some holes in. But I fear I shall not be able to get away on Saturday—or is the coach likely to take me on that day—but I hope nothing shall prevent me on Monday, & it positively shall not be later be further than Tuesday, at all events, even if I have a post chaise to Leicester, or Loughborough—but at any rate you will soon see me and you cannot be more 'impatient' than I am to see you, and all our dear darlings. I can hardly beleive that I have not seen you or my Isabel or my Charley, for five weeks.

Yesterday was another very high wind—and such a splendid evening, as I never before beheld at this time of the year, was it so with you—but in London nothing is to be seen, worth seeing, in the natural way.

I certainly will not allow of such serious interruptions as I used to do—Sir G. says it is quite serious, and alarming, and enough such are to be found who will devour your time & brains & every thing else.

Let me have a letter on Sunday, and that will be the last here, as I want to be made comfortable on my journey—which will be long & tiresome & I shall be very nervous as I get near home—therefore pray let me have a nice account of all. I shall get home by noon on the day I arrive, if I get a place in the night coach.

Ever yours most affectionately

J.C.

Just as I am doubling this letter the clock is striking nine & the bell ringing for breakfast—nothing can exceed the punctuality of this place. I beleive some great folks are coming here in December which Sir G. dreads as they interfere with his painting habits—for no artist can be more regular or fonder of it.

My very dearest Love

I hope nothing will prevent my leaving this place tomorrow afternoon, & that I shall have you in my arms on Thursday morning, and my babies—O dear how glad I shall be. I feel that I have been at school & can only hope that my long absence from you may ultimately be to my great and lasting improvement as an artist—indeed, in every thing.

If you have any friends staying with you, I beg you will dismiss them before my arrival. I long entirely to see you. Indeed I told you what a very bad way I am in & nobody on earth can cure me but you.

I did not like to surprize you, & I thought ninepence would be well laid out to spare your & my nerves—as I am very bad indeed, but it is all owing to my being away from my dear Fish so very very long.

Love to all & tell my Charley that I shall soon be with you all. Ever yours most affectionately

John Constable

26 Novr. 1823.

My dearest Love,

Sir George is so very anxious that I shall not leave him for another day or two that I shall stay 'till Friday & be with you on Saturday morning, & have a quiet day together on Sunday. I have worked so hard that I really want a day or two & he will ride with me every day—& some company are coming here on Friday so that all things will suit.

I enclose five pounds which may be of use as you may probably have by this time exhausted your *house banker*—did you send to Spring Gardens, for the money there?

My second little copy of Claude is only done this morning & it is beautifull & all wet so that I could hardly bring it with me.

Nothing can exceed the kindness of all here and Sir G. says we have been of mutual and great service to each other. No one unpleasant circumstance has happened whilst I have been with them six weeks on Tuesday since we met. O dear —it is sad—I long to see you & if you have any *friends staying* with you I beg you will dismiss them on my arrival.

Yours,

J. Constable

The house is now going to be filled with grand company.

I shall get a few more walks & rides as I have not been out hardly at all—and only made you one little sketch of the house, which is all I have done from nature.

Nothing will detain me in this house after Friday—it can't hold me, and I do not know who they are.

Ever yours most truly

J.C.

Coleorton Hall. Novr. 2d. 1823.

My very dear Fisher,

I was made most happy by the receipt at this place of your very kind letter and the good news it contained of the birth of your baby boy. I wrote to my wife to inform her of it in case she might not have seen it in the newspaper. You can never be nubilous—I am the man of clouds—

You letter is delightfull—and its coming here served to help me in the estimation of Sir George and Lady Beaumont. Nothing can be more kind and in every possible way more obliging than they both are to me—I am left entirely to do as I like with full range of the whole house—in which I may saturate myself with art, only on condition of letting them do as they like. I have copied one of the small Claudes —a breezy sunset—a most pathetic and soothing picture. Sir G. says it is a most beautifull copy. Perhaps a sketch would have answered my purpose, but I wished for a more lasting remembrance of it and a sketch of a picture is only like seeing it in one view. It is only one thing. A sketch (of a picture) will not serve more than one state of mind & will not serve to drink at again & again—in a sketch there is nothing but the one state of mind—that which you were in at the time.

I have likewise begun the little Grove by Claude—a noon day scene—which "*warms and cheers but which does not inflame or irritate*"—Mr. Price. It diffuses a life & breezy freshness into the recess of trees which make it enchanting. Through the depths are seen a water-fall & ruined temple— & a solitary shepherd is piping to some animals—

'*In closing shades & where the current strays
'Pipes the lone shepherd to his feeding flock.*'

I draw in the evening & Lady B or Sir G. read aloud. I wish you could see me painting by Sir George's side. I have free range & work in his painting room. It is delightfull to see him work so hard—painting like religion knows no difference of rank. He has know intimately many persons of talent in the last half century and is full of anecdote.

This is a magnificent country—full of the picturesque. You are fond of a joke—I thought I was going to fill my house with dogs and rubbish—& had given orders to receive them.

How odd of the bishop's people, about your picture—they must be struck dumb with its beauty.

The hall is now going to church. The family never miss twice on every Sunday—& have family prayers. I am glad to see this—but I am told the latter was not the case 'till Sir G had heard Irvine—last summer.

Some parts of the print are very like the Narcissus but the figure is as you say not so white—the print is reversed—

Yours ever—

J. Constable

In the dark recesses of these gardens, and at the end of one of the walks, I saw an urn—& bust of Sir Joshua Reynolds—& under it some beautifull verses, by Wordsworth.

It is a magnificent view from the Terrace over a mountainous region—here is a Winter Garden, the hint taken by Sir G. from the Spectator—Sir George has just sent to ask me to a walk.

Yrs. *J.C.*

You are very kind to take so much trouble with the obdurate Tinney. He is very goodnatured to me in this matter—tis ignorance only that disables him. I will write to you on my return in about a week for the picture as I should like to be at home when it arrives. It was a happy thought and kind of you to refill the place on his walls. O, when I think of the 'Ancient Masters' I am almost choaked in this breakfast room. Here hang 4 Claudes, a Cousins & a Swanevelt. The low sun in the morning sets them off to great advantage.

Appendix II: Passages from English Landscape Scenery

THE AUTHOR rests in the belief that the present collection of Prints of Rural Landscape may not be found wholly unworthy of attention. It originated in no mercenary views, but merely as a pleasing professional occupation, and was continued with a hope of imparting pleasure and instruction to others. He had imagined to himself certain objects in art, and has always pursued them.

Much of the Landscape, forming the subject of these Plates, going far to embody his ideas (owing perhaps to the rich and feeling manner in which they are engraved) he has been tempted to publish them, and offers them as the result of his own experience, founded as he conceives it to be in a just observation of natural scenery in its various aspects. From the almost universal esteem in which the Arts are now held, the Author is encouraged to hope that this work may not be found unacceptable, since perhaps no branch of the Art offers a more inviting study than Landscape.

> '*Soul-soothing Art! whom morning, noon-tide, even*
> '*Do serve with all their fitful pageantry.*'

The immediate aim of the Author in this publication is to increase the interest for, and promote the study of, the Rural Scenery of England, with all its endearing associations, its amenities, and even in its most simple localities; abounding as it does in grandeur, and every description of Pastoral Beauty: England, with her climate of more than vernal freshness, and in whose summer skies, and rich autumnal clouds, 'with thousand liveries dight', the Student of Nature may daily watch her endless varieties of effect, for by him it is, that these changes are particularly observed: '*Multa vident Pictores in imminentia et in umbris quae nos non videmus.*'—CICERO.

It is therefore perhaps in its professional character that this work may be most considered, so far as it respects the ART; its aim being to direct attention to the source of one of its most efficient principles, the 'CHIAR'-OSCURO OF NATURE', to mark the influence of light and shadow upon Landscape, not only in its general effect on the whole, and as a means of rendering a proper emphasis on the 'parts', in Painting, but also to show its use and power as a medium of expression, so as to note 'the day, the hour, the sunshine, and the shade'. In some of these subjects of Landscape an attempt has been made to arrest the more abrupt and transient appearances of the CHIAR'OSCURO IN NATURE; to shew its effect in the most striking manner, to give 'to one brief moment caught from fleeting time', a lasting and sober existence, and to render permanent many of those splendid but evanescent Exhibitions, which are ever occurring in the changes of external Nature.

In the selection of these subjects, a partiality has perhaps been given to those of a particular neighbourhood: some of them, however, may be more generally interesting, as the scenes of many of the marked historical events of our middle ages. The most of these subjects, chiefly consisting of home scenery, are from Pictures exhibited by the Author at the Royal Academy during the past few years; they are taken from real places, and are meant particularly to characterize the scenery of England; the effects of light and shadow being transcripts only of such as occurred at the time of being taken.

In Art as in Literature, however, there are two modes by which men endeavour to attain the same end, and seek distinction. In the one, the Artist, intent only on the study of departed excellence, or on what others have accomplished, becomes an imitator of their works, or he selects and combines their various beauties; in the other he seeks perfection at its PRIMITIVE SOURCE, NATURE. The one, forms a style upon the study of pictures, or the art alone; and produces, either 'imitative', 'scholastic', or that which has been termed 'Eclectic Art'. The other, by study equally legitimately founded in art, but further pursued in such a far more expansive field, soon finds for himself innumerable sources of study, hitherto unexplored, fertile in beauty, and by attempting to display them for the first time, forms a style which is original; thus adding to the Art, qualities of Nature unknown to it before.

The results of the one mode, as they merely repeat what has been done by others, and by having the appearance of that with which the eye is familiar, can be easily comprehended, soon estimated, and are at once received. Thus the rise of an artist in a sphere of his own must almost certainly be delayed; it is to time generally that the justness of his claims to a lasting reputation will be left; so few appreciate any deviation from a beaten track, can trace the indications of Talent in immaturity, or are qualified to judge of productions bearing an original cast of mind, of genuine study, and of consequent novelty of style in their mode of execution.

J.C.

This book . . . has a Title, some Introductory pages, and a page of Letterpress with each print, containing Historical notices of many of the places which are the subjects of the plates, with Poetical Allusions applicable to the scenery.

Also, Remarks on Light and Shade, to show how essentially it is connected with LANDSCAPE;—that from the congeniality of the principles of the CHIAR'OSCURO with the Material of Landscape and its Phaenomena it is indispensable in that Class of Painting;—that the Landscape Painter shall be aware that the CHIARO'OSCURO does really exist in NATURE (as well as Tone)—and, that it is the medium by which the grand and varied aspects of Landscape are dis-

played, both in the fields and on canvas:—thus he will be in possession of a power capable in itself, alone, of imparting Expression, Taste, and Sentiment.

EAST BERGHOLT, SUFFOLK

As this work was begun and pursued by the Author solely with a view to his own feelings, as well as his own notions of Art, he may be pardoned for introducing a spot to which he must naturally feel so much attached; and though to others it may be void of interest or any associations, to him it is fraught with every endearing recollection.

In this plate the endeavour has been to give, by richness of Light and Shadow, an interest to a subject otherwise by no means attractive. The broad still lights of a Summer evening, with the solemn and far-extended shadows cast round by the intervening objects, small portions of them only and of the landscape gilded by the setting sun, cannot fail to give interest to the most simple or barren subject, and even to mark it with pathos and effect.

The beauty of the surrounding scenery, the gentle declivities, the luxuriant meadow flats sprinkled with flocks and herds, and well cultivated uplands, the woods and rivers, the numerous scattered villages and churches, with farms and picturesque cottages, all impart to this particular spot an amenity and elegance hardly anywhere else to be found; and which has always caused it to be admired by all persons of taste, who have been lovers of Painting, and who can feel a pleasure in its pursuit when united with the contemplation of Nature.

Perhaps the Author in his over-weaning affection for these scenes may estimate them too highly, and may have dwelt too exclusively upon them; but interwoven as they are with his thoughts, it would have been difficult to have avoided doing so; besides, every recollection associated with the Vale of Dedham must always be dear to him, and he delights to retrace those scenes, 'where once his careless childhood strayed', among which the happy years of the morning of his life were passed, and where by a fortunate chance of events he early met those, by whose valuable and encouraging friendship he was invited to pursue his first youthful wish, and to realize his cherished hopes, and that ultimately led to fix him in that pursuit to which he felt his mind directed: and where is the student of Landscape, who in the ardour of youth, would not willingly forego the vainer pleasures of society, and seek his reward in the delights resulting from the love and study of Nature, and in his successful attempts to imitate her in the features of the scenery with which he is surrounded; so that in whatever spot he may be placed, he shall be impressed with the beauty

and majesty of Nature under all her appearances, and, thus, be led to adore the hand that has, with such lavish beneficence, scattered the principles of enjoyment and happiness throughout every department of the Creation [?].

It was in scenes such as these, and he trusts with such a feeling, that the Author's ideas of Landscape were formed: and he dwells on the retrospect of those happy days and years of 'sweet retired solitude', passed in the calm of an undisturbed congenial study, with a fondness and delight which must ever be to him a source of happiness and contentment.

> '*Nature! enchanting Nature! in whose form*
> *And lineaments divine I trace a hand*
> *That errs not, and find raptures still renew'd,*
> *Is free to all men—universal prize.*'

SPRING

This plate may perhaps give some idea of one of those bright and animated days of the early year, when all nature bears so exhilarating an aspect; when at noon large garish clouds, surcharged with hail or sleet, sweep with their broad cool shadows the fields, woods, and hills; and by the contrast of their depths and bloom enhance the value of the vivid greens and yellows, so peculiar to this season; heightening also their brightness, and by their motion causing that playful change so much desired by the painter of

> '*Light and shade alternate, warmth and cold,*
> *And bright and dewy clouds, and vernal show'rs,*
> *And all the fine variety of things.*'

The natural history—if the expression may be used—of the skies above alluded to, which are so particularly marked in the hail-squalls at this time of year, is this:—the clouds accumulate in very large and dense masses, and from their loftiness seem to move but slowly; immediately upon these large clouds appear numerous opaque patches, which, however, are only small clouds passing rapidly before them, and consisting of isolated pieces, detached probably from the larger cloud.

These floating much nearer the earth, may perhaps fall in with a much stronger current of wind, which as well as their comparative lightness, causes them to move with greater rapidity; hence they are called by windmillers and sailors 'messengers', being also the forerunners of bad weather. They float about midway in what may be termed the *lanes* of the clouds; and from being so situated, are almost uniformly in shadow, receiving only a reflected light from the clear blue sky immediately above, and which descends perpendicularly upon them into these lanes. In passing over the

bright parts of the large clouds they appear as darks; but in passing the shadowed parts they assume a gray, a pale, or lurid hue.

SUMMER MORNING

The morning—from the dawn to the hour when the sun has gained greater power, and higher above the horizon, 'flames in the forehead of the eastern sky'—has always been marked as one of the most grateful by the lovers of Nature; nor is there any time more delicious or exhilarating The breezy freshness, the serenity, and cheerfulness which attend the early part of the day, never fail to impart a kindred feeling to every living thing, and doubtless the most sublime and lovely descriptions of the poets are those which relate to the Morning.

Nature is never seen, in this climate at least, to greater perfection than at about nine o'clock in the mornings of July and August, when the sun has gained sufficient strength to give splendour to the landscape, 'still gemmed with the morning dew', without its oppressive heat; and it is still more delightful if vegetation has been refreshed with a shower during the night.

It may be well to mention the different appearances which characterize the Morning and Evening effects. The dews and moisture which the earth has imbibed during the night cause a greater depth and coolness in the shadows of the Morning; also, from the same cause, the lights are at that time more silvery and sparkling; the lights and shadows of Evening are of a more saffron or ruddy hue, vegetation being parched during the day from the drought and heat.

A SEA-BEACH.—BRIGHTON

The magnitude of a coming wave when viewed beneath the shelter of a Groyne—and which is the subject of the present plate—is most imposing; as, from being close under it, it seems overwhelming in its approach—at the same time, from its transparency, becoming illumined by the freshest and most beautiful colours.

The structures termed Groynes, a kind of jetty, are numerous here; they are composed of timber in form and manner like a quay, but projecting into the sea at right angles with the shore. Groynes are admirable and indeed the only contrivances for preserving the beach and preventing the waves from reaching and undermining the cliffs; thus the shingle which on this coast is drifted from the West is arrested in its progress by them, and being so collected forms a beach which by its gradual slope and ample extent wards off the encroachments of the sea.

Of all the works of the Creation none is so imposing as the Ocean; nor does Nature anywhere present a scene that is more exhilarating than a sea-beach, or one so replete with interesting material to fill the canvass of the Painter; the continual change and ever-varying aspect of its surface always suggesting the most impressive and agreeable sentiments,—whether like the Poet he enjoys in solitude 'The wild music of the waves', or when more actively engaged he exercises his pencil amongst the busy haunts of the fishermen, or in the bustle and animation of the port or harbour.

It is intended in this print to give one of those animated days when the masses of clouds, agitated and torn, are passing rapidly; the wind at the same time meeting with a certain set of the tide, causes the sea to rise and swell with great animation; when perhaps a larger wave, easily distinguished by its scroll-like crest, may be seen running along over the rest coming rapidly forward; on nearing the shore it curls over, then in the elegant form of an alcove suddenly falling upon the beach, it spreads itself and retires.

In such weather the voice of a solitary sea-fowl is heard from time to time 'Mingling its note with those of wind and wave'; when he may be observed beating his steady course for miles along the beach just above the breakers, and ready 'To drop for prey within the sweeping surge'. These birds, whether solitary or in flocks, add to the wildness and to the sentiment of melancholy always attendant on the ocean.

STOKE BY NEYLAND, SUFFOLK

The solemn stillness of Nature in a Summer's Noon, when attended by thunder-clouds, is the sentiment attempted in this print; at the same time an endeavour has been made to give additional interest to this Landscape by the introduction of the Rainbow, and other attending circumstances that might occur at such an hour. The effect of light and shadow on the sky and landscape are such as would be observed when looking to the northward at noon; that time of the day being decidedly marked by the direction of the shadows and the sun shining full on the south side of the Church.

Of the RAINBOW—the following observations can hardly fail to be useful to the Landscape Painter. When the Rainbow appears at Noon, the height of the sun at that hour of the day causes but a small segment of the circle to be seen, and this gives the Bow its low or flat appearance; the Noonday-bow is therefore best seen 'Smiling in a Winter's day', as in the Summer, after the sun has passed a certain altitude, a Rainbow cannot appear: it must be observed that a Rainbow can never appear foreshortened, or be seen obliquely, as it must be parallel with the plane of the picture, though a part of it only may be introduced; nor can a Rainbow be seen through any intervening cloud, however small or thin, as the

reflected rays are dispersed by it, and are thus prevented from reaching the eye; consequently the Bow is imperfect in that part.

Nature, in all the varied aspects of her beauty, exhibits no feature more lovely nor any that awaken a more soothing reflection than the Rainbow, 'Mild arch of promise'; and when this phenomenon appears under unusual circumstances it excites a more lively interest. This is the case with the 'Noon-tide Bow', but more especially with that most beautiful and rare occurrence, the 'Lunar Bow'. The morning and evening Bows are more frequent than those at noon, and are far more imposing and attractive from their loftiness and span; the colours are also more brilliant, 'Flashing brief splendour through the clouds awhile'. For the same reason the exterior or secondary Bow is at these times also brighter, but the colours of it are reversed. A third, and even fourth Bow, may sometimes be seen, with the colours alternating in each; these are always necessarily fainter, from the quantity of light last at each reflection within the drop, according to the received principle of the Bow.

OLD SARUM

In no department of Painting is the want of its first attracting quality, 'General Effect', so immediately felt, or its absence so much to be regretted, as in Landscape; nor is there any class of Painting, where the Artist may more confidently rely on the principles of 'Colour' and 'Chiar'oscuro' for making his work efficient. Capable as this aid of 'Light and Shadow' is of varying the aspect of everything it touches, it is, from the nature of the subject, nowhere more required than in Landscape; and happily there is no kind of subject in which the Artist is less controlled in its application; he ought, indeed, to have these powerful organs of expression entirely at his command, that he may use them in every possible form, as well as that he may do so with the most perfect freedom; therefore, whether he wishes to make the subject of a joyous, solemn, or meditative character, by flinging over it the cheerful aspect which the sun bestows, by a proper disposition of shade, or by the appearances that beautify its rising or its setting, a true 'General Effect' should never be lost sight of by him throughout the production of his work, as the sentiment he intends to convey will be wholly influenced by it.

The subject of this plate, which from its barren and deserted character seems to embody the words of the poet— 'Paint me a desolation',—is grand in itself, and interesting in its associations, so that no kind of effect could be introduced too striking, or too impressive to portray it; and among the various appearances of the elements, we naturally look to the grander phenomena of Nature, as according best with the character of such a scene. Sudden and abrupt appearances of light, thunder clouds, wild autumnal evenings, solemn and shadowy twilights, 'flinging half an image on the straining sight', with variously tinted clouds, dark, cold and gray, or ruddy and bright, with transitory gleams of light; even conflicts of the elements, to heighten, if possible, the sentiment which belongs to a subject so awful and impressive.

DEDHAM MILL (A FRAGMENT)

The subject of this print is little more than assemblage of material calculated to produce a rich Chiar'oscuro, and is noticed solely with that view. A cloudy or stormy day at noon with partial bright and humid gleam of light over meadow scenery, and near the banks of rivers with trees, boats and buildings, are most desirable objects with a painter, who delights in Colour and Light and Shade. In this case, the middle tints are generally of a low tone and shades deep, and the lights few, and bearing a small proportion to the whole. The mode of treatment is perhaps most of all calculated for rich and solemn subjects, as it never fails to give importance to the most trivial scenery.

Appendix III: Constable's sayings

On nature and landscape

How much real delight I have had with the study of nature this summer. Either I am myself improved 'in the art of seeing Nature' (which Sir Joshua Reynolds calls painting) or Nature has unveiled her beauties to me with a less fastidious hand . . . *1812* (II: 81)

Landscape is my mistress—'tis to her I look for fame, and all that the warmth of imagination renders dear to man. *1812* (II: 87)

The mind and feeling which produced the 'Selborne' is such an one as I have always envied . . . it only shows what a real love for nature will do—surely the serene & blameless life of Mr White, so different from the folly & quackery of the world, must have fitted him for such a clear & intimate view of nature. It proves the truth of Sir Joshua Reynolds' idea that the virtuous man alone has true taste. *1821* (VI: 66)

The sound of water escaping from Mill dams, so do Willows, Old rotten Banks, slimy posts, & brickwork. I love such things—Shakespeare could make anything poetical . . . As long as I do paint I shall never cease to paint such Places. They have always been my delight. . . . I should paint my own places best—Painting is but another word for feeling. I associate my 'careless boyhood' to all that lies on the banks of the *Stour*. They made me a painter (& I am gratefull) that is I had often thought of pictures of them before I had ever touched a pencil, and your picture is one of the strongest instances I can recollect of it. But I will say no more—for I am fond of being an Egotist, in whatever relates to painting. *1821* (VI: 7–8)

A man sees nothing in nature but what he knows. *1823* (VI: 113)

The landscape painter must walk in the fields with a humble mind. No arrogant man was ever permitted to see nature in all her beauty. If I may be allowed to use a very solemn quotation, I would say most emphatically to the student, 'Remember now thy Creator in the days of thy youth.' *1836. Lectures,* p. 72

There has never been an age, however rude or uncultivated, in which the love of landscape has not in some way been manifested. And how could it be otherwise? for man is the sole intellectual inhabitant of one vast natural landscape. His nature is congenial with the elements of the planet itself, and he cannot but sympathize with its features, its various aspects, and its phenomena in all situations. *1836. Lectures,* p. 72

Paley observed of himself, that 'the happiest hours of a sufficiently happy life were passed by the side of a stream'; and I am greatly mistaken if every landscape painter will not acknowledge that his most serene hours have been spent in the open air, with his palette on his hand. 'It is a great happiness', says Bacon, 'when men's professions and their inclinations accord.' *1836. Lectures,* p. 74

The world is wide; no two days are alike, nor even two hours; neither were there ever two leaves of a tree alike since the creation of the world; and the genuine productions of art, like those of nature, are all distinct from each other. Leslie, *Life,* p. 273

I never did admire the Autumnal tints, even in nature, so little of a painter am I in the eyes of commonplace connoisseurship. I love the exhilerating freshness of Spring.

The landscape painter who does not make his skies a very material part of his composition, neglects to avail himself of one of his greatest aids.

It will be difficult to name a class of landscape in which the sky is not the key note, the standard of scale, and the chief organ of sentiment.

Chiaroscuro is by no means confined to dark pictures; the works of Cuyp, though generally light, are full of it. It may be defined as that power which creates space; we find it everywhere and at all times in nature; opposition, union, light, shade, reflection, and refraction, all contribute to it. By this power, the moment we come into a room, we see that the chairs are not standing on the tables, but a glance shows us the relative distances of all the objects from the eye, though the darkest or the lightest may be the furthest off. *1836. Lectures,* p. 62

On his painting and his pictures

I now fear (for my family's sake) I shall never be a popular artist—a Gentlemen and Ladies painter—but I am spared making a fool of myself—and your hand stretched forth teaches me to value my own natural dignity of mind (if I may say so) above all things. This is of more consequence than Gentlemen and Ladies can well imagine as its influence is very apparent in a painters works—sometimes the '*Eclats*' of other artists occasionally cross my mind—but I look to what I possess and find ample consolation. *1821* (VI: 63)

Though I am here in the midst of the world I am out of it—and am happy—and endeavour to keep myself unspoiled. I have a kingdom of my own both fertile & populous—my landscape and my children. I am envied by many, and much richer people. *1823* (VI: 116)

Am I doomed never to see the living scenes—which inspired the landscape of Wilson & Claude Lorraine? No! but I was born to paint a happier land, my own dear England—and when I forsake that, or cease to love my country—may I as Wordsworth says

> 'never more, hear
> Her green leaves rustle
> Or her torrents roar.'

1823 (VI: 117)

My picture is liked at the Academy. Indeed it forms a decided feature and its light cannot be put out, because it is the light of nature—the Mother of all that is valuable in poetry, painting or anything else—where an appeal to the soul is required. The language of the heart is the only one that is universal—and Sterne says that he disregards all rules—but makes his way to the heart as he can. My execution annoys most of them and all the scholastic ones—perhaps the sacrifices I make for *lightness* and *brightness* is too much, but these things are the essence of landscape. Any extreem is better than white lead and oil and *dado* painting. [*The Lock*] *1824* (VI: 157)

I am planning a large picture—I regard all you say but I do not enter into that notion of varying one's plans to keep the Publick in good humour—subject and change of weather & effect will afford variety in landscape. I have to combat from high quarters, even Lawrence, the seeming plausible arguments that subject makes the picture. Perhaps you think an evening-effect—or a warm picture—might do. Perhaps it might start me some new admirers—but I should lose many old ones. I imagine myself driving a nail. I have driven it some way—by preservering with this nail I may drive it home . . . November *1824* (VI: 181)

The truth is, could I divest myself of anxiety of mind I should never ail any thing. My life is a struggle between my 'social affections' and 'my love of art'. I dayly feel the remark of Lord Bacon's that 'single men are the best servants of the publick' I have a wife . . . in delicate health and five infant children. I am not happy apart from them even for a few days, or hours, and the summer months separate us too much, and disturb my quiet habits at my easil.
. . . I love England and my own home. I would rather be a poor man here than a rich man abroad. I am neither an ambitious man, nor a man of the world . . .
To gain the publick for my patron . . . *1825* (IV: 99)

It is easy for a bye stander like you to watch one struggling in the water and then say your difficulties are only imaginary. I have a great part to perform & you a much greater, but only with this difference. You are removed from the ills of life—you are almost placed beyond circumstances. My master the publick is hard, cruel and unrelenting, making no allowance for a backsliding. the publick is always more against than for us, in both our lots, but then there is this difference. Your own profession closes in and protects you, mine rejoices in the opportunity of ridding itself of a member who is sure to be in somebodys way or other. *1825* (VI: 210)

I am now thank God quietly at my easil again. I find it a cure for all ills besides its being the source of all my joys and all my woe. My income is derived from it and now that after 20 years hard uphill work—now that I have disappointed the hopes of many—and realized the hopes of a few (you can best apply this)—now that I have got the publick into my hands—and want not a patron—and now that my ambition is on fire—to be kept from my easil is death to me. *1825* (VI: 204)

It is always my endeavour however in making a picture that it should be without a companion in the world, at least such should be the painter's ambition. . . . *1828* (IV: 139)

My Wood is liked but I suffer for want of that little completion which you always feel the regret of—and you are quite right. I have filled my head with certain notions of *freshness* —*sparkle*—brightness—till it has influenced my practice in no small degree, & is in fact taking the place of truth so invidious is manner, in all things—it is a species of self worship—which should always be combated—& we have nature (another word for moral feeling) always in our reach to do it with—if we will have the resolution to look at her. *1830* (VI: 258)

The painter himself is totally unpopular, and ever will be on this side of the grave certainly—the subjects nothing, but 'The Arts' and 'buyers' are totally ignorant of that . . . *1831* (III: 344)

The book is made by me to avoid all that is to be found there—a total absence of breadth, richness, tone, chiaroscuro—and substituting soot, black fog, smoke, crackle, prickly rubble, scratches, edginess, want of keeping, & an intolerable & restless irritation. *1831* (IV: 362)

I am determined not to harrass *my mind* and HEALTH by scrambling over my canvas—as I hitherto have too often done. Why should I—I have little to lose and *nothing* to gain. It is time at 56 to begin at least to *know* 'one's self'—and I do know what *I am not*, and your regard for me has at last awakened me to beleive in the possibility that I may yet make some impression with my 'light'—my 'dew'— my 'breezes'—my *bloom* 'and my freshness'—no one of which qualities has yet been perfected on the canvas of any painter in the world. *1833* (III: 96)

I can hardly write, for looking at the 'silvery clouds' and skies. How I sigh for that *peace* (to paint them) which this world cannot give—at least to me. Yet I well know, 'happiness is to be found everywhere, or nowhere'—but this last year, though, thank God, attended with no calamity, has been most unpropitious to my happiness. *1833* (III: 106)

It is much to my advantage that several of my pictures should be seen together, as it displays to advantage their varieties of conception and also of execution, and what they gain by the mellowing hand of time, which should never be forced or anticipated. Thus my pictures when first coming forth have a comparative harshness which at the time acts to my disadvantage. *1834?* (IV: 129)

'Tis late in life for me to think of ever becoming a popular painter. Besides a knowledge of the world and I have little of it, goes further towards that than a knowledge of art. *1835* (V: 27)

I have got my picture into a very beautifull state. I have kept my brightness without my spottiness, and I have preserved God Almighty's daylight, which is enjoyed by all mankind, excepting only the lovers of old dirty canvas, perished pictures at a thousand guineas each, cart grease, tar and snuff of candles. Mr Wells, an admirer of common place, called to see my picture and did not like it at all, so I am sure there is something good in it. Soon after, Mr Vernon called, and bought it, having never seen it before in any state. *1835* (V: 20)

I am making a rich plumb pudding of mine, but it keeps me in a 'death sweat'—I am in the divil of a funk about it—and yet I like it and am confident. *1835* (III: 124)

I have lately turned out one of my best bits of Heath, so fresh, so bright, dewy & sunshiny, that I preferred to any former effort, at about 2 feet 6, painted for a very old friend—an amateur who knows well how to appreciate it, for I now see that I shall never be able to paint down to ignorance. Almost all the world is ignorant & vulgar. *1836* (V: 35)

I told him [Mr William Wells] that I have perhaps other notions of the art than picture admirers in general—I looked on *pictures* as *things* to be avoided. Connoisseurs looked on them as things to be *imitated,* & this too with a deference and humbleness of submission amounting to a total prostration of mind and original feeling, that must obliterate all future attempts—and serve only to fill the world with abortions . . . Good God, what a sad thing it is that this lovely art—is so wrested to its own destruction—only used to blind our eyes and senses from seeing the sun shine, the

fields bloom, the trees blossom, & to hear the foliage rustle—and old black rubbed-out dirty bits of canvas to take the place of God's own works. (III: 94–5)

Can you give me a print or two of Bonnington's—to convince you, that I don't wholly overlook him. But there is a moral feeling in art as well as everything else—it is not right in a young man to assume great dash—great compleation—without study, or pains. 'Labor with genius' is the price the Gods have set upon excellence. *1830* (IV: 141)

On art, connoisseurship and connoisseurs

The art will go out—there will be no genuine painting in England in 30 years. This is owing to *pictures*—driven into the empty heads of the junior artists by their *owners*—the Governors of the Institution, etc etc. In the early ages of all the arts, the reproductions were more affecting & sublime—owing to the artists being without human exemplars—they were forced to have recourse to nature. In the later ages of Raphael & of Claude, the productions were more perfect (less uncouth) because the artists could then avail themselves or rather *strengthen* themselves by the *experience* only of what was done before to get at nature more surely. They had the *experience* of those who went before—but did not take them at their word—that is, imitate them. *1822* (VI: 101)

You see the wealthy regard artists as only a superior sort of work people to be employed at their caprice: & have no notion of the mind & intellect & independent character of a man entering into his compositions. *1822* (VI: 103)

I could not help being angry when I last wrote to you, about the patrons. Should there be a national gallery (as it is talked) there will be an end to the Art in poor old England, & she will become the same non entity as any other country which has one.
The reason is both plain & certain. The manufacturers of pictures are then made the criterion & not nature. *1822* (VI: 107)

The art pleases by *reminding*, not by *deceiving*. *1823*. Leslie, *Life*, p. 106

Last Tuesday, the finest day that ever was, we went to the Dyke—which is in fact a Roman remains of an embankment, overlooking—perhaps the most grand & affecting natural landscape in the world—and consequently a scene the most unfit for a picture. It is the business of a painter not to contend with nature & put this scene (a valley filled with imagery 50 miles long) on a canvas of a few inches, but to make something out of nothing, in attempting which he must almost of necessity become poetical . . . *1824* (VI: 172)

If artists (creatures of feeling, visionaries) are to be judged of by every day usage—like pound of butter men—they must always be in scrapes and on the wrong side. *1825* (VI: 208)

It appears to me that pictures have been over-valued; held up by a blind admiration as ideal things, and almost as standards by which nature is to be judged rather than the reverse; and this false estimate has been sanctioned by the extravagant epithets that have been applied to painters, as 'the divine', 'the inspired', and so forth. Yet, in reality, what are the most sublime productions of the pencil but selections of some of the forms of nature, and copies of a few of her evanescent effects; and this is the result, not of inspiration, but of long and patient study, under the direction of much good sense. *1836. Lectures,* p. 68

I am anxious that the world should be inclined to look to painters for information on painting. I hope to show that ours is a regularly taught profession; that it is *scientific* as well as *poetic*; that imagination alone never did, and never can, produce works that are to stand by a comparison with *realities. 1836. Lectures,* p. 39

If the *mannerists had never existed, painting would always have been easily understood.* The education of a professed connoisseur being chiefly formed in the picture gallery and auction room, seldom enables him to perceive the vast difference between the mannerist and the genuine painter. To do this requires long and close study, and a constant comparison of the art with nature. So few among the buyers and sellers of pictures possess any knowledge so derived, that the works of the mannerists often bear as large a price in the market as those of the genuine painters. *1836. Lectures,* p. 57

Manner is always seductive. It is more or less an imitation of what has been done already,—therefore always plausible. It promises the short road, the near cut to present fame and emolument, by availing ourselves of the labours of others. It leads to almost immediate reputation, because it is the wonder of the ignorant world. It is always accompanied by certain blandishments, showy and plausible, and which catch the eye. As manner comes by degrees, and is fostered by success in the world, flattery, &c, all painters who would be really great should be perpetually on their guard against it. Nothing but a close and continual observance of nature can protect them from the danger of becoming mannerists. *1836. Lectures,* p. 58

Painting is a science, and should be pursued as an inquiry into the laws of nature. Why, then, may not landscape be considered as a branch of natural philosophy, of which pictures are but the experiments? *1836. Lectures,* p. 69

In such an age as this, painting should be *understood*, not looked on with blind wonder, nor considered only as a poetic aspiration, but as a pursuit, *legitimate, scientific, and mechanical.* [Note found by Leslie.]

On painters

BOUCHER

But the climax of absurdity to which the art may be carried, when led away from nature by fashion, may best be seen in the works of Boucher.

His scenery is a bewildered dream of the picturesque. From cottages adorned with festoons of ivy, sparrow pots, &c, are seen issuing opera dancers with mops, brooms, milk pails, and guitars; children with cocked hats, queues, bag wigs, and swords—cats, poultry, and pigs. The scenery is diversified with winding streams, broken bridges, and water wheels; hedge stakes dancing minuets—and groves bowing and curtsying to each other; the whole leaving the mind in a state of bewilderment and confusion, from which laughter alone can relieve it.

CLAUDE

Claude is a painter whose works have given unalloyed pleasure for two centuries. In Claude's landscape all is lovely—all amiable—all is amenity and repose; the calm sunshine of the heart. He carried landscape, indeed, to perfection, that is, *human perfection.*

Brightness was the characteristic excellence of Claude; brightness, independent on colour, for what colour is there here?

[At this point Constable held up a glass of water.]

The *St. Ursula* in the National Gallery is probably the finest picture of *middle tint* in the world. The sun is rising through a thin mist, which, like the effect of a gauze blind in a room, diffuses the light equally. There are no large dark masses. The darks are in the local colours of the foreground figures, and in small spots; yet as a whole, it is perfect in breadth. There is no evasion in any part of this admirable work, every object is fairly painted in a firm style of execution, yet in no other picture have I seen the evanescent character of light so well expressed.

DAVID

I have seen David's pictures. They are indeed loathsome, & the work would not be tolerable were it not for the urbane & agreeable manners of the Colonel. David seems to have formed his mind in three sources—*the scaffold, the hospital, and a bawdy house.*

David and his contemporaries exhibited their stern and heartless petrifactions of men and women—with trees, rocks, tables, and chairs, all equally bound to the ground by a relentless outline, and destitute of chiaroscuro, the soul and medium of art.

GAINSBOROUGH

The Gainsborough was down when I was at Petworth. I placed it as it suited me—& I now, even now think of it with tears in my eyes. No feeling of landscape ever equalled it. With particulars he had nothing to do, his object was to deliver a fine sentiment—& he has fully accomplished it. Mind—I use no comparisons in my delight of thinking on this lovely canvas—nothing injures ones mind more than such modes of reasoning—no fine things will bear & want comparison with one another—every fine thing is unique

The landscape of Gainsborough is soothing, tender, and affecting. The stillness of noon, the depths of twilight, and the dews and pearls of the morning, are all to be found on the canvases of this most benevolent and kind-hearted man. On looking at them, we find tears in our eyes, and know not what brings them. The lonely haunts of the solitary shepherd,—the return of the rustic with his bill and bundle of wood,—the darksome lane or dell,—the sweet little cottage girl at the spring with her pitcher,—were the things he delighted to paint, and which he painted with exquisite refinement, yet not a refinement beyond nature.

POUSSIN

Every walk of landscape—historic, poetic, classic, and pastoral—were familiar to Nicolo Poussin; and so various were his powers, that each class, in his hands, vies with the rest for preference. He was gifted with a peculiarly sound judgment; tranquil, penetrating, and studious of what was true rather than of what was novel and specious.

Poussin . . . It cannot surely be saying too much when I assert that his landscape is full of religious & moral feeling, & shows how much of his own nature God has implanted in the mind of man.

JACOB VAN RUISDAEL

The landscapes of Ruysdael present the greatest possible contrast to those of Claude, showing how powerfully, from the most opposite directions, genius may command our homage. In Claude's pictures, with scarcely an exception, the sun ever shines. Ruysdael, on the contrary, delighted in, and has made delightful to our eyes, those solemn days, peculiar to his country and ours, when without storm, large rolling clouds scarcely permit a ray of sunlight to break the shades of the forest. By these effects he enveloped the most ordinary scenes in grandeur.

RUBENS

In no other branch of the art is Rubens greater than in landscape; the freshness and dewy light, the joyous and animated character which he has imparted to it, impressing on the level monotonous scenery of Flanders all the richness which belongs to its noblest features. Rubens delighted in phenomena;—rainbows upon a stormy sky—bursts of sunshine—moonlight—meteors—and impetuous torrents mingling their sound with wind and waves.

TURNER

Turner has some golden visions—glorious and beautiful, but they are only visions—yet still they are art—& one could live with such pictures in the house.

List of plates

14. *A country lane. c.* 1809–14. Oil on paper, $8 \times 11\frac{3}{4}$ in. (203×298 mm.) London, Tate Gallery

15. *East Bergholt Church.* Signed and dated 1811. Watercolour, 16×24 in. (406×610 mm.) Port Sunlight, Lady Lever Art Gallery

16. *Landscape near Dedham.* 1815–20. Oil on panel, $5\frac{1}{2} \times 8\frac{3}{4}$ in. (140×220 mm.) From the collection of Mr and Mrs Paul Mellon

17. *Landscape near Dedham.* ?1815–20. Oil on canvas, $8\frac{1}{4} \times 13\frac{1}{4}$ in. (210×335 mm.) From the collection of Mr and Mrs Paul Mellon

18. *Morning in Dedham Vale.* Signed and dated 1811. Oil on canvas, $30\frac{1}{2} \times 50\frac{1}{4}$ in. ($775 \times 1,275$ mm.) Elton Hall, Major Sir R. G. Proby, Bt.

19. *Summer morning.* 1831. Mezzotint by David Lucas after *Dedham Vale from Langham* (Plate 20)

20. *Dedham Vale from Langham.* Inscribed '13 July 1812.' Oil on canvas, $7\frac{1}{2} \times 12\frac{5}{8}$ in. (190×320 mm.) Oxford, Ashmolean Museum

21. *A hayfield near East Bergholt at sunset.* Inscribed 'July 4 1812.' Oil on paper, $6\frac{1}{4} \times 12\frac{1}{2}$ in. (160×318 mm.) London, Victoria and Albert Museum

22. *Wooded landscape at sunset, with a figure. c.* 1802. Oil on canvas, $13 \times 16\frac{1}{2}$ in. (330×420 mm.) From the collection of Mr and Mrs Paul Mellon

23. *Scenes on the Stour.* Dated 1813. Pencil, $3\frac{1}{2} \times 4\frac{3}{4}$ in. (89×120 mm.) London, Victoria and Albert Museum

24. *Dedham: the skylark.* 1813. Pencil, $3\frac{1}{2} \times 4\frac{3}{4}$ in. (89×120 mm.) London, Victoria and Albert Museum

25. *Landscape, with trees and cottages under a lowering sky.* Inscribed 'Augt 6. 1812.' Oil on canvas laid on millboard, $3\frac{5}{8} \times 9\frac{1}{2}$ in. (92×241 mm.) London, Victoria and Albert Museum

26. *Dedham from Langham. c.* 1813. Oil on canvas, $5\frac{3}{8} \times 7\frac{1}{2}$ in. (137×190 mm.) London, Tate Gallery

27. *Flatford Mill.* 1813. Pencil, $3\frac{1}{2} \times 4\frac{3}{4}$ in. (89×120 mm.) London, Victoria and Albert Museum

28. *A woman crossing a footbridge.* 1813. Pencil, $3\frac{1}{2} \times 4\frac{3}{4}$ in. (89×120 mm.) London, Victoria and Albert Museum

29. *Landscape study: cottage and rainbow.* Oil on paper laid on board, $5\frac{1}{2} \times 8\frac{1}{2}$ in. (140×216 mm.) London, Royal Academy of Arts

30. *Landscape and double rainbow.* Inscribed '28 July 1812.' Oil on paper laid on canvas, $13\frac{1}{4} \times 15\frac{1}{8}$ in. (337×384 mm.) London, Victoria and Albert Museum

31. *The mill stream.* 1813–14. Oil on board, $8 \times 11\frac{1}{4}$ in. (203×286 mm.) London, Tate Gallery

32. *The mill stream.* Exhibited 1814. Oil on canvas, 28×36 in. (711×914 mm.) Ipswich, Christchurch Mansion

33. *Flatford Mill from a lock on the Stour. c.* 1811. Oil on canvas, $9\frac{3}{4} \times 11\frac{3}{4}$ in. (248×298 mm.) London, Victoria and Albert Museum

34. *Barges on the Stour, with Dedham Church in the distance. c.* 1811. Oil on paper laid on canvas, $10\frac{1}{4} \times 12\frac{1}{4}$ in. (260×311 mm.) London, Victoria and Albert Museum

35. *Autumn sunset. c.* 1812. Oil on paper and canvas, $6\frac{3}{4} \times 13\frac{1}{4}$ in. (171×336 mm.) London, Victoria and Albert Museum

36. *Golding Constable's flower garden. c.* 1812–16. Oil on canvas, 13×20 in. (330×508 mm.) Ipswich, Christchurch Mansion

37. *Golding Constable's kitchen garden. c.* 1812–16. Oil on canvas, 13×20 in. (330×508 mm.) Ipswich, Christchurch Mansion

38. *Dedham Vale with ploughmen. c.* 1815. Oil on canvas, $16\frac{3}{4} \times 30$ in. (425×760 mm.) From the collection of Mr and Mrs Paul Mellon

39. *Boat-building near Flatford Mill.* 1815. Oil on canvas, $20 \times 24\frac{1}{2}$ in. (508×616 mm.) London, Victoria and Albert Museum

40. *The Stour Valley and Dedham Church.* Dated 1814. Oil on canvas, $15\frac{1}{2} \times 22$ in. (394×559 mm.) Leeds, City Art Galleries

41. *The Stour Valley and Dedham Church.* 1814–15. Oil on canvas, $21\frac{1}{4} \times 30\frac{3}{4}$ in. (552×781 mm.) Boston, Museum of Fine Arts

42. *Coast scene. c.* 1816. Oil on millboard, $7\frac{1}{8} \times 13$ in. (180×330 mm.) Oxford, Ashmolean Museum

43. *Harwich: the Low lighthouse and Beda Beacon Hill. c.* 1819. Oil on canvas, $12\frac{7}{8} \times 19\frac{3}{4}$ in. (327×502 mm.) London, Tate Gallery

44. *Near Stoke-by-Nayland*(?) *c.* 1820. Oil on canvas, $14 \times 17\frac{1}{2}$ in. (356×444 mm.) London, Tate Gallery

45. *Looking over to Harrow. c.* 1820. Oil on canvas, $13\frac{1}{2} \times 17$ in. (343×432 mm.) From the collection of Mr and Mrs Paul Mellon

46. *Dedham Lock and Mill. c.* 1810–15. Oil on paper, $7\frac{1}{8} \times 9\frac{3}{4}$ in. (181×248 mm.) London, Victoria and Albert Museum

47. *Dedham Lock and Mill.* Signed and dated 1820. Oil on canvas, $21\frac{1}{8} \times 30$ in. (537×762 mm.) London, Victoria and Albert Museum

48. *Hampstead Heath. c.* 1820. Oil on canvas, $15 \times 26\frac{1}{8}$ in. (381×664 mm.) London, Tate Gallery

49. *Hampstead Heath. c.* 1820. Oil on canvas, $21\frac{3}{4} \times 30\frac{1}{4}$ in. (552×768 mm.) Cambridge, Fitzwilliam Museum

50. *Malvern Hall.* 1820–1. Oil on canvas, $21\frac{3}{8} \times 30\frac{3}{4}$ in. (542×782 mm.) Williamstown, Massachusetts, Sterling and Francine Clark Art Institute

51. *Wivenhoe Park, Essex.* Exhibited 1817. Oil on canvas, $22\frac{1}{8} \times 39\frac{7}{8}$ in. ($561 \times 1,012$ mm.) Washington, D.C., National Gallery of Art (Widener Collection)

52. Detail from *The White Horse* (Plate 53)

53. *The White Horse.* Signed and dated 1819. Oil on canvas, $51\frac{3}{4} \times 74\frac{1}{8}$ in. ($1,314 \times 1,883$ mm.) New York, The Frick Collection

54. *Landscape sketch ('Stratford Mill').* 1819–20. Oil on canvas, $12 \times 16\frac{1}{2}$ in. (305×420 mm.) England, Private Collection

55. *Stratford Mill.* Exhibited 1820. Oil on canvas, 50×72 in. ($1,270 \times 1,829$ mm.) England, Private Collection

56. *Weymouth Bay.* ?1816. Oil on millboard, $8 \times 9\frac{3}{4}$ in. (203×247 mm.) London, Victoria and Albert Museum

57. *Weymouth Bay. c.* 1817. Oil on canvas, $20\frac{3}{4} \times 29\frac{1}{2}$ in. (527×749 mm.) London, National Gallery

58. *Flatford Mill, on the River Stour.* Signed and dated 1817. Oil on canvas, 40×50 in. ($1,016 \times 1,245$ mm.) London, Tate Gallery

59. *Landscape study: Hampstead looking west.* 1820. Oil on paper on canvas, $10 \times 11\frac{3}{4}$ in. (254×298 mm.) London, Royal Academy of Arts

60. *Cloud study: horizon of trees.* 1821. Oil on paper on panel, $9\frac{3}{4} \times 11\frac{1}{2}$ in. (248×292 mm.) London, Royal Academy of Arts

61. *Cloud study, sunset. c.* 1820–2. Oil on paper on millboard, $6 \times 9\frac{1}{2}$ in. (152×240 mm.) From the collection of Mr and Mrs Paul Mellon

62. *Study of cumulus clouds.* Dated 1822. Oil on paper on panel, $11\frac{1}{4} \times 19$ in. (285×485 mm.) From the collection of Mr and Mrs Paul Mellon

63. *Strato-cumulus cloud.* Dated 1821. Oil on paper on board, $9\frac{3}{4} \times 11\frac{7}{8}$ in. (247×302 mm.) From the collection of Mr and Mrs Paul Mellon

64. *Dark cloud study.* Dated 1821. Oil on paper on panel, $8\frac{3}{8} \times 11\frac{1}{2}$ in. (212×290 mm.) From the collection of Mr and Mrs Paul Mellon

65. *Evening landscape after rain. c.* 1820–1. Oil on paper on panel, $7 \times 9\frac{1}{2}$ in. (177×240 mm.) From the collection of Mr and Mrs Paul Mellon

66. *Study of cirrus clouds. c.* 1822. Oil on paper, $4\frac{1}{2} \times 7$ in. (114×178 mm.) London, Victoria and Albert Museum

67. *Study of cumulus clouds.* Dated 1822. Oil on paper on panel, $11\frac{1}{4} \times 19$ in. (285×485 mm.) From the collection of Mr and Mrs Paul Mellon

68. *Branch Hill Pond, evening. c.* 1822. Oil on paper, $9 \times 7\frac{1}{2}$ in. (229×190 mm.) London, Victoria and Albert Museum

69. *Hampstead after a thunderstorm. c.* 1822. Oil on paper on panel, $6\frac{1}{8} \times 7\frac{5}{8}$ in. (155×195 mm.) From the collection of Mr and Mrs Paul Mellon

70. *Landscape sketch ('The Hay Wain'). c.* 1821. Oil on panel, $4\frac{7}{8} \times 7$ in. (125×180 mm.) From the collection of Mr and Mrs Paul Mellon

71. *Willy Lott's house. c.* 1810–15. Oil on paper, $9\frac{1}{2} \times 7\frac{1}{8}$ in. (241×181 mm.) London, Victoria and Albert Museum

72. *The Hay Wain.* Signed and dated 1821. Oil on canvas, 51¼ × 73 in. (1,305 × 1,855 mm.) London, National Gallery
73. Detail from *The Cornfield* (Plate 119)
74. *Landscape sketch* ('*The Hay Wain*'). 1820–1. Oil on canvas, 54 × 74 in. (1,370 × 1,880 mm.) London, Victoria and Albert Museum
75. *Sketch at Hampstead: evening.* 1820. Oil on card, 6¼ × 8 in. (159 × 203 mm.) London, Victoria and Albert Museum
76. *A sandbank at Hampstead Heath.* Dated 1821. Oil on paper, 9¾ × 11¾ in. (248 × 298 mm.) London, Victoria and Albert Museum
77. *Study of tree trunks. c.* 1821. Oil on paper, 9¾ × 11½ in. (248 × 292 mm.) London, Victoria and Albert Museum
78. *Study of the trunk of an elm tree. c.* 1821. Oil on paper, 12 × 9¾ in. (306 × 248 mm.) London, Victoria and Albert Museum
79. *Landscape sketch* (*View on the Stour near Dedham*). 1821–2. Oil on canvas, 51 × 73 in. (1,295 × 1,854 mm.) London, Holloway College
80. *View on the Stour near Dedham.* Exhibited 1822. Oil on canvas, 51 × 74 in. (1,295 × 1,880 mm.) San Marino, California, Henry E. Huntington Library and Art Gallery
81. *Salisbury Cathedral and the Close.* Dated 1820. Oil on canvas, 9⅞ × 11⅞ in. (251 × 302 mm.) London, Victoria and Albert Museum
82. *Salisbury Cathedral from the river.* 1820s. Oil on canvas, 20¾ × 30¼ in. (525 × 770 mm.) London, National Gallery
83. *Salisbury Cathedral from the south-west.* Inscribed 'Salisbury Cathedral Sept. 11 & 12—1811—S.W. view—.' Black and white chalk on grey paper, 7⅝ × 11¾ in. (195 × 299 mm.) London, Victoria and Albert Museum
84. *Salisbury: the Close wall. c.* 1821. Oil on canvas, 23¾ × 20¼ in. (603 × 514 mm.) Cambridge, Fitzwilliam Museum
85. *Salisbury Cathedral from the Bishop's Grounds.* Signed and dated 1823. Oil on canvas, 34½ × 44 in. (876 × 1,118 mm.) London, Victoria and Albert Museum
86. *A view of Salisbury Cathedral.* ?1820–2. Oil on canvas, 28¾ × 36 in. (730 × 910 mm.) Washington, D.C., National Gallery of Art
87. *Landscape sketch* (*Salisbury Cathedral from the Bishop's Grounds*). *c.* 1823. Oil on canvas, 24 × 29 in. (610 × 737 mm.) Birmingham, City Museum and Art Gallery
88. *Branch Hill Pond, Hampstead.* Dated 1819. Oil on canvas, 10 × 11⅞ in. (254 × 300 mm.) London, Victoria and Albert Museum
89. *Hampstead Heath at sunset, looking towards Harrow.* ?1820–5. Oil on canvas, 11⅝ × 19 in. (295 × 485 mm.) From the collection of Mr and Mrs Paul Mellon
90. *Hampstead Heath.* 1820–5. Oil on canvas, 25 × 38 in. (635 × 965 mm.) Glasgow, Art Gallery and Museum
91. *Sketch of the Thames and Waterloo Bridge.* ?1820–4. Paper on canvas, 8¼ × 12½ in. (210 × 317 mm.) London, Royal Academy of Arts
92. *Waterloo Bridge from the west. c.* 1819. Pencil, 12 × 16⅛ in. (306 × 410 mm.) London, Victoria and Albert Museum
93. *The Thames and Waterloo Bridge. c.* 1824. Oil on canvas, 21¾ × 30¾ in. (552 × 781 mm.) Cincinnati, Ohio, Art Museum
94. *Summer afternoon after a shower. c.* 1824–5. Oil on canvas, 13⅝ × 17½ in. (346 × 435 mm.) London, Tate Gallery
95. *Trees at Hampstead: the path to the Church.* ?1821. Oil on canvas, 36 × 28½ in. (914 × 724 mm.) London, Victoria and Albert Museum
96. *Landscape sketch* ('*The Leaping Horse*'). *c.* 1824. Oil on wood, 6¾ × 9 in. (171 × 229 mm.) London, Tate Gallery
97. *Landscape sketch* ('*The Leaping Horse*'). 1824–5. Oil on canvas, 51 × 74 in. (1,294 × 1,880 mm.) London, Victoria and Albert Museum
98. *Drawing for 'The Leaping Horse'.* Chalk and ink wash, 8 × 11⅞ in. (203 × 302 mm.) London, British Museum
99. *The Leaping Horse.* Exhibited 1825. Oil on canvas, 56 × 73¾ in. (1,422 × 1,873 mm.) London, Royal Academy of Arts
100. *Landscape sketch* ('*The Lock*'). 1823–4. Oil on canvas, 55¼ × 48¼ in. (1,416 × 1,225 mm.) Philadelphia, Museum of Art
101. *A lock on the Stour.* Inscribed '11 Oct. 1827.' Pencil, 8⅞ × 13⅛ in. (224 × 332 mm.) London, Victoria and Albert Museum

102. *A boat passing a lock*. Signed and dated 1826. 40×50 in. (1,016×1,270 mm.) London, Royal Academy of Arts
103. *Bardon Hill*. 1823. Oil on canvas on board, 8×10 in. (202×255 mm.) From the collection of Mr and Mrs Paul Mellon
104. *A cottage and lane at Langham ('The Glebe Farm')*. ?1810–15. Oil on canvas, 7¾×11 in. (197×280 mm.) London, Victoria and Albert Museum
105. *The Glebe Farm. c.* 1827. Oil on canvas, 25⅝×37⅝ in. (651×956 mm.) London, Tate Gallery
106. *Dedham Vale*. 1802. Oil on canvas, 17⅛×13½ in. (435×344 mm.) London, Victoria and Albert Museum
107. *Study of Foliage*. 1820–30. Oil on paper, 6×9½ in. (152×242 mm.) London, Victoria and Albert Museum
108. *Dedham Vale*. Exhibited 1828. Oil on canvas, 55½×48 in. (1,410×1,219 mm.) Edinburgh, National Gallery of Scotland
109. *Seascape study with rain clouds (near Brighton?). c.* 1824–5. Oil on paper on canvas, 8⅝×12¼ in. (220×310 mm.) London, Royal Academy of Arts
110. *A windmill near Brighton*. Dated 1824. Oil on paper, 6⅜ × 12⅛ in. (162×308 mm.) London, Victoria and Albert Museum
111. *Brighton Beach, with colliers*. Dated 1824. Oil on paper, 5⅞×9¾ in. (149×248 mm.) London, Victoria and Albert Museum
112. *The road into Gillingham, Dorset*. 1820. Pencil, 4½×7¼ in. (115×185 mm.) London Victoria and Albert Museum
113. *Parham Mill, Gillingham*. 1826. Oil on canvas, 19¾×23¾ in. (500×605 mm.) From the collection of Mr and Mrs Paul Mellon
114. *A watermill at Gillingham*. Exhibited 1827. Oil on canvas, 24¾×20½ in. (630×520 mm.) London, Victoria and Albert Museum
115. *Hove Beach. c.* 1824. Oil on paper laid on canvas, 12½×19½ in. (317×495 mm.) London, Victoria and Albert Museum
116. *Sketch ('The Marine Parade and Chain Pier, Brighton'). c.* 1824. 24×39 in. (610×991 mm.) Philadelphia, Museum of Art
117. *The Marine Parade and Chain Pier, Brighton*. Exhibited 1827. Oil on canvas, 50×72¾ in. (1,270×1,848 mm.) London, Tate Gallery
118. *Landscape sketch ('The Cornfield')*. 1825–6. Oil on canvas, 23½×19⅜ in. (597×492 mm.) Birmingham, City Museum and Art Gallery (on loan)
119. *The Cornfield*. Signed and dated 1826. Oil on canvas, 56¼×48 in. (1,429×1,225 mm.) London, National Gallery
120. *Landscape sketch (Hadleigh Castle)*. ?1828–9. Oil on cardboard, 7⅞×9½ in. (200×240 mm.) From the collection of Mr and Mrs Paul Mellon
121. *Hadleigh Castle*. Exhibited 1829. Oil on canvas, 48×64¾ in. (1,220×1,645 mm.) From the collection of Mr and Mrs Paul Mellon
122. *Landscape sketch (Hadleigh Castle)*. ?1828–9. Oil on canvas, 48½×65¾ in. (1,232×1,670 mm.) London, Tate Gallery
123. *Hadleigh Castle*. 1814. Pencil, 3¼×4⅜ in. (81×111 mm.) London, Victoria and Albert Museum
124. *Coast at Brighton, stormy day*. Inscribed 'Brighton, Sunday Evening, July 20, 1828.' Oil on canvas, 5¾×10 in. (145×255 mm.) From the collection of Mr and Mrs Paul Mellon
125. *Waterloo Bridge from Whitehall Stairs. c.* 1819. Oil on millboard, 11½×19 in. (292×483 mm.) London, Victoria and Albert Museum
126. *Trees and a stretch of water on the Stour (?). c.* 1830–6. Pencil and sepia wash, 8×6⅜ in. (205×162 mm.) London, Victoria and Albert Museum
127. *The Dell in Helmingham Park*. Exhibited 1830. Oil on canvas, 44⅝×51½ in. (1,133×1,308 mm.) Kansas City, Missouri, Nelson Gallery–Atkins Museum
128. *Coast scene, Brighton (?): evening. c.* 1828. Oil on paper, 7⅞×9¾ in. (200×248 mm.) London, Victoria and Albert Museum
129. *The sea near Brighton*. 1826. Oil on paper, 6¾×9⅜ in. (171×238 mm.) London, Tate Gallery
130. *The Dell in Helmingham Park*. ?1830. Oil on canvas, 25×29⅞ in. (635×759 mm.) London, Tate Gallery

131. *Dedham, a lock.* 1820–30. Oil on paper on panel, $4\frac{1}{2} \times 6\frac{1}{2}$ in. (115×165 mm.) From the collection of Mr and Mrs Paul Mellon

132. *Dedham, a lock. c.* 1828. Oil on paper, $6\frac{1}{2} \times 10$ in. (165×254 mm.) London, Tate Gallery

133. *Hampstead Heath in a storm.* Watercolour, $7\frac{3}{4} \times 12\frac{3}{4}$ in. (197×324 mm.) London, British Museum

134. *Hampstead Heath: Branch Hill Pond.* 1828. Oil on canvas, $23\frac{1}{2} \times 30\frac{1}{2}$ in. (596×776 mm.) London, Victoria and Albert Museum

135. *The cottage in a cornfield.* Exhibited 1833. Oil on canvas, $24\frac{1}{2} \times 20\frac{1}{4}$ in. (620×515 mm.) London, Victoria and Albert Museum

136. Detail from *Flatford Mill* (Plate 58)

137. Detail from *The Leaping Horse* (Plate 98)

138. Text to 'Spring', from *English Landscape Scenery,* corrected by Constable

139. *Summer evening.* Mezzotint by David Lucas after Constable

140. *A view at Salisbury, from the library of Archdeacon Fisher's house.* Dated 1829. Oil on paper, $6\frac{3}{8} \times 12$ in. (162×305 mm.) London, Victoria and Albert Museum

141. *Salisbury Cathedral from the north-west, with cottages.* 1829. Pen and bistre ink and watercolour, $9\frac{1}{4} \times 13\frac{1}{4}$ in. (234×337 mm.) London, Victoria and Albert Museum

142. *Old Sarum.* 1829. Oil on thin card, $5\frac{5}{8} \times 8\frac{1}{4}$ in. (143×210 mm.) London, Victoria and Albert Museum

143. *Old Sarum.* Mezzotint by David Lucas after *Old Sarum* (Plate 142)

144. *Stonehenge.* Watercolour over black chalk, $6\frac{5}{8} \times 9\frac{7}{8}$ in. (168×249 mm.) London, British Museum

145. *Stonehenge.* 1836. Watercolour, $15\frac{1}{4} \times 23\frac{1}{4}$ in. (387×591 mm.) London, Victoria and Albert Museum

146. *Stormy effect, Littlehampton.* Inscribed 'Little Hampton July 8 1835.' Watercolour, $4\frac{1}{2} \times 7\frac{1}{4}$ in. (114×184 mm.) London, British Museum

147. *Tillington Church.* Inscribed 'Tillington Sep 17 1834.' Watercolour, $9\frac{1}{8} \times 10\frac{1}{2}$ in. (232×267 mm.) London, British Museum

148. *Landscape sketch (Salisbury Cathedral from the meadows).* Oil on canvas, $53\frac{1}{2} \times 74$ in. ($1,359 \times 1,880$ mm.) London, Guildhall Art Gallery

149. *Water-meadows near Salisbury.* 1829. Oil on canvas, $18 \times 21\frac{3}{4}$ in. (457×553 mm.) London, Victoria and Albert Museum

150. *Salisbury Cathedral from the meadows.* Exhibited 1831. Oil on canvas, $59\frac{3}{4} \times 74\frac{3}{4}$ in. ($1,518 \times 1,899$ mm.) Lord Ashton of Hyde

151. *The Grove, Hampstead (The Admiral's House).* Exhibited 1832? Oil on canvas, $14 \times 11\frac{7}{8}$ in. (356×302 mm.) London, Tate Gallery

152. *The ruins of Cowdray Castle.* Inscribed 'Sep 14 1834.' Watercolour over pencil, $10\frac{1}{2} \times 10\frac{7}{8}$ in. (267×276 mm.) London, British Museum

153. *A sluice, on the Stour* (?). ?1830–6. Oil on paper laid on canvas, $8\frac{5}{8} \times 7\frac{3}{8}$ in. (219×187 mm.) London, Victoria and Albert Museum

154. *Whitehall Stairs: the opening of Waterloo Bridge.* 1832. Oil on canvas, $53 \times 86\frac{1}{2}$ in. ($1,346 \times 2,197$ mm.) Private Collection

155. *The Cenotaph at Coleorton.* Inscribed 'Coleorton Hall. Novr. 28. 1823.' Pencil and grey wash, $10\frac{1}{4} \times 7\frac{1}{8}$ in. (260×181 mm.) London, Victoria and Albert Museum

156. *The Cenotaph at Coleorton.* Exhibited 1836. Oil on canvas, $52 \times 42\frac{3}{4}$ in. ($1,321 \times 1,086$ mm.) London, National Gallery

157. *A view of London, with Sir Richard Steele's house.* Exhibited 1832. Oil on canvas, $8\frac{1}{4} \times 11\frac{1}{4}$ in. (210×286 mm.) From the collection of Mr and Mrs Paul Mellon

158. *Hampstead Heath with a rainbow.* 1836. Oil on canvas, 20×30 in. (508×762 mm.) London, Tate Gallery

159. *Landscape sketch ('The Valley Farm').* c. 1835. Oil on canvas, $10 \times 8\frac{1}{4}$ in. (254×210 mm.) London, Victoria and Albert Museum

160. *The Valley Farm.* Exhibited 1835. Oil on canvas, $58\frac{1}{2} \times 49\frac{1}{2}$ in. ($1,486 \times 1,257$ mm.) London, Tate Gallery

161. *A river scene, with a farmhouse near the water's edge. c.* 1830–6. Oil on canvas, 10×13¾ in. (254×349 mm.) London, Victoria and Albert Museum
162. *On the river Stour.* ?1830–7. Oil on canvas, 24×31 in. (610×787 mm.) Washington, D.C., The Phillips Collection
163. *Cottage at East Bergholt.* ?1835–7. Oil on canvas, 33×43½ in. (838×1,105 mm.) Port Sunlight, Lady Lever Art Gallery
164. *A tree in a hollow, Fittleworth.* Inscribed 'Fittleworth 16 July 1835.' Pencil, 4½×7⅜ in. (115×188 mm.) London, Victoria and Albert Museum
165. *Stoke-by-Nayland.* 1830–6. Oil on canvas, 49×66 in. (1,244×1,676 mm.) Chicago, Art Institute of Chicago
166. *The ruins of Maison Dieu, Arundel.* Inscribed 'Arundel July 8th. 1835 Maison Dieu.' Pencil, 8⅝×11 in. (220×281 mm.) London, Victoria and Albert Museum
167. *Arundel Castle.* Inscribed '19th. July 1835. Arundel—dear Minna's birthday.' Pencil, 4½×7⅜ in. (115×188 mm.) London, Victoria and Albert Museum
168. *Arundel Mill and Castle.* Exhibited 1837. 28⅝×39⅝ in. (727×1,006 mm.) Toledo, Ohio, Museum of Art

Works by earlier artists who influenced Constable

169. AELBERT CUYP (1620–91): *Hilly landscape near Ubbergen.* Panel, 17×20 in. (425×510 mm.) Cardiff, National Museum of Wales
170. RUBENS (1577–1640): *A landscape with a shepherd and his flock. c.* 1638. Oil on wood, 19½×32⅞ in. (495×835 mm.) London, National Gallery
171. RUBENS (1577–1640): *An autumn landscape with a view of Het Steen.* 1636. Oil on wood, 51¾×90½ in. (1,318×2,299 mm.) London, National Gallery
172. JACOB VAN RUISDAEL (1628/9–82): *A bleaching ground.* ?1650, Oil on wood, 20¾×26¾ in. (525×678 mm.) London, National Gallery
173. GASPARD DUGHET (1615–75): *Landscape: Abraham and Isaac.* Oil on canvas, 60×76¾ in. (1,525×1,950 mm.) London, National Gallery
174. CLAUDE (1600–82): *Landscape: Narcissus.* 1644. Oil on canvas, 37¼×46½ in. (945×1,180 mm.) London, National Gallery
175. CLAUDE (1600–82): *Landscape: Hagar and the Angel.* Oil on canvas on wood, 20¾×17¼ in. (520×440 mm.) London, National Gallery
176. THOMAS GAINSBOROUGH (1727–88): *The Market Cart.* 1786–7. Oil on canvas, 72½×60¼ in. (1,841×1,530 mm.) London, Tate Gallery
177. THOMAS GAINSBOROUGH (1727–88): *Gainsborough's Forest ('Cornard Wood'). c.* 1748. Oil on canvas, 48×61 in. (1,220×1,550 mm.) London, National Gallery

Select bibliography

CONSIDERING THE QUALITY of Constable's art and his historical importance, the literature devoted to him is small. There is no complete catalogue of his surviving works, no detailed modern biography and no book in print, apart from the present one, in which an extensive range of his pictures is effectively reproduced. The list of books which follows therefore, although not exhaustive, includes most of the more substantial and informative publications.

Primary sources

John Constable's Correspondence, edited and annotated by R. B. Beckett. These six volumes published by the Suffolk Records Society, are as follows:

 I. *The Family at East Bergholt 1807–1837*, 1962 (4)

 II. *Early Friends and Maria Bicknell (Mrs Constable)* 1964 (6)

 III. *The Correspondence with C. R. Leslie, R.A.* 1965 (8)

 IV. *Patrons, Dealers and Fellow Artists* 1966 (10)

 V. *Various Friends, with Charles Boner and the Artist's Children* 1967 (11)

 VI. *The Fishers* 1968 (12)

(The numbers in brackets are those given to these volumes in the general sequence of the Suffolk Records Society publications)

John Constable's Discourses, edited by R. B. Beckett, 1970. This contains the texts belonging to the Constable–Lucas publication, *Various Subjects of Landscape Characteristic of English Scenery*, and the notes on the artist's lectures on landscape painting, being mainly those taken down by Leslie. This publication, published by the Suffolk Records Society (No 14) in 1970, is a supplement to the volumes mentioned above.

The Published Mezzotints of David Lucas after John Constable, edited and introduced by the Hon. Andrew Shirley, 1930. Besides reproducing and cataloguing all the mezzotints, this volume includes the letters which passed between the artists, a superior edition of which is to be found in Beckett, *John Constable's Correspondence*, Vol. IV.

Memoirs of the Life of John Constable composed chiefly of his Letters, by C. R. Leslie, R.A. This work was originally published in 1843, but it is the second and enlarged edition of 1845 which has been the basis of the later reprints. Of these the most comprehensive is that 'revised and enlarged' by the Hon. Andrew Shirley, with 160 plates (1937). Another useful edition is that edited by Jonathan Mayne with 72 plates (Phaidon, 1951).

Secondary sources

Catalogue of the Constable Collection in the Victoria and Albert Museum, by Graham Reynolds, 1960. All the 597 paintings and drawings in the Museum collection are here reproduced.

Constable and his Influence on Landscape Painting by Sir Charles Holmes, 1902. Still the only full-length critical study of Constable's artistic development.

Constable, the Natural Painter, by Graham Reynolds, 1965. This is by far the best compact study of the artist's life and work to have appeared since Leslie's *Memoirs*.

Specialized studies

Among the more specialized studies, the following are particularly useful:

John Constable's Clouds, by Kurt Badt, 1950.

Article by Michael Kitson, 'John Constable, 1810–1816: a Chronological Study', *Journal of the Warburg and Courtauld Institutes*, Vol. xx, 1957.

Constable's Writings on Art, by Louis Hawes. This unpublished doctoral thesis, of which there is a copy in the Victoria and Albert Museum Library, treats Constable's statements about painting in relation to his pictures and to European art theory.

Other detailed studies are mentioned at the appropriate point in the text of this volume.

Collections of work by Constable

Although there are important examples elsewhere, especially in American public and private collections, the largest body of works by the artist are to be seen in London. The Victoria and Albert Museum, the National Gallery, the Tate Gallery and the Royal Academy all contain numerous works given or bequeathed by the painter's daughter, Isabel, as well as important bequests by such nineteenth-century collectors as John Sheepshanks, Robert Vernon and Henry Vaughan.

Index of works

Index of names

Constable

Paintings, drawings and watercolours